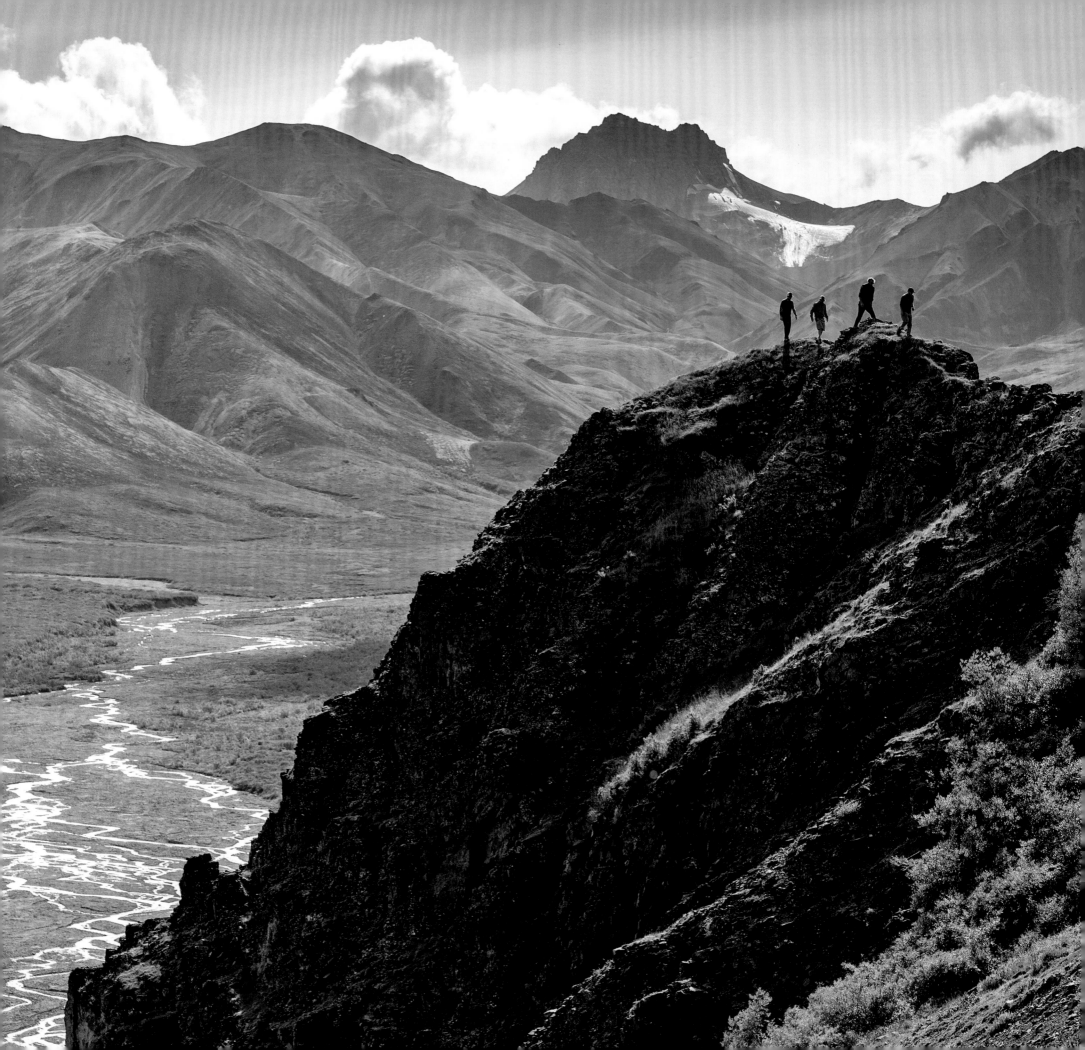

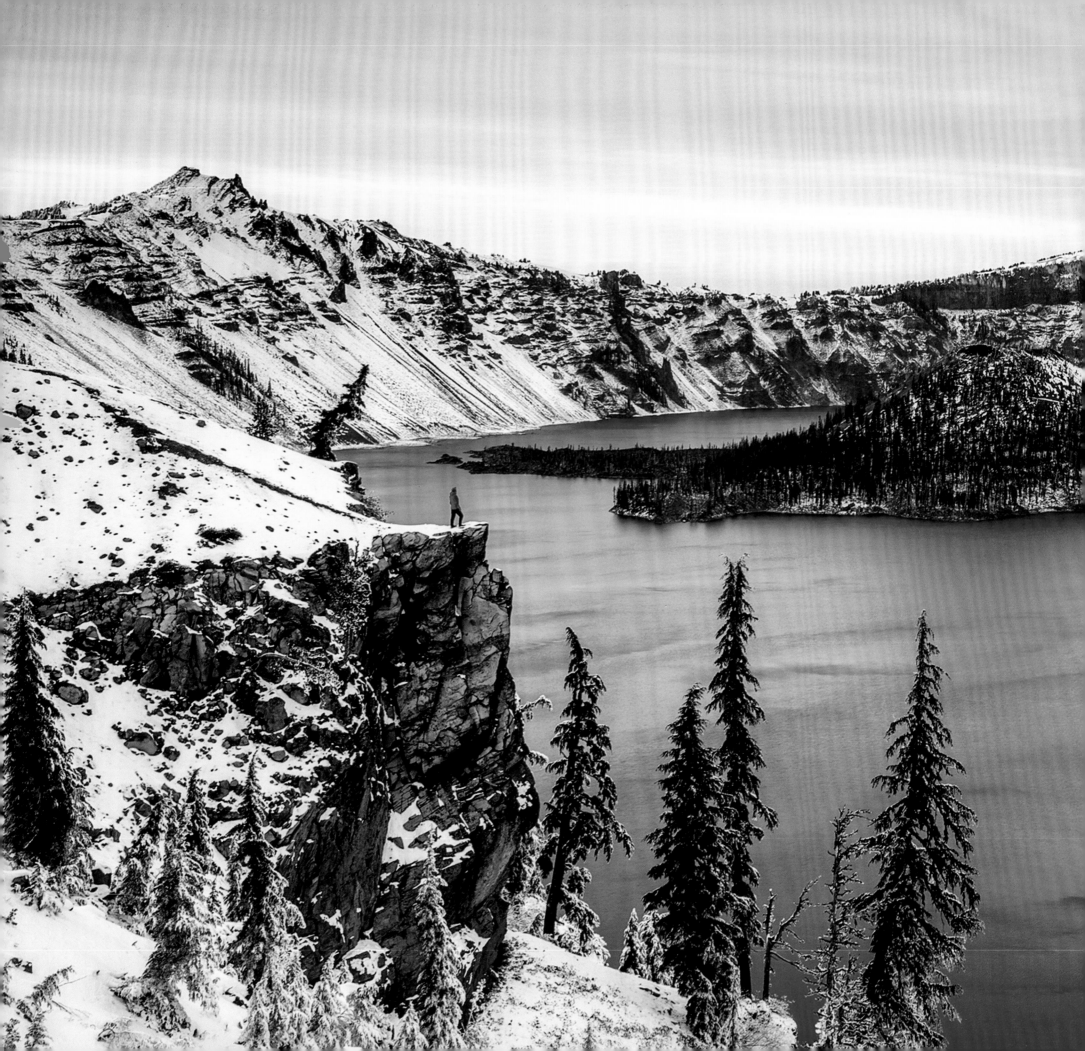

October 2015

Dear Bill and Gail,

No book can truly capture the stunning beauty of our national parks, but this one comes close. After you look through the pages, I am sure you will understand why Ian is considered the leading national park photographer of our time. The hundreds of photographs are the perfect companion to the essays which pay tribute not only to the parks, but all who visit, work for, and protect these places of wonder and inspiration.

I was proud to contribute to this celebration of the national park's past and preview of its future. And it has been an honor to work with you to protect and enhance our national parks. I know NPCA is in good hands.

Best,

NATIONAL
PARKS
CONSERVATION
ASSOCIATION

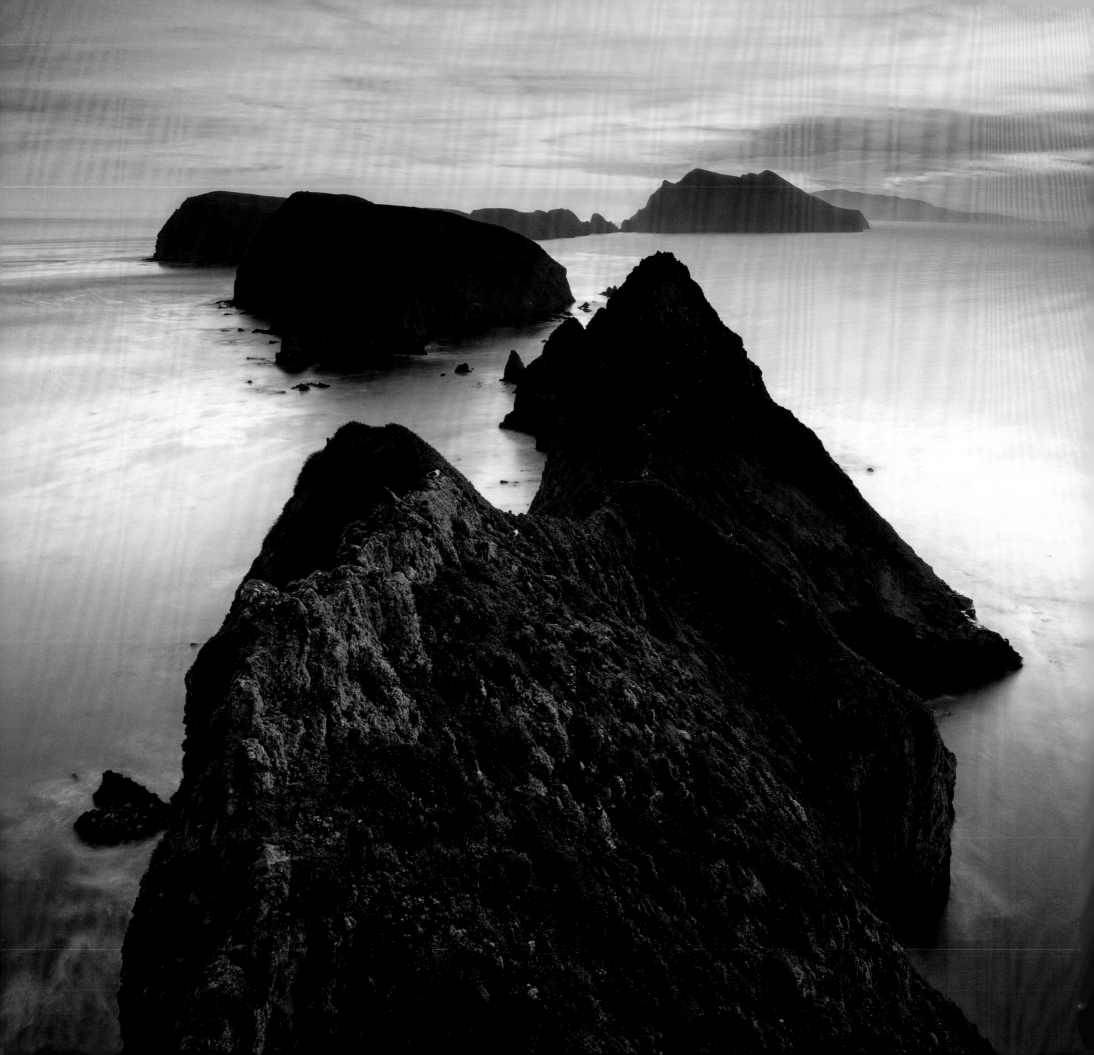

THE NATIONAL PARKS

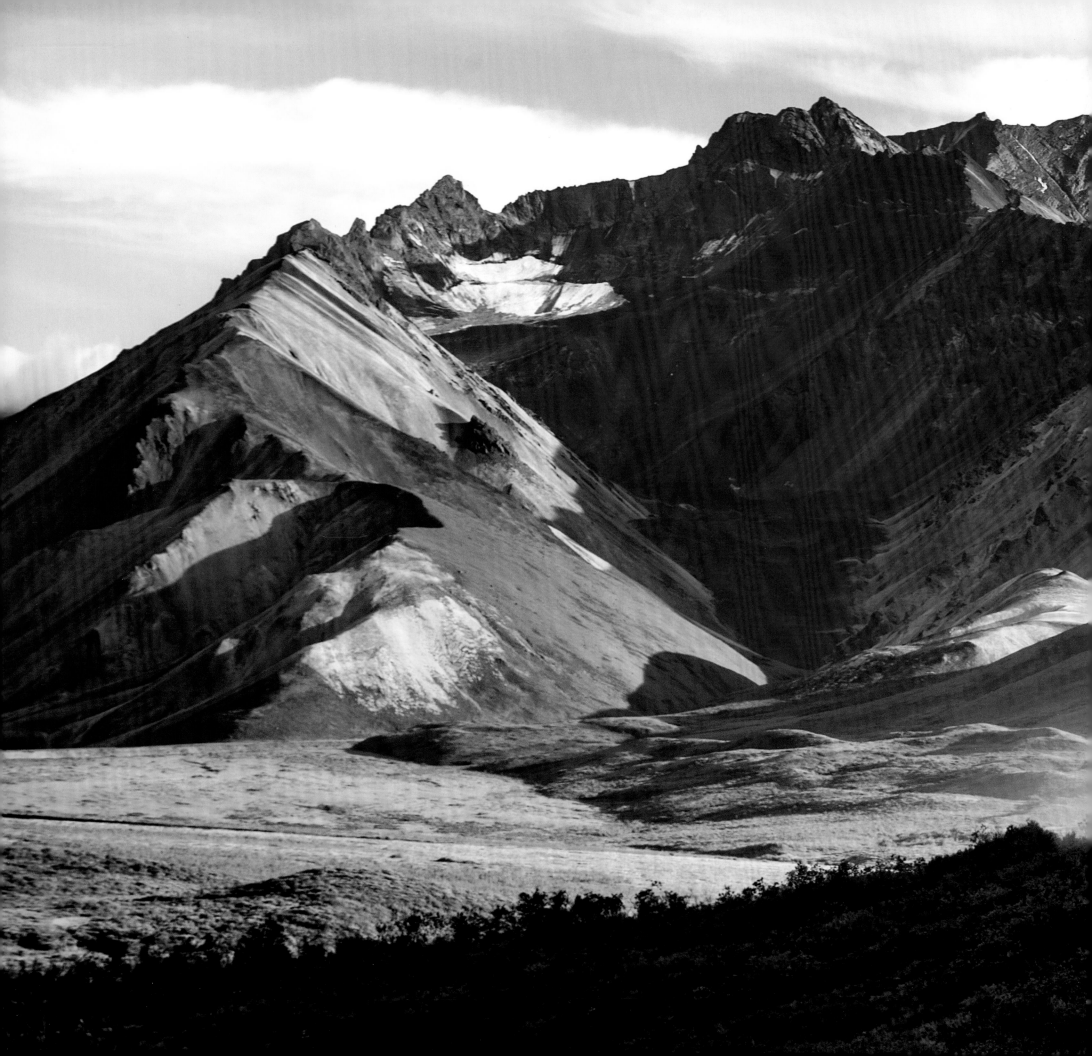

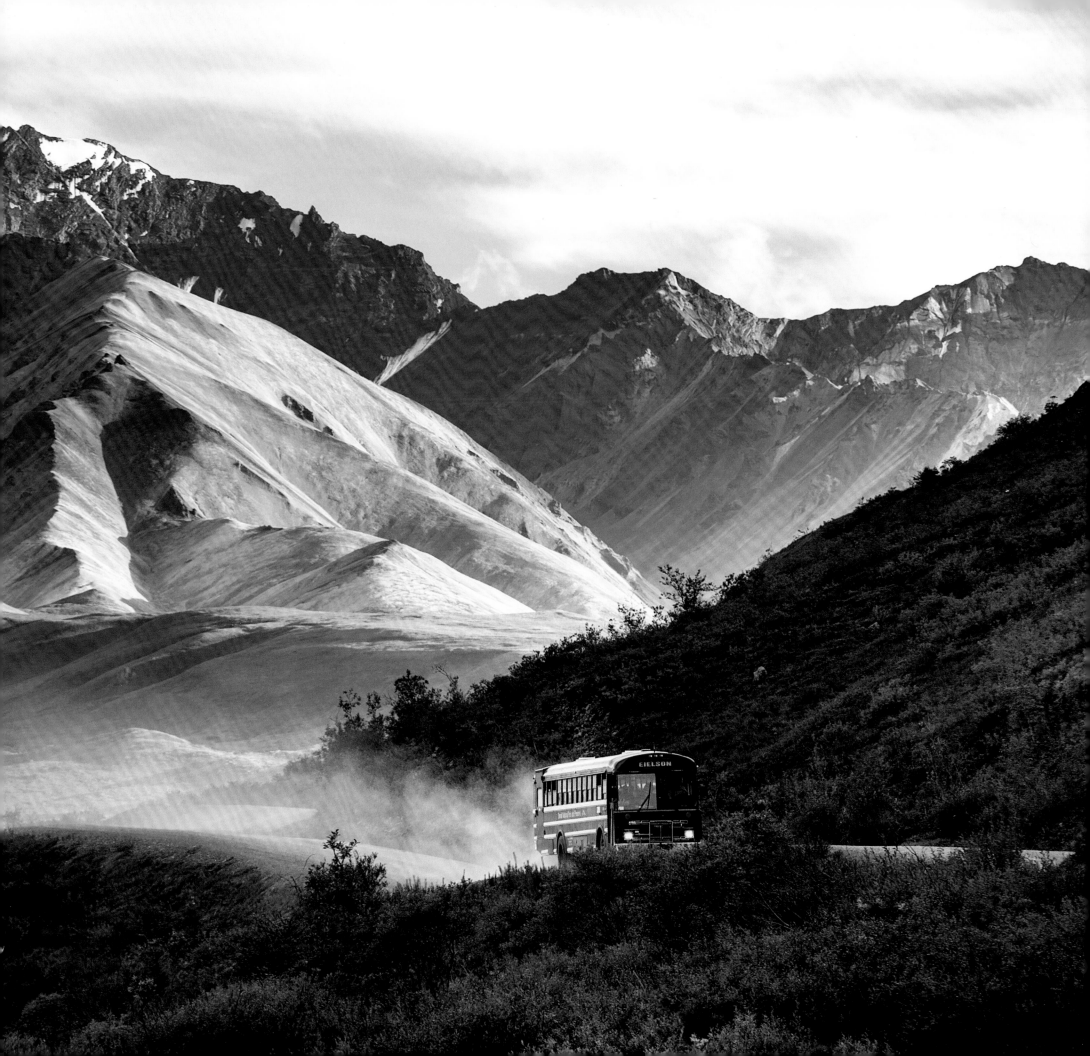

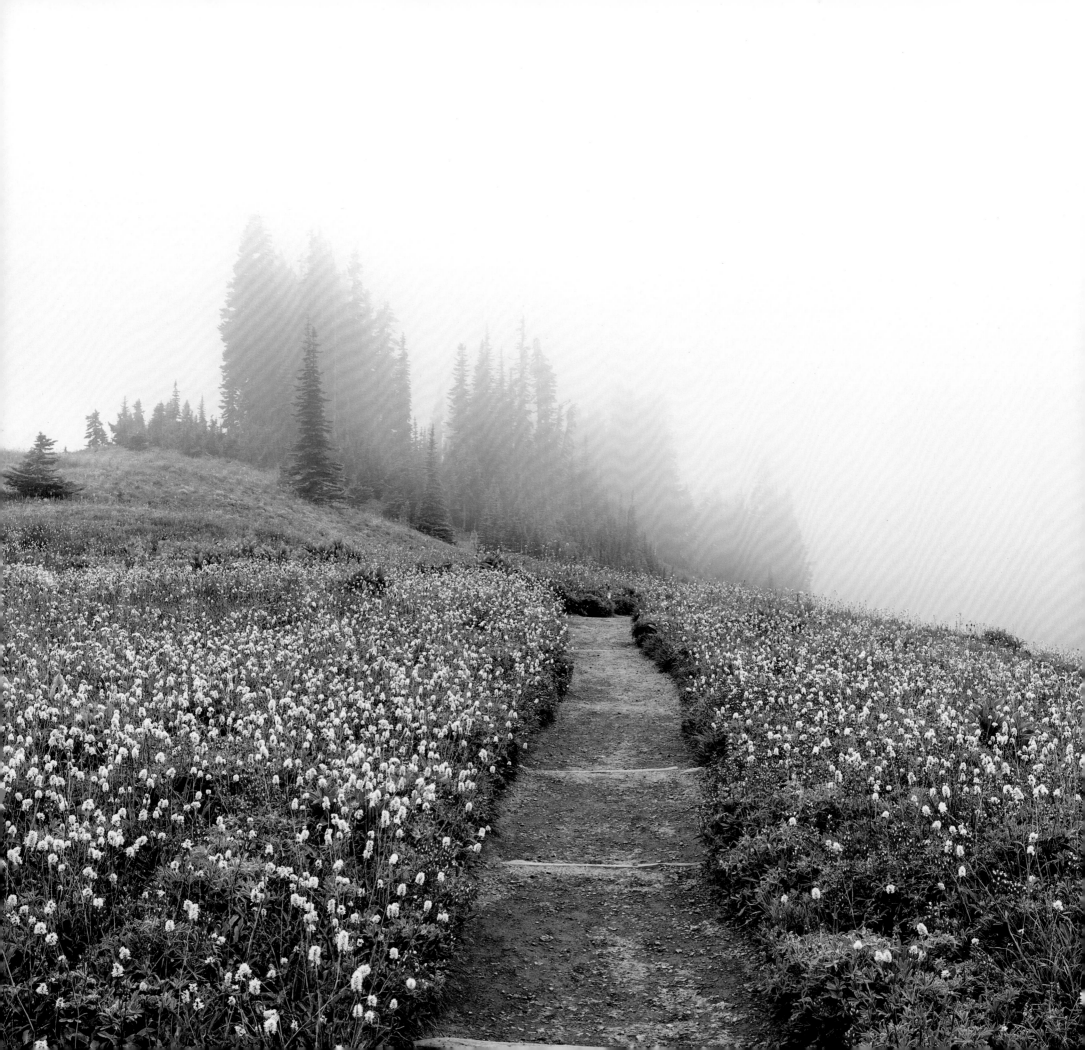

THE NATIONAL PARKS

AN AMERICAN LEGACY

CELEBRATING 100 YEARS OF THE NATIONAL PARK SERVICE

PHOTOGRAPHS BY IAN SHIVE

INTRODUCTION BY W. CLARK BUNTING

EARTH AWARE
EDITIONS

San Rafael, California

CONTENTS

THE PHOTOGRAPHIC FOOTPRINT
Ian Shive
14

INTRODUCTION
W. Clark Bunting
18

THE NATIONAL PARKS
22

ESSAYS

Friends of Acadia
61

NatureBridge
81

Yellowstone Park Foundation
96

Friends of the Smokies
134

The Everglades Foundation
162

Glacier National Park Conservancy
168

Grand Teton National Park Foundation
180

INDEX
234

ACKNOWLEDGMENTS
238

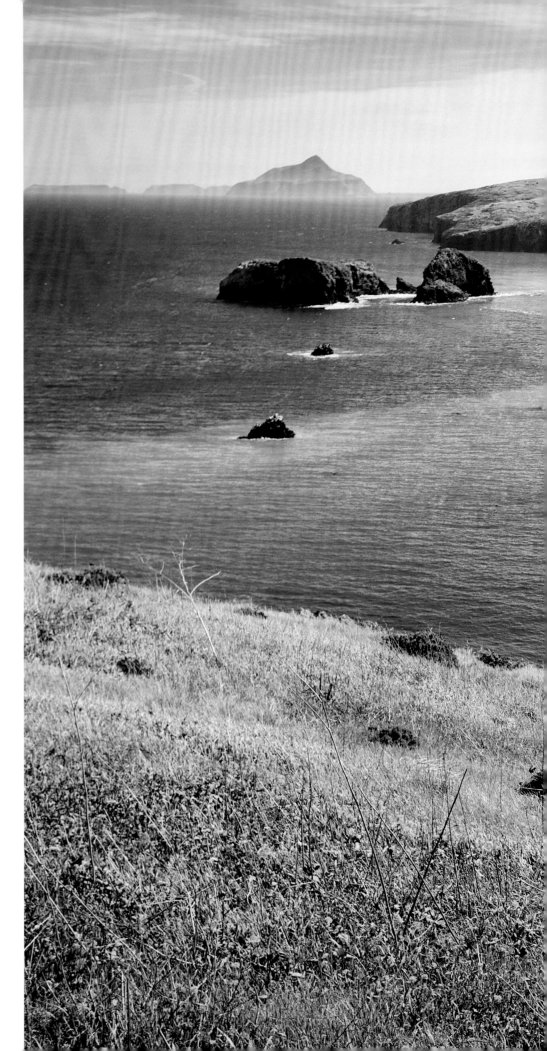

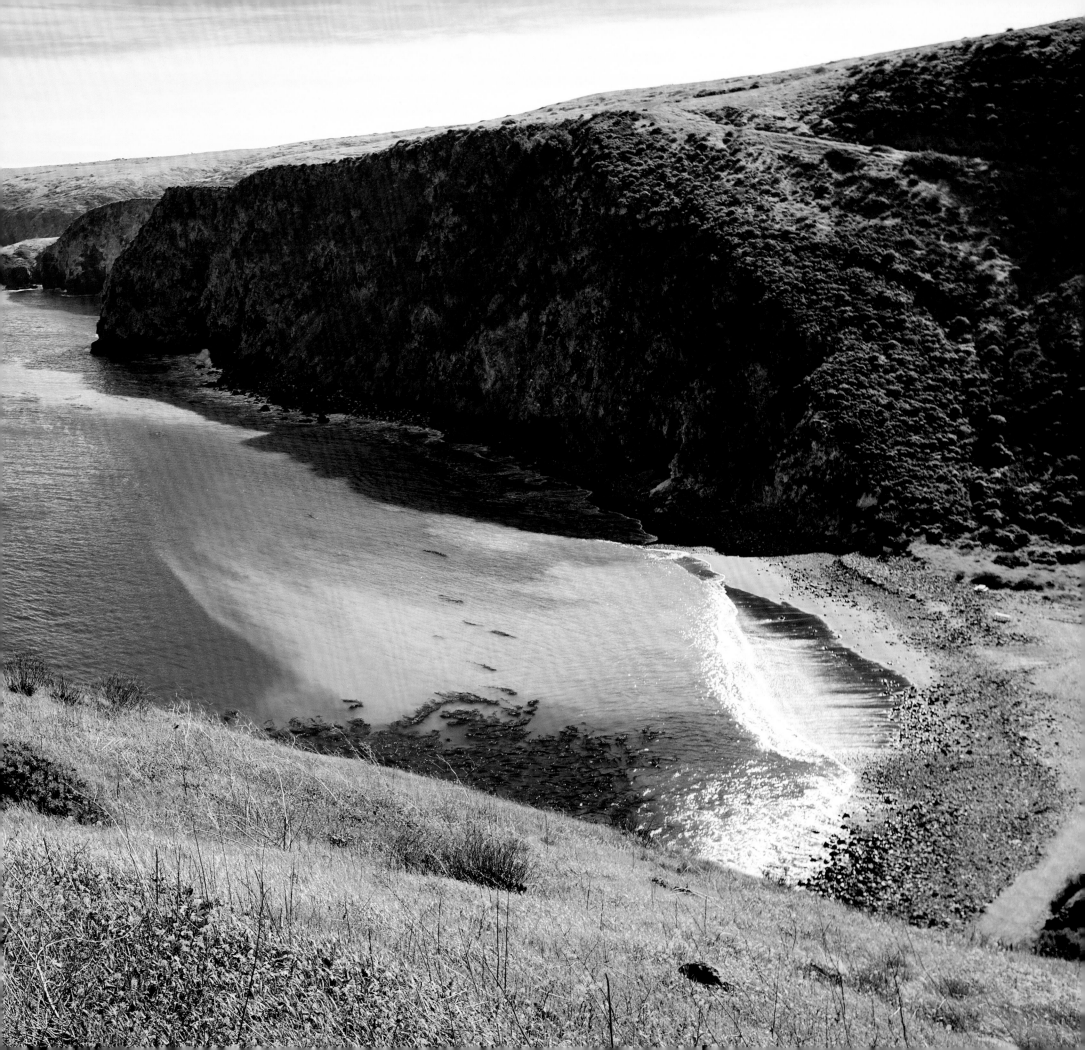

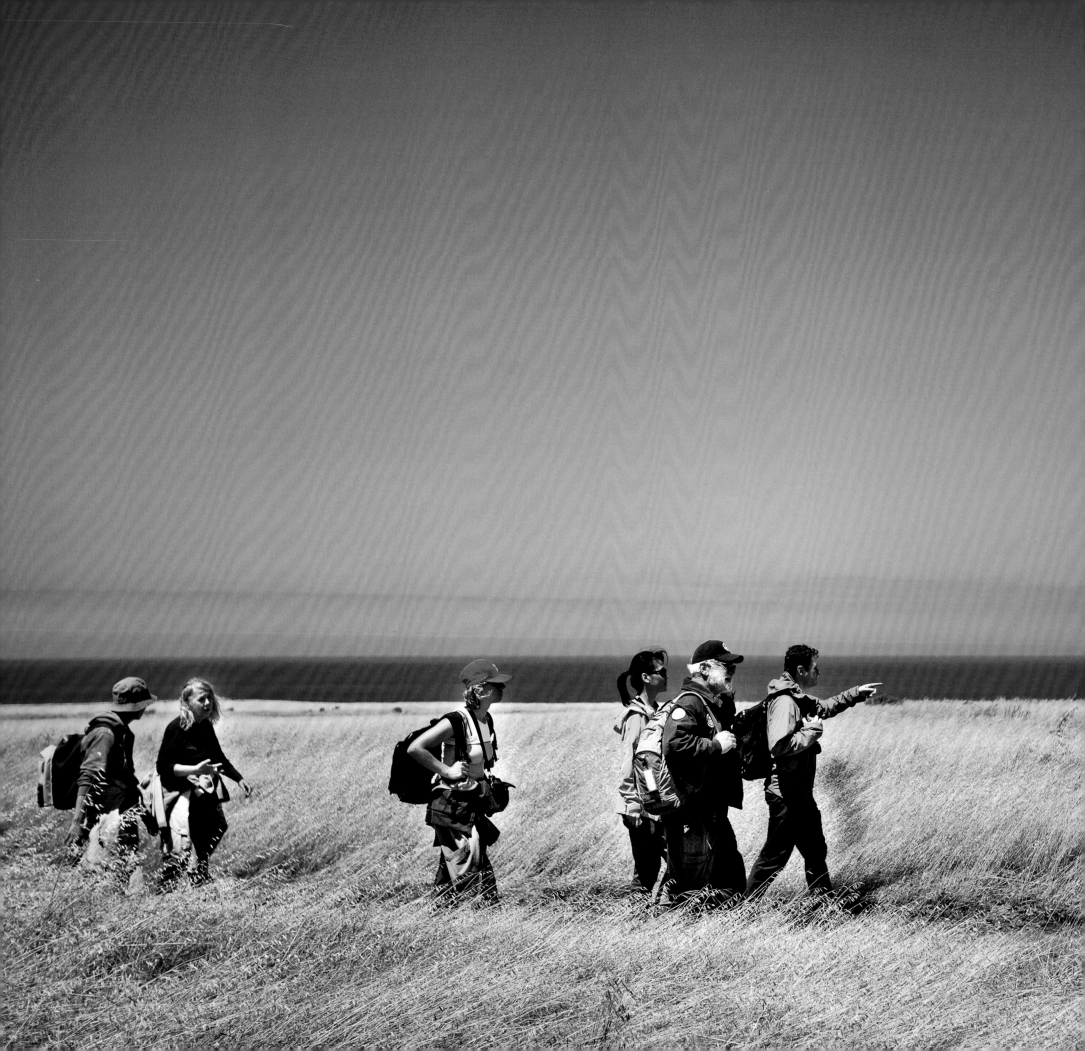

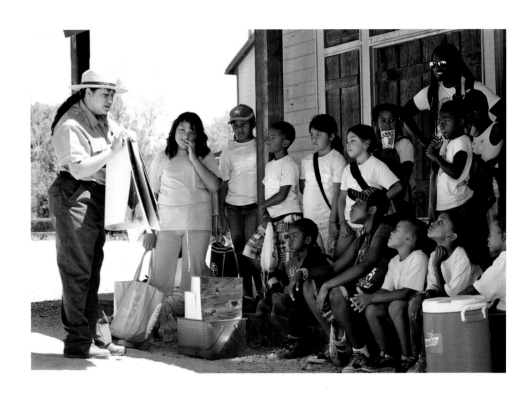

THIS BOOK IS DEDICATED TO THE MEN AND WOMEN
OF THE NATIONAL PARK SERVICE.

THE PHOTOGRAPHIC FOOTPRINT

IAN SHIVE

Our national parks are islands, isolated pieces of some of the most magnificent land humanity has ever seen, almost perfectly preserved in the state in which we found them. This preservation often means that we think of the national parks in a historical context: Is this what Yellowstone was like when Thomas Moran first painted it? Does Half Dome stand as iconic against the sky as when Ansel Adams photographed it? Does the Grand Canyon look the same as it did when I rafted it with my parents, my eyes wide with amazement that places like this even existed? The parks give us an uncanny ability to look back in time, but in doing so, we sometimes forget to think of the parks' important role in our future.

Shaping the way we view the parks in a modern context—what they are today and where they will go in the future—is a complicated task. Since before the parks existed, paintings and photographs have been an important way in which people capture and share these vast and wild places, and that remains true today. As cameras have become ubiquitous and as technology has advanced, I have seen major changes within this image-making niche. No longer am I, a working professional, the lone romantic on a windswept cliff interpreting the light on El Capitan, but rather I'm one of possibly hundreds of photographers waking up early to beat the crowds and secure just the right spot. When I find myself photographing in the parks, I spend more time avoiding crowds than I do working on my creative approach. This is actually something I enjoy despite how competitive it can sometimes be to secure the "best" spot. Despite the frustration of the crowds and having to work around them, it is instantly rewarding to hear a hundred people inhale a collective gasp as the sun rises over Zabriskie Point in Death Valley and illuminates the landscape. In those moments it becomes clear that we photographers are not just documenting an experience—we are capturing an emotion. Only in nature, and especially in our national parks, will you see so many people clamoring to witness the sunrise. How great that is!

However, there are challenges arising from this ever-growing genre of photography. Higher attendance and large crowds of photographers are only a small piece of the modern park experience. Technology itself is driving a new mentality among a younger generation, often dubbed "generation photo." Social media has propagated photography as an art but also as a bragging right. Cameras no longer just line our pockets or backpacks, but are lifting to the skies, hovering just above us. Sharing these magical experiences has, for some, become a game of one-upmanship, which in more than a few cases has sadly become destructive. All of this means that we need to broaden our sense of responsibility and consider not just our environmental footprint but our photographic one, too.

While the parks have had their challenges, they have managed to stand the test of time. Eventually, even our most destructive acts will begin to fade away like ancient rock art. In the meantime, we photographers, professional and aspiring alike, have an incredible opportunity to share our beautiful country with a worldwide audience, but we must be responsible for how we do it. We should remember to leave things as we found them and "take only photos."

I recognize how lucky I am to have worked as a photographer in these grand places alongside so many park rangers, volunteers, scientists and recreationists. I also recognize the need to always respect these places and these people so that one day these irreplaceable resources are found untouched not only in photographs but also in real life. I hope that the photos in this book will inspire you to do the same.

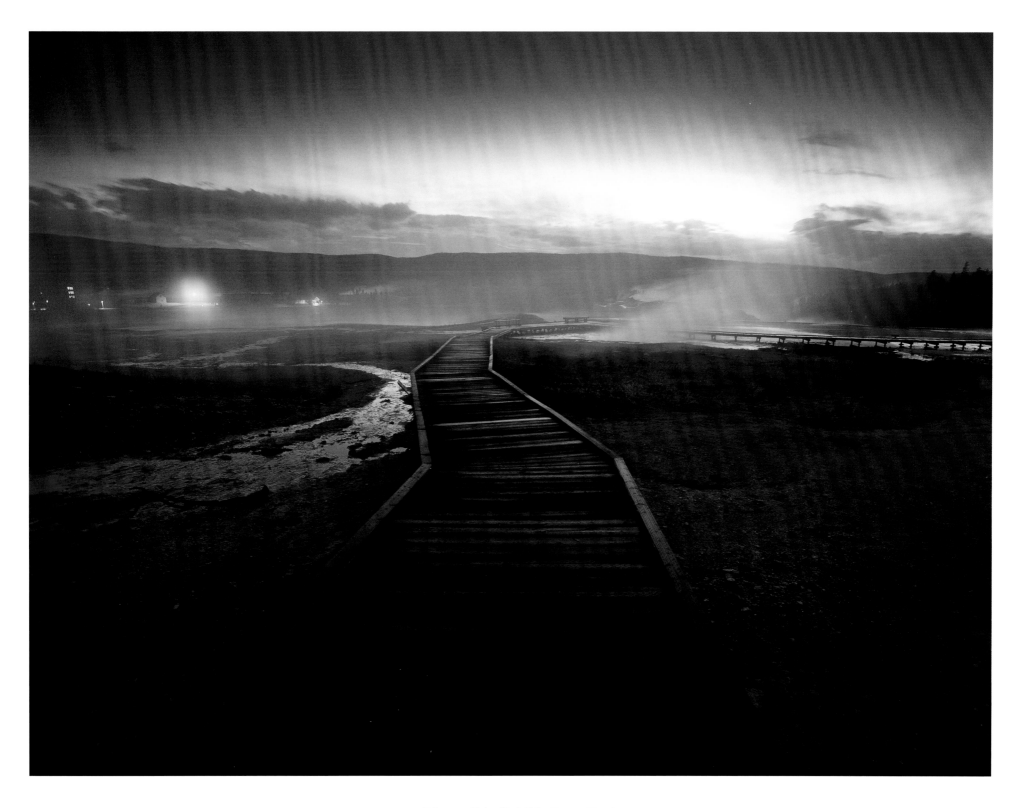

ABOVE: Yellowstone National Park; Idaho, Montana, Wyoming
Sulfuric steam rises above Geyser Basin near Old Faithful.

FOLLOWING PAGES: Haleakalā National Park, Maui, Hawai'i
Clouds forming on cinder cones and volcanic formations inside the Haleakalā Crater.

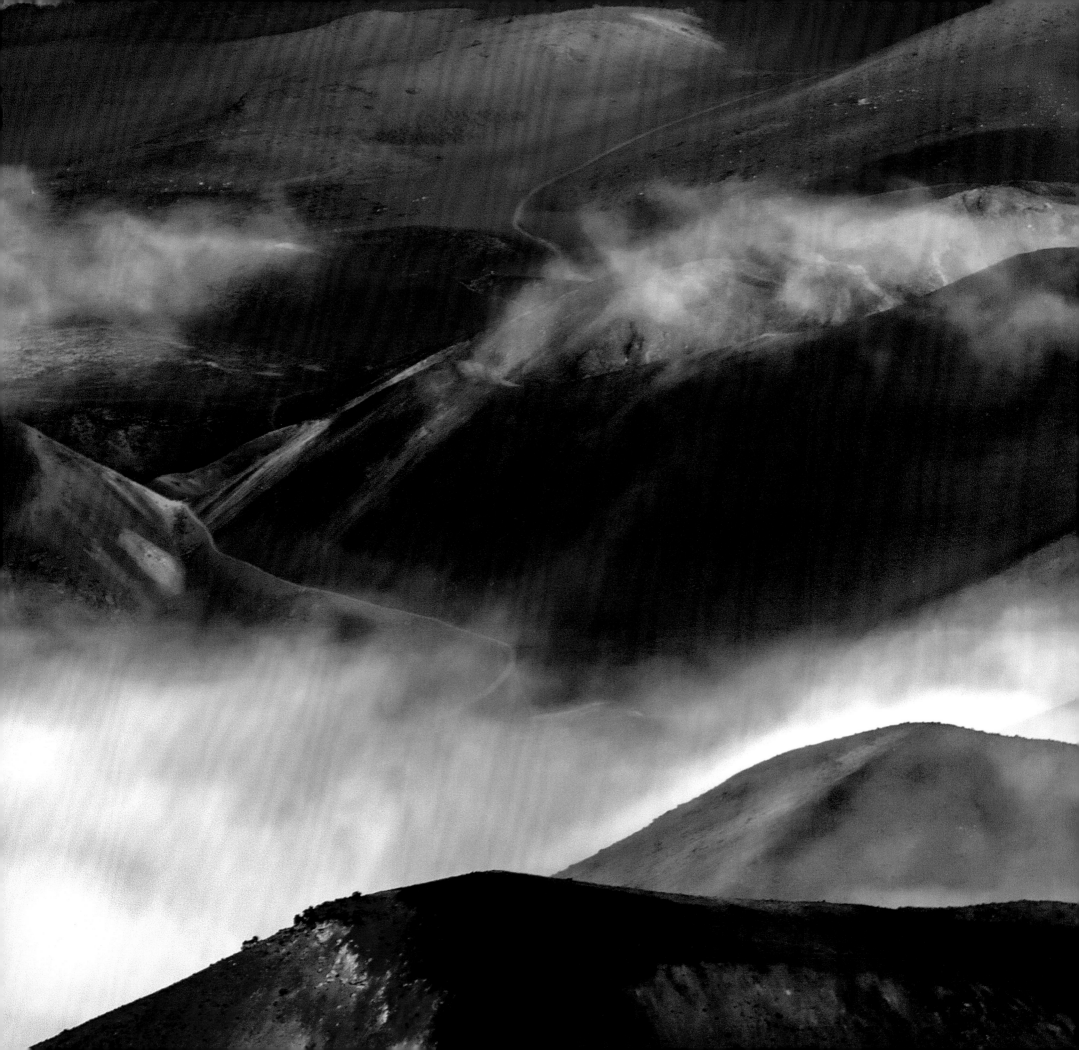

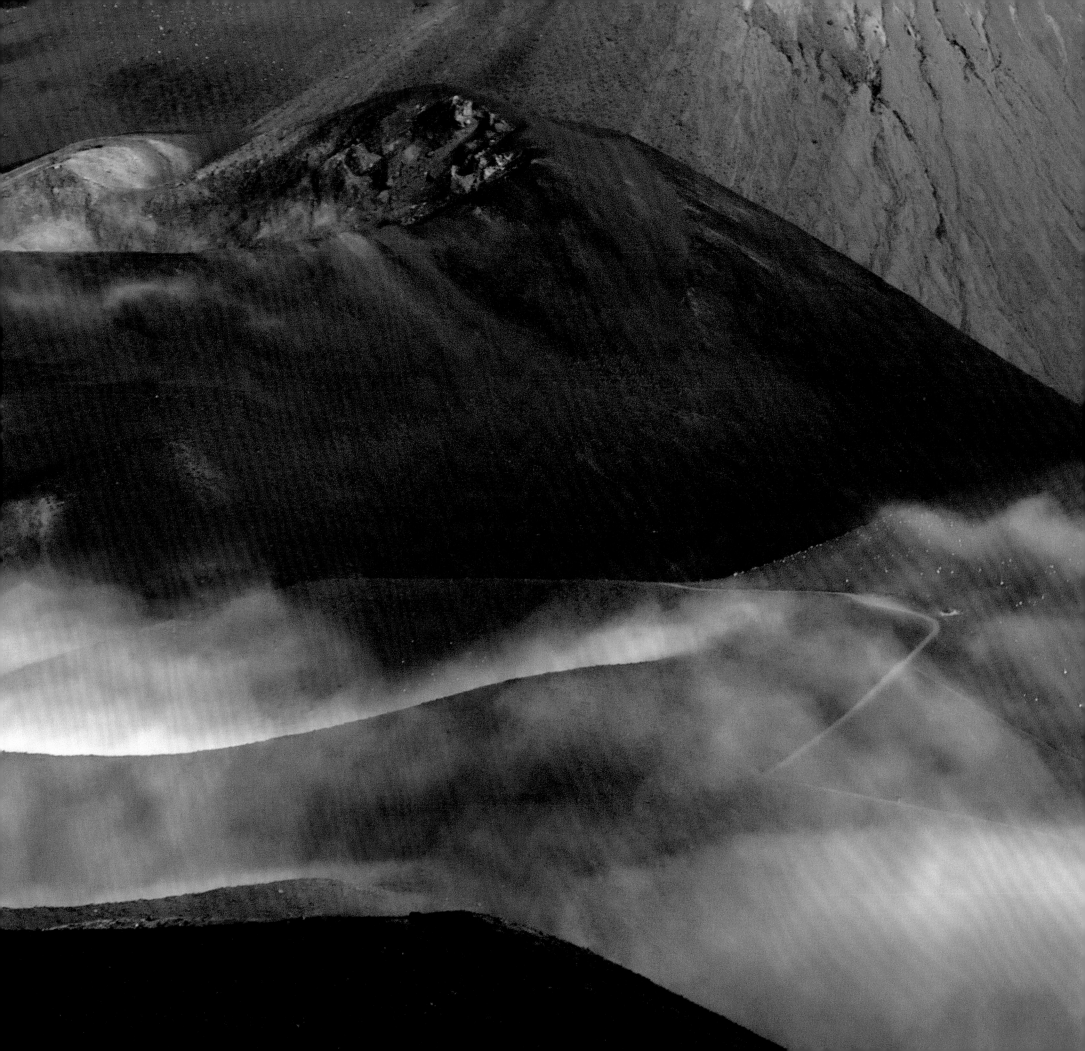

INTRODUCTION

W. CLARK BUNTING

President and CEO of the National Parks Conservation Association

I joined the National Parks Conservation Association (NPCA) just prior to the National Park Service Centennial in 2016. As I began my work with NPCA I often thought about those early stewards of the parks a hundred years ago who contemplated what could be, as opposed to what was. And then they made it happen. The result is more than four hundred parks that showcase some of our nation's defining historical moments and breathtaking landscapes.

It's inspiring to look back at the intellectual and strategic brilliance of those early park champions, but also to contemplate the future and ask, "What does the next century look like?" If we can continue to live up to their standards while charting our own twenty-first century course, we, too, can leave a robust National Park System for future generations.

As I think about the future, I also think about some of the daunting effects climate change will have on our parks and the ripple effect it will have on a global scale. When I was at Discovery, I worked with a brilliant science historian and author named James Burke who did a television series with us called *Connections*. The guiding premise of the project was the "daisy chain theory," which postulated that everything in the world is connected, even if it's not apparent.

When I think about large landscape conservation, I think about connectivity—of the land, yes, but also the air, the water, the wildlife, the migratory patterns and corridors—and how all these things know no park boundaries. They connect into a greater whole that is a tapestry made up not just of the parks, but of natural spaces in a much broader sense.

Seeing, understanding, and preserving those connections is perhaps the great conservation challenge of our generation. We've got to manage our resources in a thoughtful way that recognizes and nurtures the interconnectivity of the planet. Fortunately, because of the foresight and hard work of those who came before us, we've inherited the national parks—one of the best resources we have to visualize that interconnection.

The parks' contribution to the creation of knowledge is remarkable—they are living classrooms, not just for scientists, but also for the American, and global, population. It is in our parks, under the open sky, where people learn to truly care about the natural world.

Broadcaster and naturalist David Attenborough once said, "No one will protect what they don't care about; and no one will care about what they've never experienced." The parks are there not only as preserved natural spaces, but also to enrich the human experience. They speak to our connectedness with the natural world and our love for it, and they contribute to our health and well-being.

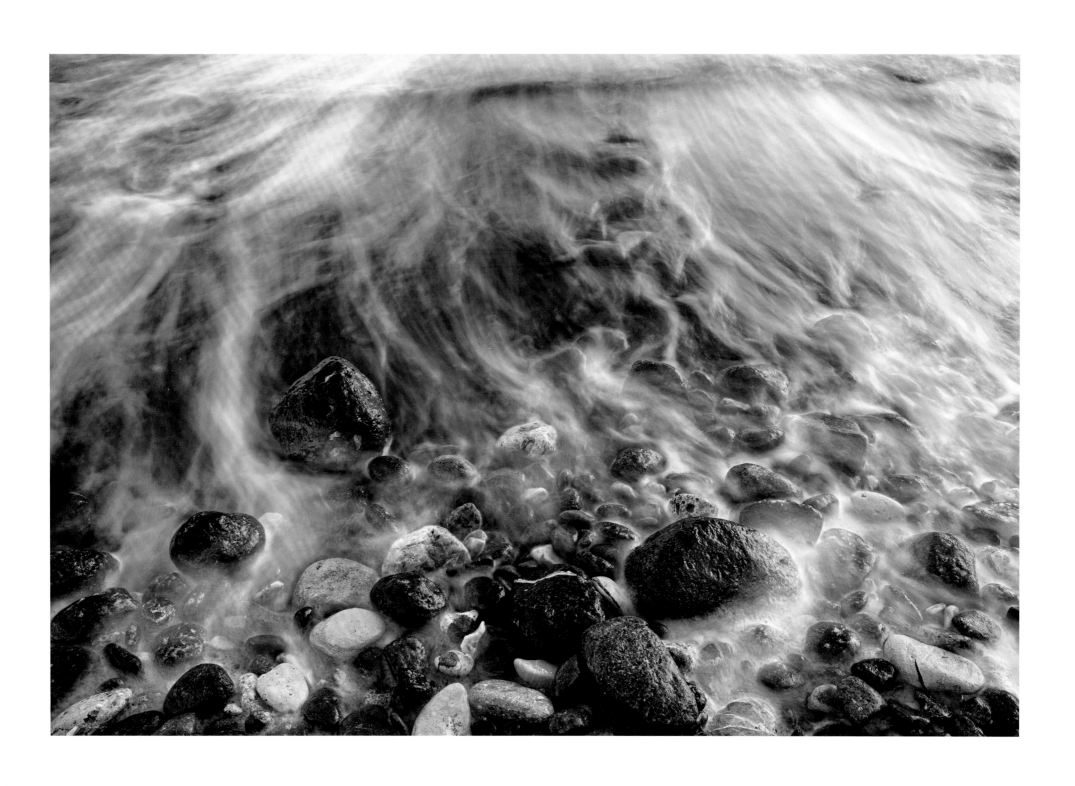

Channel Islands National Park, California
Sunrise on the rocks of Santa Cruz Island's Scorpion Anchorage.

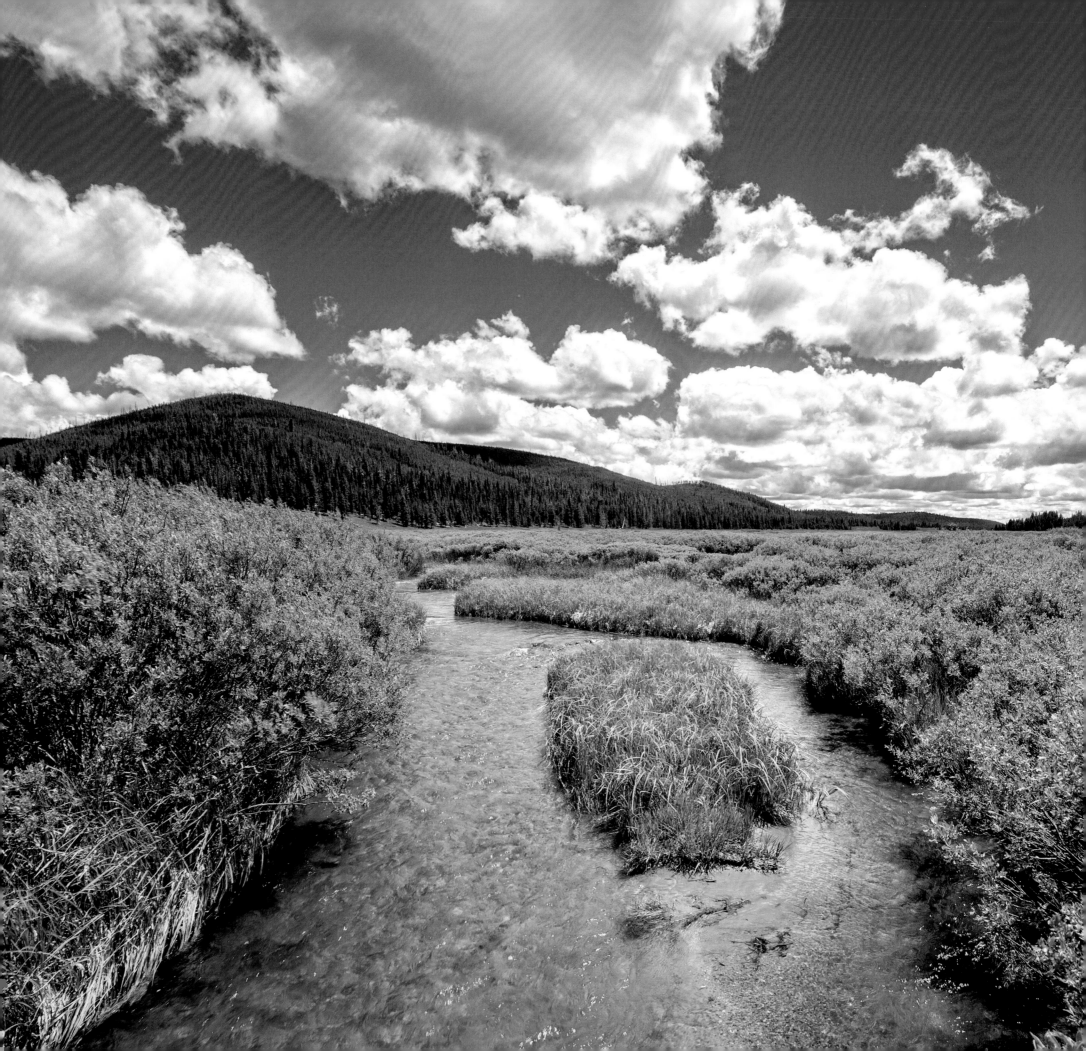

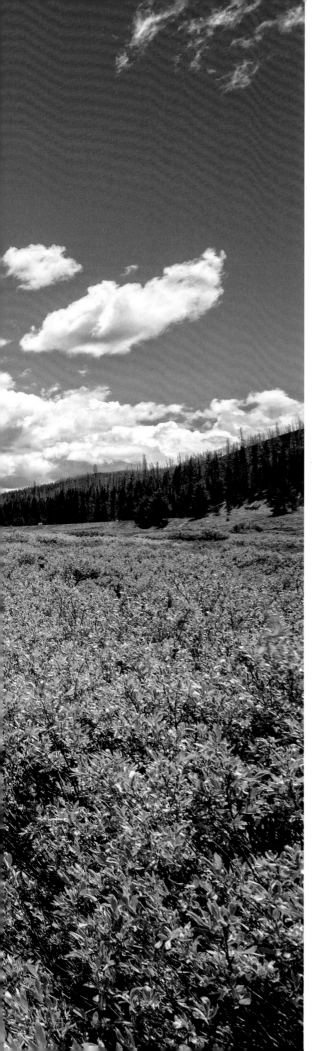

If we can get people to think about two things—why parks matter and why we care—then we've made real progress. There's seldom an individual who's not emotionally moved by visiting the parks. Photography can have that impact too. The photographs in this book address those questions in a direct and powerful way. Without a park designation, the landscapes you see in this book would likely be threatened, if not erased entirely. Photographs of natural spaces or of the creatures that call those spaces home should not reassure us of their resilience but rather remind us of their fragility.

That's what great conservation photography does. Each photograph is a story that inspires us to contemplate our role in this gigantic world, motivates us to care about and connect to landscapes, and spurs us to want to protect the places we love.

Unfortunately, many people visit the national parks and assume they will be forever protected. But there's an overwhelming number of practical and financial challenges facing the parks system. The parks currently have an $11. 5 billion-dollar deficit, an almost incomprehensible number. At some point, the challenges of ongoing preservation and stewardship feel too big and the cause too far lost. But there is power in passion and in like-minded individuals coming together in the voting booth and saying these places are too important to ignore. There's power in writing your members of Congress and telling them why you care and why parks matter. Caring about the parks on an individual level, and knowing why you care, is where action starts.

Conservation advocacy is not a single action with a finite result. No single park designation, no single victory, no single photograph, regardless of how moving it might be, is going to preserve and protect our natural landscape indefinitely. It's an ongoing process and everyone who cares and knows why they care has to stay vigilant. This vigilance is particularly poignant now in light of the centennial of the National Park Service. The vigilance shown by park champions over the last hundred years is remarkable and has inspired countless advocacy groups, NPCA among them, to make a strong and continuing stand for the national parks. Together, we're the Lorax in the book by Dr. Seuss: the voice of the trees. On a good day, we are the voice of the national parks.

As a species, we have the opportunity to affect the outcome of this planet. The conservation work that has occurred in the parks over the last hundred years has endowed us with a valuable resource, one that articulates our relationship with nature as well as our relationship with each other as a nation. The national parks are beautiful places that we should appreciate, love, and treasure, but at the end of the day, we have a self-interest as well. Our fate as a species is linked with the parks. As I look over the horizon I think, "As the parks go, so shall we."

My hope is that this book and the images throughout serve as a reminder of this fact and of the hard work the National Park Service has done over the last hundred years—and of the great things in store for the next hundred years if we continue to pursue their vision for the parks with vigilance. After all, our national parks are just that. *Our* national parks.

LEFT: Yosemite National Park, California
Cathedral Peak and meadow with water from Cathedral Lakes flowing out into the channels.

FOLLOWING PAGES: The westernmost side of Yellowstone National Park; Idaho, Montana, Wyoming

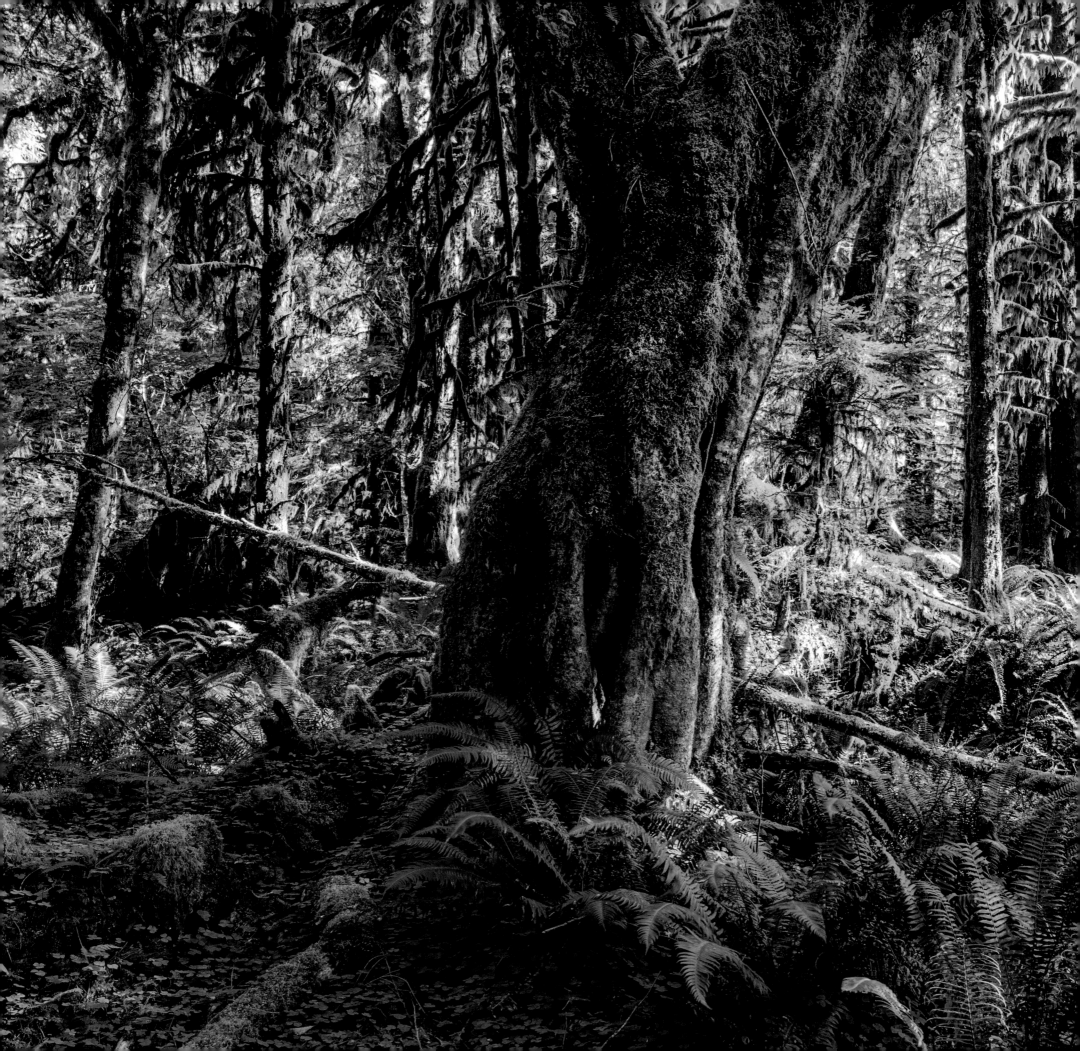

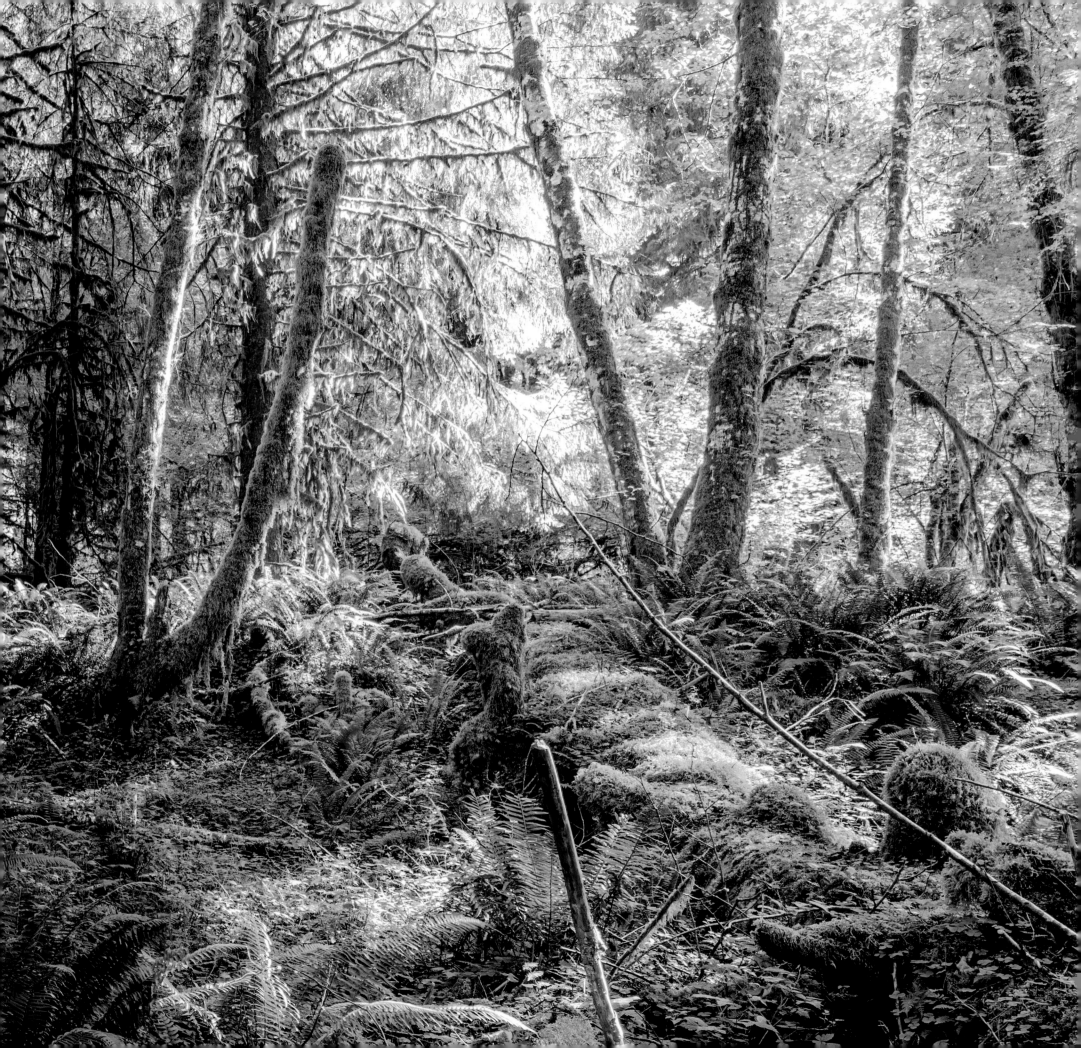

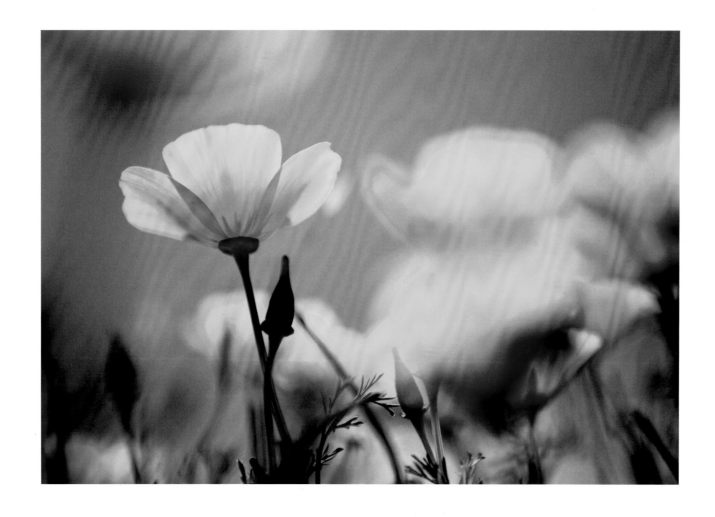

ABOVE: Channel Islands National Park, California
California poppies (Eschscholzia californica) on Santa Rosa Island. The species is native to the Channel Islands.

RIGHT: Mount Rainier National Park, Washington
Sunset at Reflection Lakes with Mount Rainier in the background.

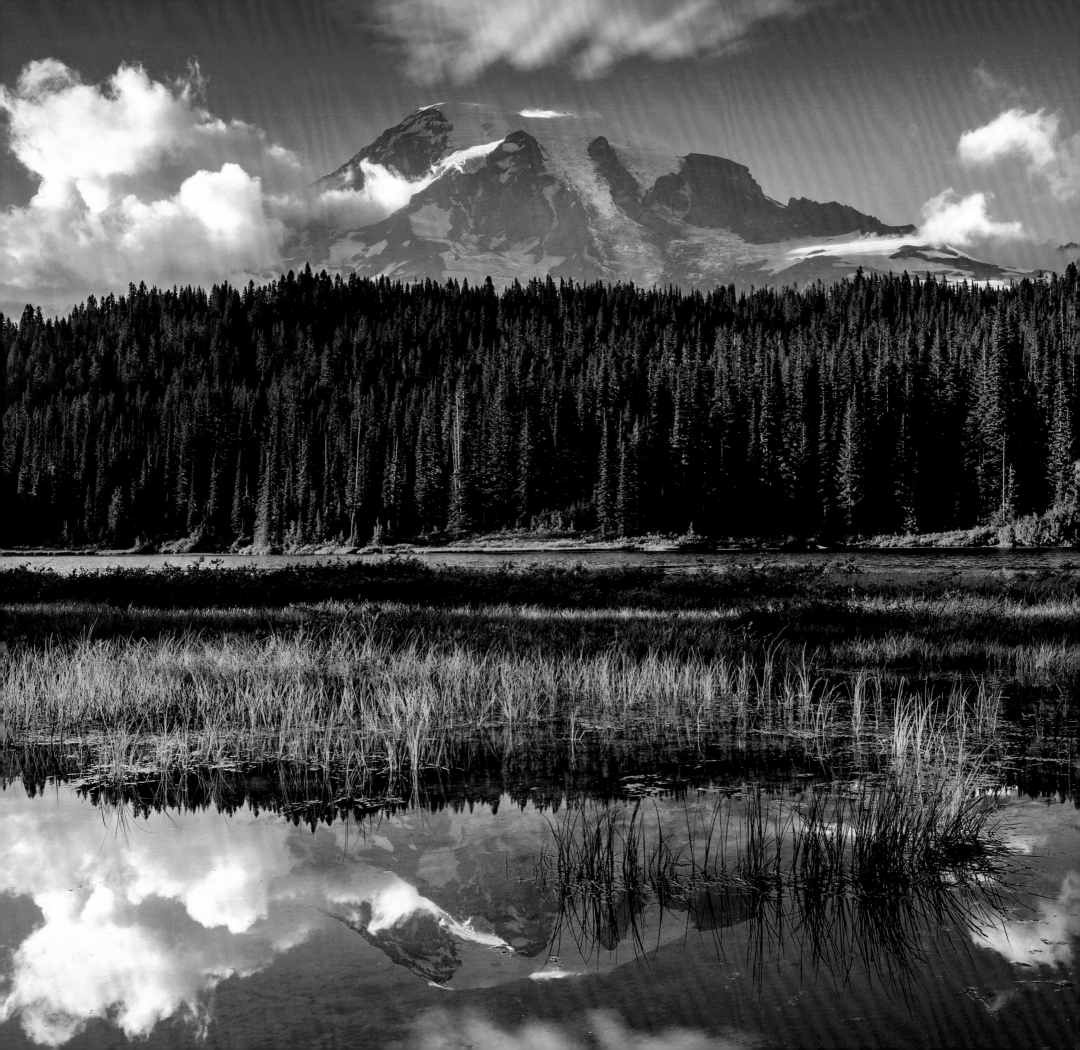

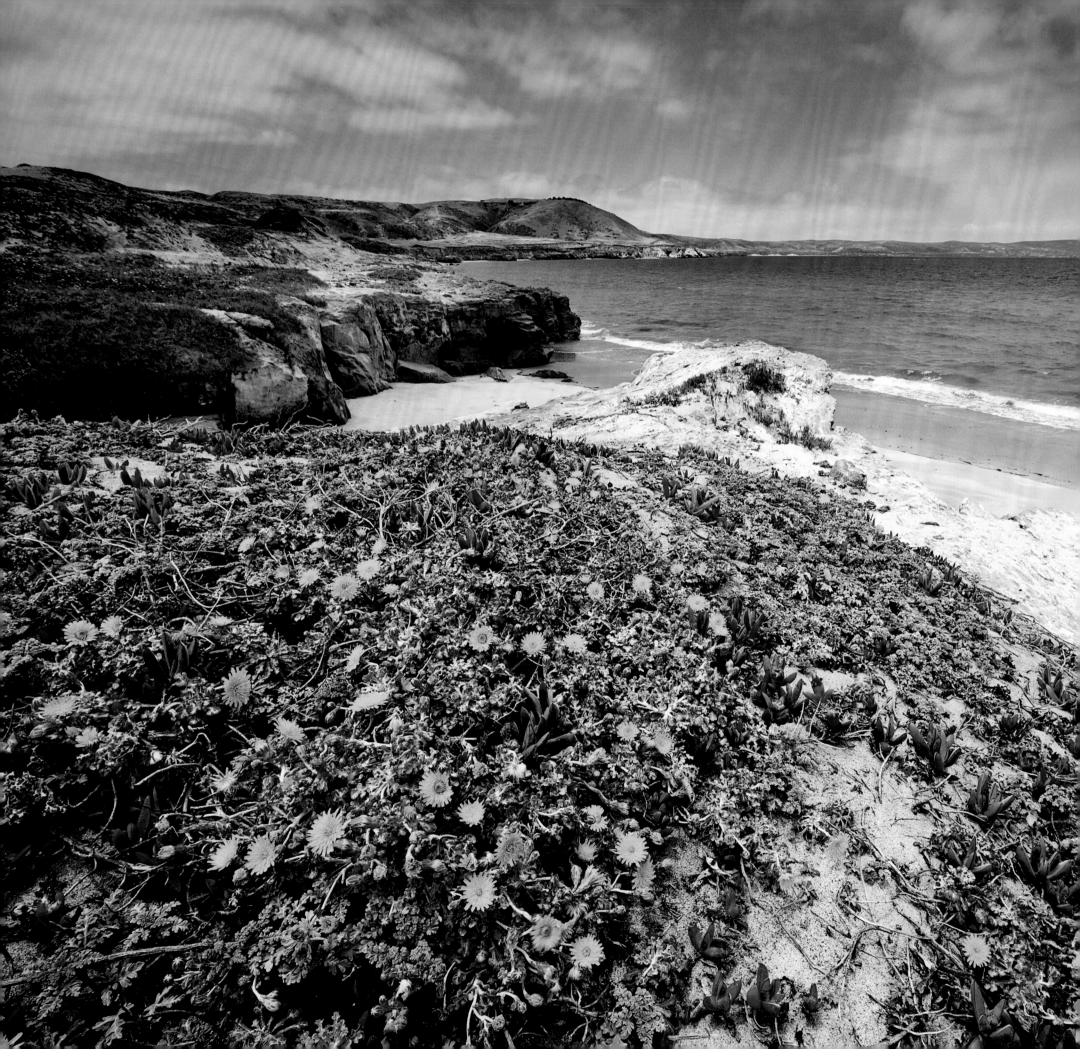

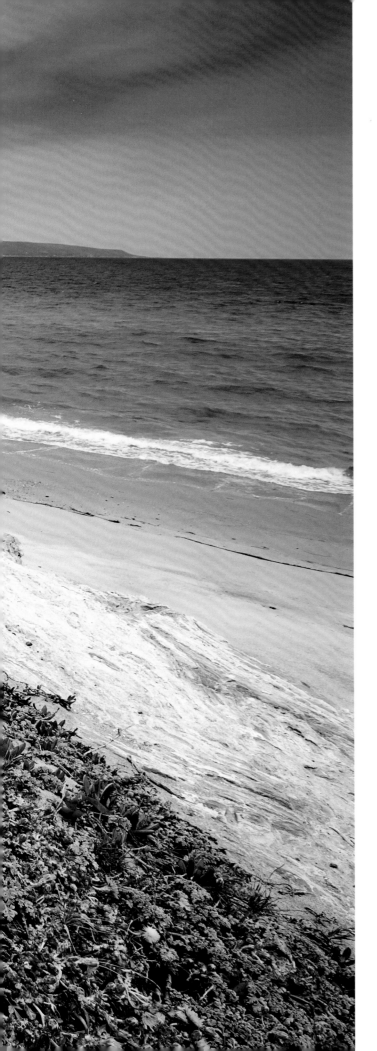

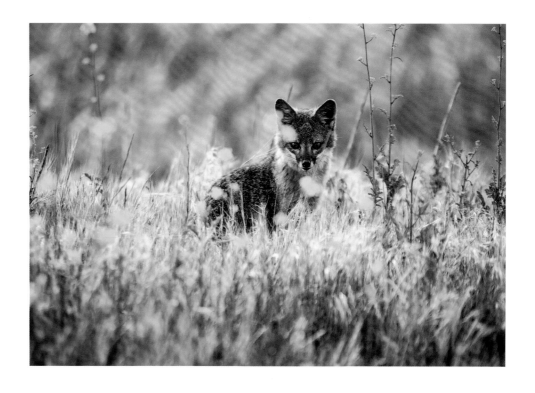

LEFT: Channel Islands National Park, California
Wildflowers along a hidden cove near East Point on Santa Rosa Island.

ABOVE: Channel Islands National Park, California
An island fox (Urocyon littoralis), a critically endangered species that is endemic to the Channel Islands, amongst wildflowers on Santa Cruz Island.

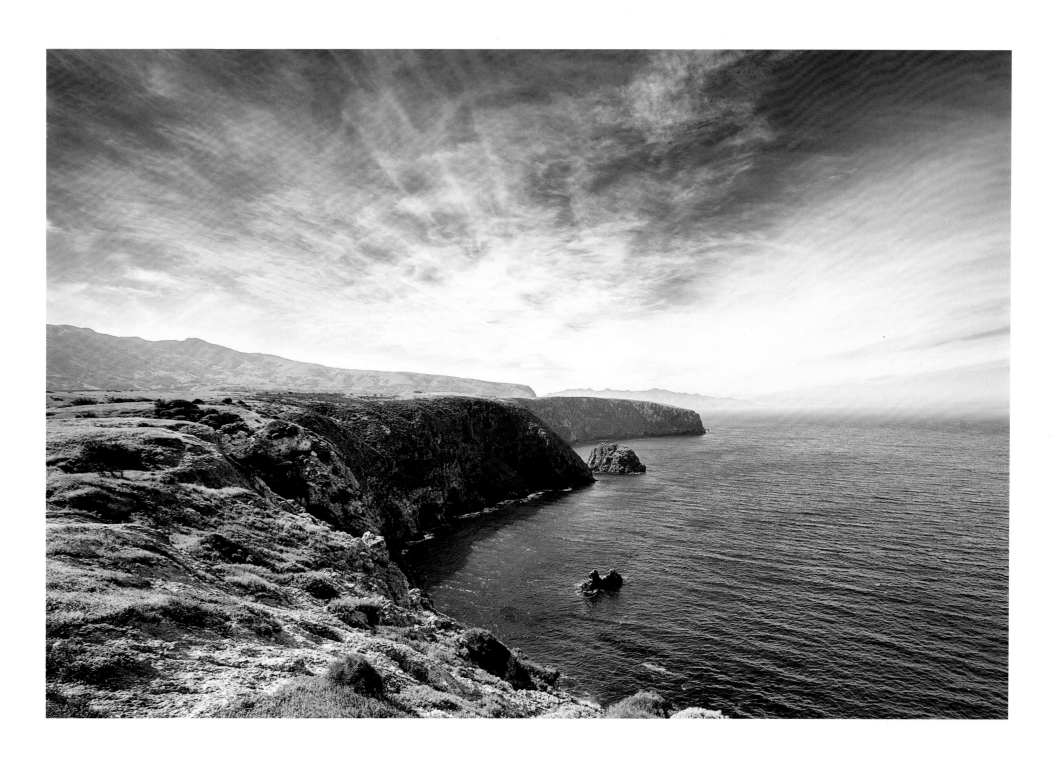

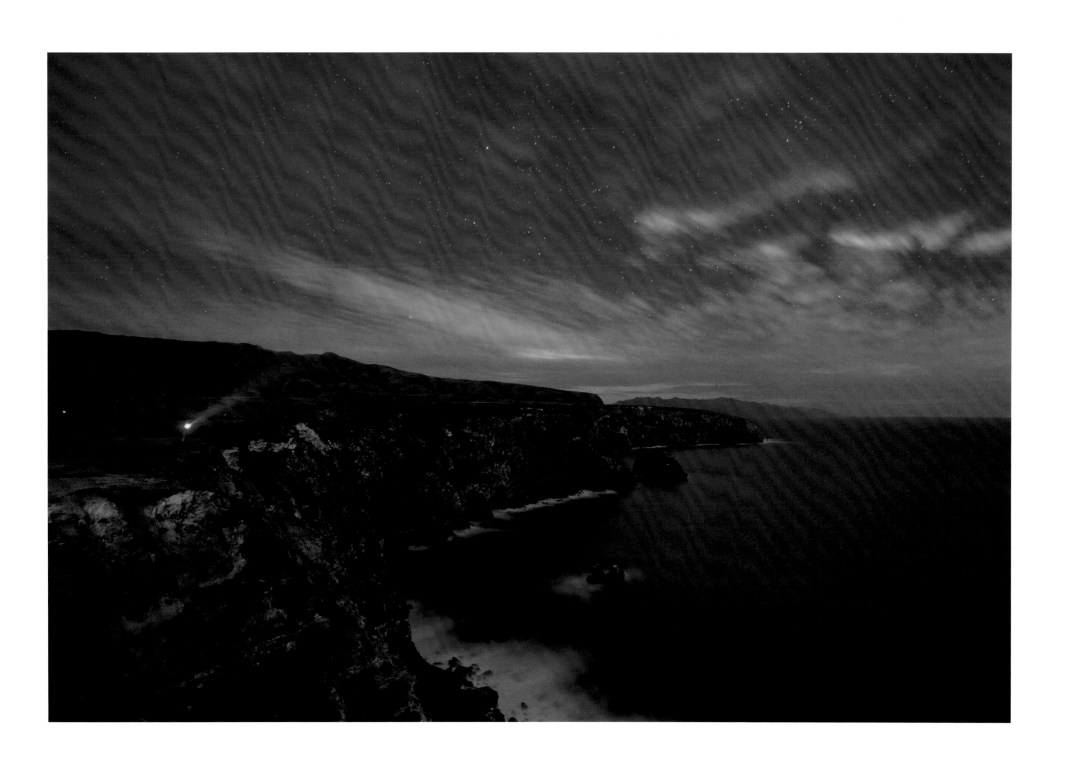

OPPOSITE AND ABOVE: Channel Islands National Park, California
The view from Santa Cruz Island's Cavern Point Trail looking toward Santa Rosa Island, which is visible in the distance.

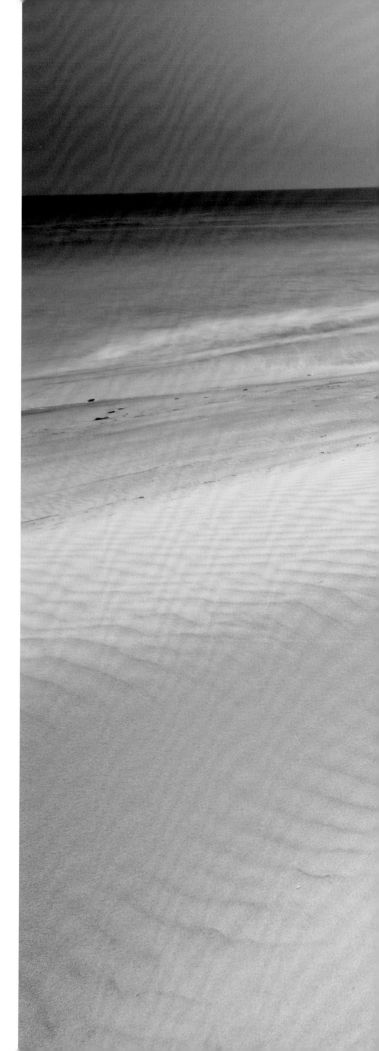

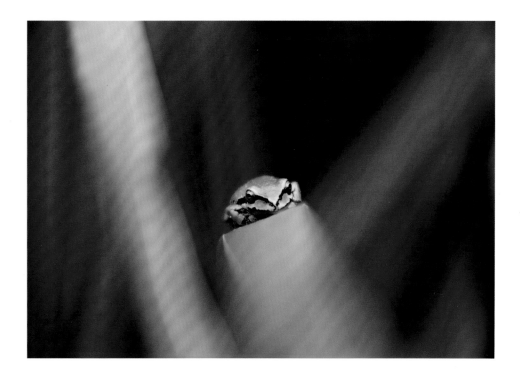

ABOVE: Channel Islands National Park, California
The Pacific chorus frog (Pseudacris regilla) *is one of only two amphibians found on Santa Rosa Island.*

RIGHT: Channel Islands National Park, California
Evening on Santa Rosa Island's Bechers Bay beach.

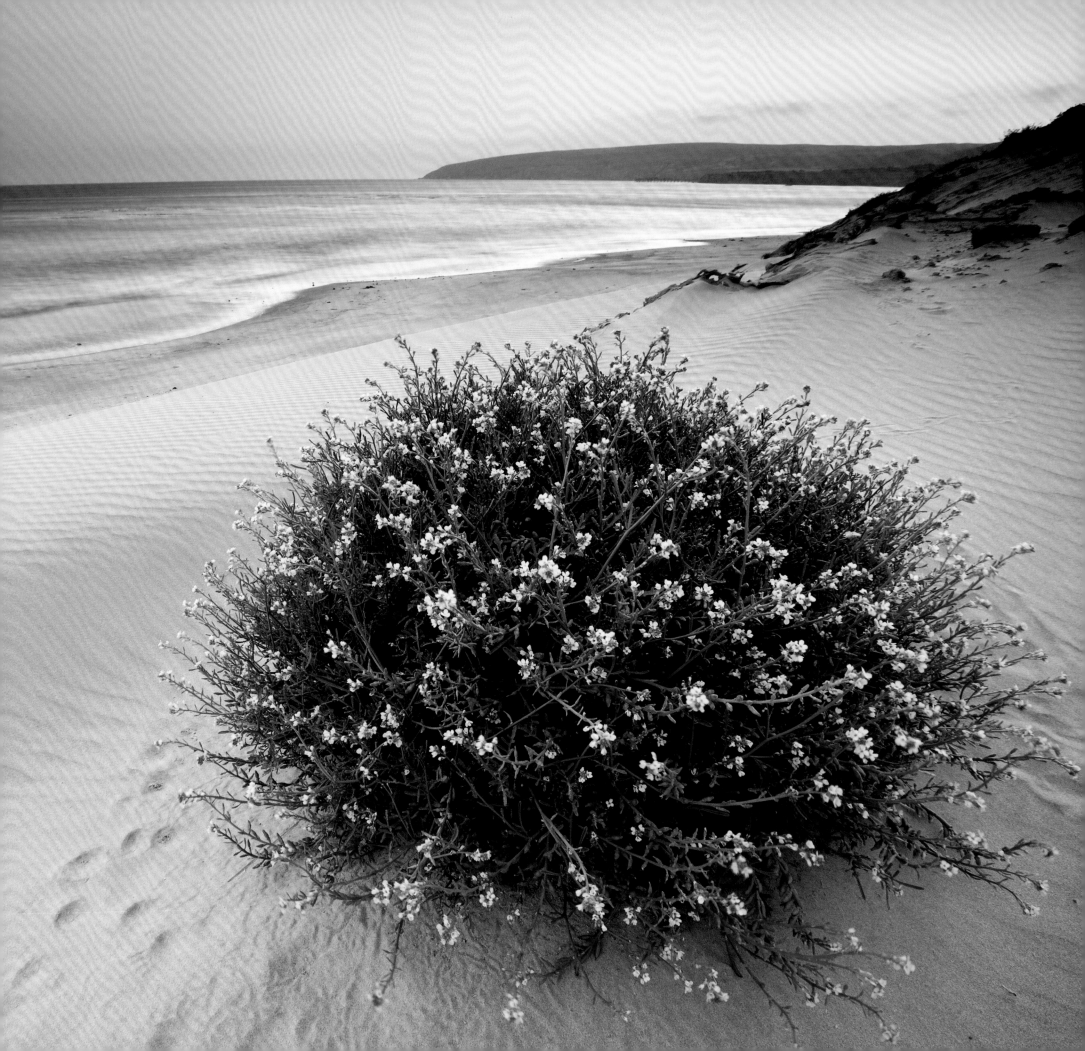

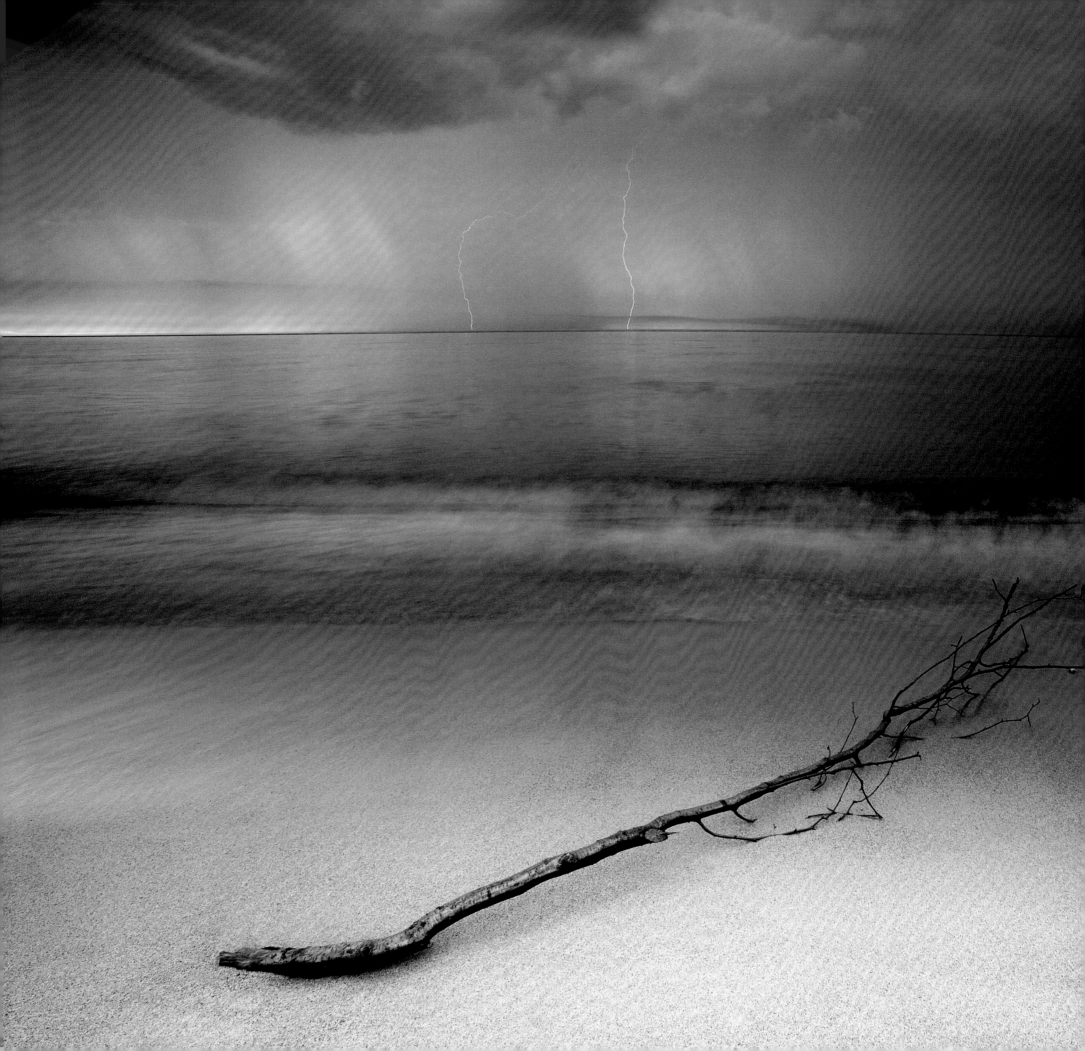

Apostle Islands National Lakeshore, Wisconsin
Lightning strikes on the horizon at Lake Superior.

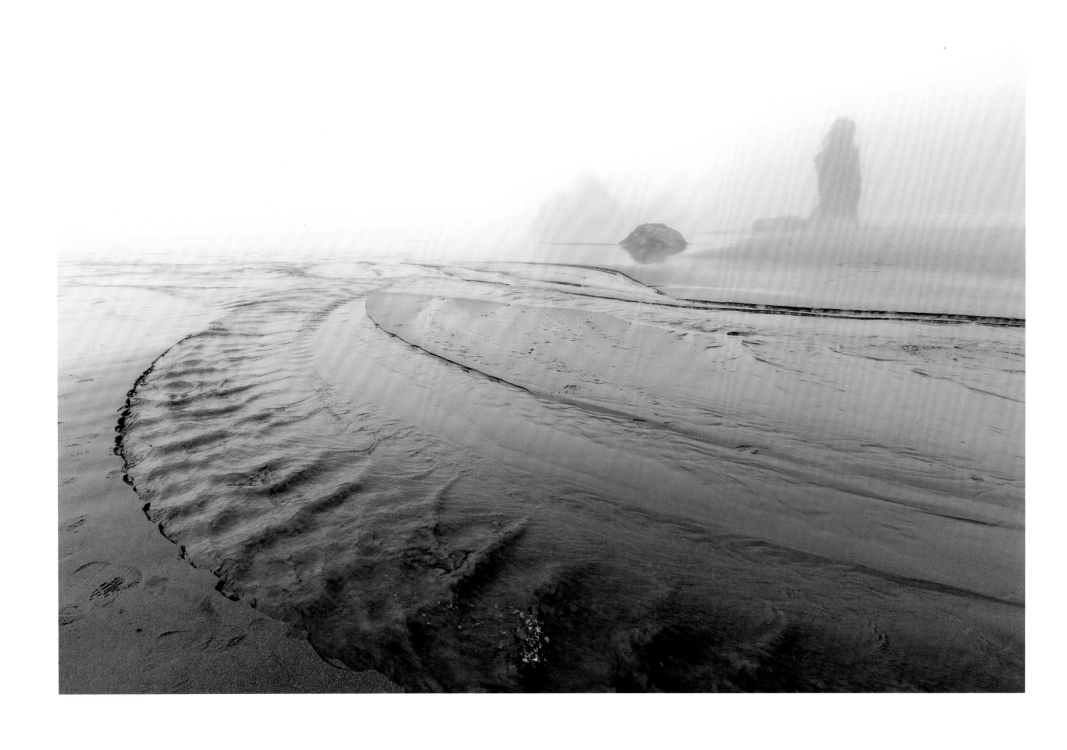

ABOVE AND OPPOSITE:
Olympic National Park, Washington
Ruby Beach.

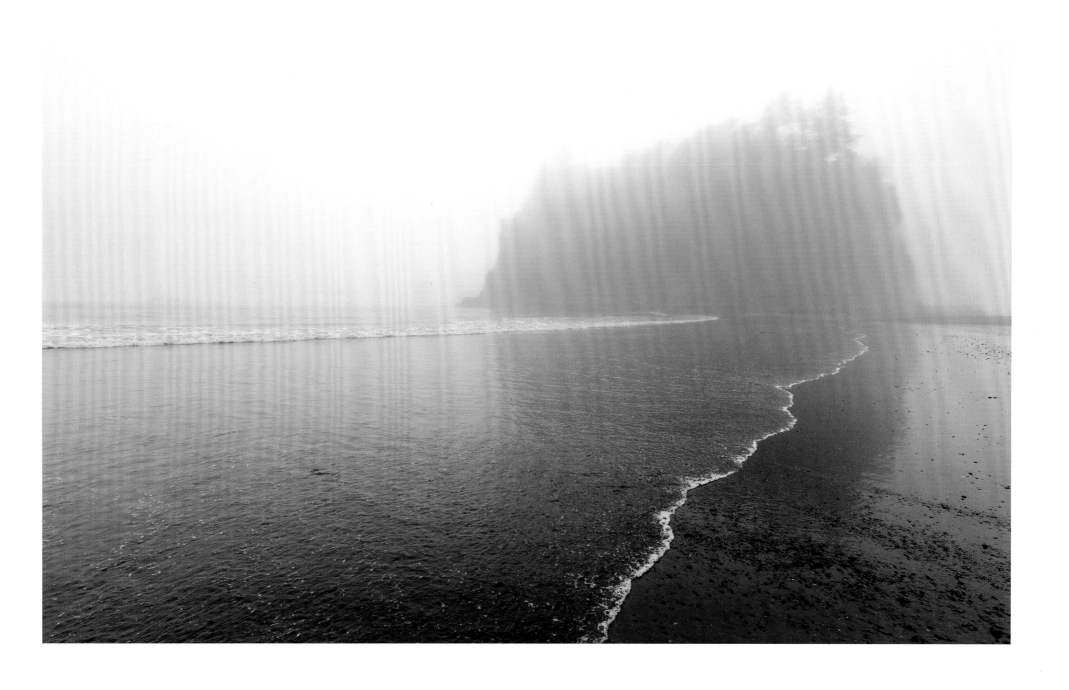

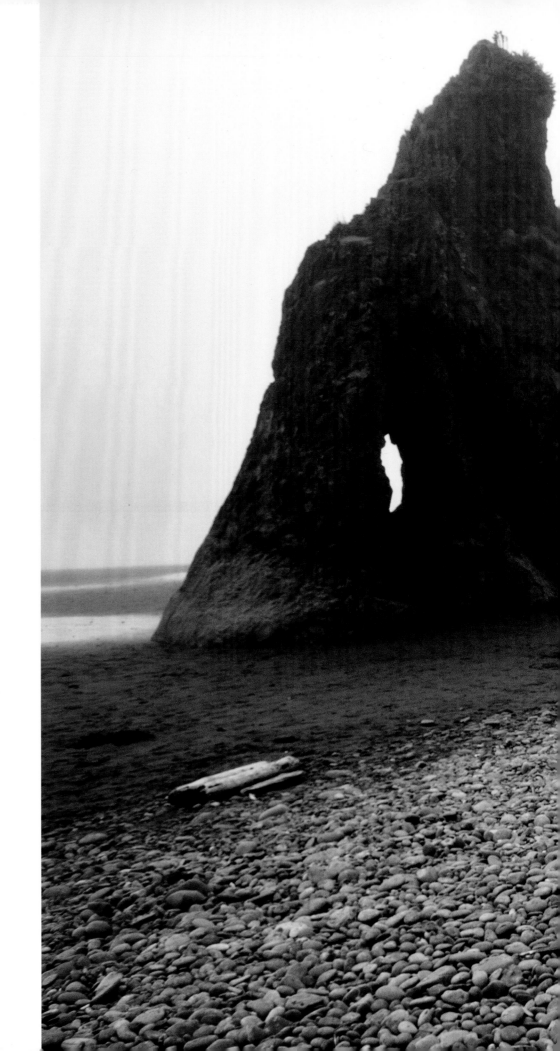

Olympic National Park, Washington
Ruby Beach.

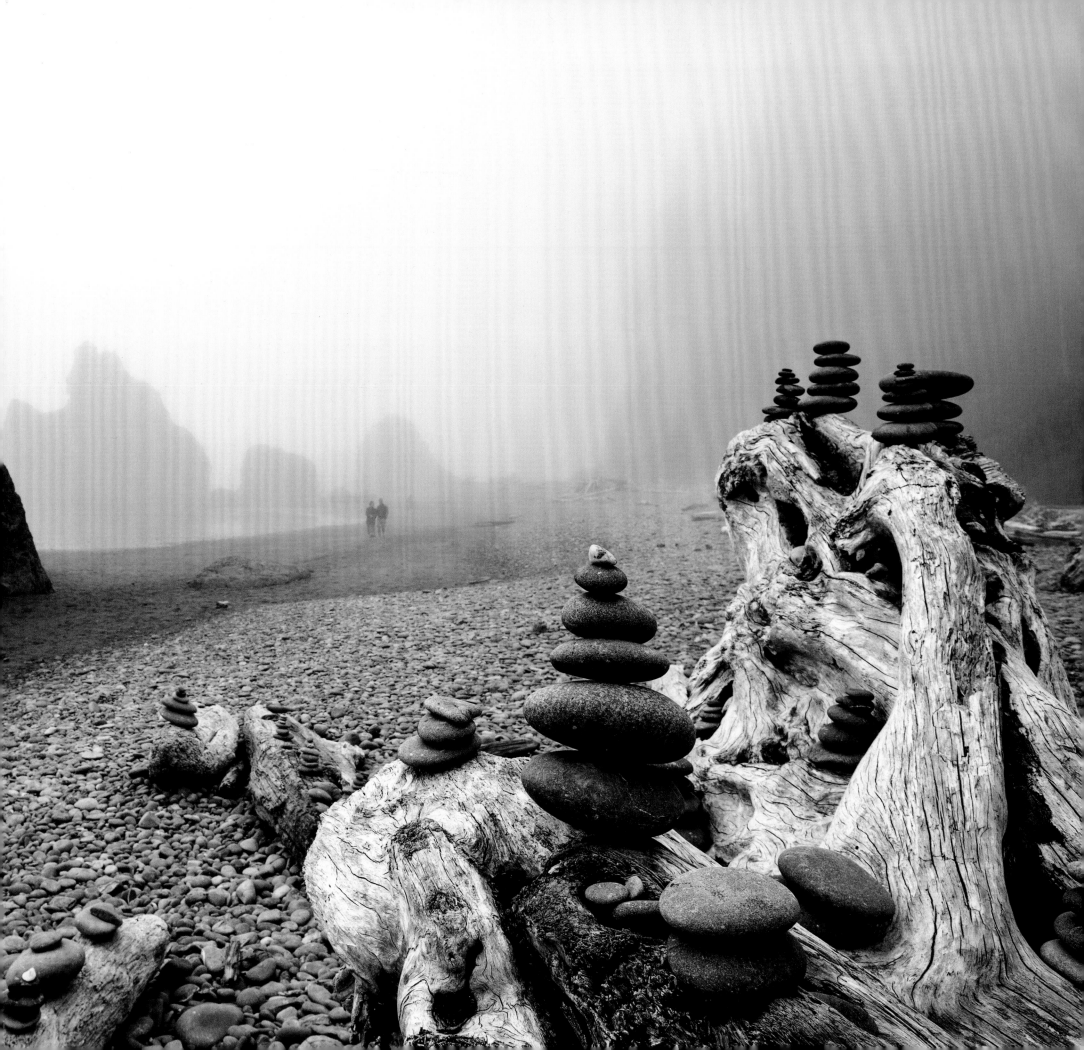

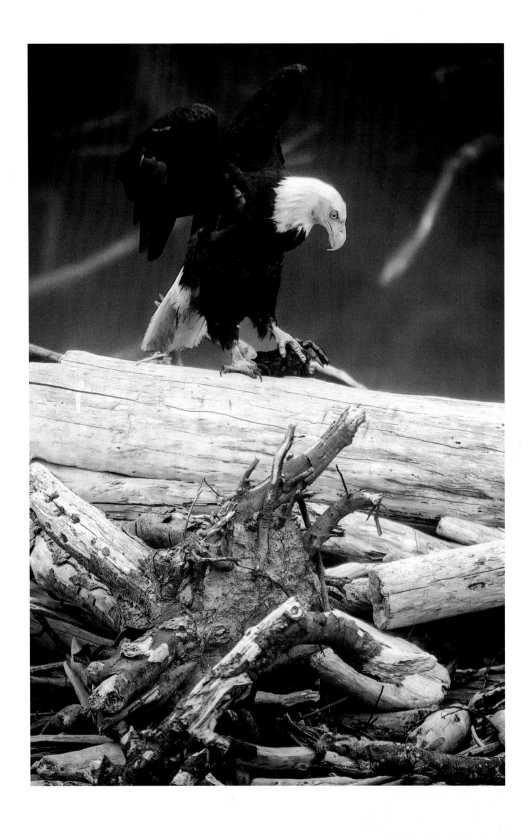

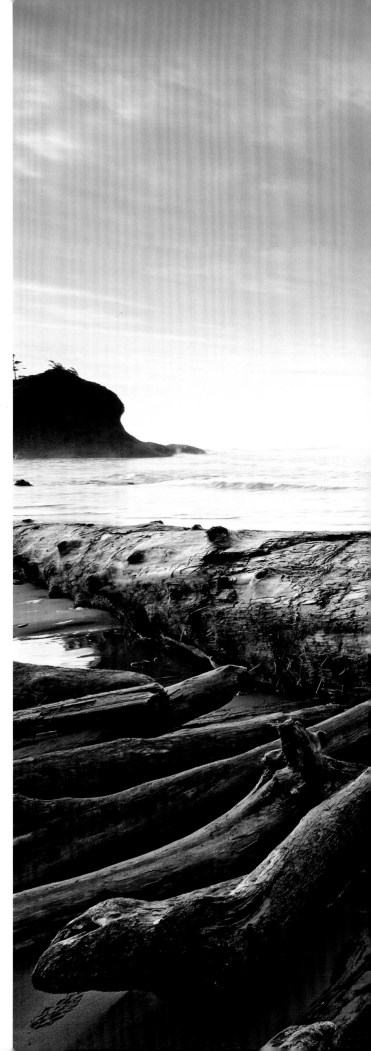

ABOVE: Olympic National Park, Washington
Bald eagle with prey on Ruby Beach.

RIGHT: Olympic National Park, Washington
Second Beach.

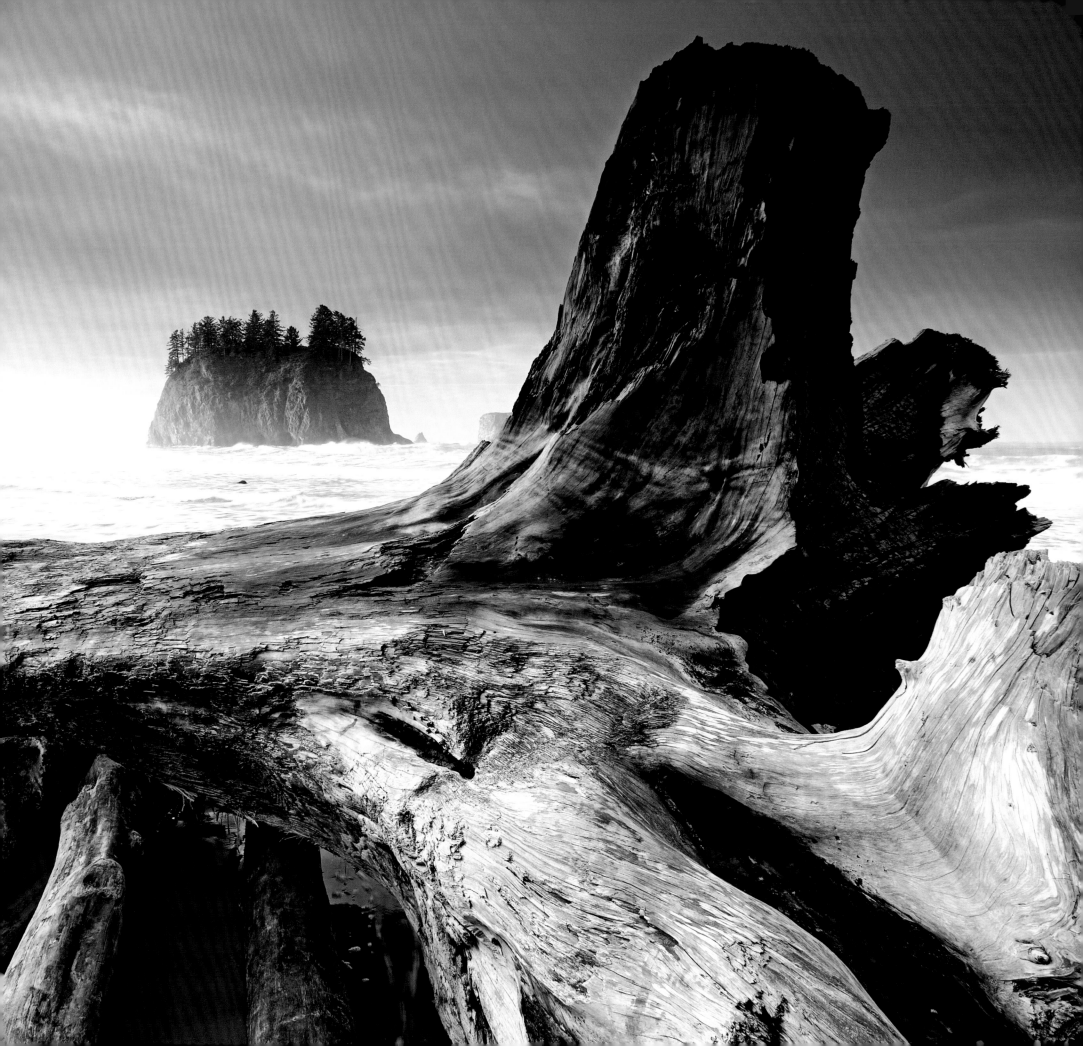

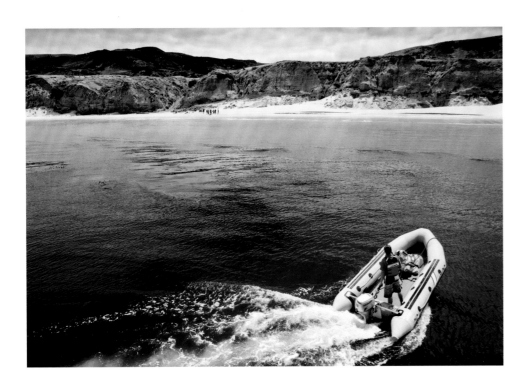

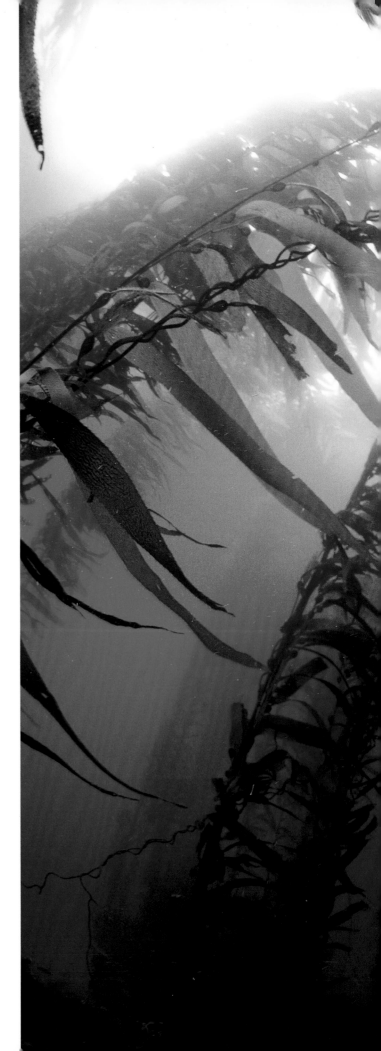

ABOVE: Channel Islands National Park, California
Santa Rosa Island: A skiff heads to the island to pick up tourists to take them back to the mainland.

RIGHT: Channel Islands National Park, California
The view underwater of a kelp (macrocystis) forest off Anacapa Island. Kelp worldwide is threatened by climate change.

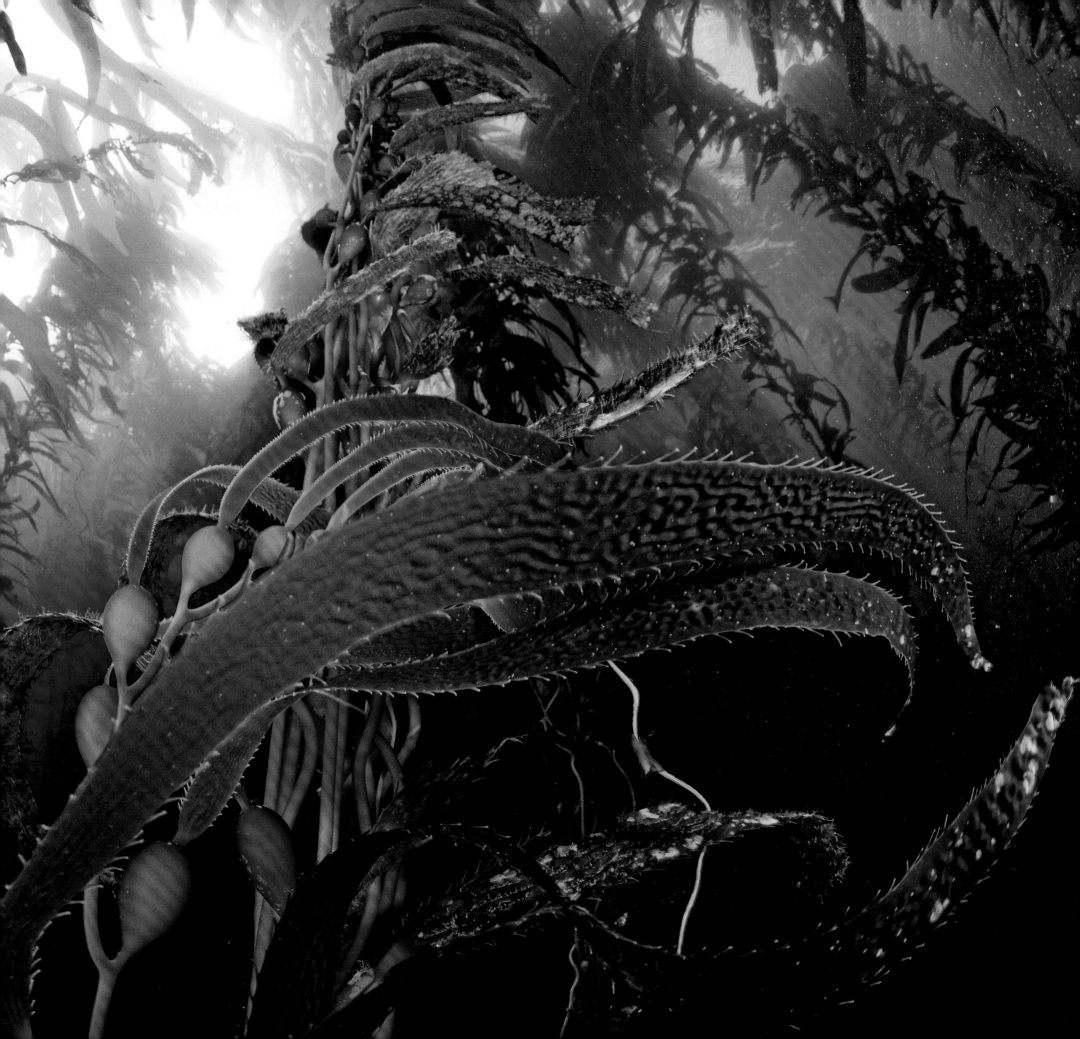

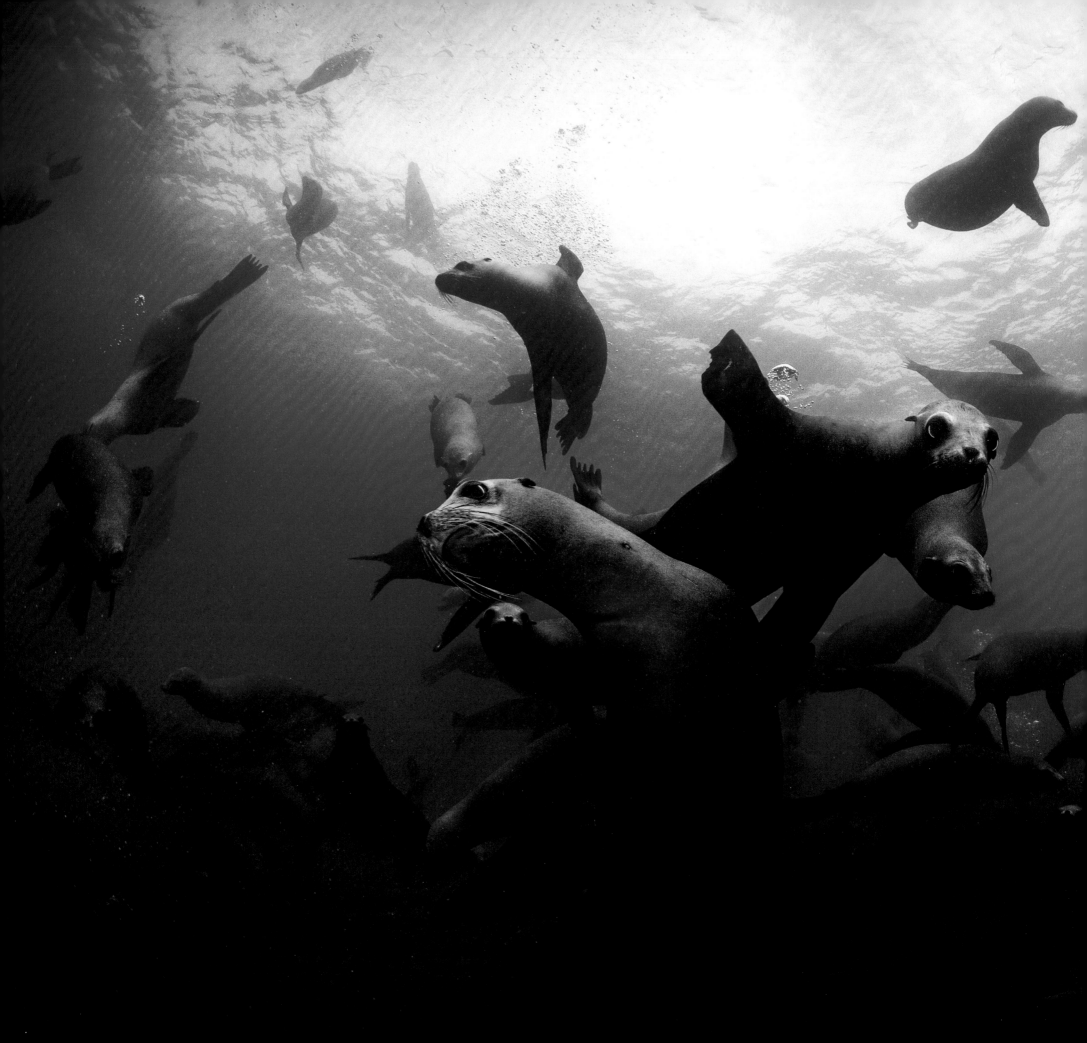

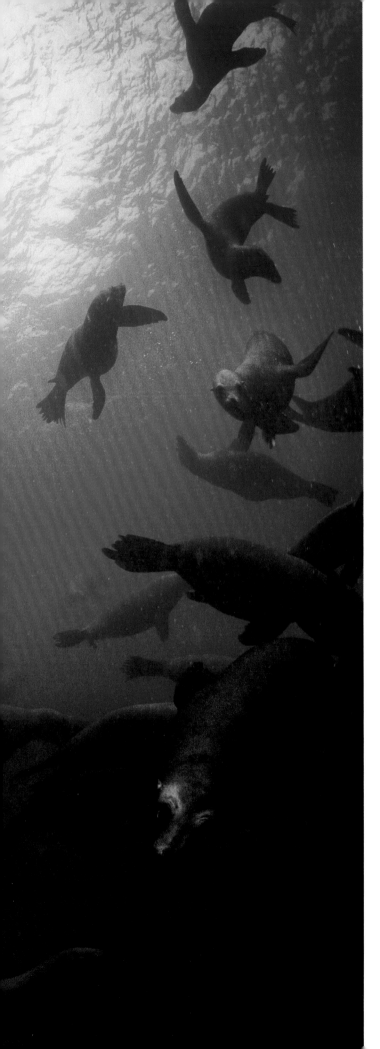

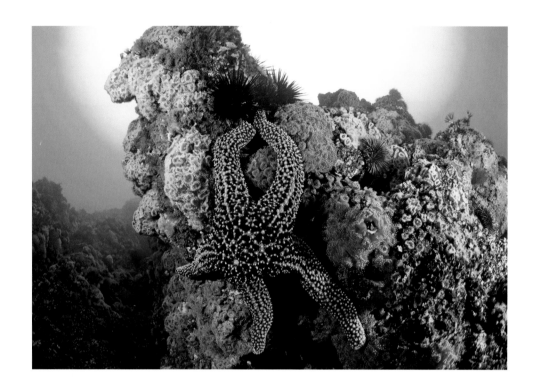

LEFT: Channel Islands National Park, California
California sea lions (Zalophus californianus) *off Anacapa Island.*

ABOVE: Channel Islands National Park, California
A starfish surrounded by strawberry anemone (Corynactis
californica) *off Anacapa Island.*

43

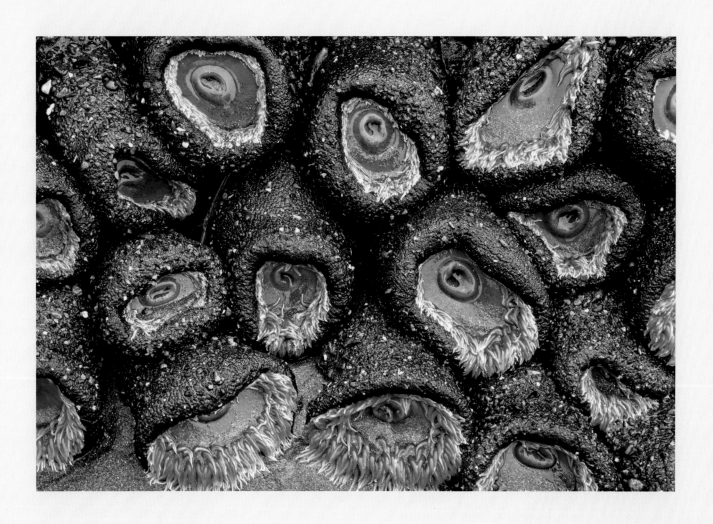

ABOVE: Olympic National Park, Washington
Giant green sea anemones (Anthopleura xanthogrammica).

OPPOSITE: Olympic National Park, Washington
Ruby Beach.

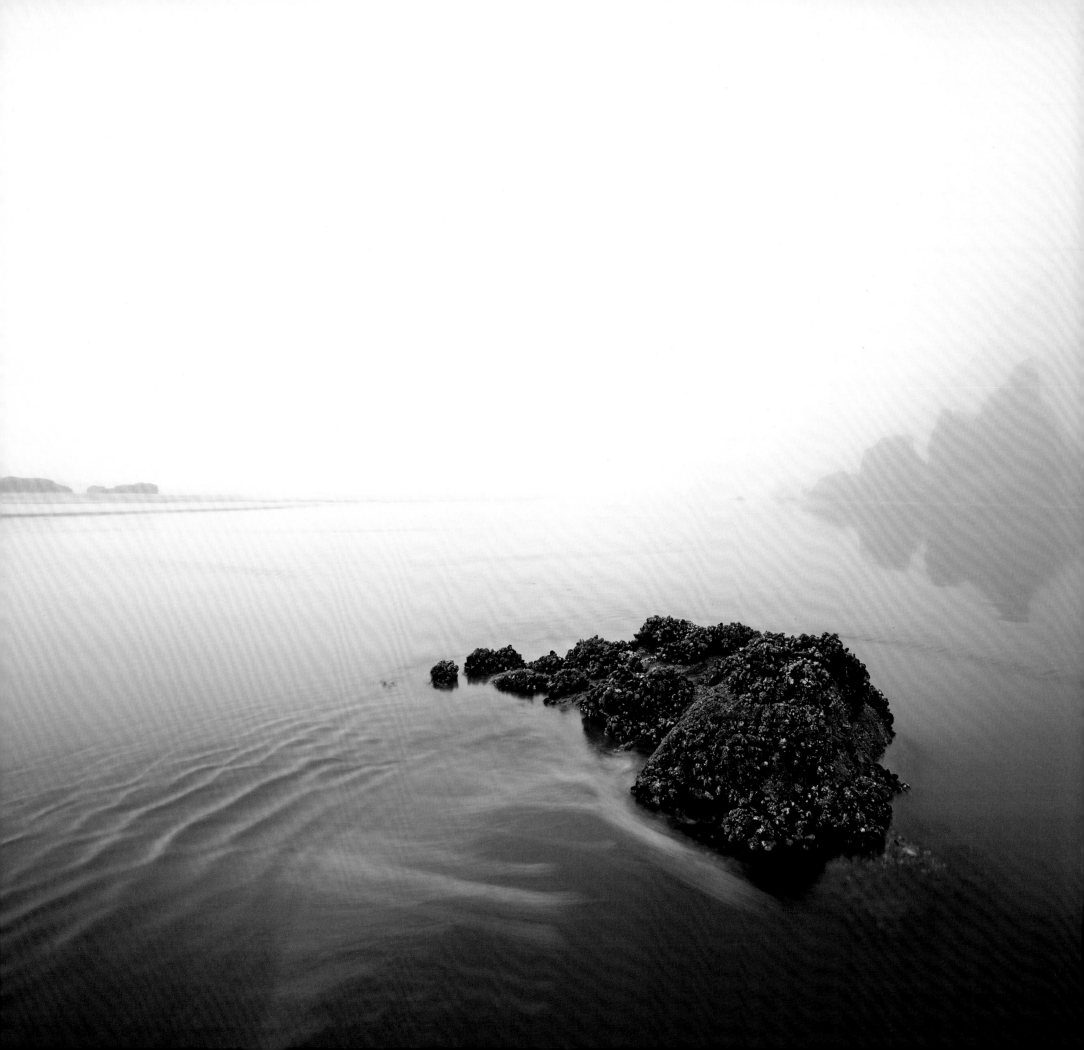

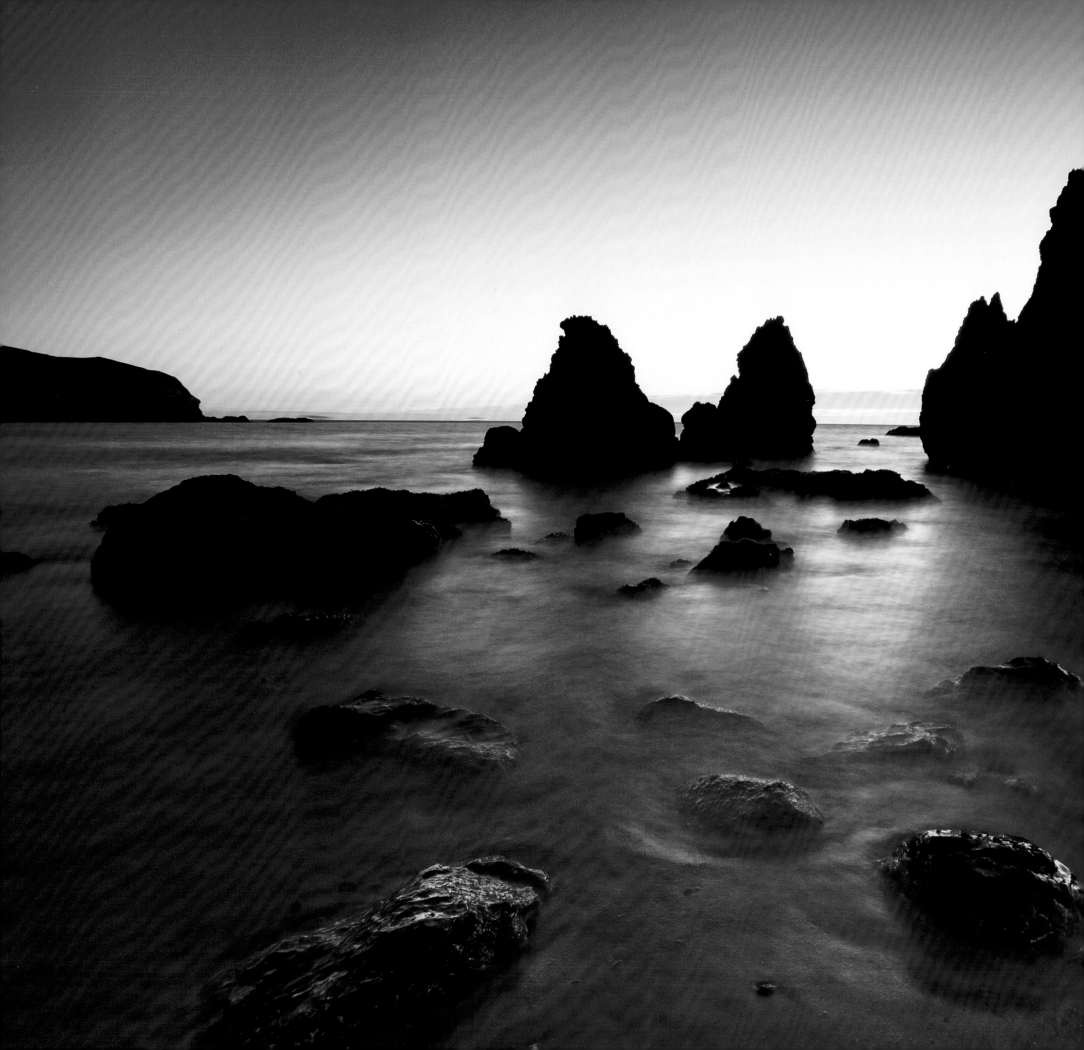

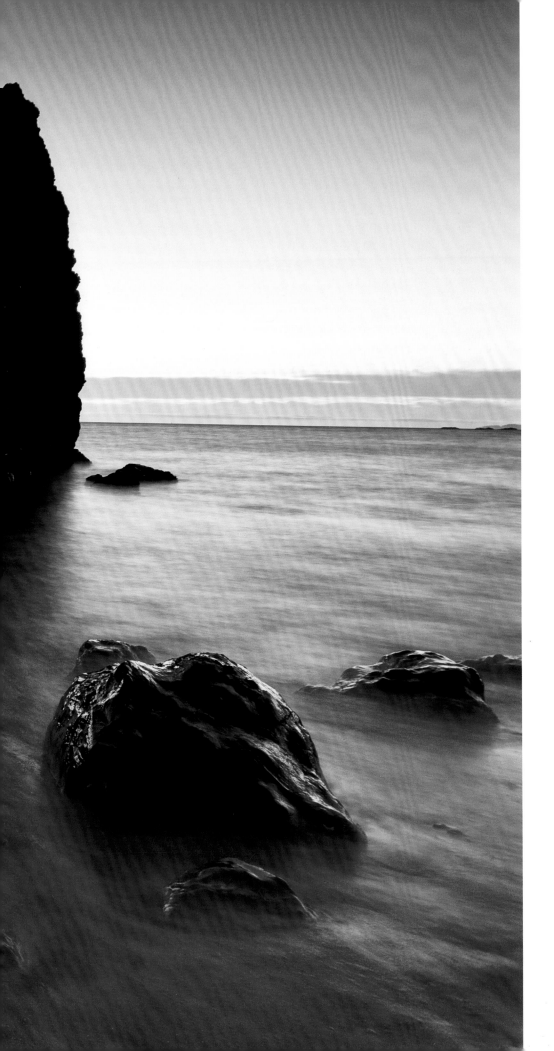

Golden Gate National Recreation Area,
Marin Headlands, California
The famous rocks at Rodeo Beach.

47

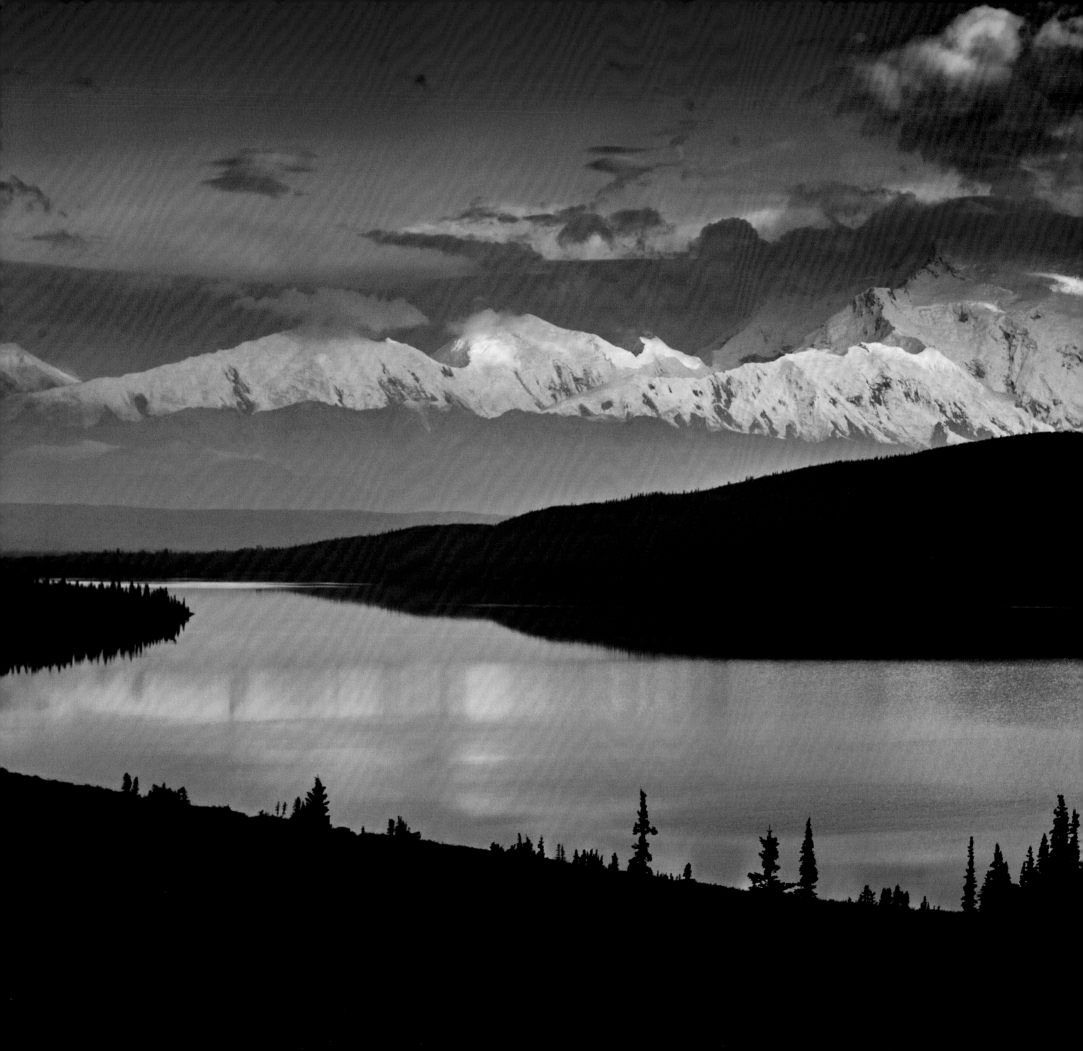

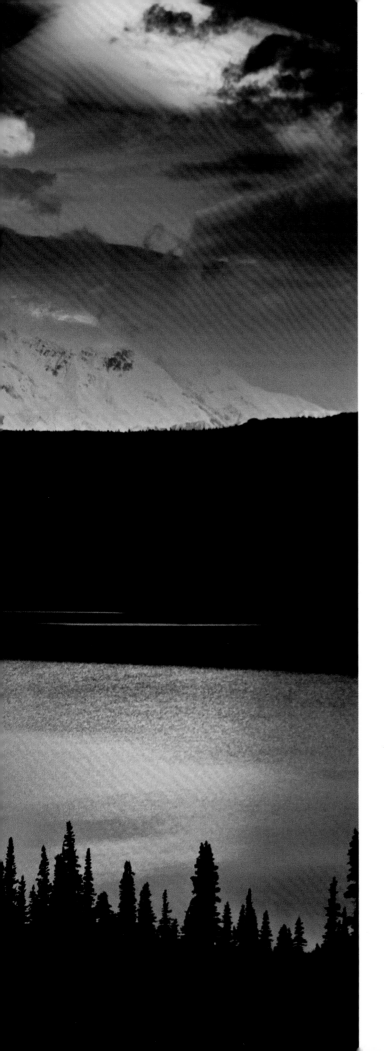

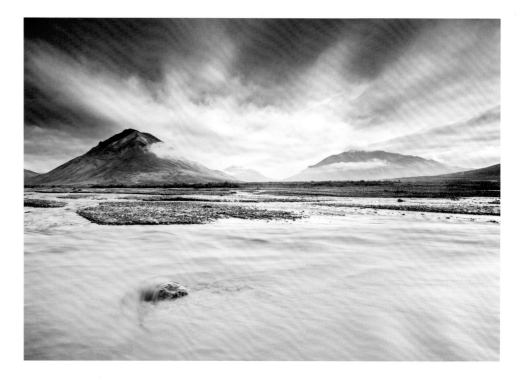

LEFT: Denali National Park and Preserve, Alaska
View of Mount McKinley photographed from Wonder Lake.

ABOVE: Denali National Park and Preserve, Alaska
Sunset on the Toklat River.

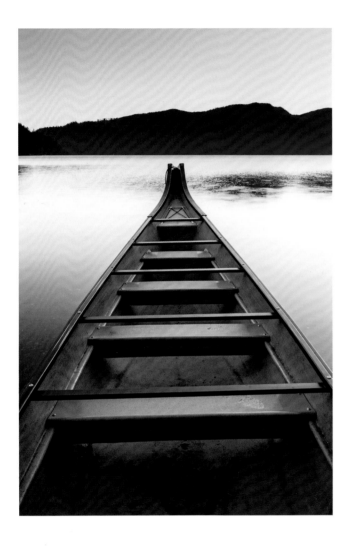

ABOVE: Olympic National Park, Washington
Lake Crescent at sunrise.

RIGHT: Yosemite National Park, California
Sunset light on Tuolumne River and Meadows.
In the distance is Lembert Dome.

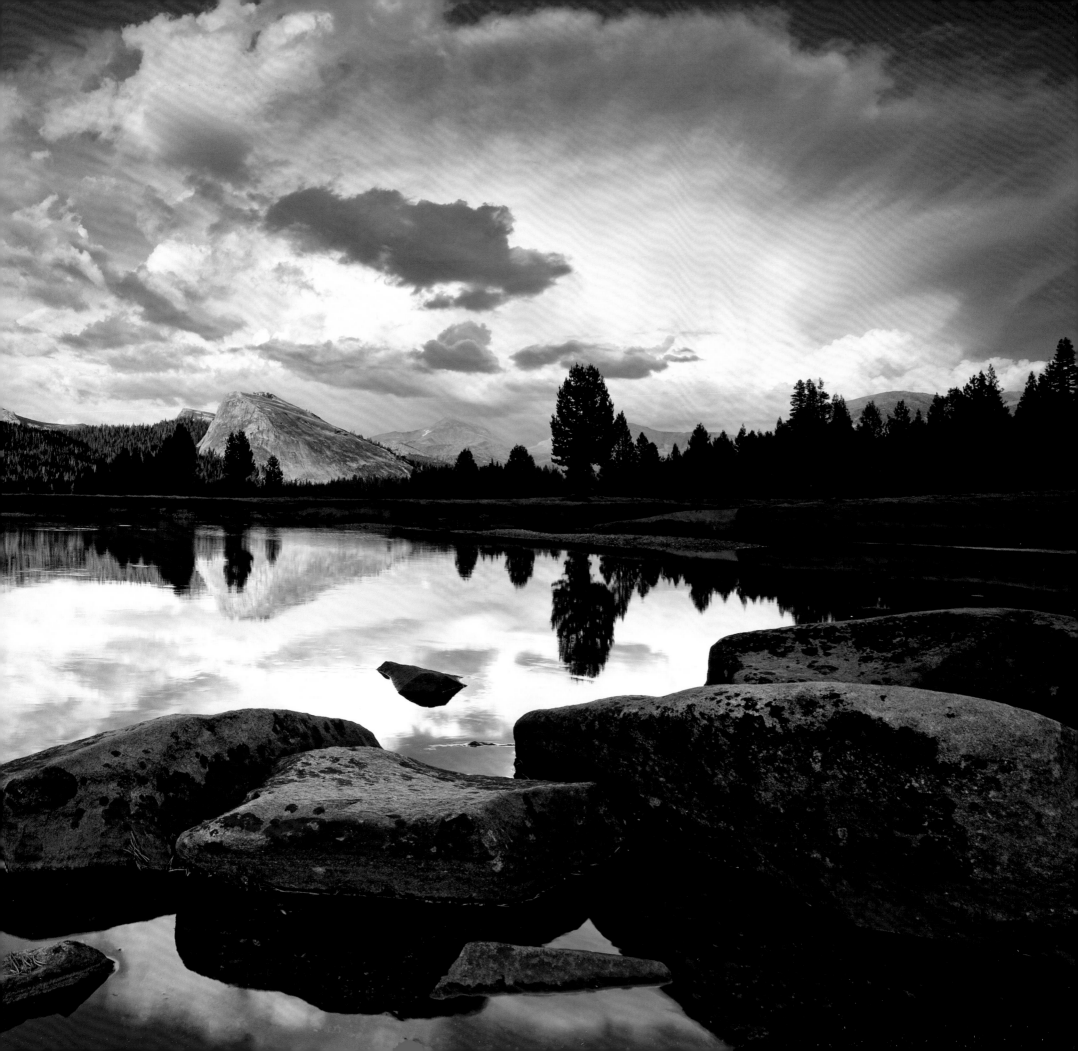

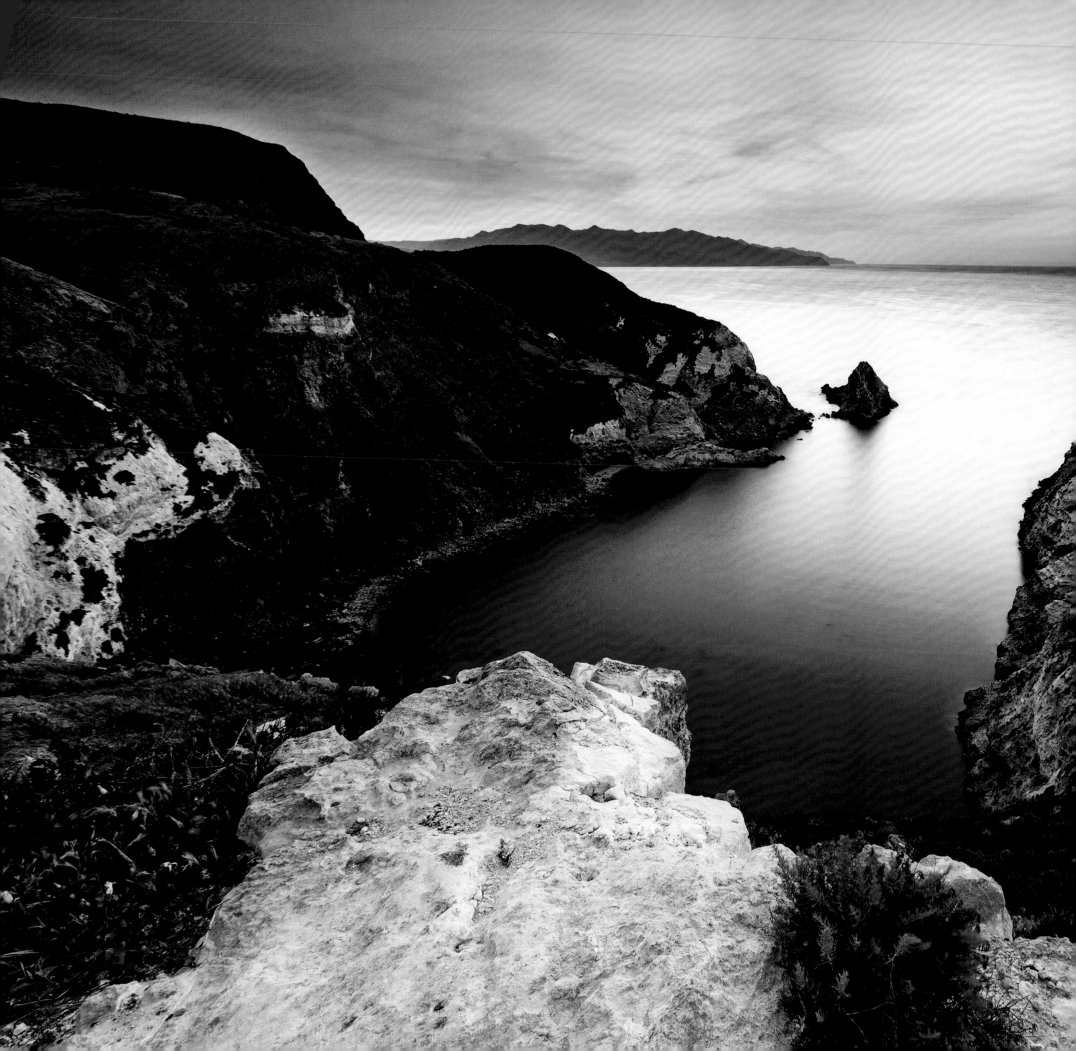

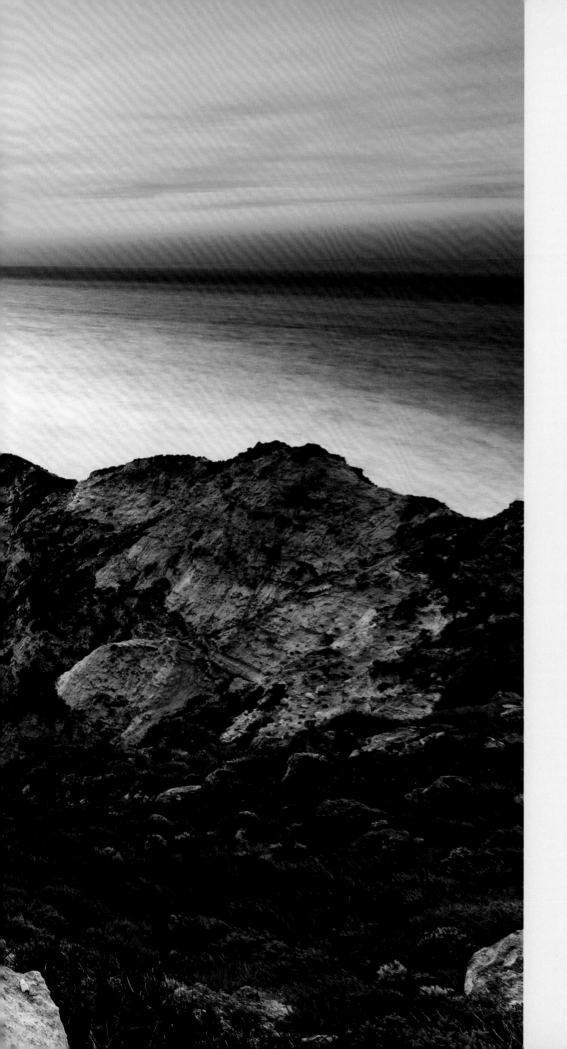

Channel Islands National Park, California
Sunset on Santa Cruz Island's Potato Harbor.

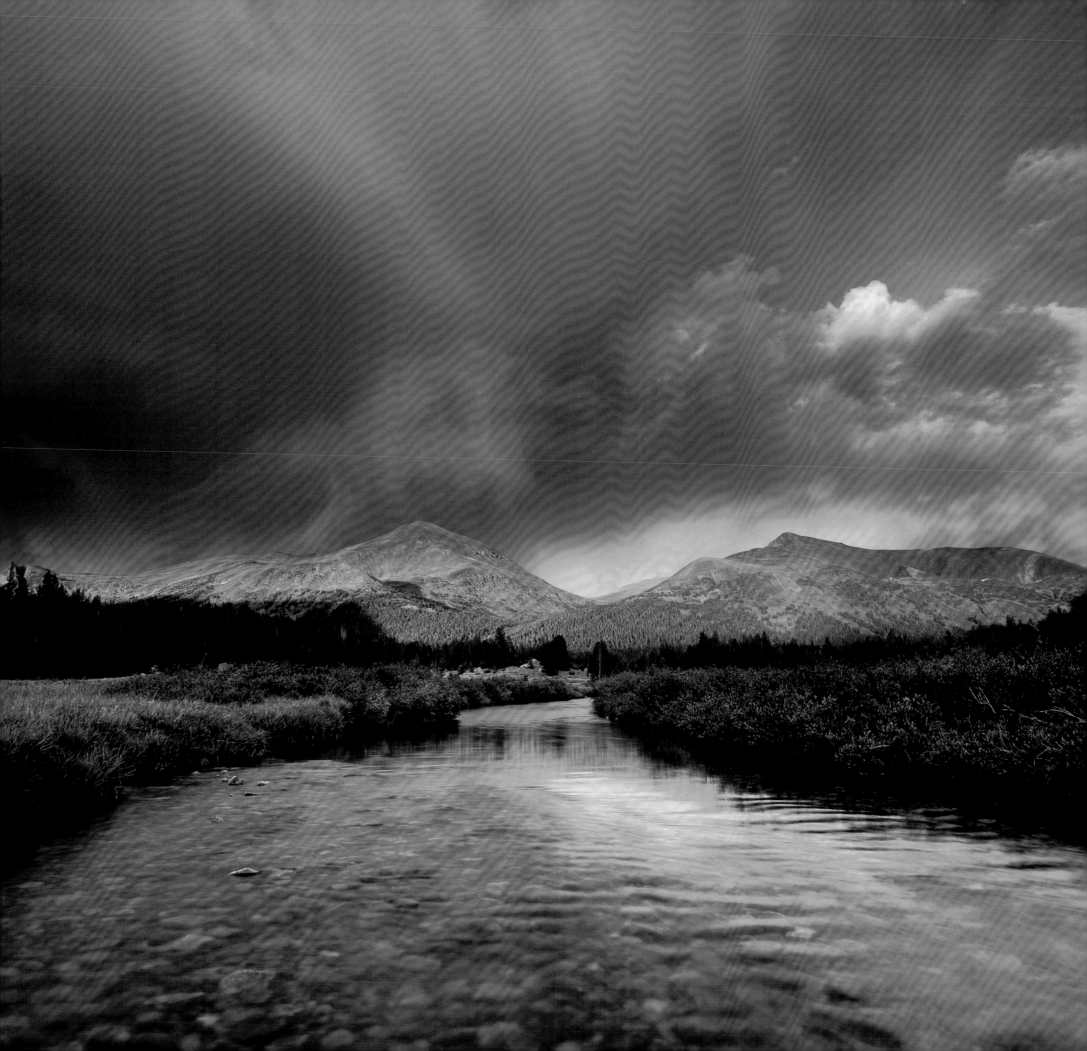

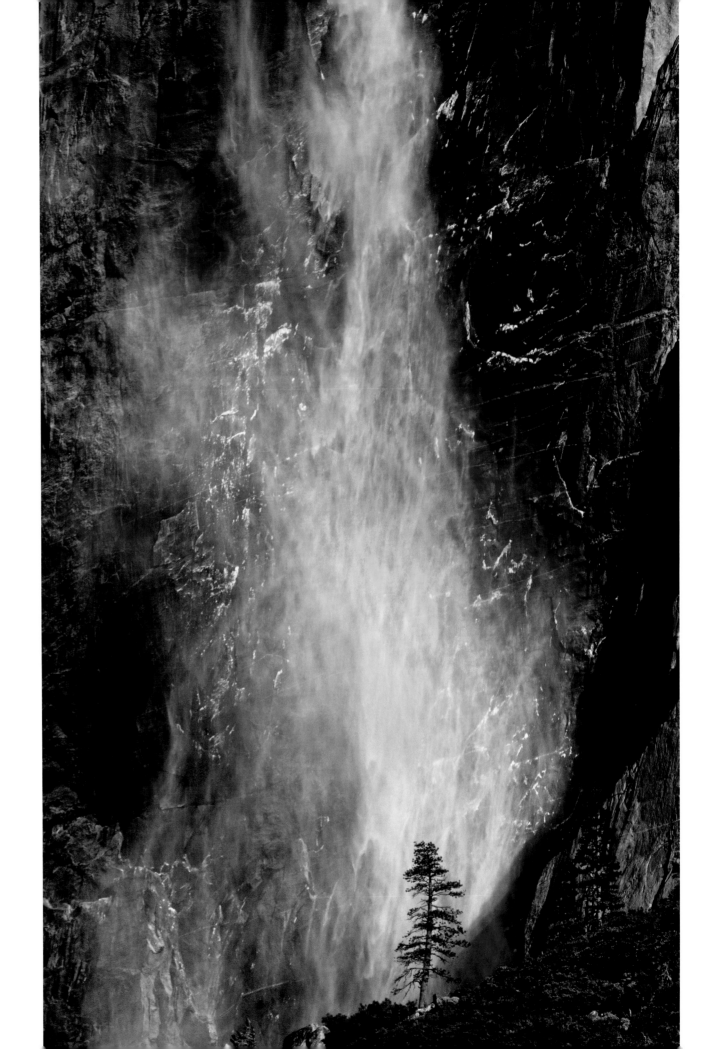

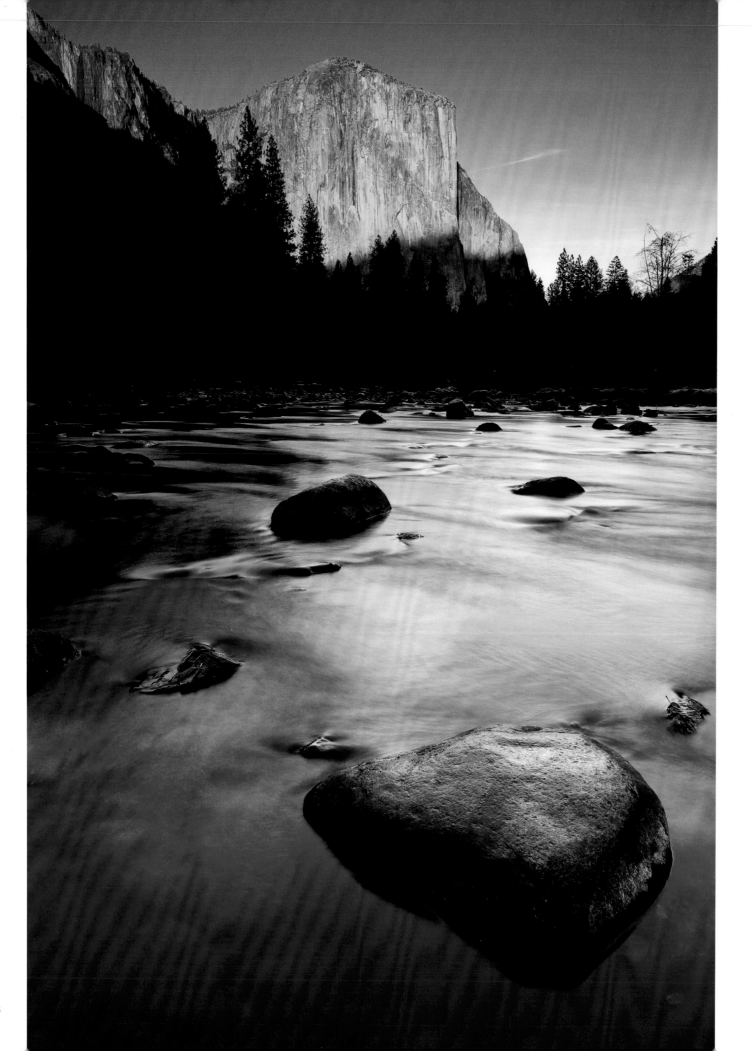

ABOVE: Yosemite National Park, California
Merced River beneath El Capitan.

RIGHT: Yosemite National Park, California
Tuolumne Meadows.

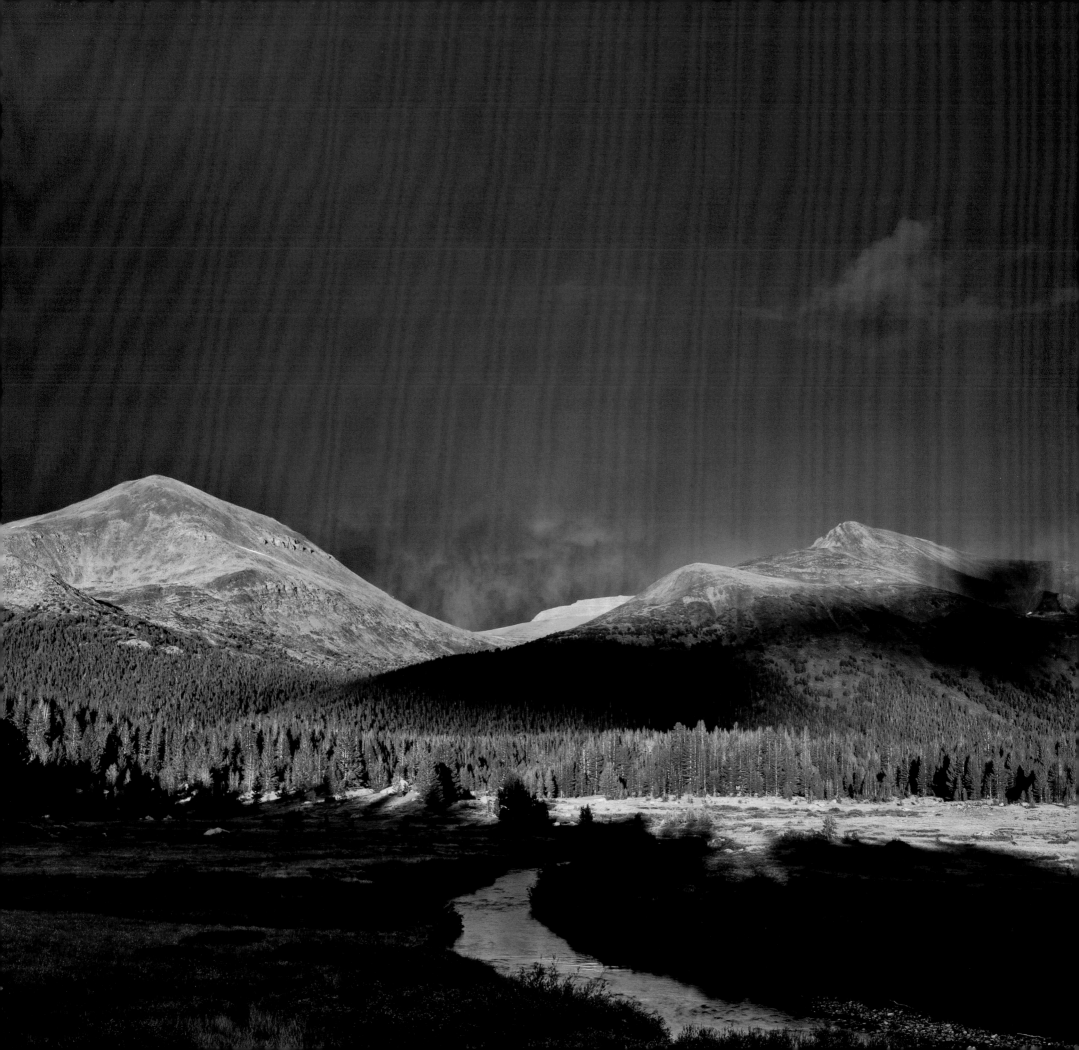

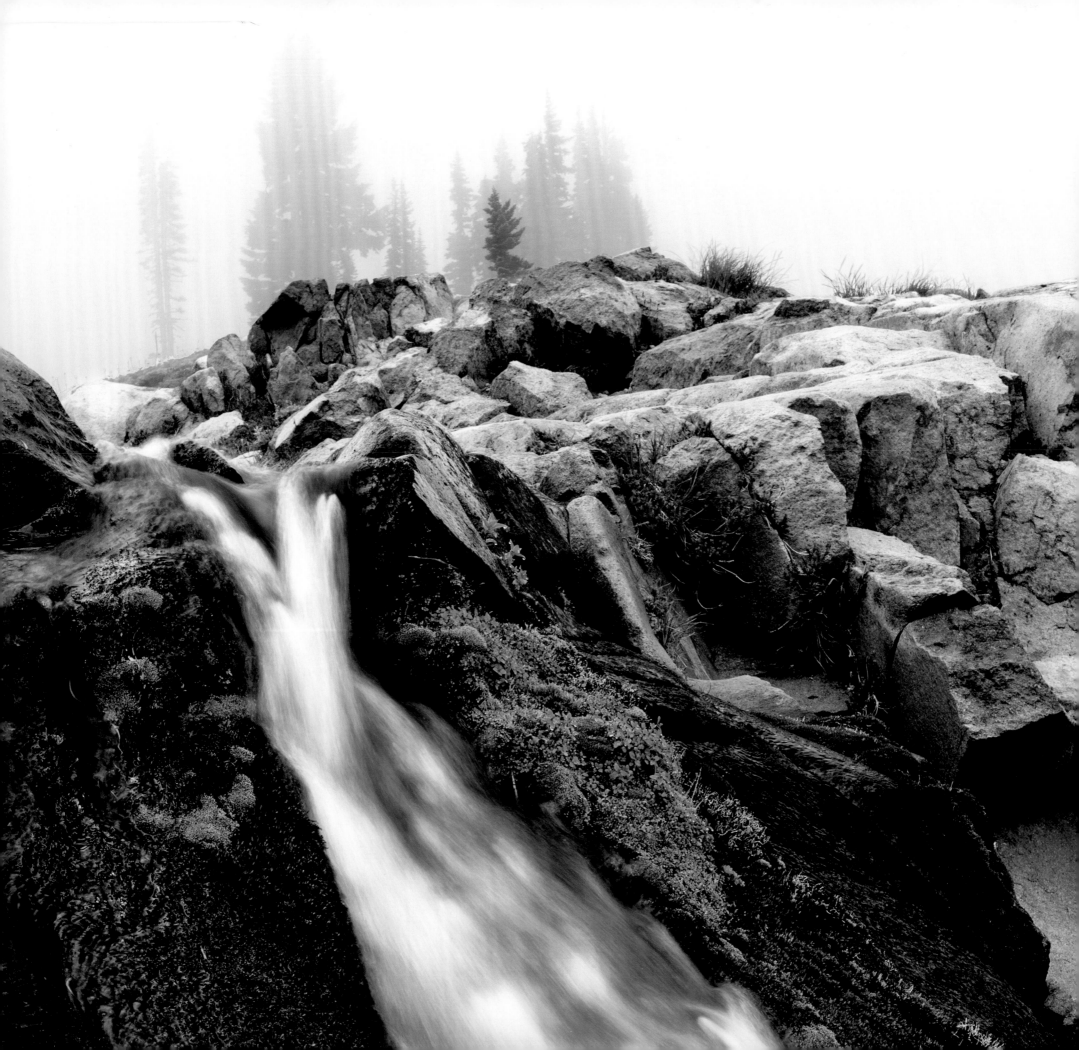

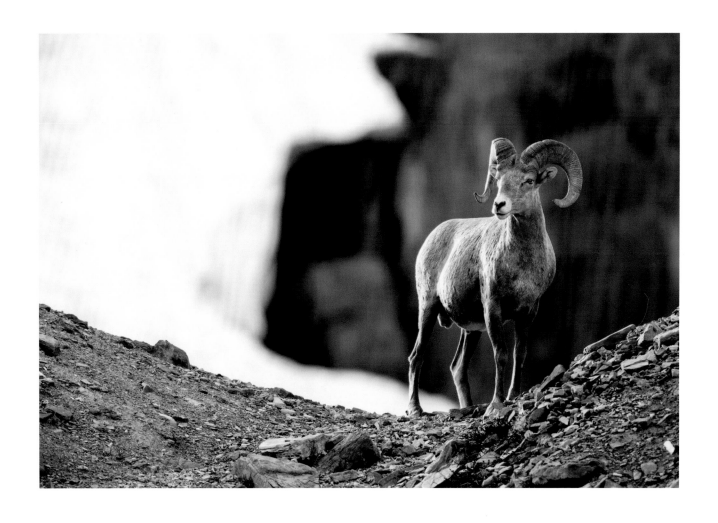

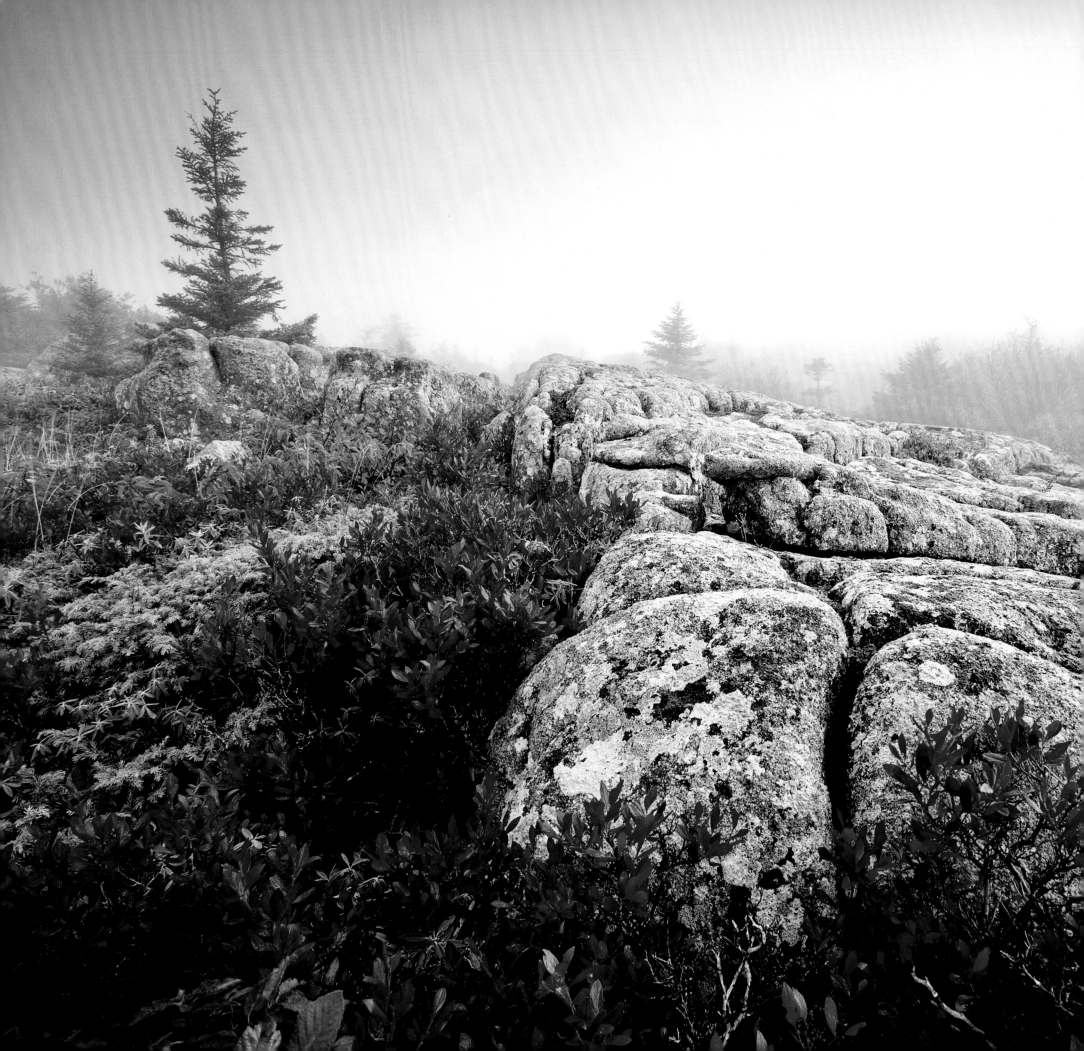

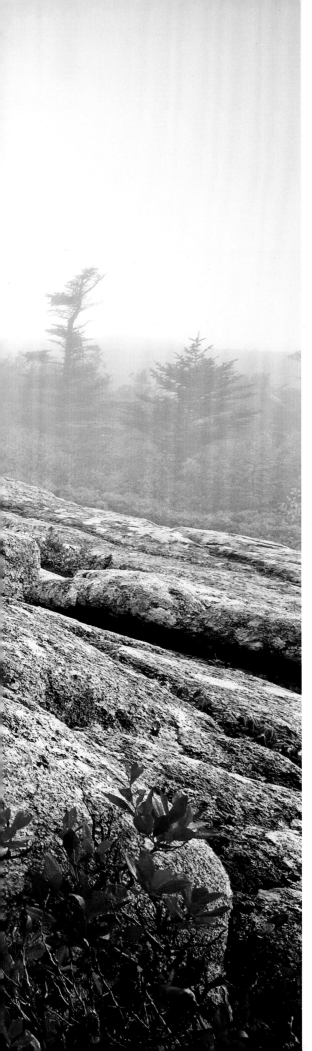

ACADIA NATIONAL PARK AND FRIENDS OF ACADIA
A Remarkable Legacy

Encompassing forty-five thousand acres on two islands and a mainland peninsula on Maine's rugged DownEast coast, Acadia National Park is a jewel of pink granite mountains, glacier-carved lakes and coastlines, historic hiking paths and carriage roads, dazzling night skies, and uniquely varied communities of plant and animal life.

Acadia is also the only U.S. national park initially created by individual donations of private land. On July 8, 1916—six weeks before the creation of the National Park Service—the lands that would become Acadia were gifted to the American people by a farsighted group of residents. Today the park's boundary and history are still closely interwoven with the coastal Maine communities that surround it. This intersection of human and natural influences is a key part of Acadia's character and the foundation for the legacy of private philanthropy and engagement that has so shaped this remarkable place.

Drawing more than 2.5 million visitors each year, Acadia is one of the ten most popular national parks in the United States. It is also one of the smallest and most vulnerable. Prevailing winds bring in pollution from across the country. Narrow, winding roads and low stone bridges, designed to harmonize perfectly with their surroundings, cannot handle ever-increasing numbers and sizes of cars and buses. Invasive plants and light pollution easily cross park boundaries from the surrounding communities. Higher temperatures due to climate change allow more invasive species to thrive and threaten migrant populations that may arrive out of sync with the food sources they depend on. So, too, rising sea levels and more extreme storms threaten shoreline habitats, fish nurseries, and the integrity of cultural treasures, such as the unpaved carriage roads.

This is why Friends of Acadia exists. We are an independent organization of passionate people, inspiring those who love Acadia to make a real and lasting difference for the park. Friends of Acadia uses a mix of grants, volunteerism, programs, and partnerships to find innovative and effective solutions to pressing park problems. Solutions like Acadia Trails Forever, which established the first endowed hiking trail network in the country; solutions like the Island Explorer, a fare-free, propane-powered bus service that connects popular park destinations with the surrounding communities to reduce automobile congestion and pollution on Acadia's historic scenic drives; solutions like Take Pride in Acadia Day, which draws up to five-hundred volunteers one November morning each year, to rake leaves and protect Acadia's carriage roads from the ravages of a Maine winter; solutions like the Wild Acadia initiative, building a more intact and resilient ecosystem one watershed at a time; and solutions like the Acadia Youth Technology Team, a for-youth, by-youth think tank that is finding creative ways to get kids and teens excited about Acadia and the outdoors.

The people who love Acadia come from all over the world, from all walks of life. Each has their own favorite places and activities here—with coastal cliffs, cobble and sand beaches, bare summits, placid forests, and clear ponds all nestled amongst towns of many different characters, Acadia offers something to everyone. Some grew up here in the same villages their distant ancestors helped to build. Some families have summered on Mount Desert Island or the Schoodic Peninsula since their grandparents were young. Some have visited twenty times—or only once—and have fallen completely in love with this place. Through their gifts of dollars or physical effort, they become a part of the story of this park every bit as much as the park founders of a century back, the Wabanaki people, the English and French settlers, the Rusticators, the Civilian Conservation Corps, the local engineers who headed the road crews . . . in short, every individual whose love and whose gifts have given us Acadia National Park. Friends of Acadia is proud to be a part of the legacy of personal ties and collective effort for the benefit of this magnificent natural treasure.

—Aimee Beal Church
Editor, Friends of Acadia Journal

LEFT AND FOLLOWING PAGES:
Acadia National Park, Maine
Cadillac Mountain.

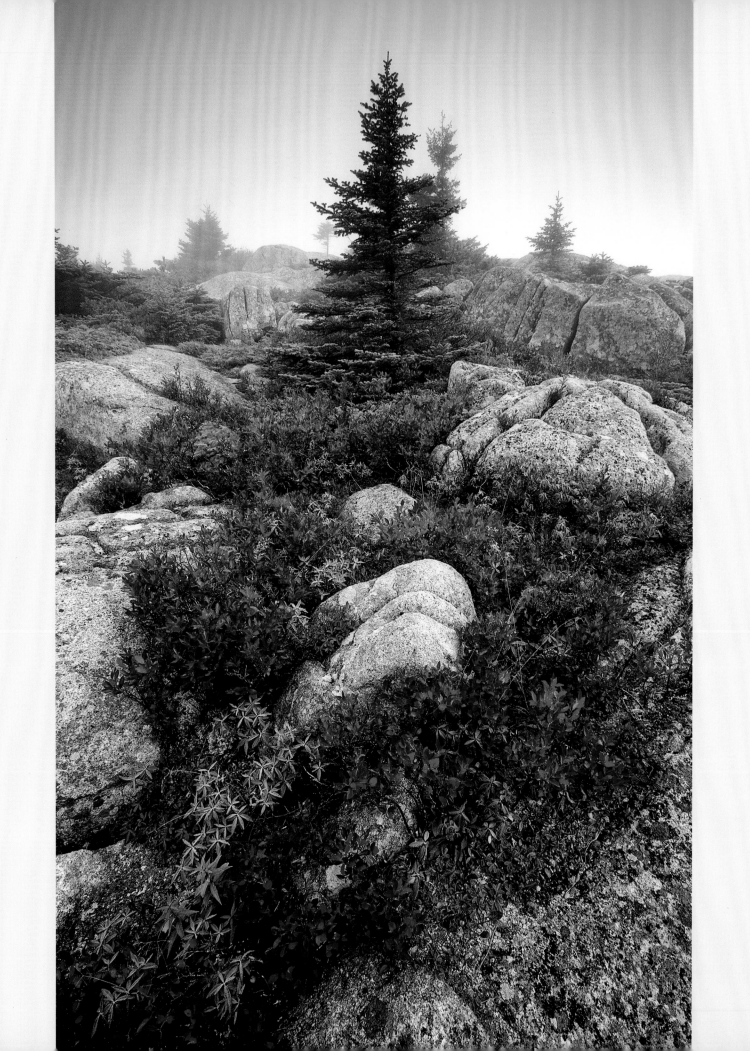

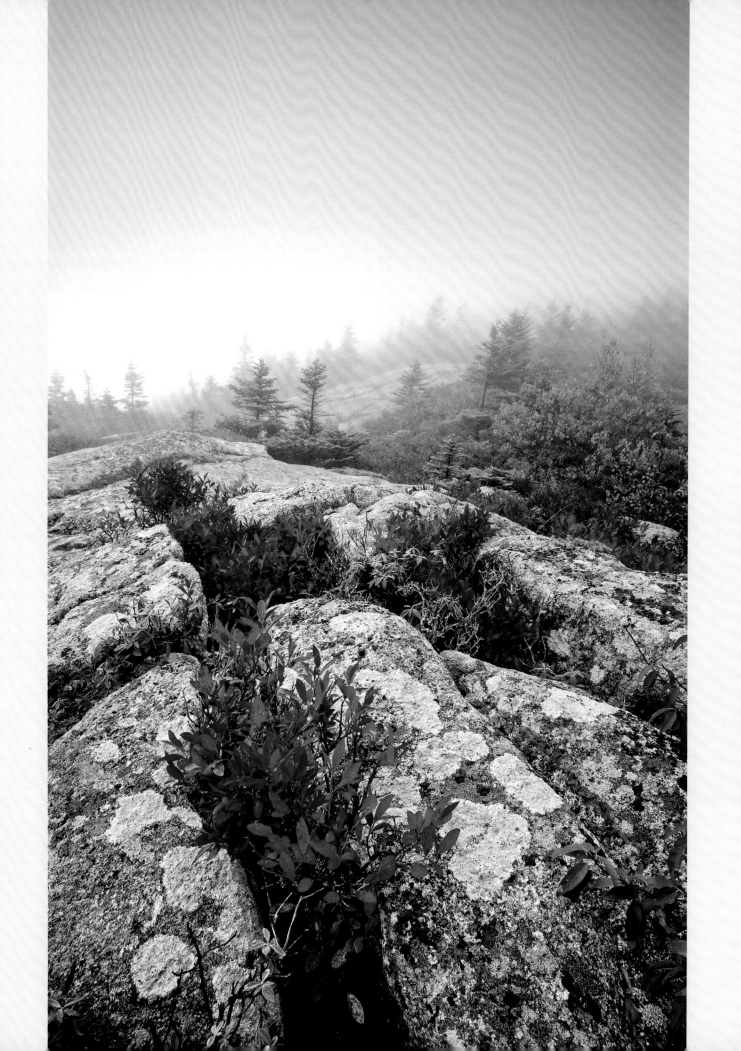

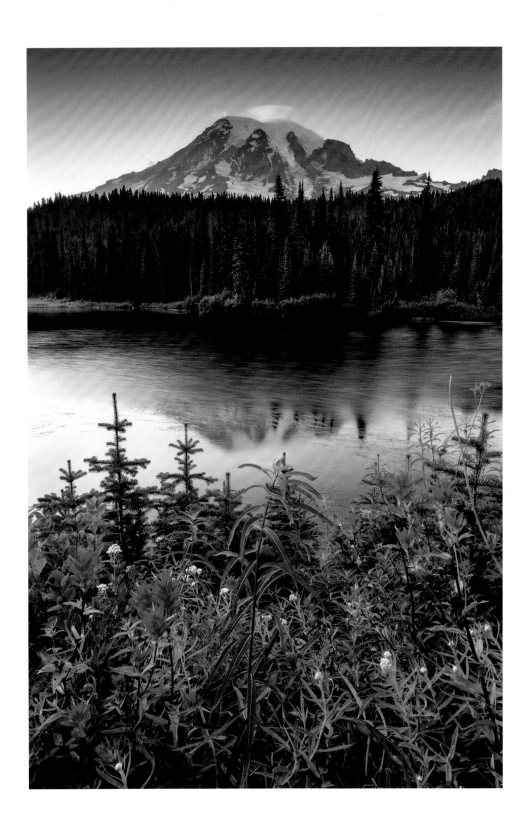

ABOVE: Mount Rainier National Park, Washington
Reflection Lakes with Mount Rainier in the background.

RIGHT: Mount Rainier National Park, Washington
Wildflowers along Paradise River.

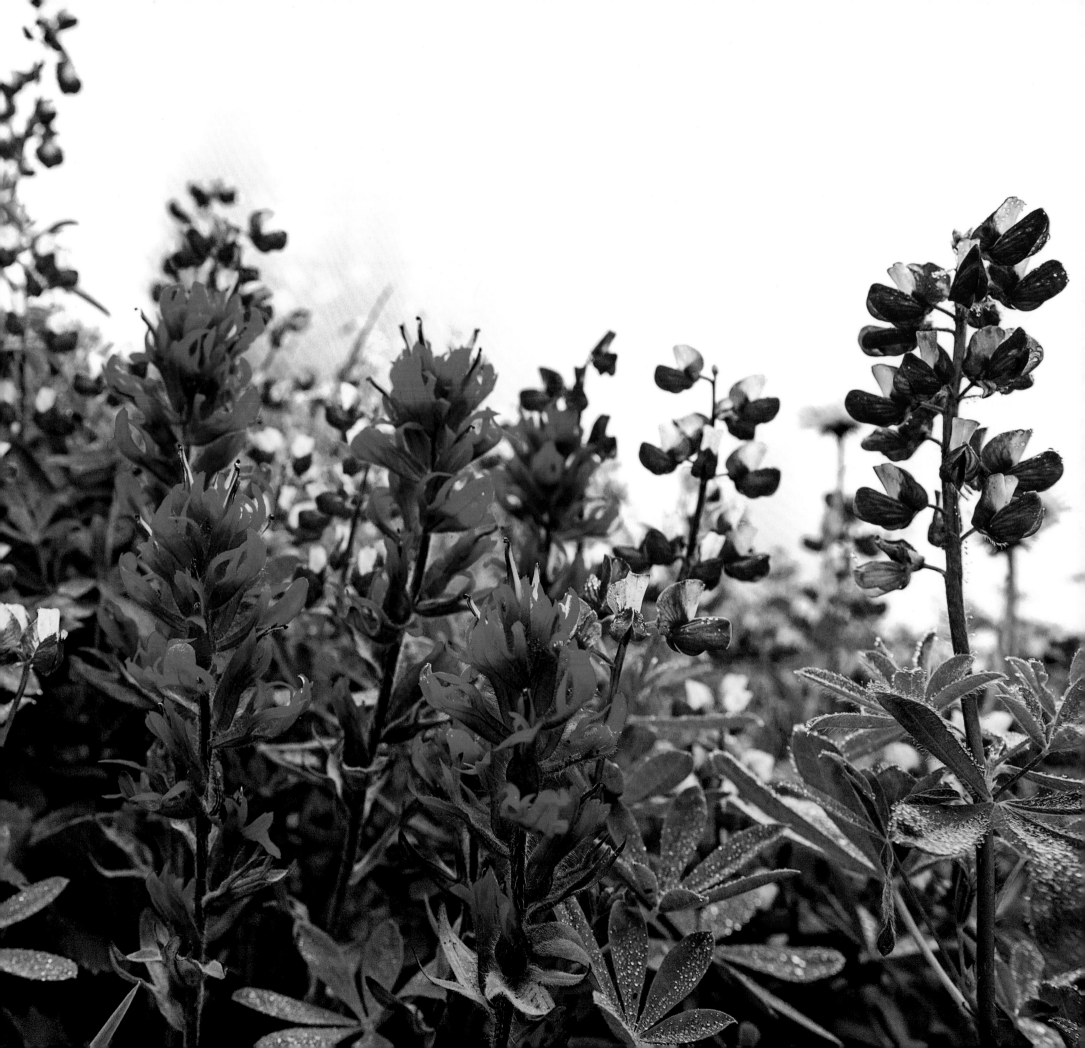

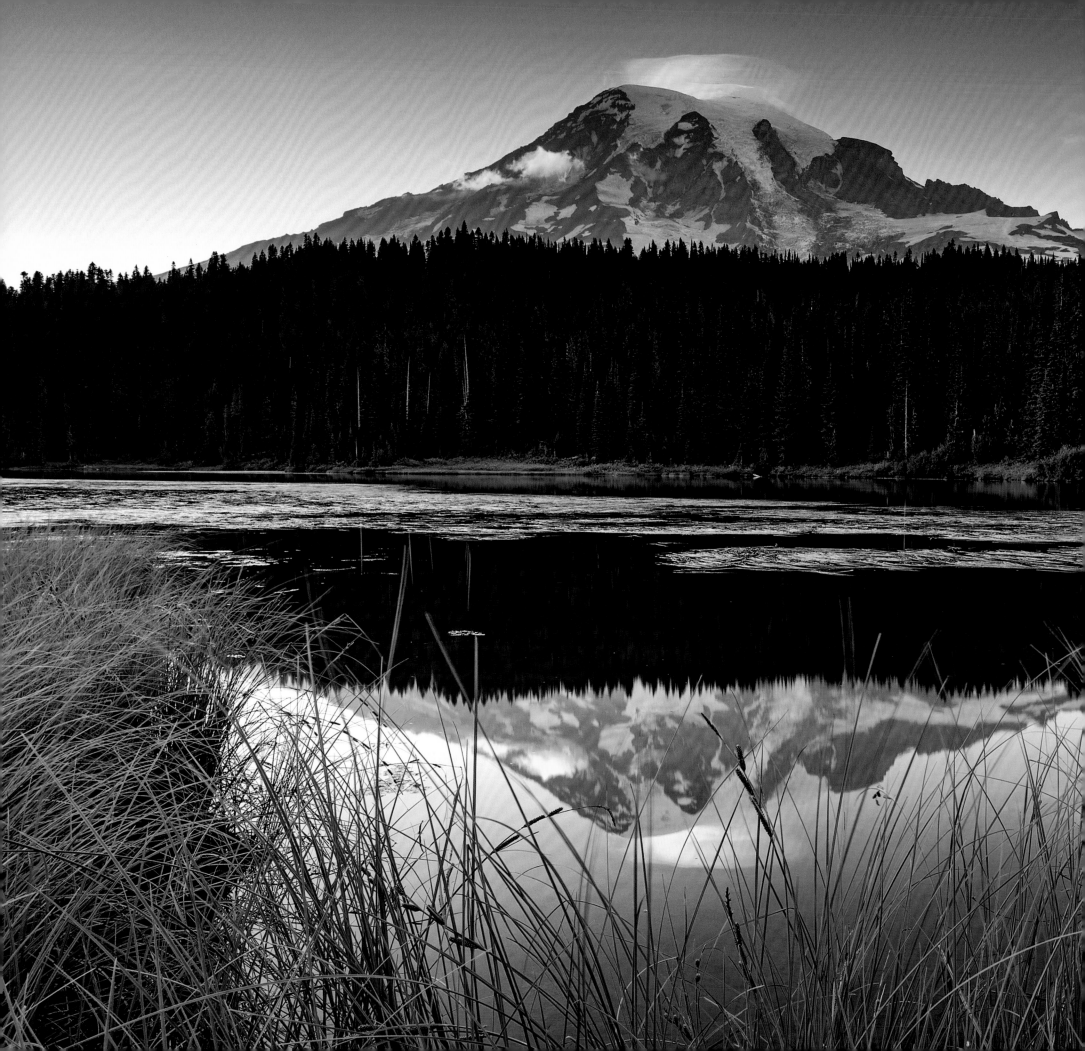

Mount Rainier National Park, Washington
Sunset at Reflection Lakes with Mount Rainier in the background.

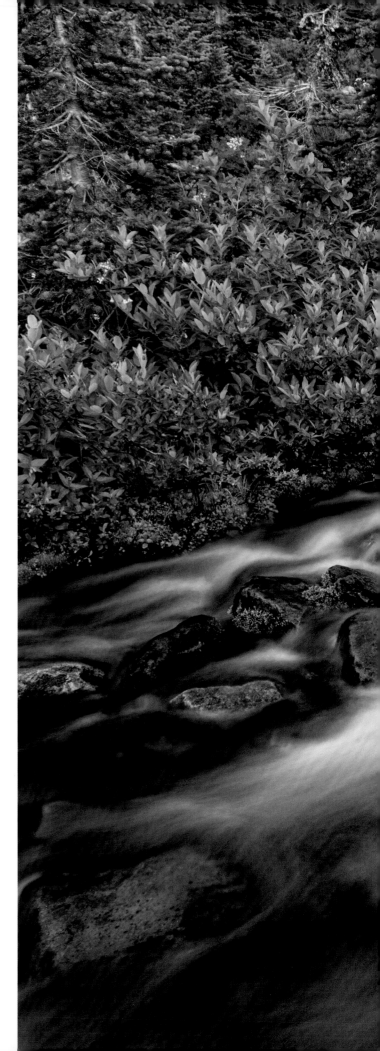

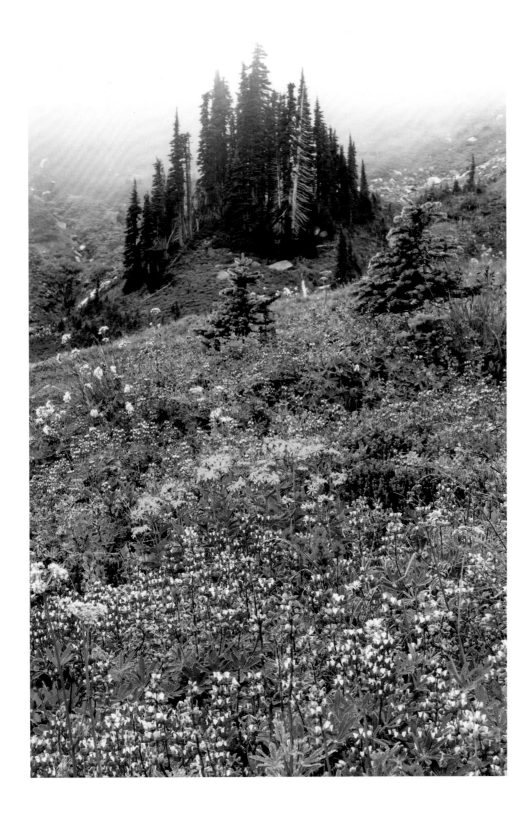

ABOVE: Mount Rainier National Park, Washington
Wildflowers along the Skyline Trail.

RIGHT: Mount Rainier National Park, Washington
Summer wildflowers along Paradise River.

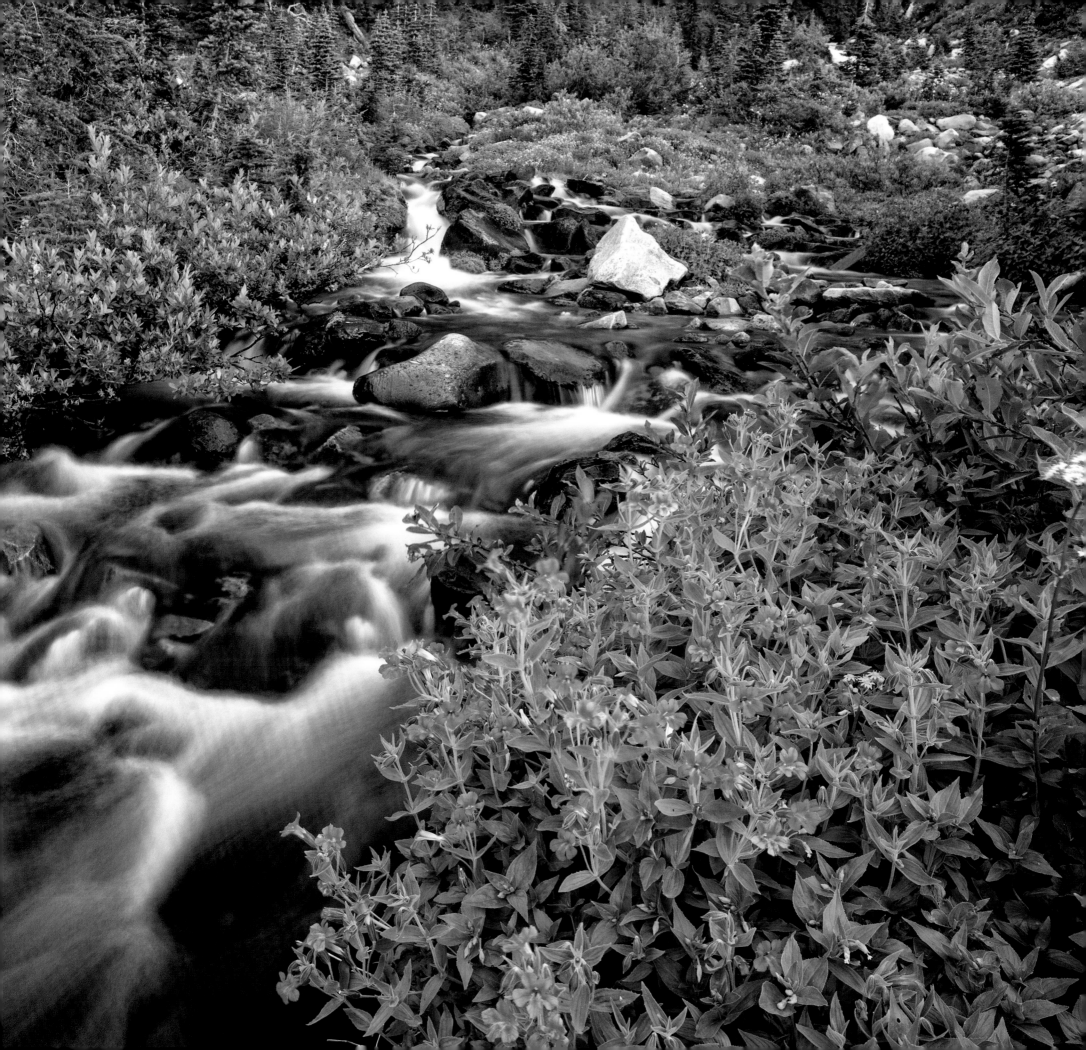

ABOVE: Golden Gate National Recreation Area, Marin Headlands, California
Detail of wildflowers along the Marin Headlands' Miwok and Wolf Ridge Trails.

OPPOSITE: Grand Teton National Park, Wyoming
Sunrise on a beaver pond.

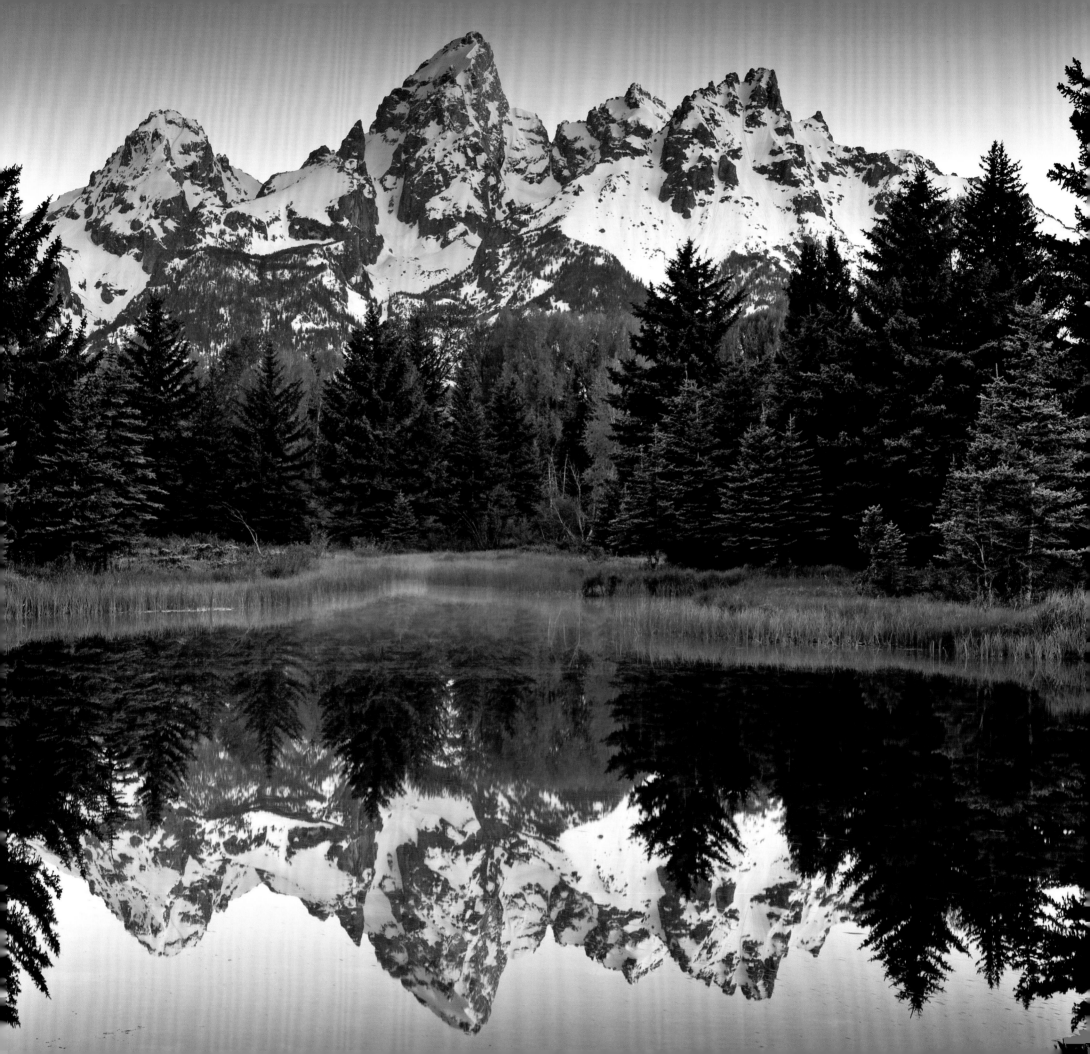

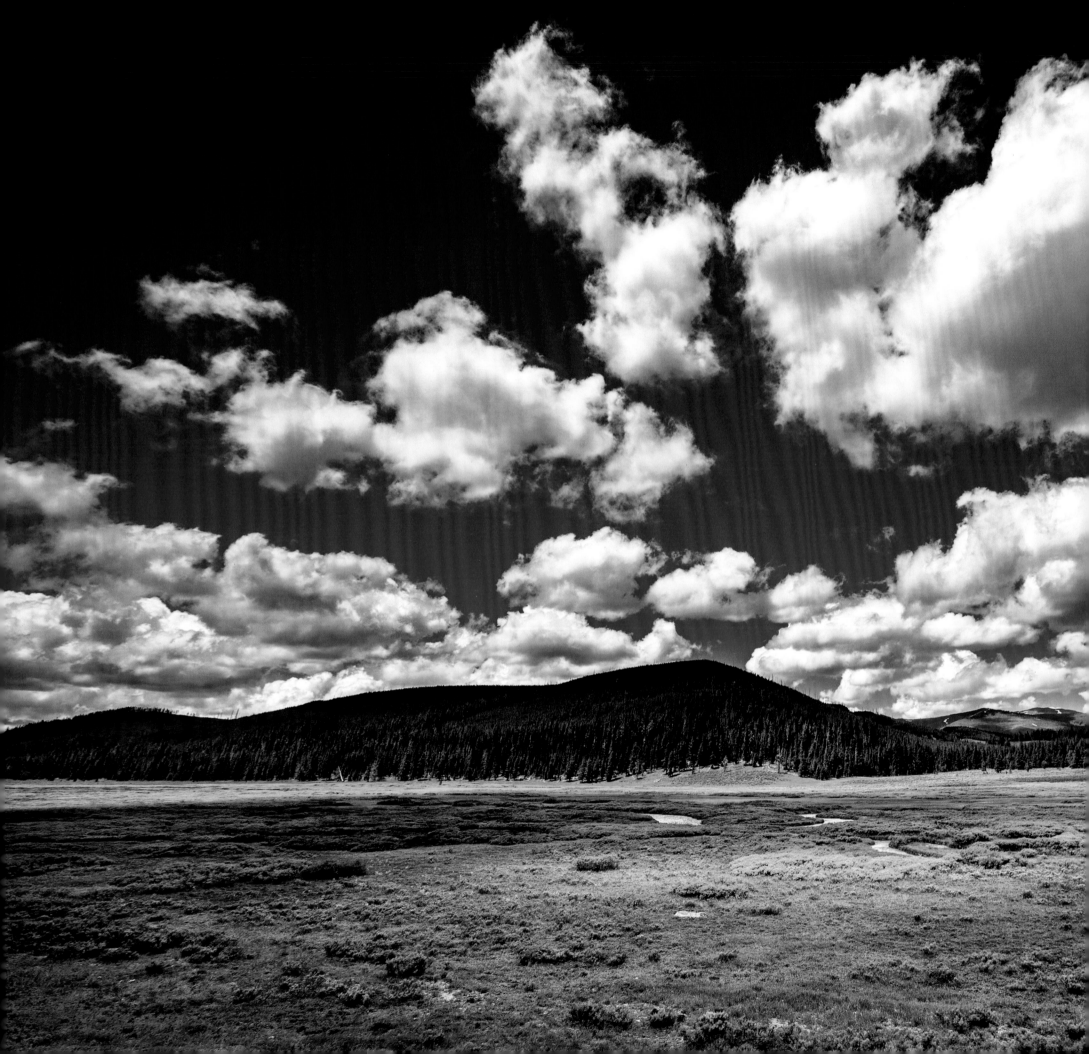

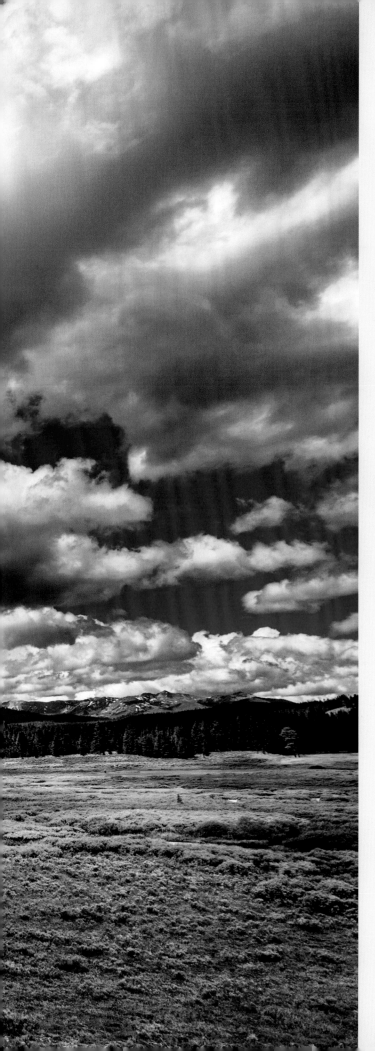

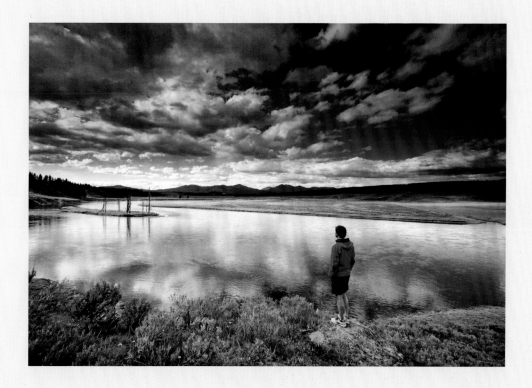

LEFT: Yellowstone National Park; Idaho, Montana, Wyoming
The westernmost edge of Yellowstone National Park just outside Big Sky, Montana.

ABOVE: Yellowstone National Park; Idaho, Montana, Wyoming
A man stands at the edge of the Yellowstone River in Hayden Valley.

FOLLOWING PAGES: Yosemite National Park, California
Sunset light on Tuolumne River and Meadows with Lembert Dome in the distance.

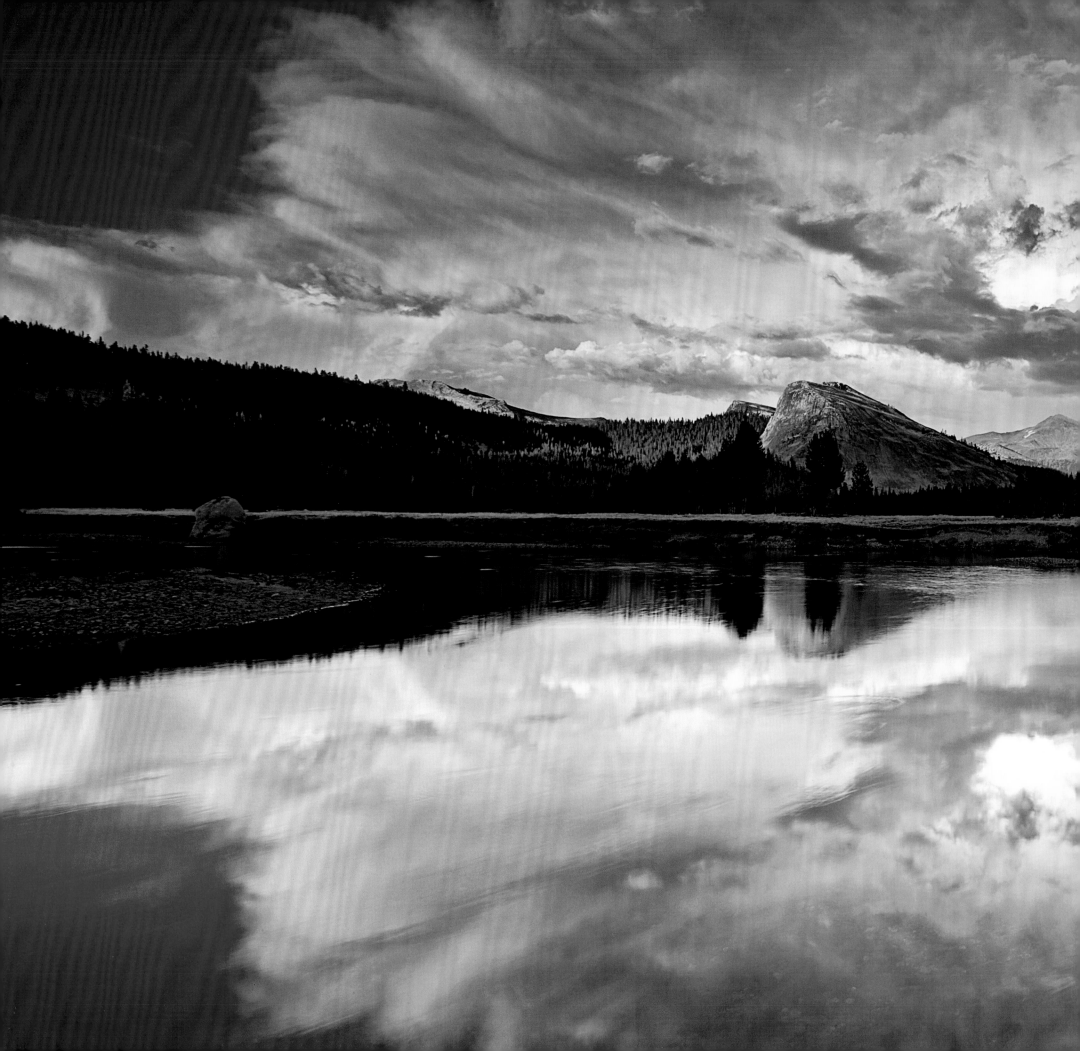

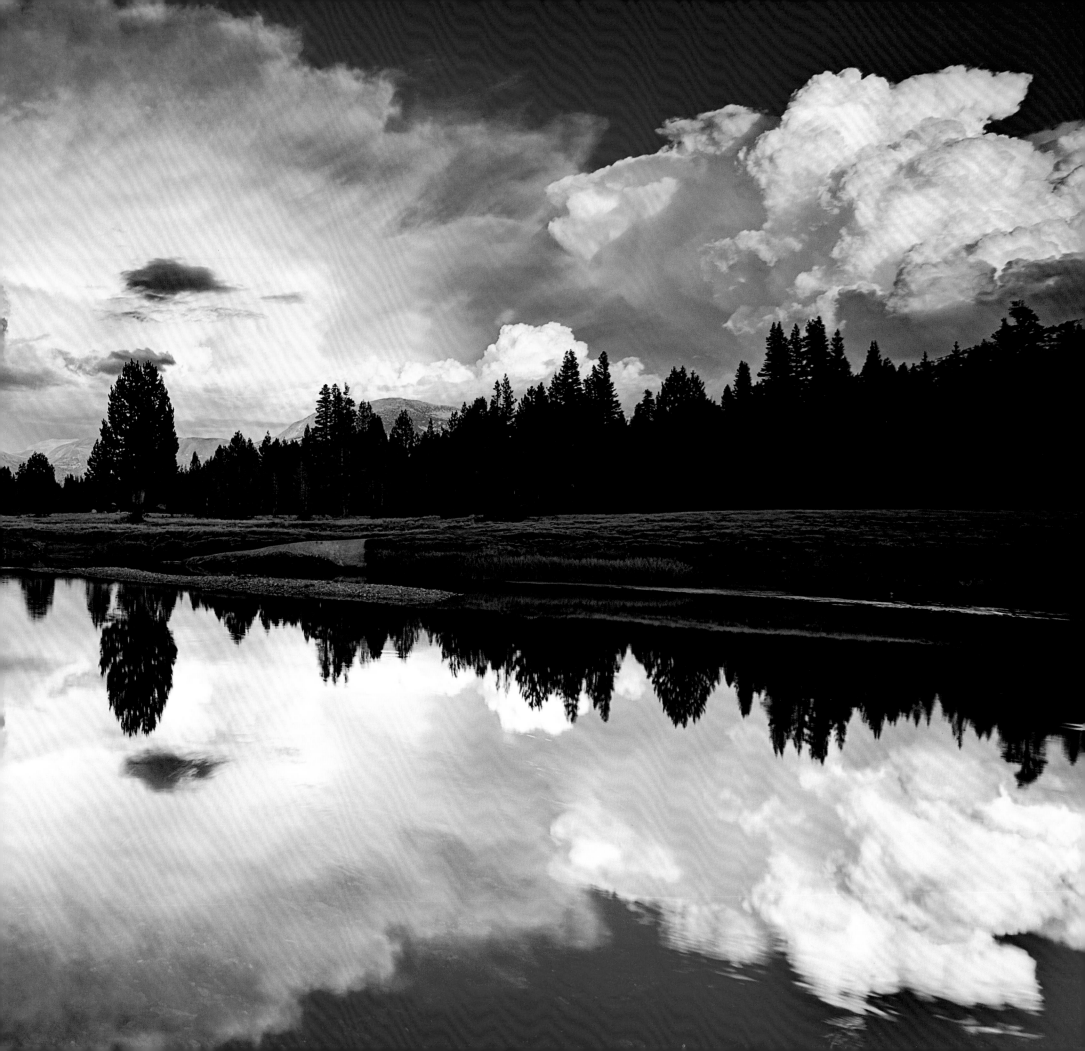

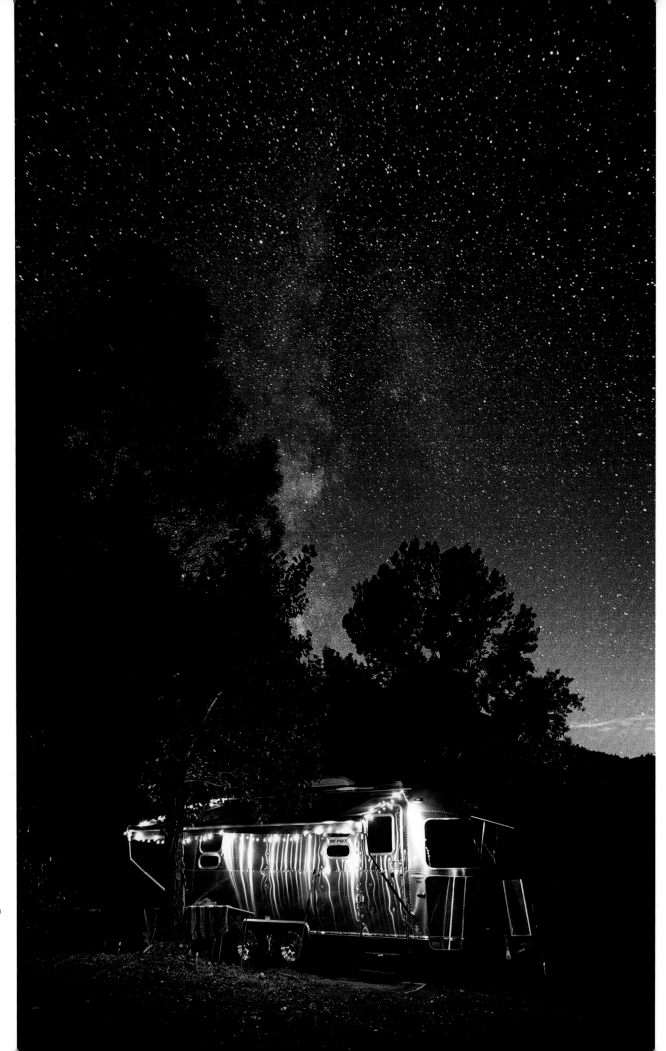

RIGHT: Yosemite National Park, California
An Airstream parked just outside the park in El Portal.

OPPOSITE: Yosemite National Park, California
Lower Yosemite Falls under moonlight.

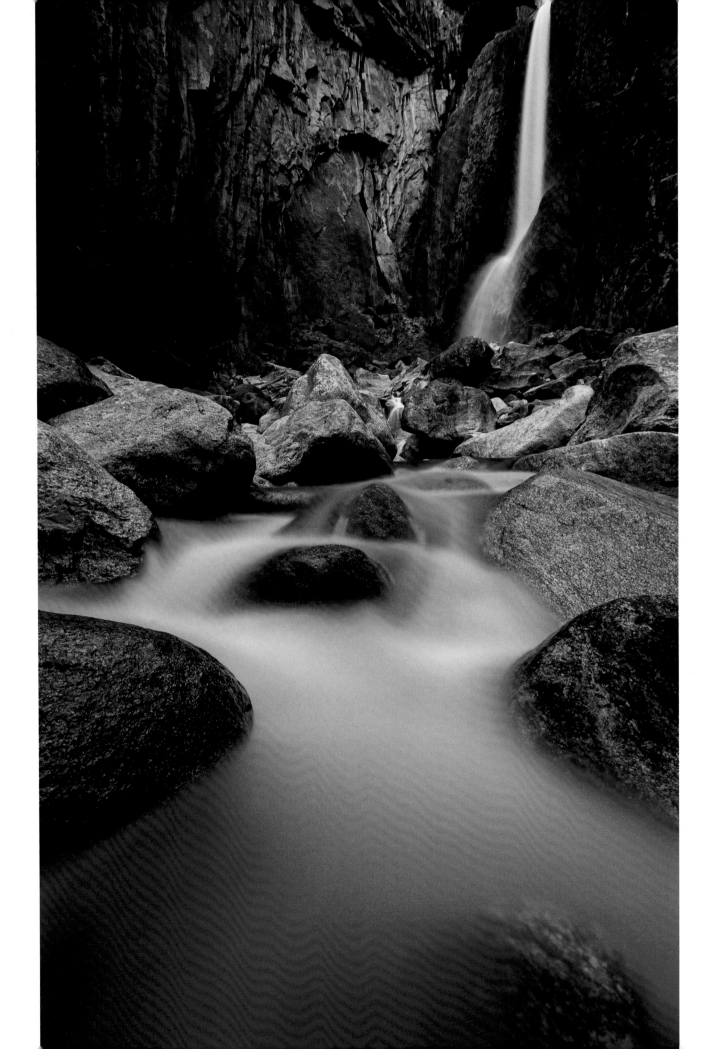

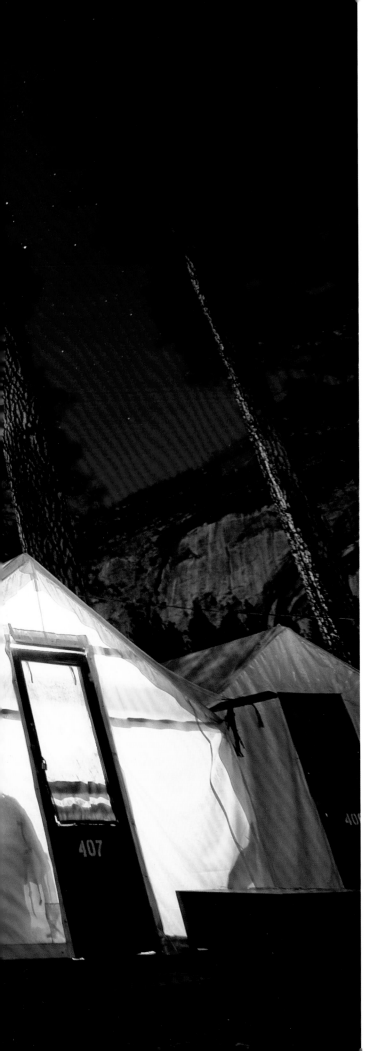

LEFT: Yosemite National Park, California

ABOVE: Yosemite National Park, California
Detail of ice patterns.

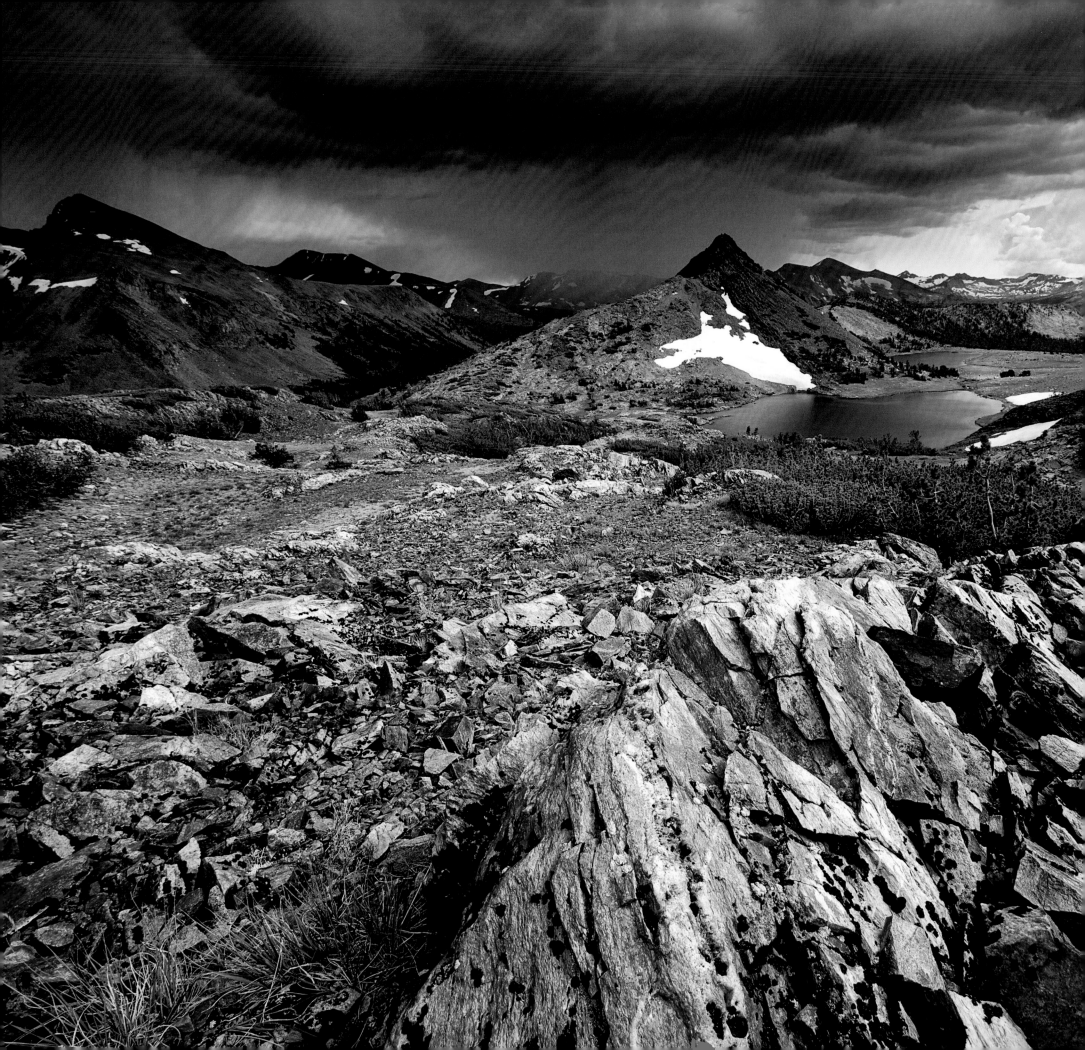

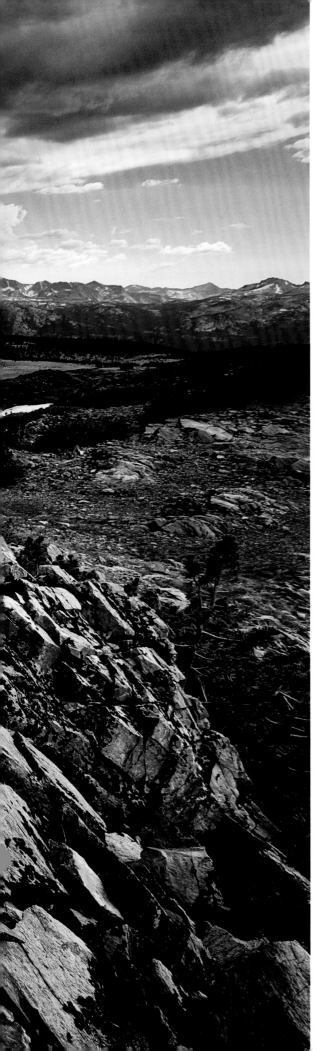

YOSEMITE NATIONAL PARK

Feeling awe, even for a moment, can shake the foundation of what we believe. Its resonance is undeniable. At its most basic it incites pause, and at its most potent, a lifetime of dedication.

Awe can come from many places, but nothing parallels nature's ability to humble and astound. The pinnacle expression of nature's awe-inducing prowess is the majesty of Yosemite National Park. Standing at the base of El Capitan, toeing the edge of Glacier Point, walking amongst giant sequoias in the Mariposa Grove, or basking in the embrace of the grand cathedral of the Yosemite Valley, your heart flutters, your thoughts slow, and a feeling unlike any other overwhelms. That is awesome.

As the pace of modern demands exponentially quickens, experiencing awe and wonder is rare. However, since 1941, NatureBridge and Yosemite National Park have partnered to plant the seed of environmental stewardship in our youth, through immersive experiences in nature paired with science-based education. We use the same Yosemite locales that inspire awe as living laboratories to inspire and motivate students and to move science learning beyond books into tangible, real-world learning opportunities. In nature's classroom, students learn geology from granite monoliths and an iconic dome. They adopt the perspective of a two-thousand-year-old giant sequoia tree to understand delicate ecological relationships and how humans can take action

to protect and sustain our natural resources. NatureBridge identifies awe as a powerful feeling that can be expanded into an impetus for learning. For caring.

Increasingly complex environmental challenges inspired us to broaden the impact of NatureBridge programs. After establishing our roots in one of the most iconic, inspiring places in the United States forty-four years ago, NatureBridge has provided excellent environmental science experiences to over one million students in our six national park locations across the United States: Yosemite, Golden Gate, Olympic, Santa Monica Mountains, Channel Islands, and Prince William Forest. Through multiday residential environmental science programs, we inspire our students' curiosity and build their confidence to critically analyze the world around them. By exposing students to the wonder and science of nature, we teach them to analyze and understand scientific data, we encourage collaboration with peers, and we increase their science literacy.

In a resounding commitment to conservancy and to life-changing educational experiences and their cumulative impact on multiple generations of young people, NatureBridge is dedicated to teaching a million more children. Our goal is to provide every child with the environmental know-how to create healthy communities and healthy national parks, because natural treasures deserve to be admired and explored by every future generation.

—NatureBridge

Yosemite National Park, California
View from the summit near the Great Sierra Mine Historic Site. Visible in the distance are Upper Gaylor Lake and Lower Gaylor Lake.

ABOVE: Yosemite National Park, California · *Detail of two decaying leaves.*

OPPOSITE: Yosemite National Park, California · *Pine trees in the fog above Mariposa Grove.*

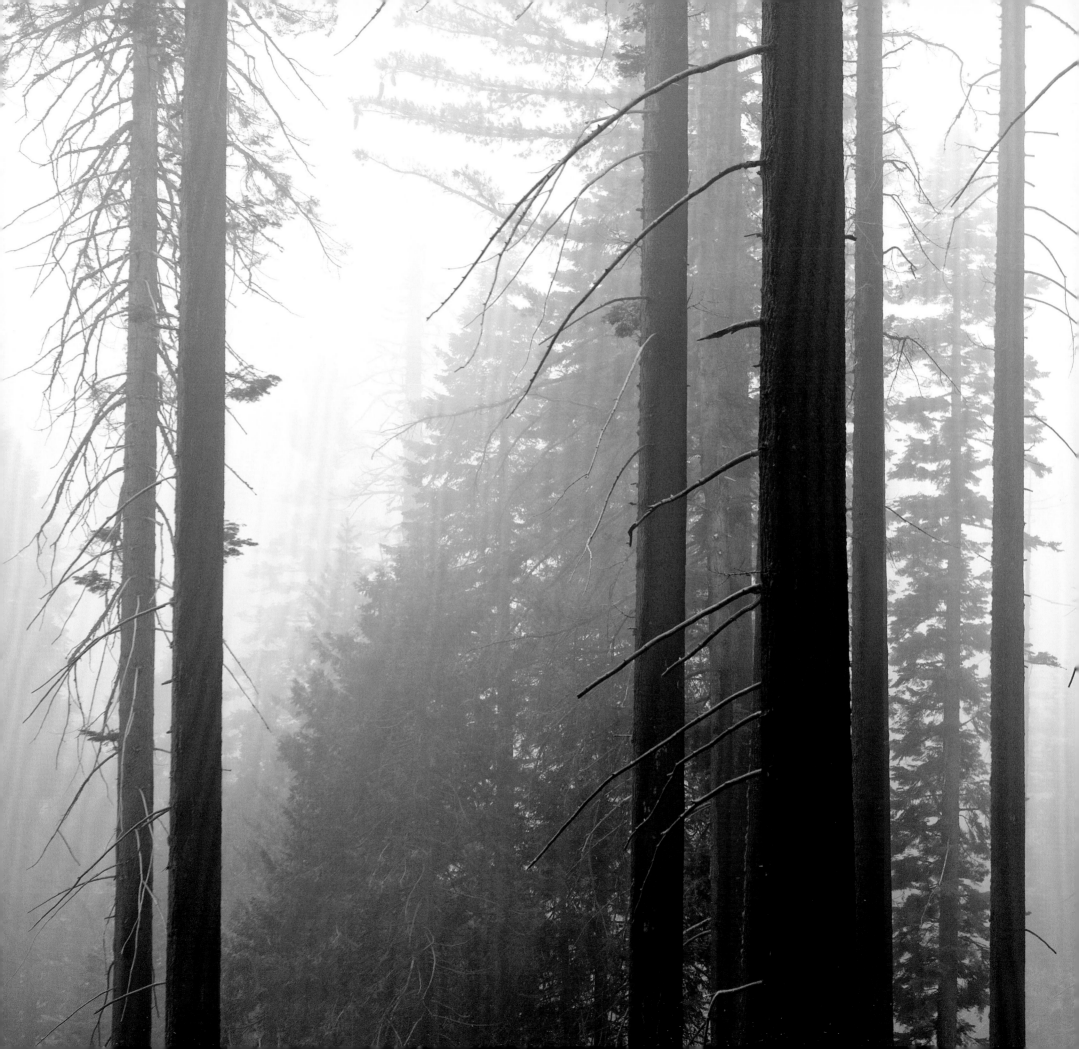

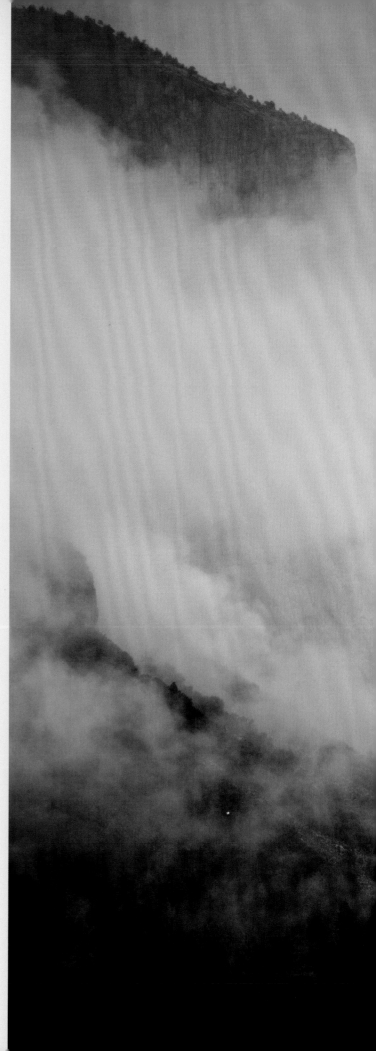

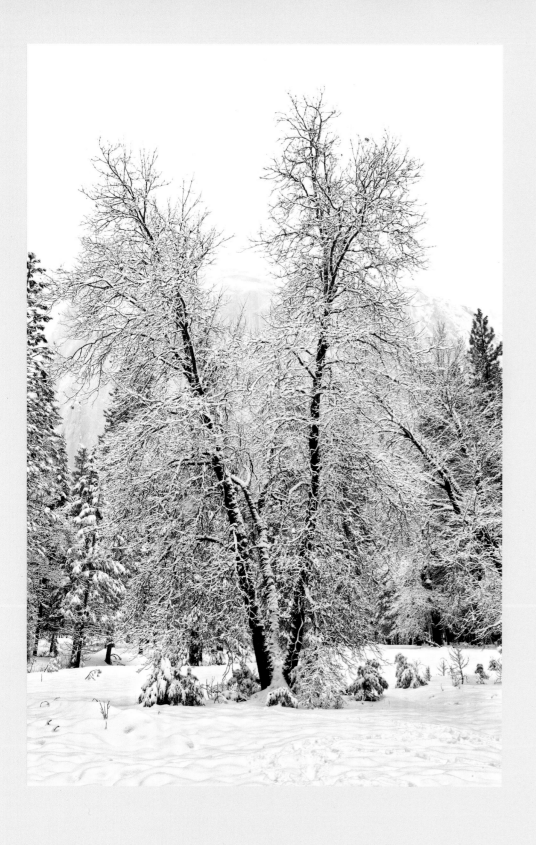

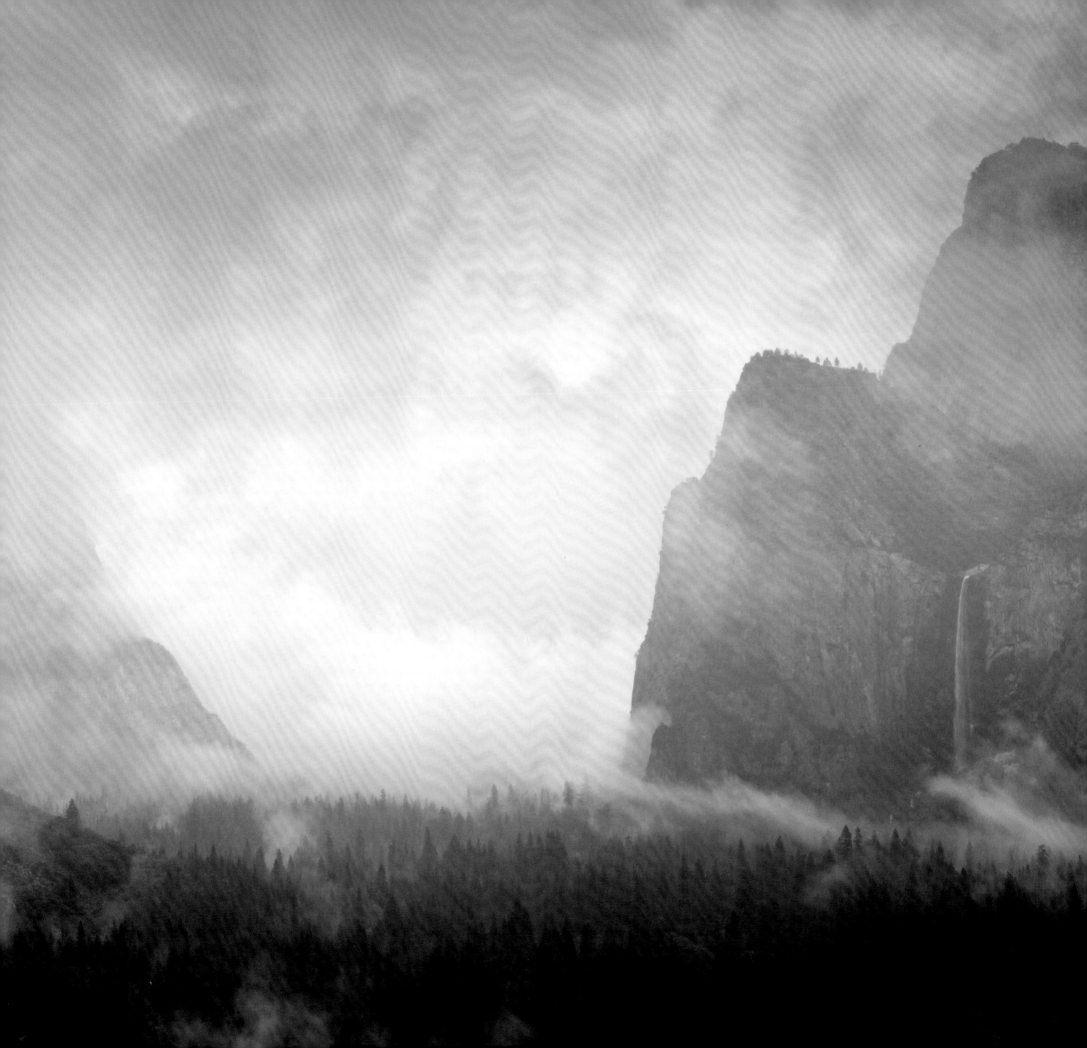

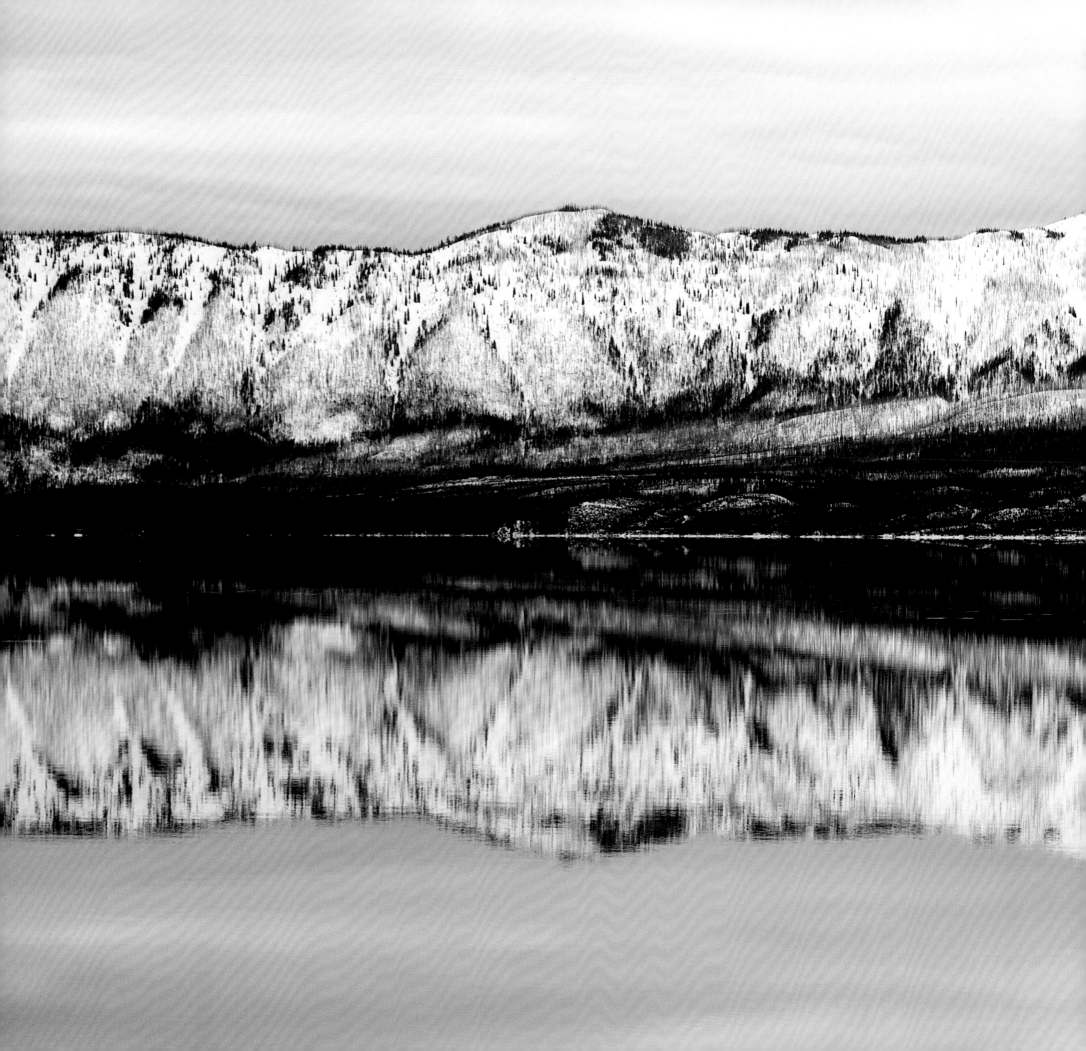

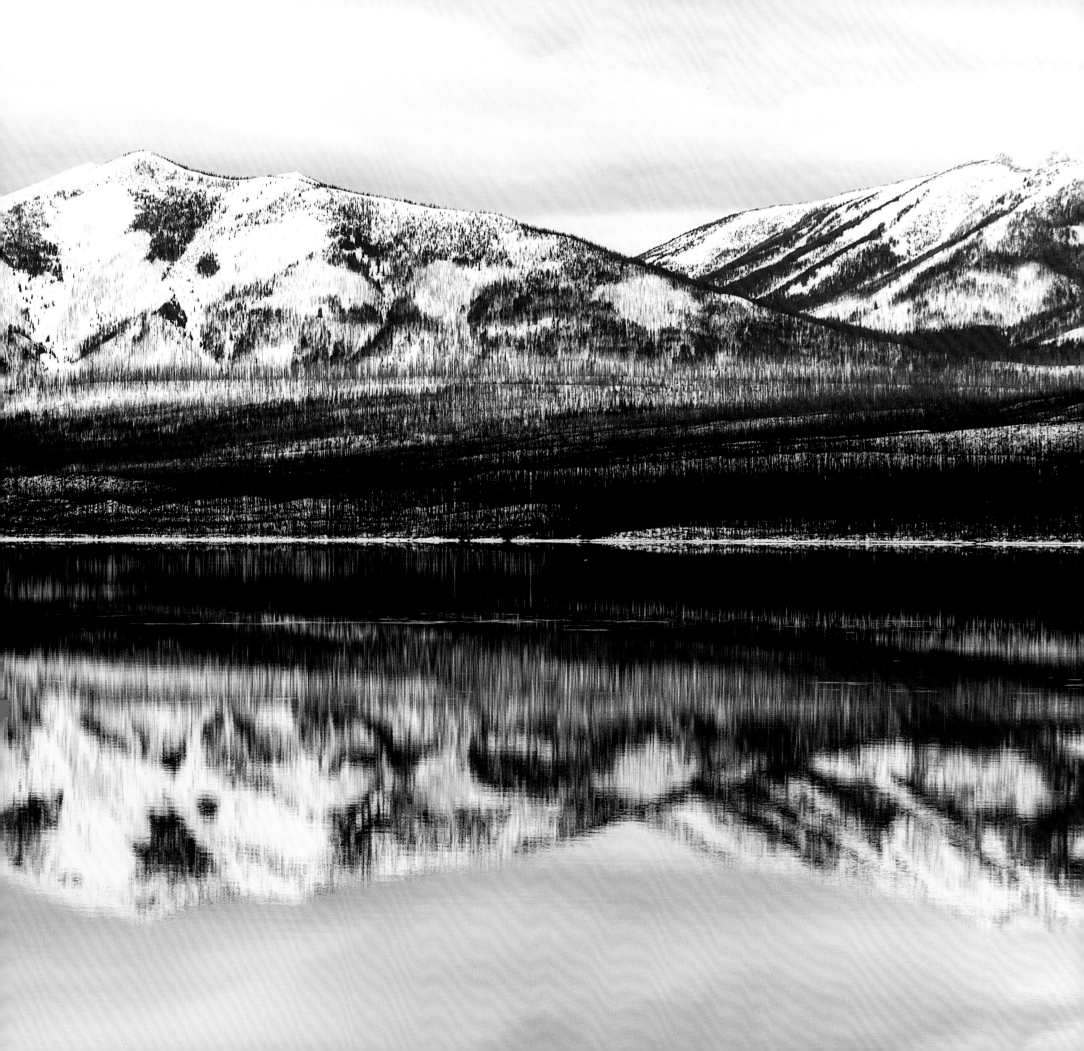

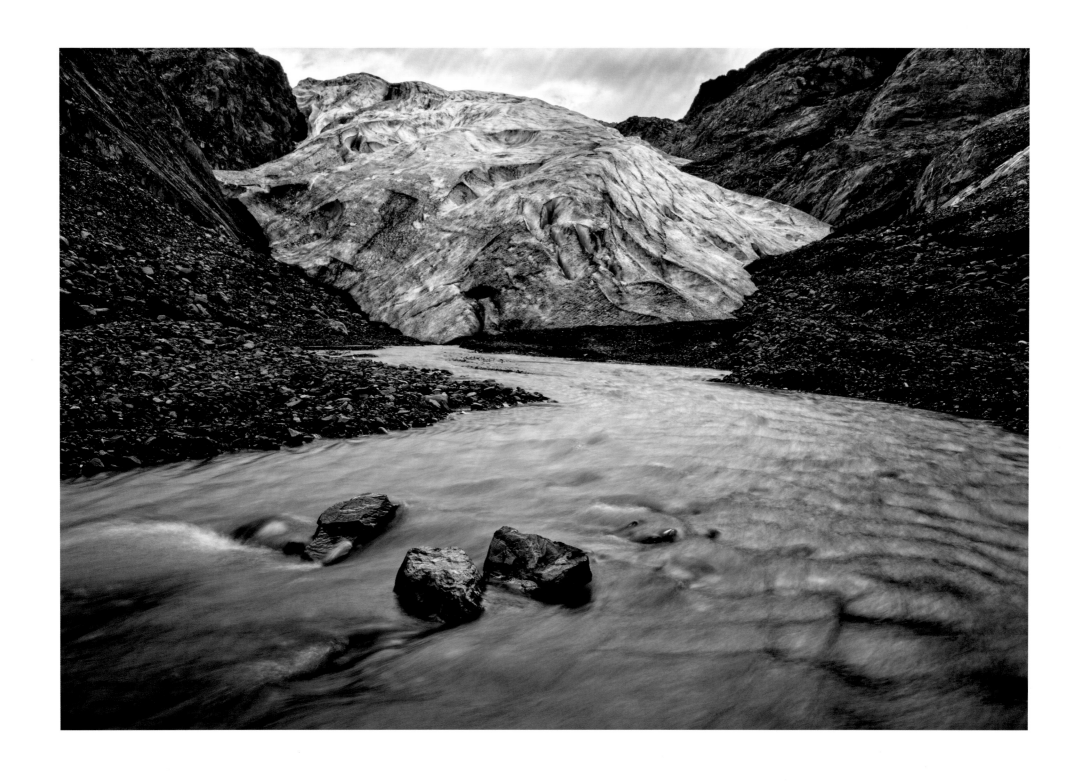

Kenai Fjords National Park, Alaska
*Detail of Exit Glacier, the main attraction and the glacier most
easily accessible to visitors at Kenai Fjords National Park.*

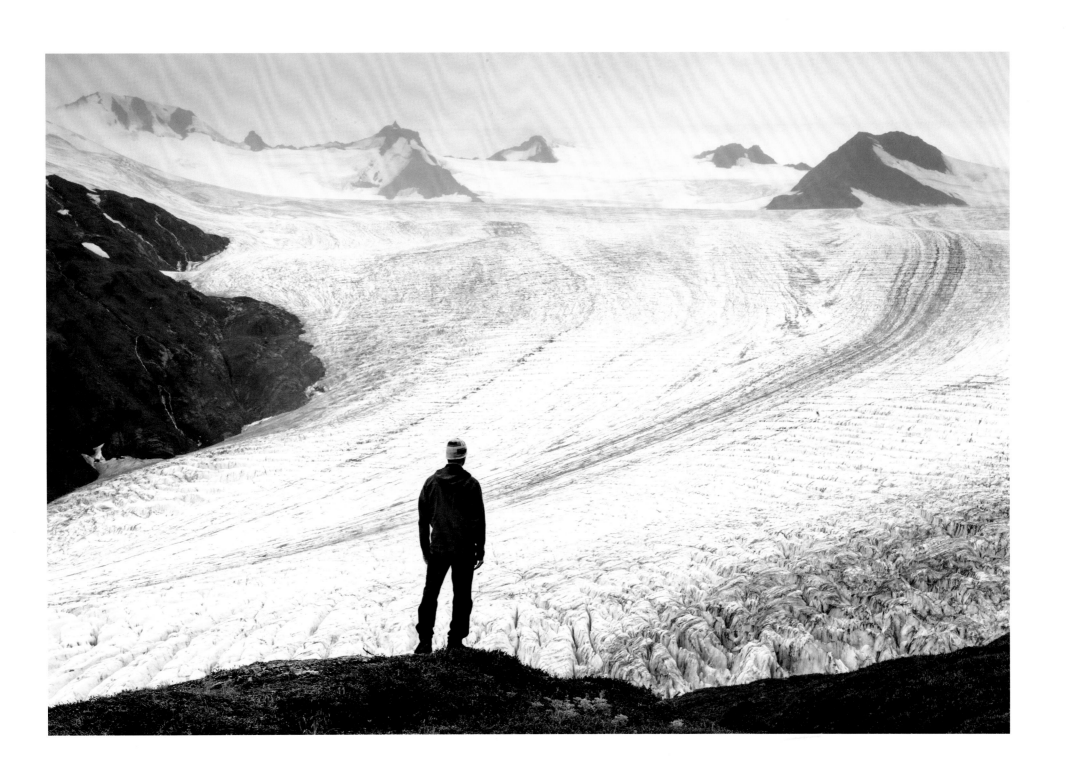

Kenai Fjords National Park, Alaska
A man looks out over the Harding Icefield.

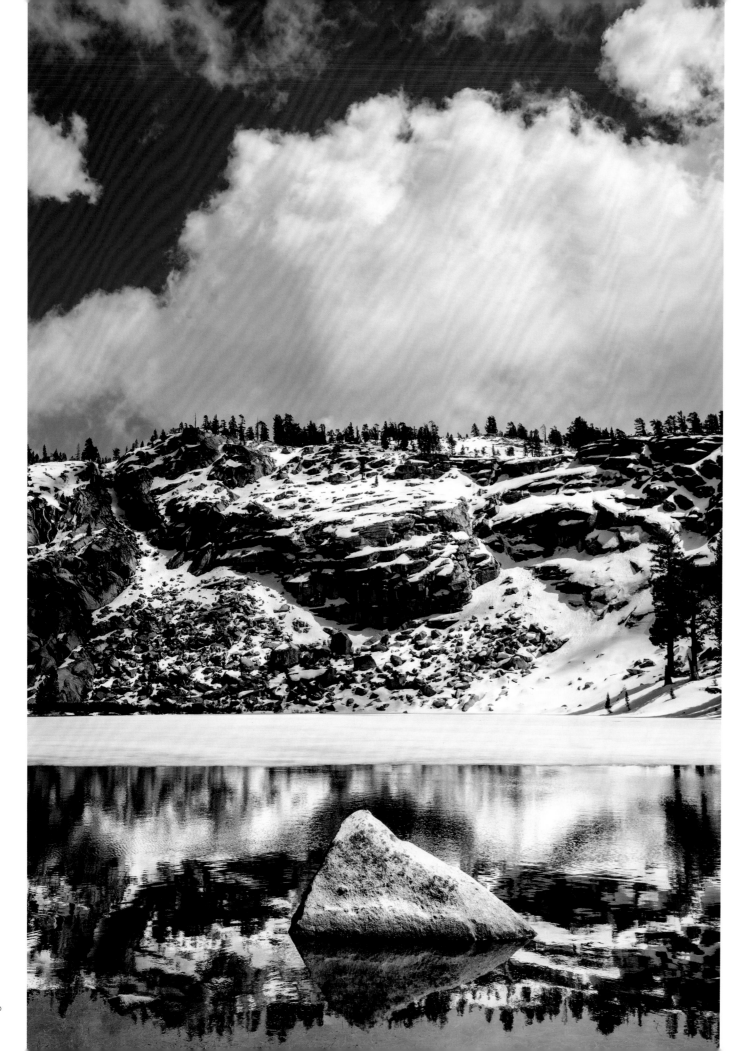

LEFT: Sequoia National Park, California
The high alpine lakes area known as Twin Lakes is
approximately seven miles into the backcountry.

OPPOSITE: Denali National Park and Preserve, Alaska
Aerial view of the Alaska Range.

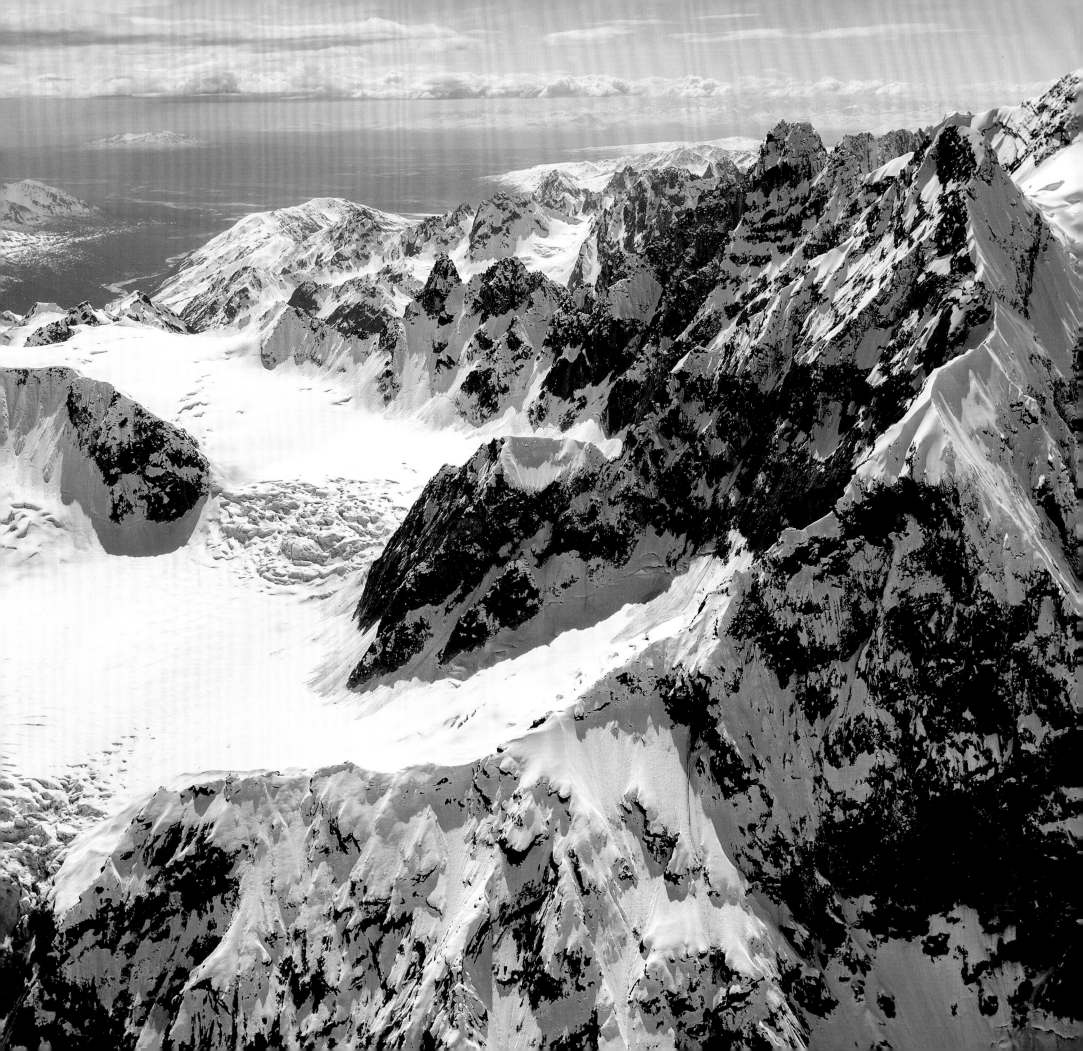

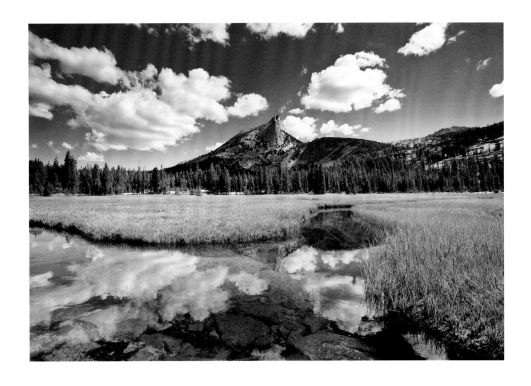

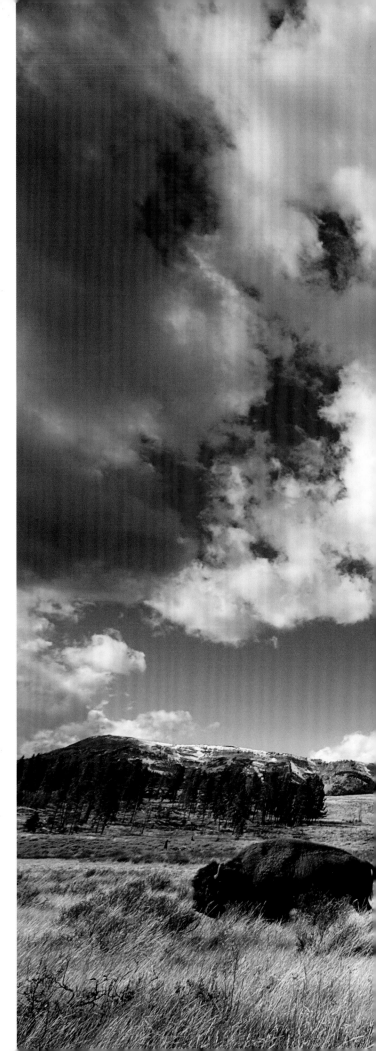

ABOVE: Yosemite National Park, California
Cathedral Peak and meadow below with Cathedral Lakes flowing out into the channels of water. This is a popular meandering trail approximately three-and-a-half miles to the lakes from Tuolumne Meadows.

RIGHT: Yellowstone National Park; Idaho, Montana, Wyoming
American bison (Bison bison).

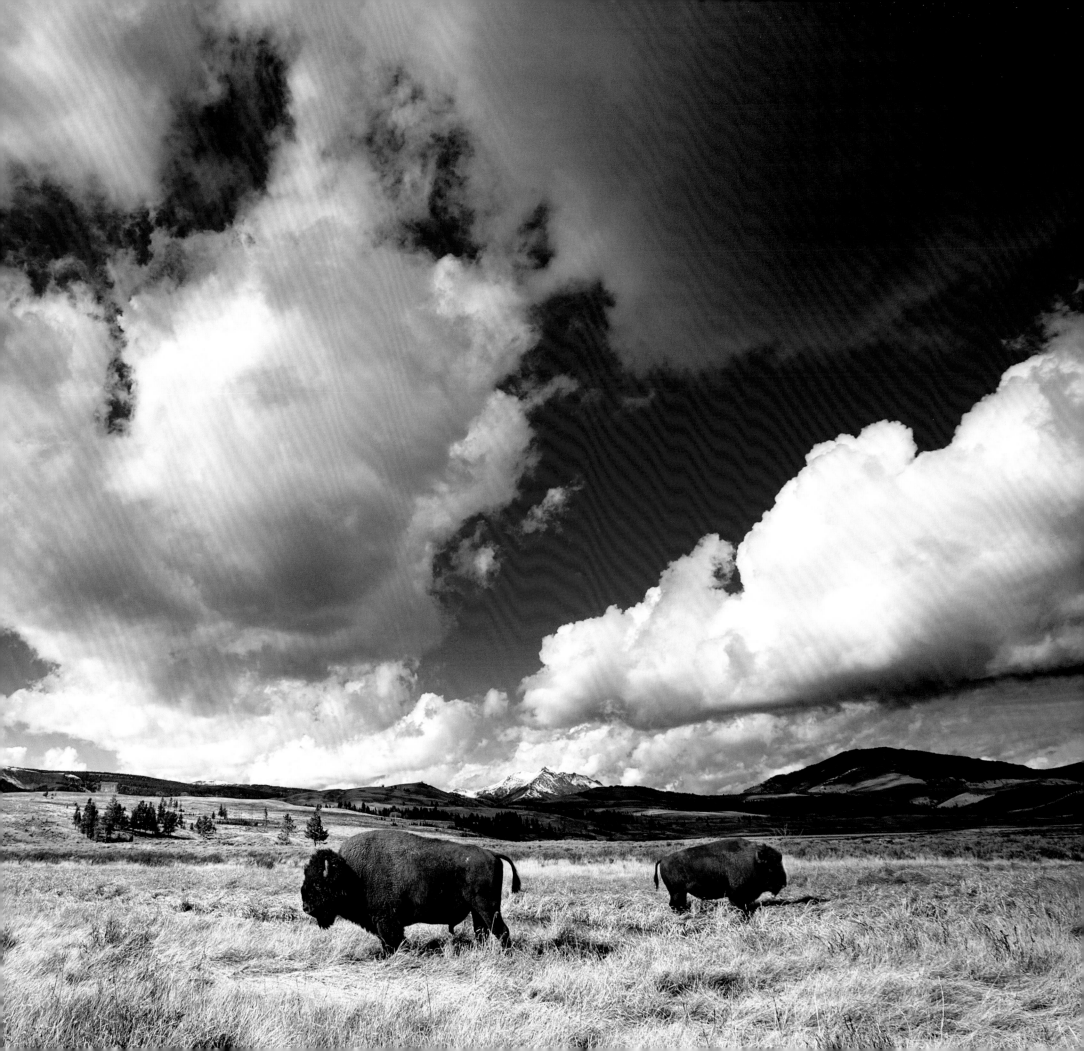

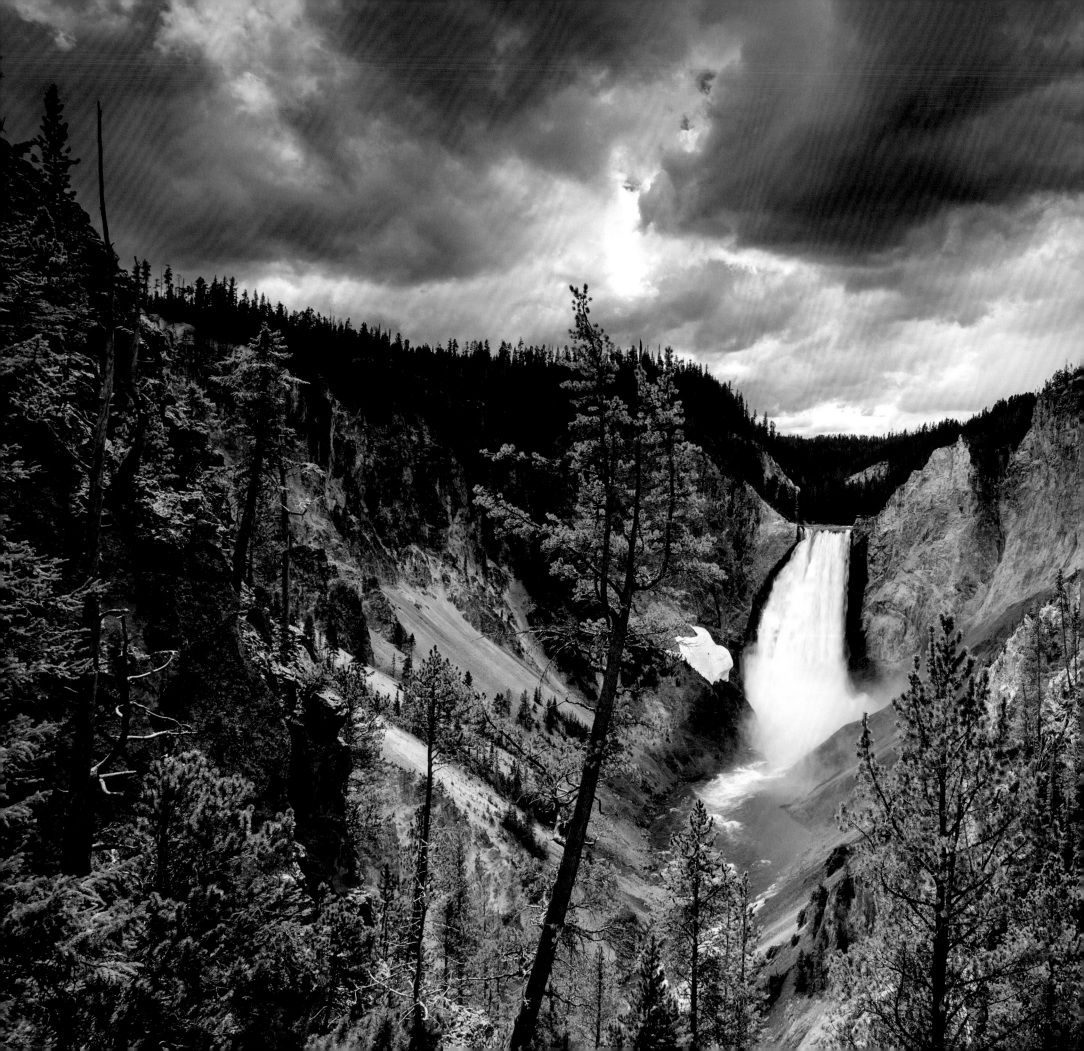

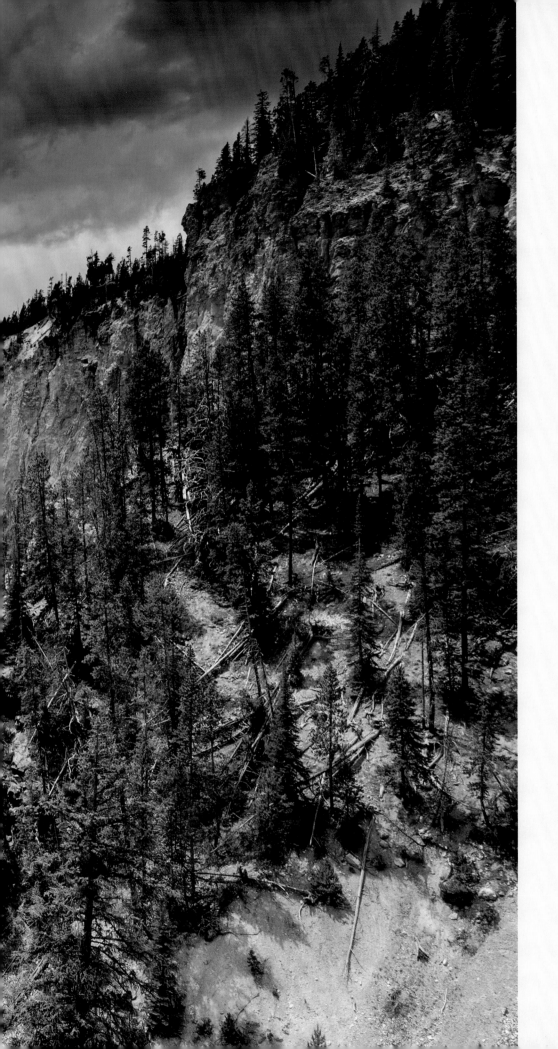

LEFT: Yellowstone National Park; Idaho, Montana, Wyoming
Lower Yellowstone Falls, the Grand Canyon of the Yellowstone River.

YELLOWSTONE NATIONAL PARK

Yellowstone National Park has captured the imagination of the world since it became the first national park in 1872. Its unusual beauty, with geysers spewing faithfully, free-roaming wildlife, and one of the last nearly intact natural ecosystems found in the earth's temperate zones, make it one of the greatest science laboratories anywhere.

As our techno-driven lives get more complex and more isolated, it is easy to forget what a gift nature can be to soothe, heal, and reconnect us to what is truly important. As we celebrate the National Park Service's one-hundredth anniversary in 2016, the words of its founder and first director, Stephen T. Mather, could not be more relevant.

Mather eloquently stated that a park visit "inspires love of country; begets contentment; engenders pride of possession; and contains the antidote for national restlessness. . . ." That statement was made in the early part of the twentieth century and is especially true today. That is why the Yellowstone Park Foundation has worked to make sure there is a Yellowstone forever since the foundation was formed in 1996. During this time, the foundation has raised over $85 million and funded more than three hundred important projects that the federal government simply cannot cover.

The Yellowstone Park Foundation has supported wildlife research, including studies of raptors, wolves, cougars, and bears; restoration of cutthroat trout, an important food source for grizzly bears, birds of prey, and other wildlife; trail restoration, so all of us can explore this magnificent place safely; and youth education to help kids have an outstanding learning adventure in this unique place.

And the work will continue. The Yellowstone Park Foundation is funding many new projects that will contribute to an extraordinary visitor experience for the 3.5 million people who come to satisfy their fascination with Yellowstone each year. A new youth campus, a revised grand entryway at historic Roosevelt Arch, and better viewing areas at the overlooks of the Grand Canyon of Yellowstone will greet visitors in the future.

These projects would not be possible without the commitment of those passionate about Yellowstone and its future, including the generous donors to the Yellowstone Park Foundation.

The next time you are in Yellowstone, take in all of its majestic beauty, and pause for a moment, in gratitude, that wild places like Yellowstone are there for all of us.

—Yellowstone Park Foundation

Yellowstone National Park; Idaho, Montana, Wyoming
Mammoth Hot Springs.

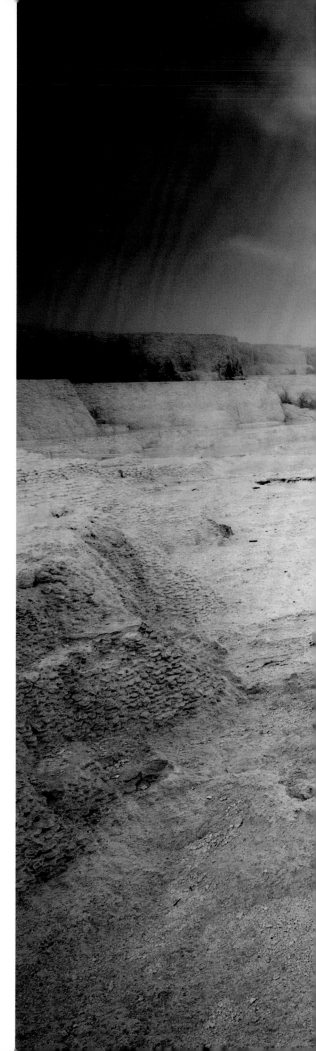

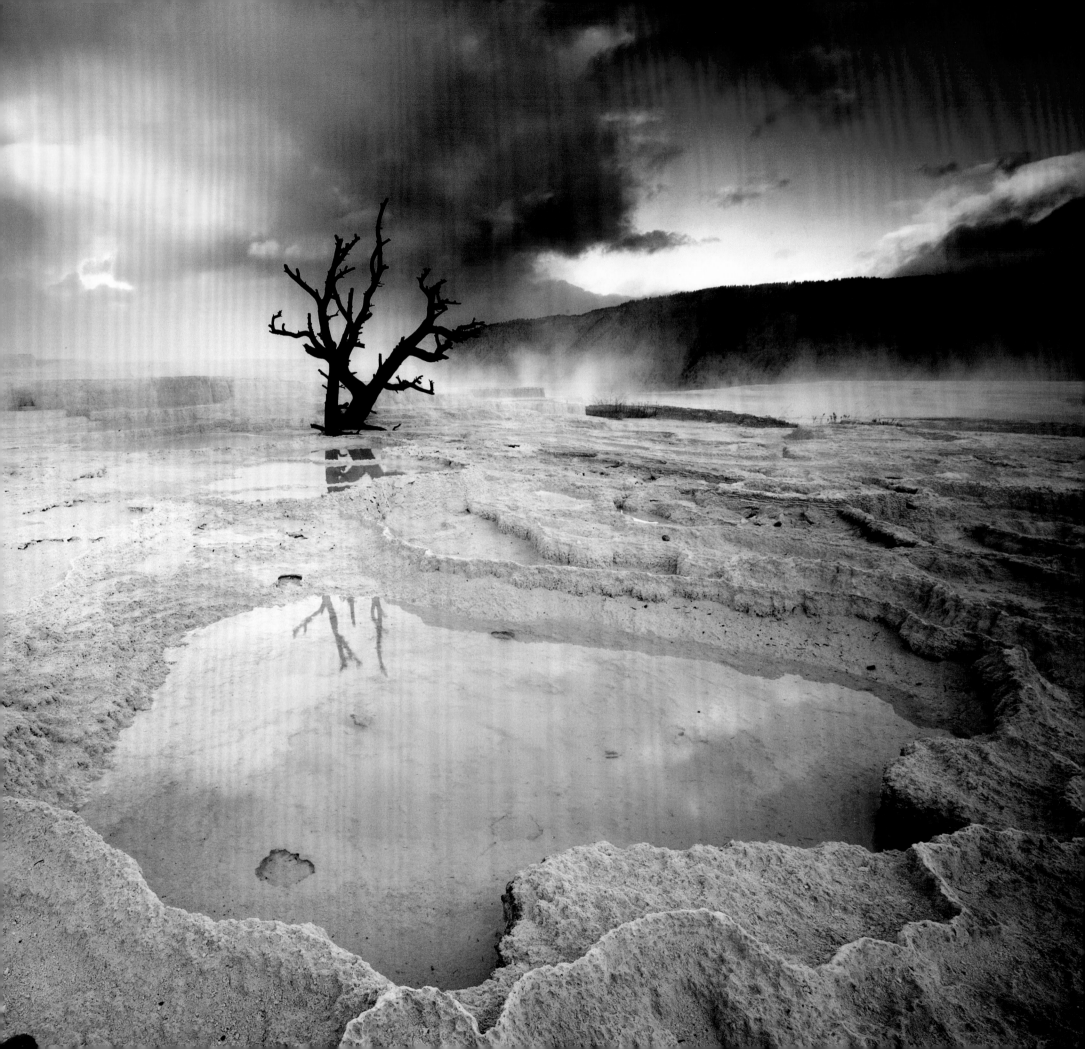

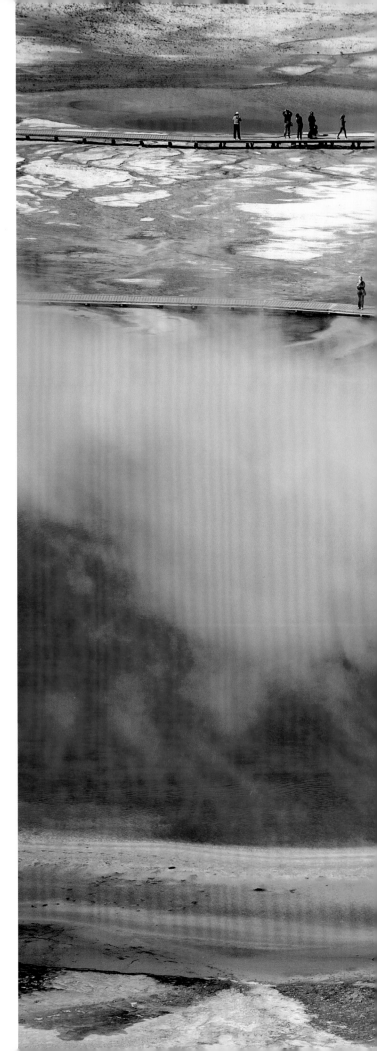

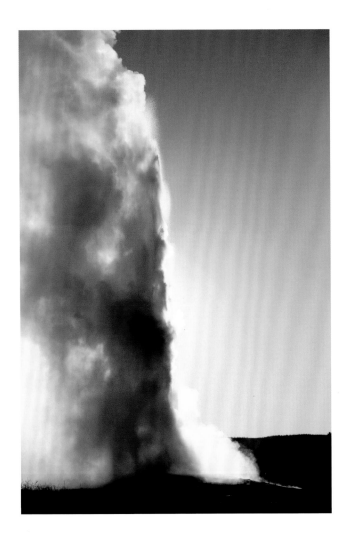

ABOVE: Yellowstone National Park; Idaho, Montana, Wyoming
Old Faithful erupts, backlit by the setting sun.

RIGHT: Yellowstone National Park; Idaho, Montana, Wyoming
Grand Prismatic Spring during summer.

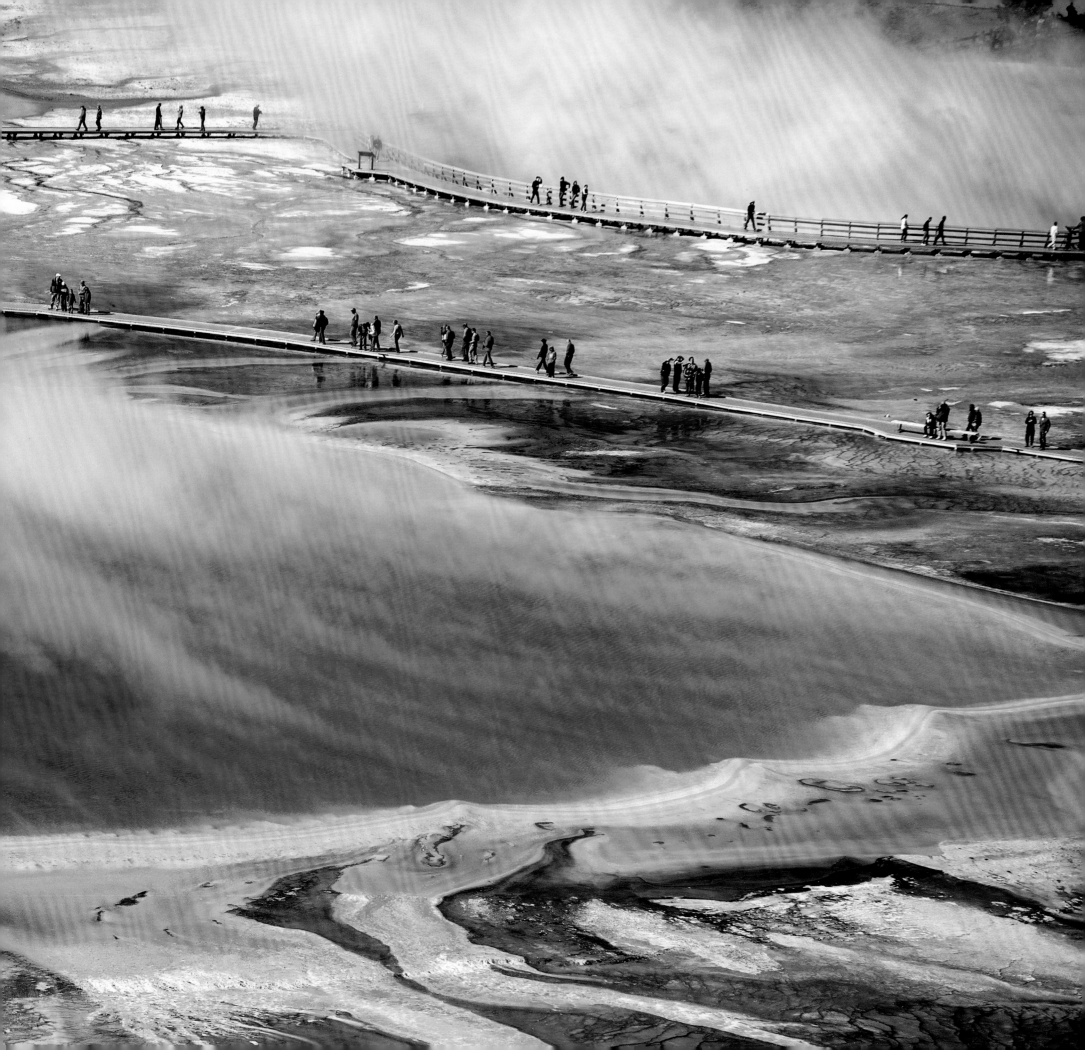

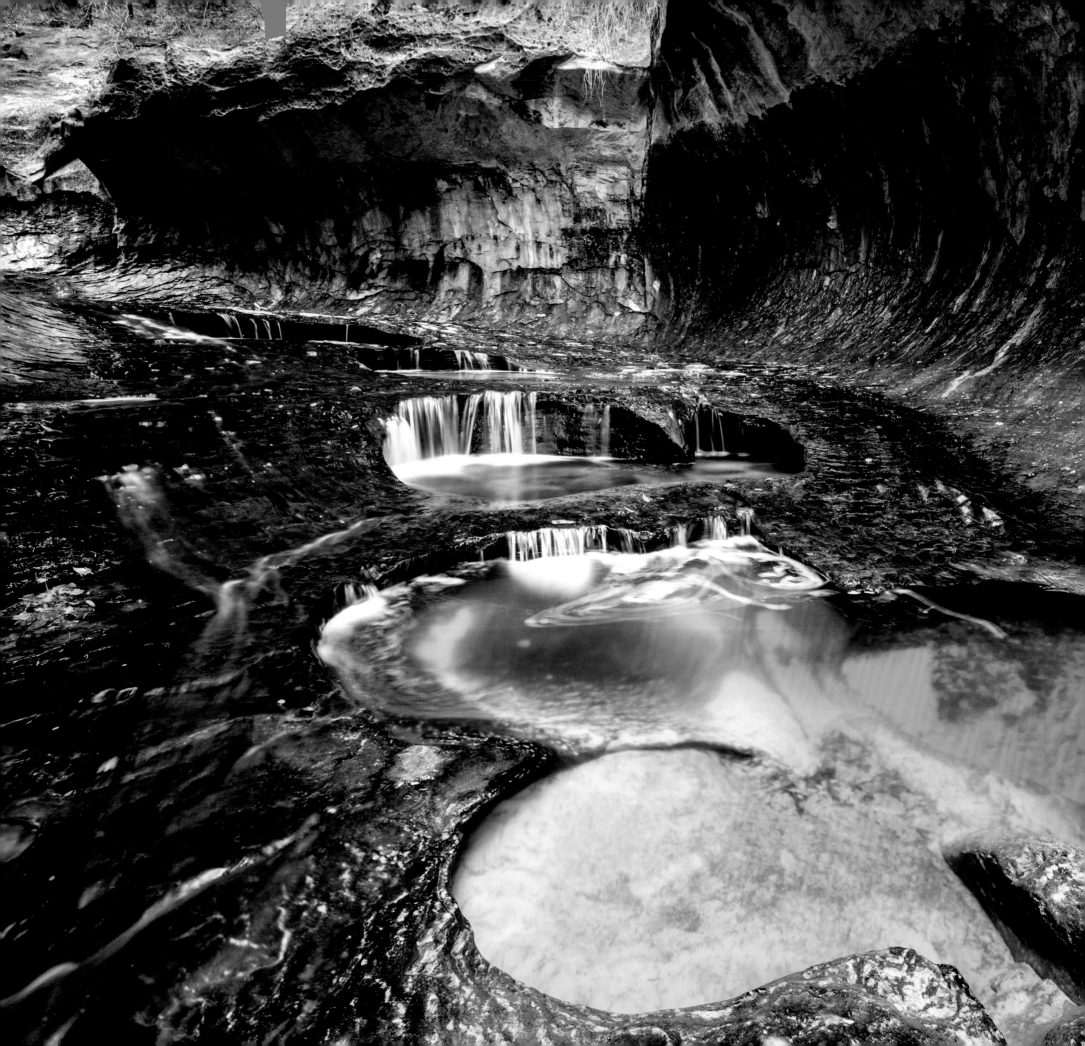

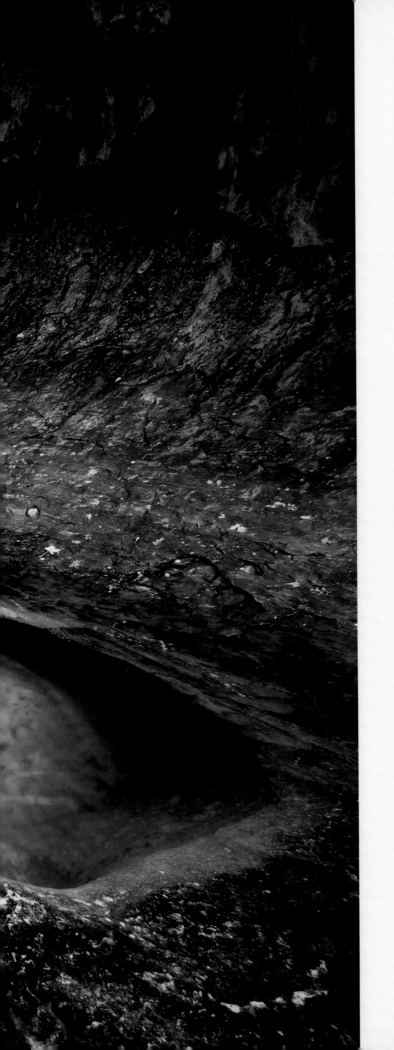

Zion National Park, Utah
The Subway.

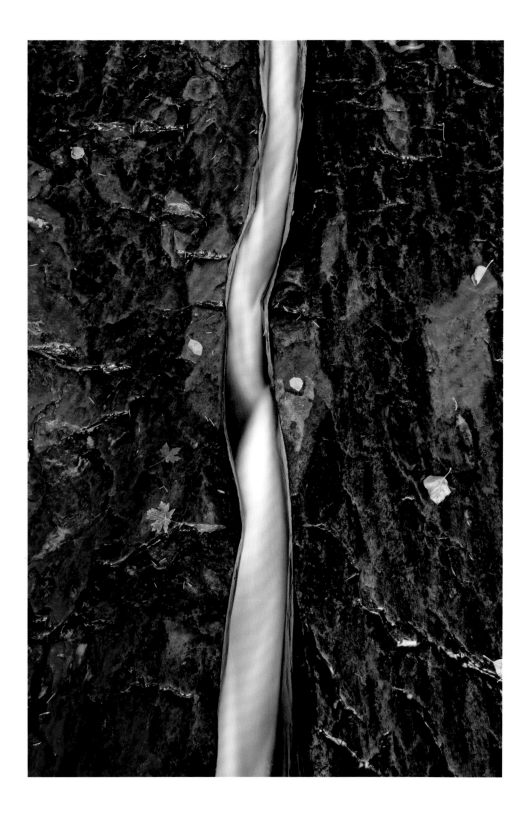

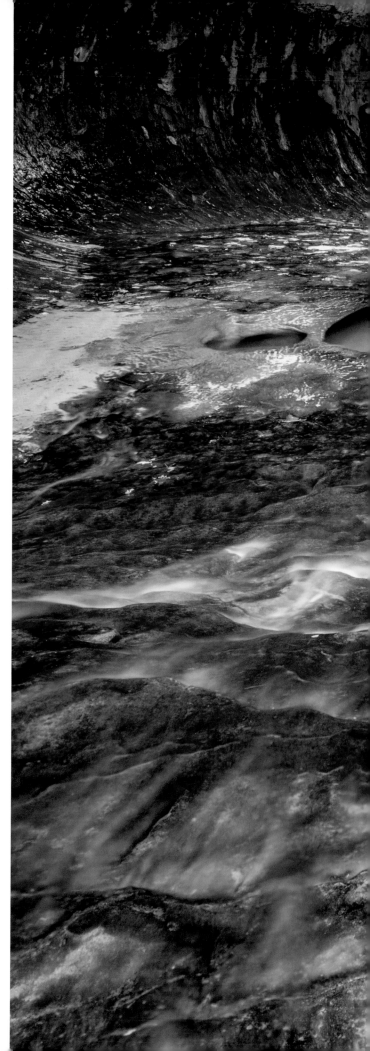

FOLLOWING PAGES, LEFT: Zion National Park, Utah
Water flowing through a fissure in red rock.

FOLLOWING PAGES, RIGHT: Zion National Park, Utah
The Subway.

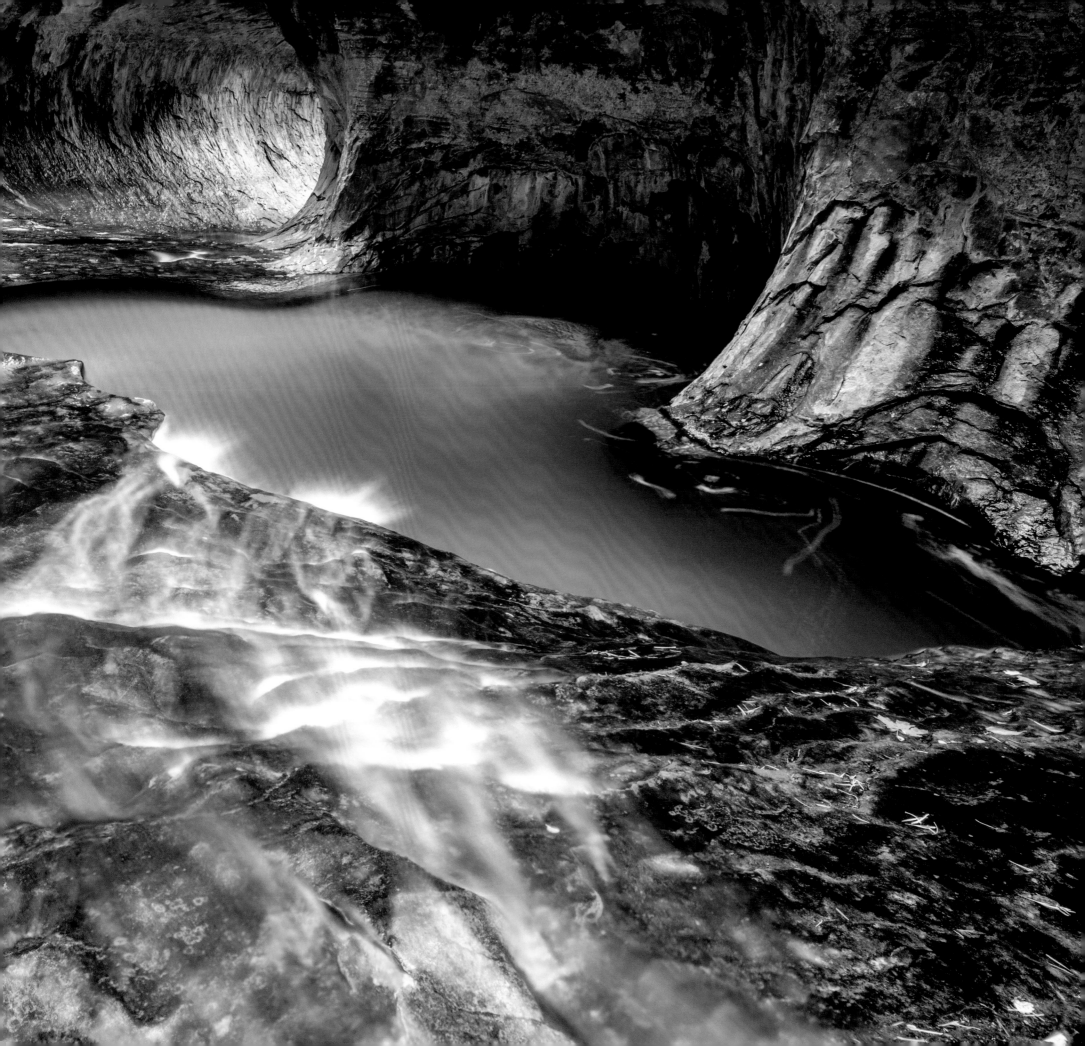

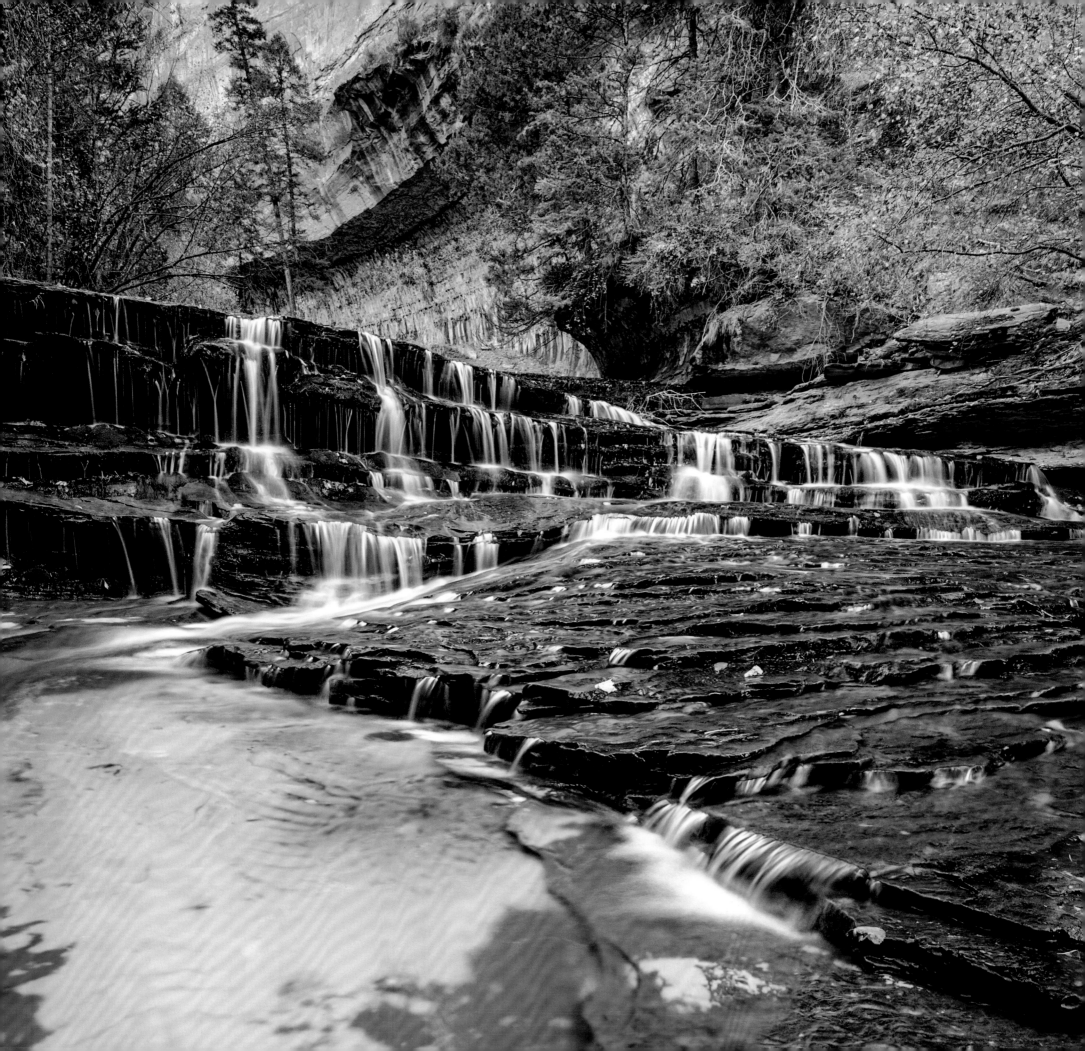

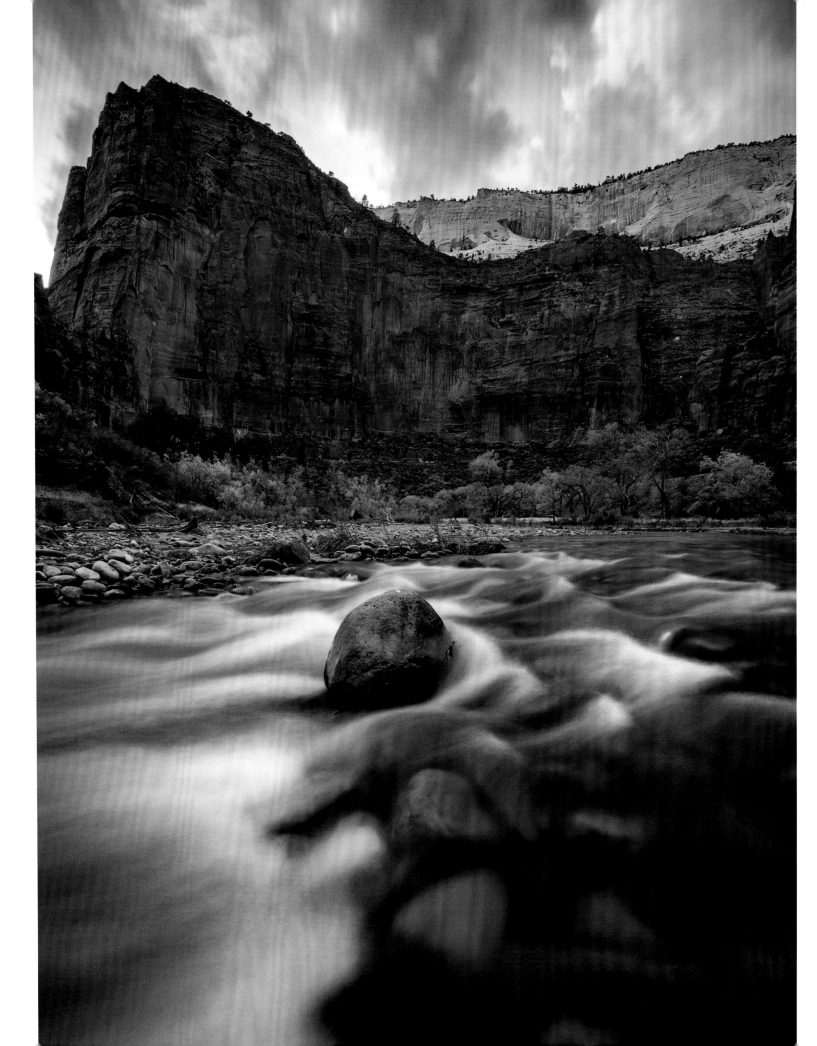

OPPOSITE: Zion National Park, Utah
Archangel Cascades of the Left Fork of North Creek along the hike to the Subway.

RIGHT: Zion National Park, Utah
Near Big Bend along the Virgin River at dusk.

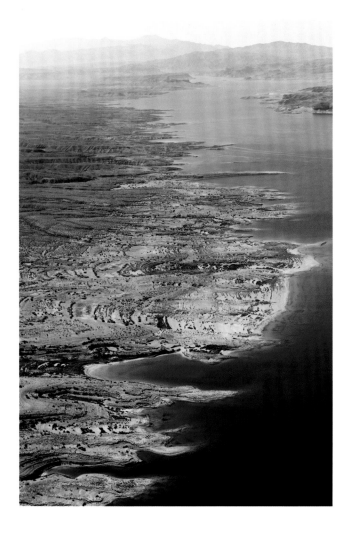

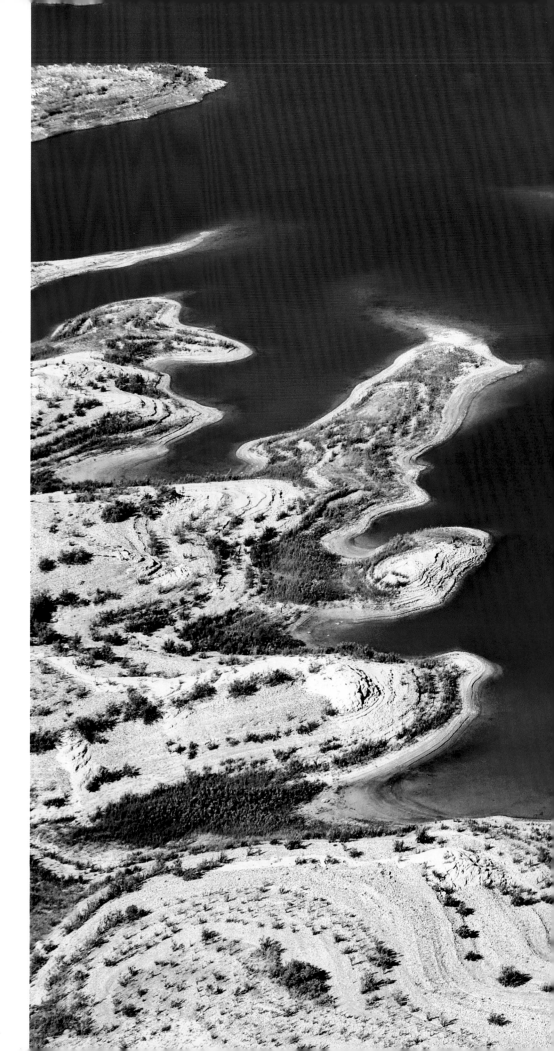

ABOVE AND RIGHT: Lake Mead National
Recreation Area; Arizona, Nevada
Aerial views of Lake Mead.

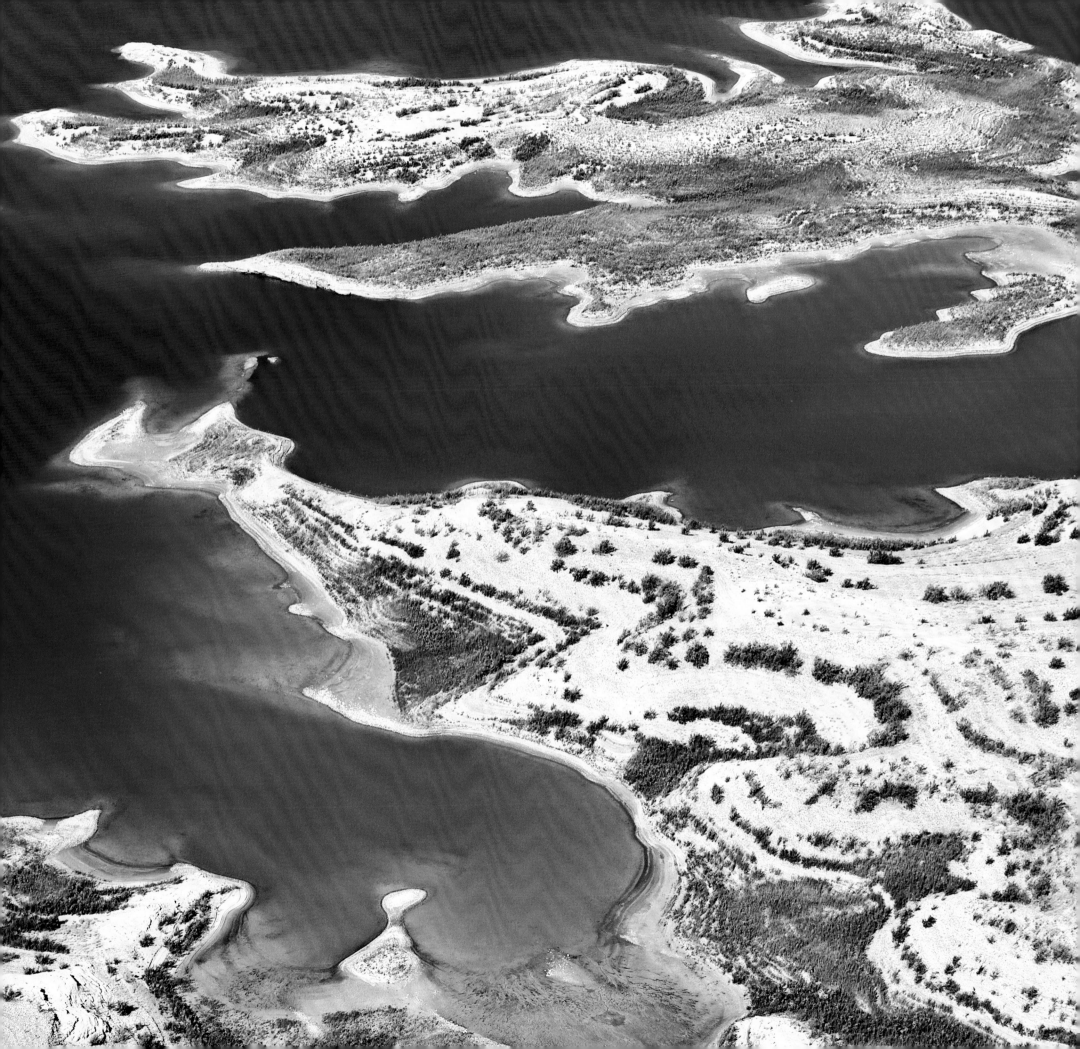

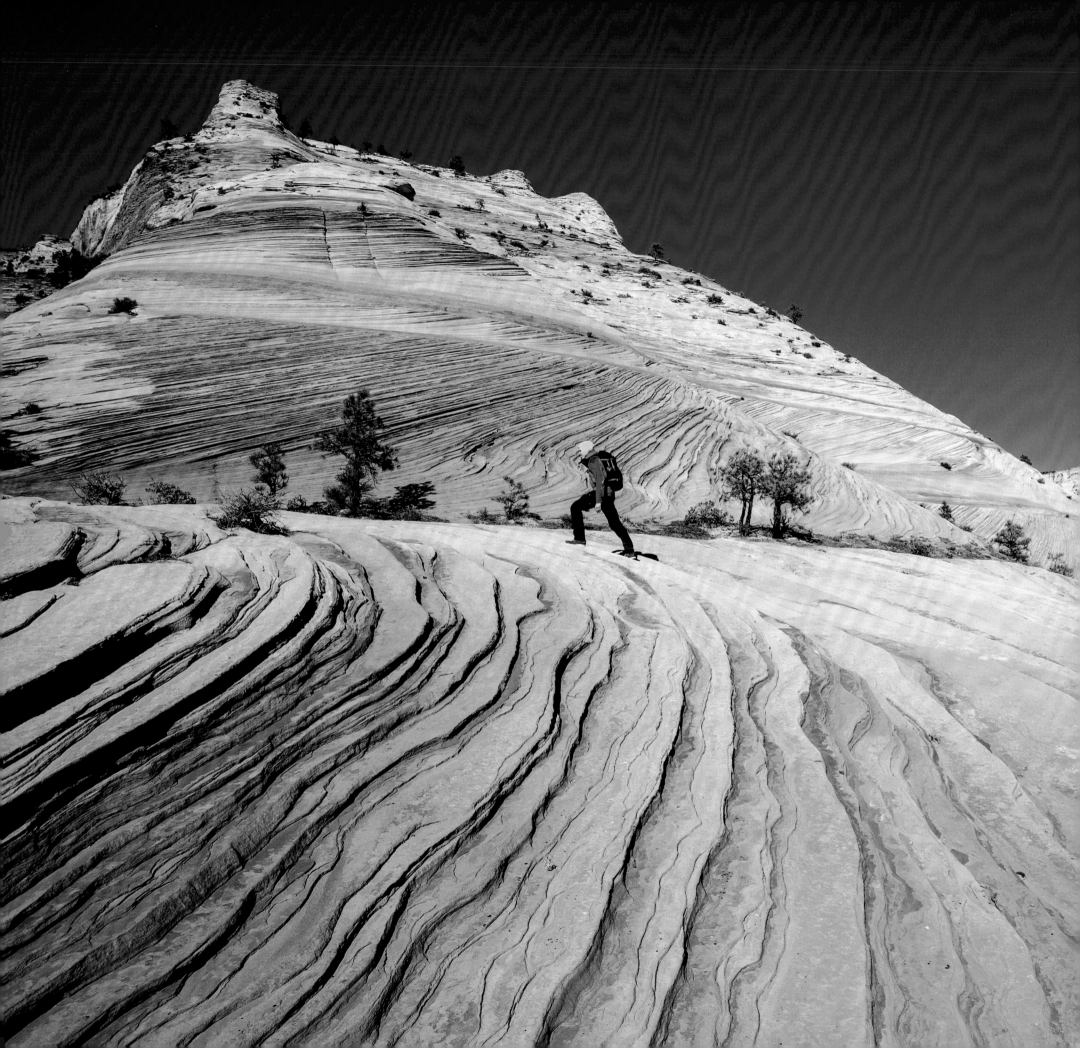

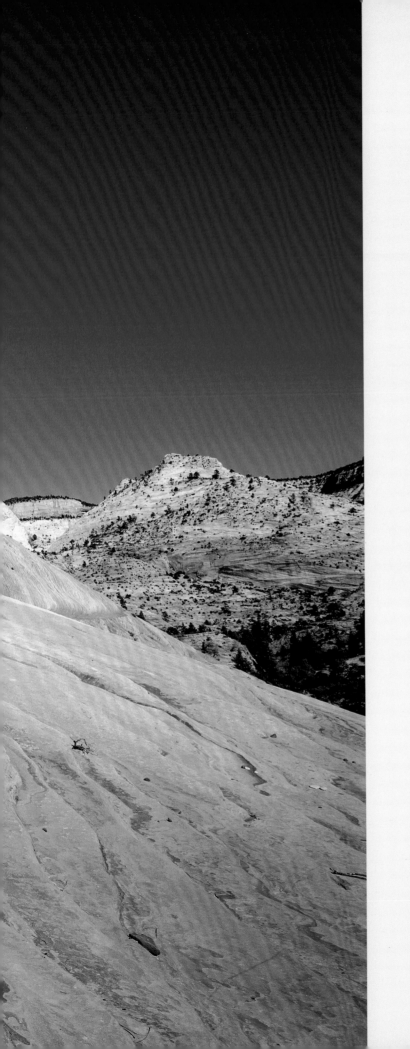

Zion National Park, Utah
A man hikes across sandstone formations near Checkerboard Mesa.

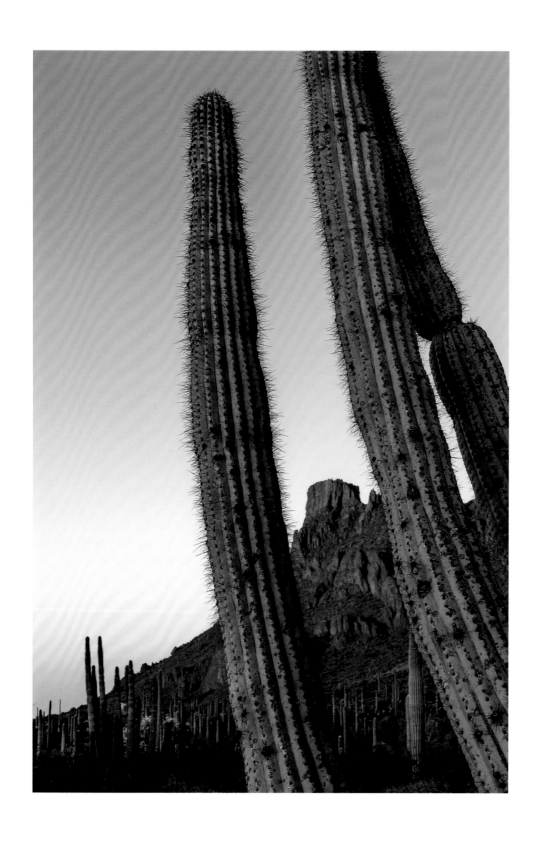

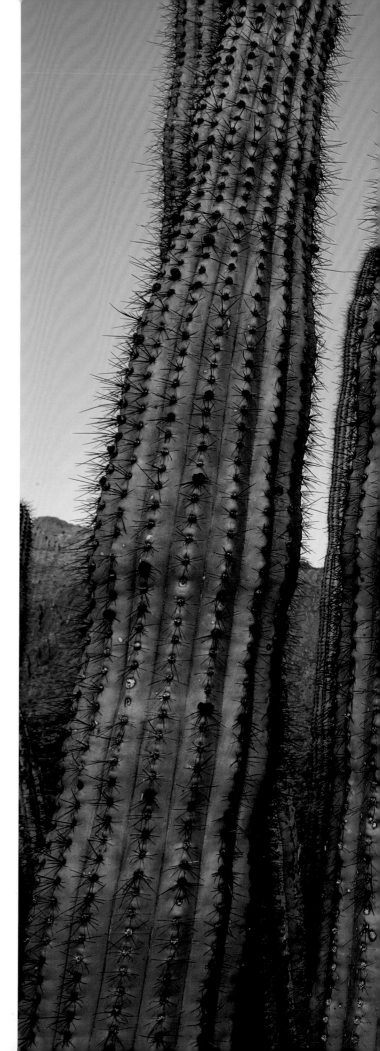

ABOVE AND RIGHT: Organ Pipe Cactus National Monument, Arizona
Sunset in Alamo Canyon; the cactus in the foreground is an organ pipe cactus
(Stenocereus thurberi).

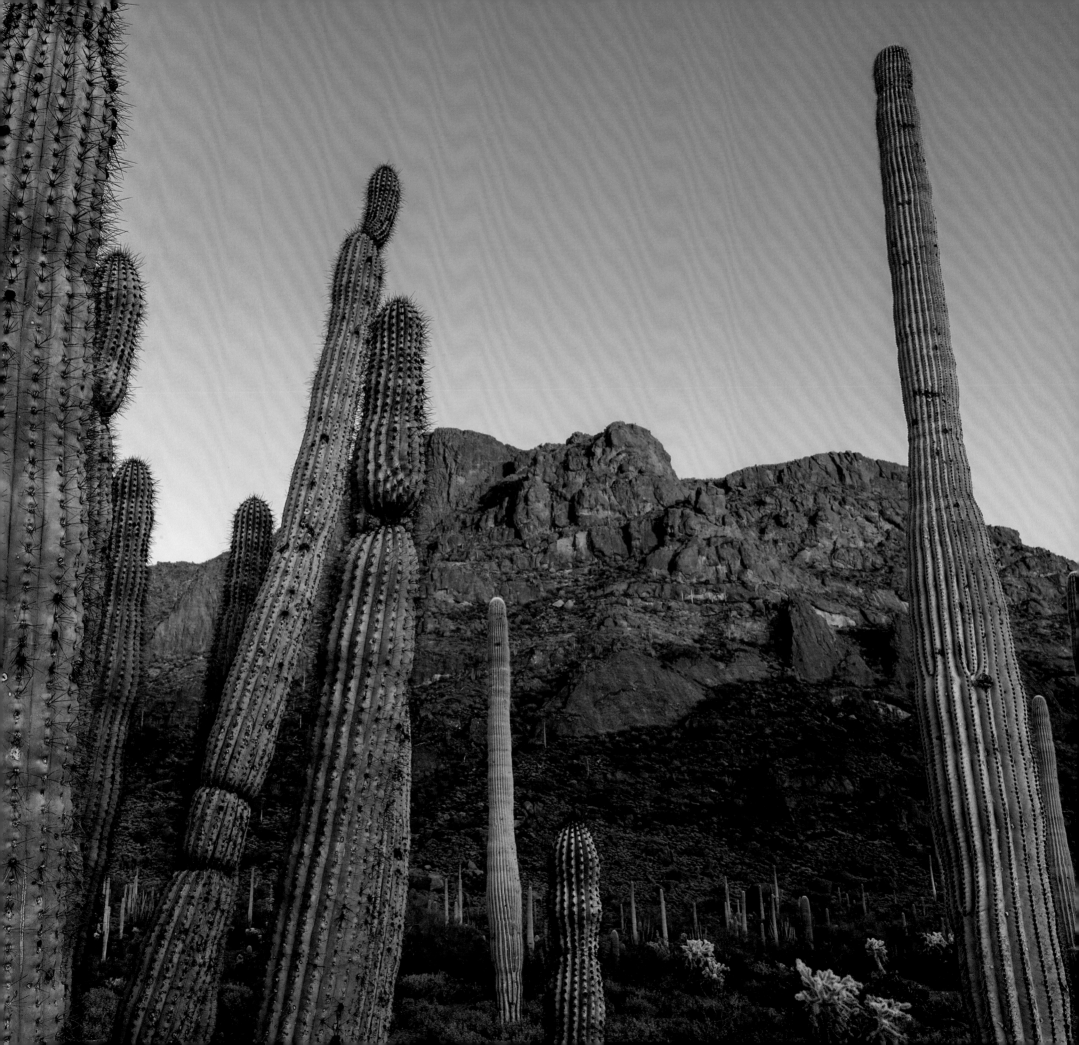

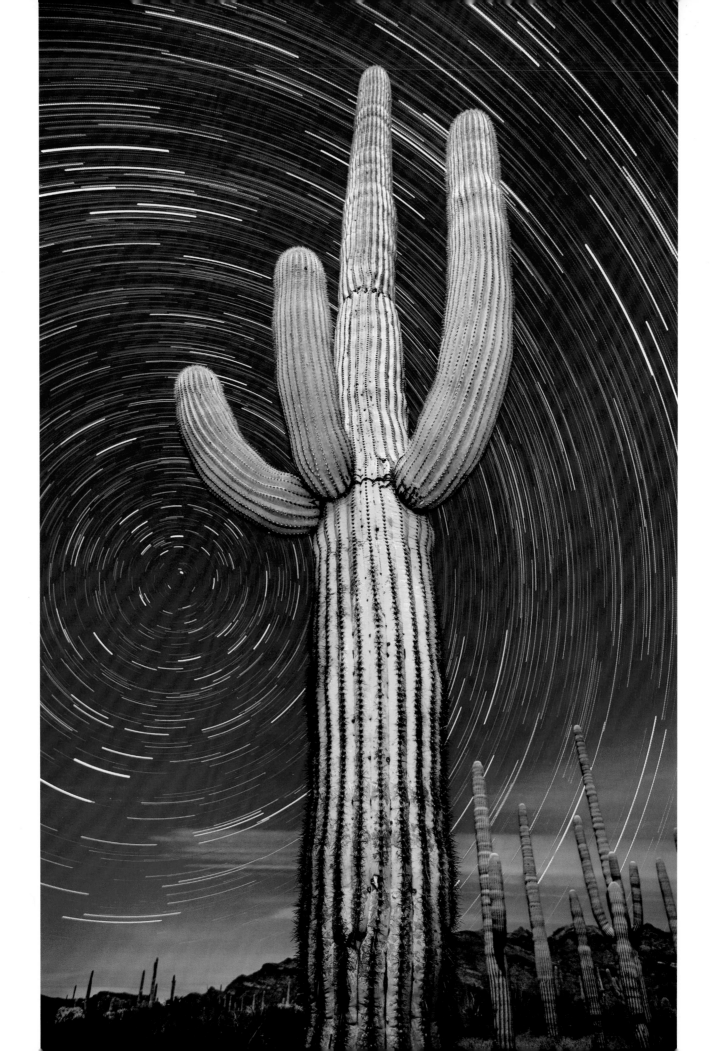

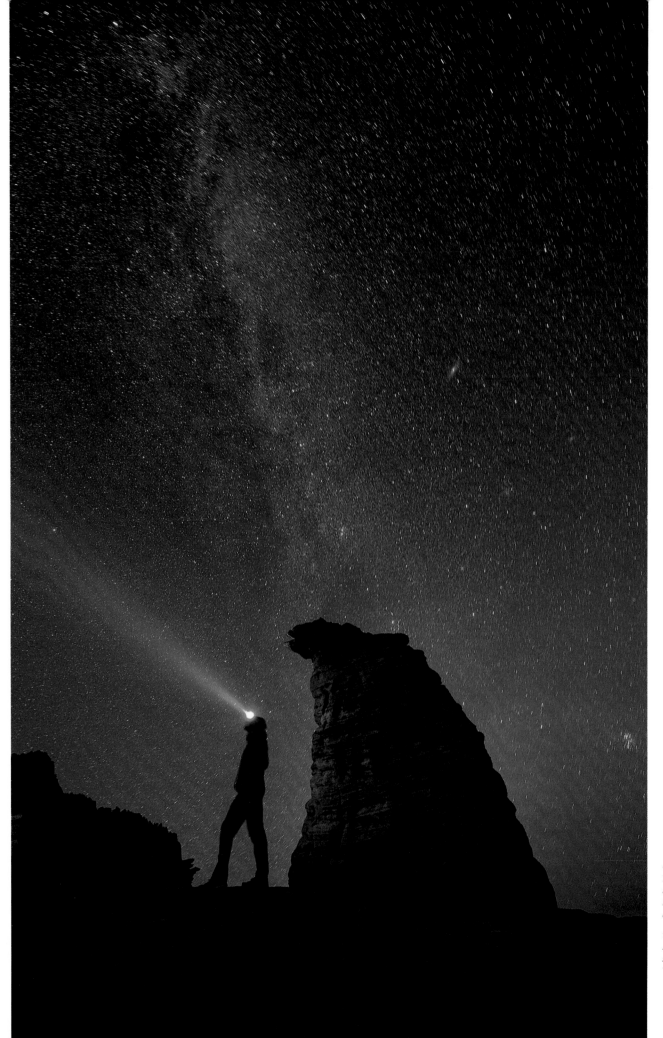

OPPOSITE: Organ Pipe Cactus National Monument, Arizona
Seventy-five-minute time-lapse photo looking toward the North Pole of stars and a saguaro cactus (Carnegiea gigantean).

LEFT: Zion National Park, Utah
A person with a headlamp admires the night sky near Checkerboard Mesa. The Milky Way is visible above the rock formation.

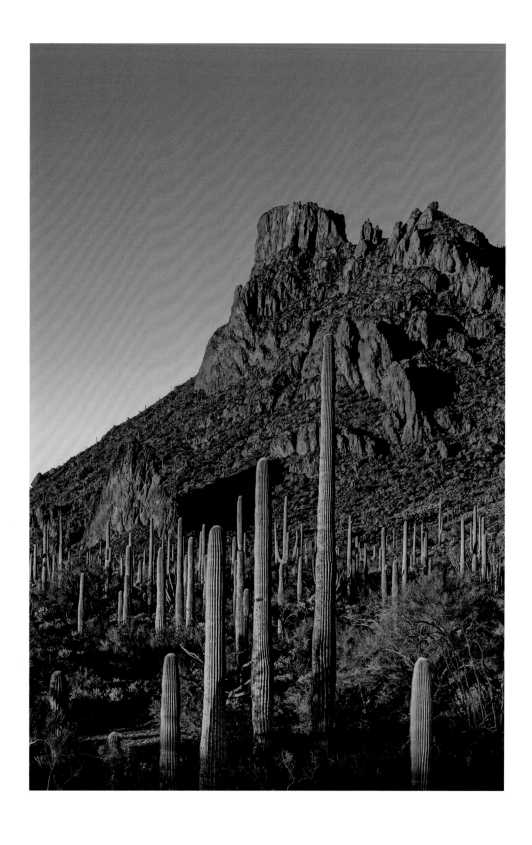

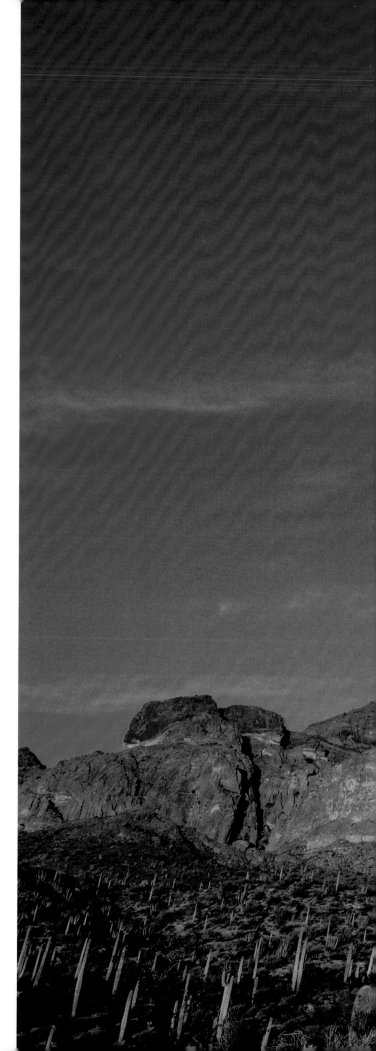

ABOVE: Organ Pipe Cactus National Monument, Arizona
Sunset in Alamo Canyon.

RIGHT: Organ Pipe Cactus National Monument, Arizona
*Along the Ajo Mountain Drive, a twenty-one-mile dirt road that loops through
rolling hills and desert landscapes. Saguaro cactus are abundant, standing
tall against the mountains.*

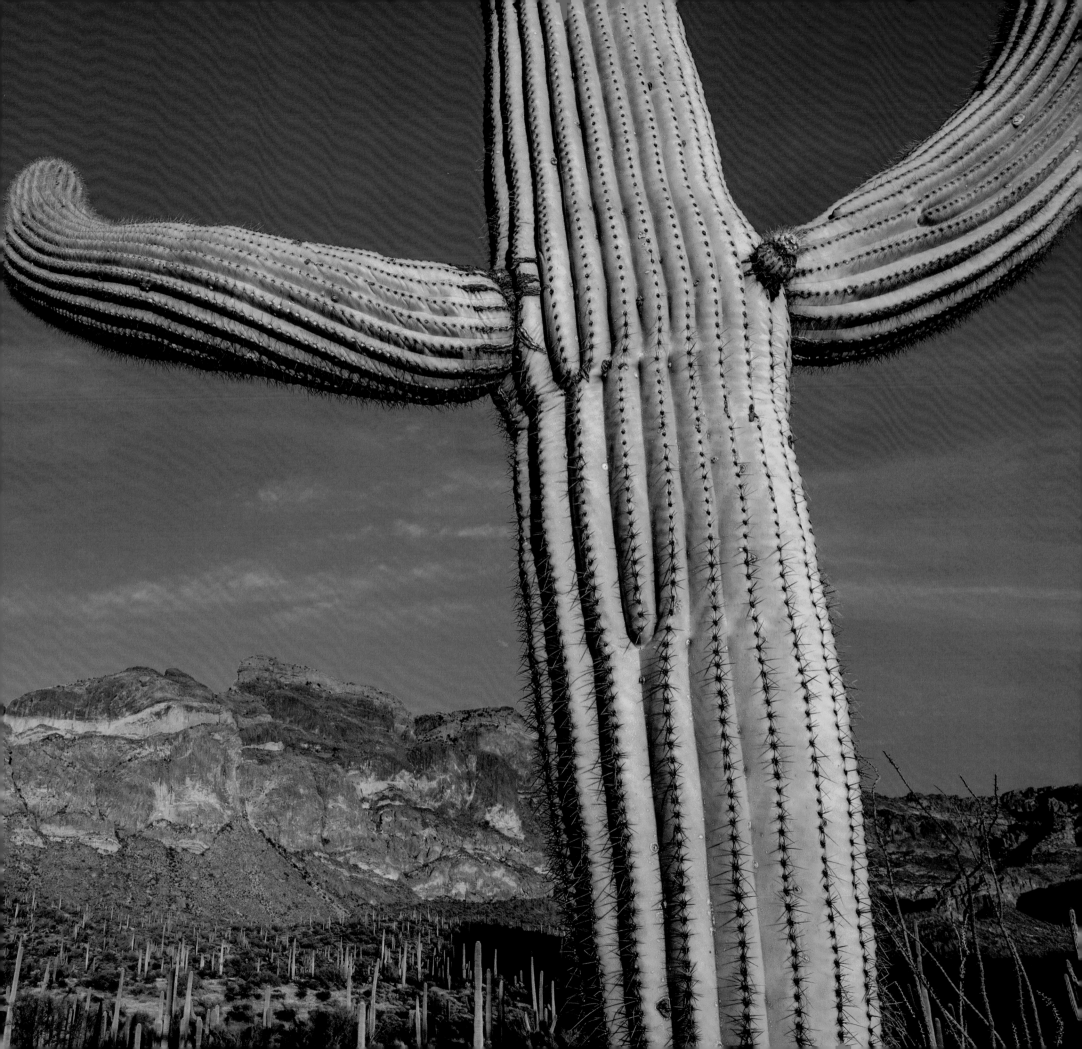

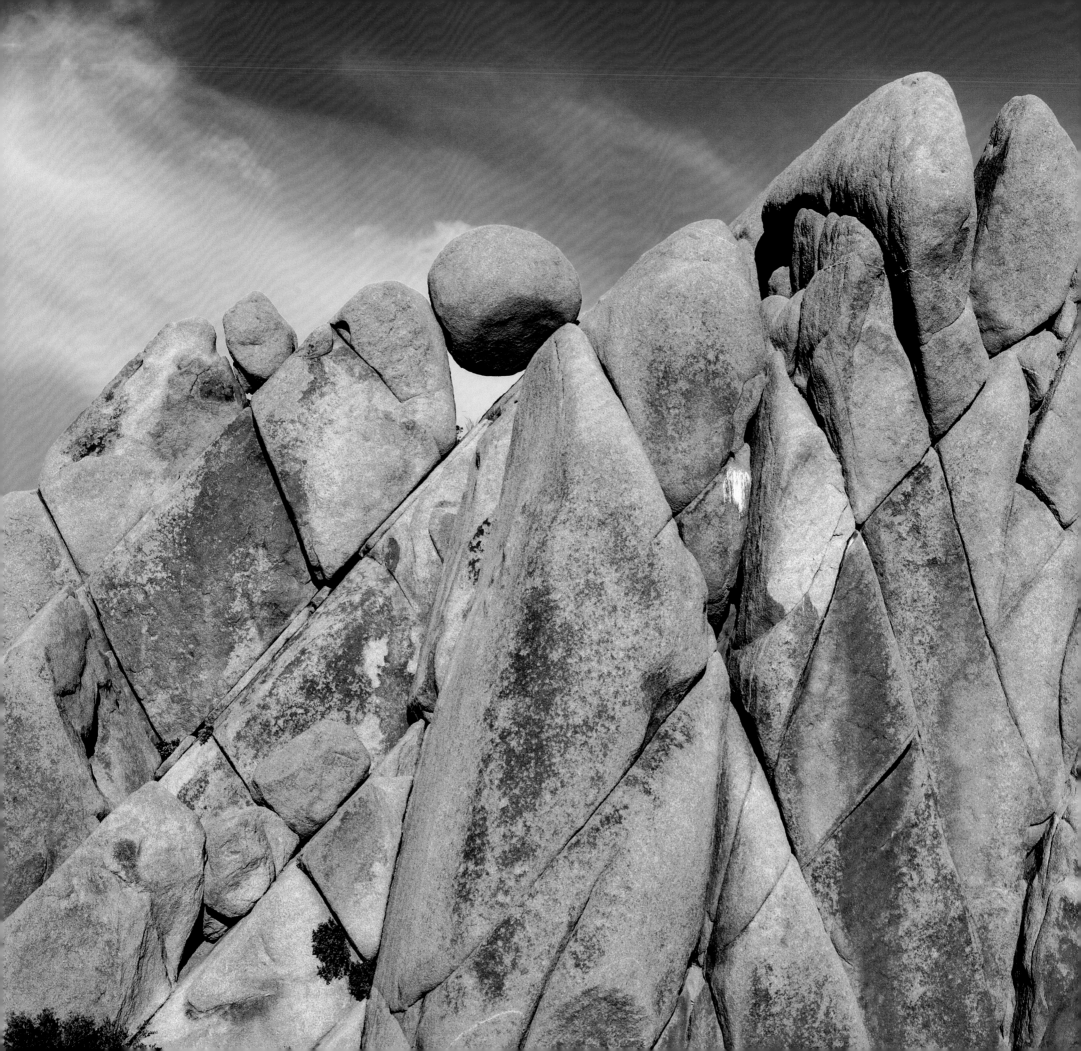

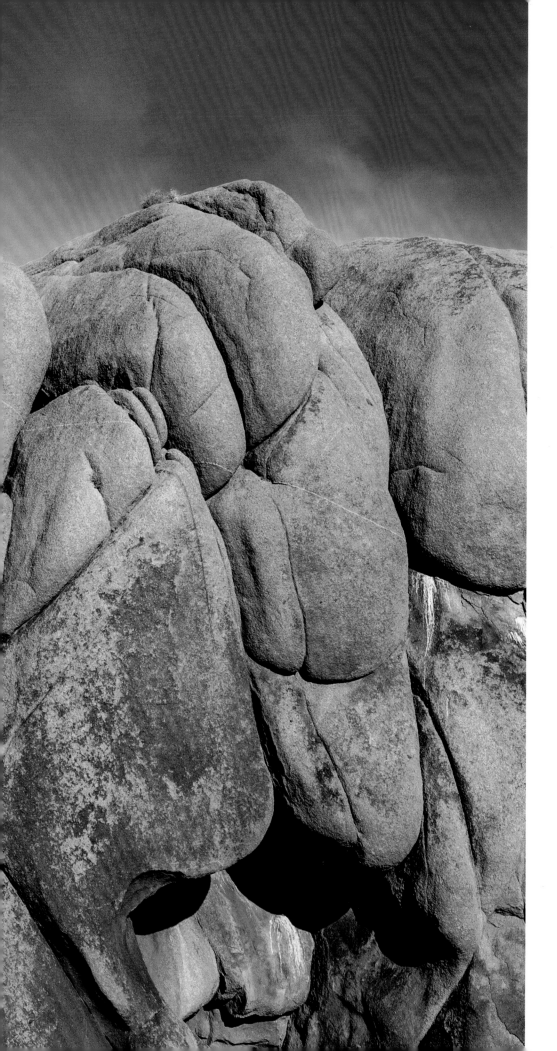

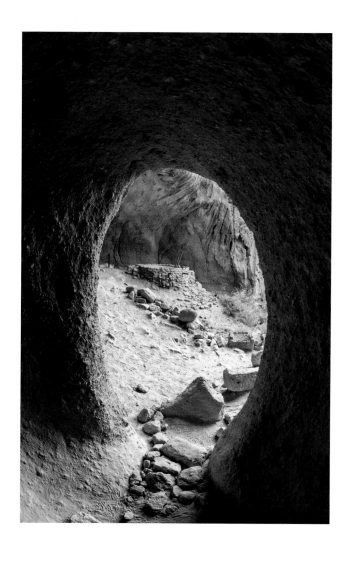

LEFT: Joshua Tree National Park, California
Rock formations in Jumbo Rock Campground.

ABOVE: Bandelier National Monument, New Mexico

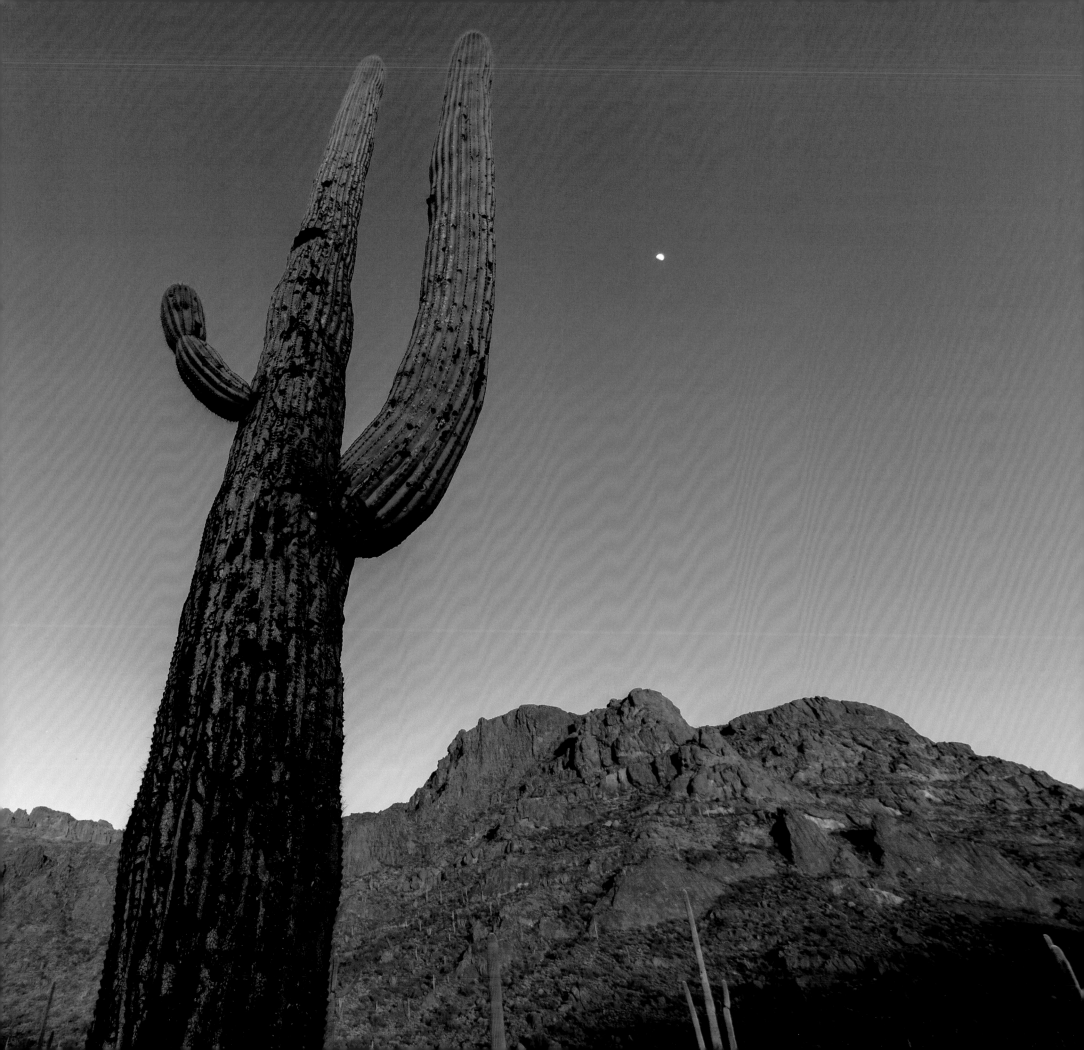

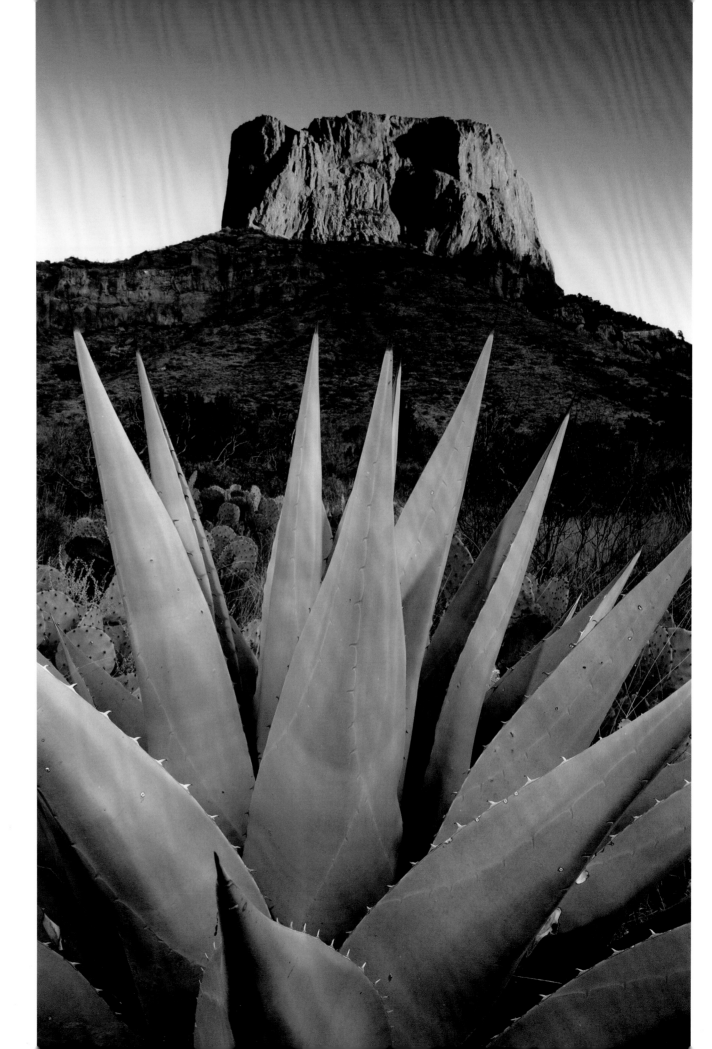

OPPOSITE: Organ Pipe Cactus National Monument, Arizona
Old saguaro at sunset in Alamo Canyon.

RIGHT: Big Bend National Park, Texas
Warm light from the sunset illuminates Casa Grande.

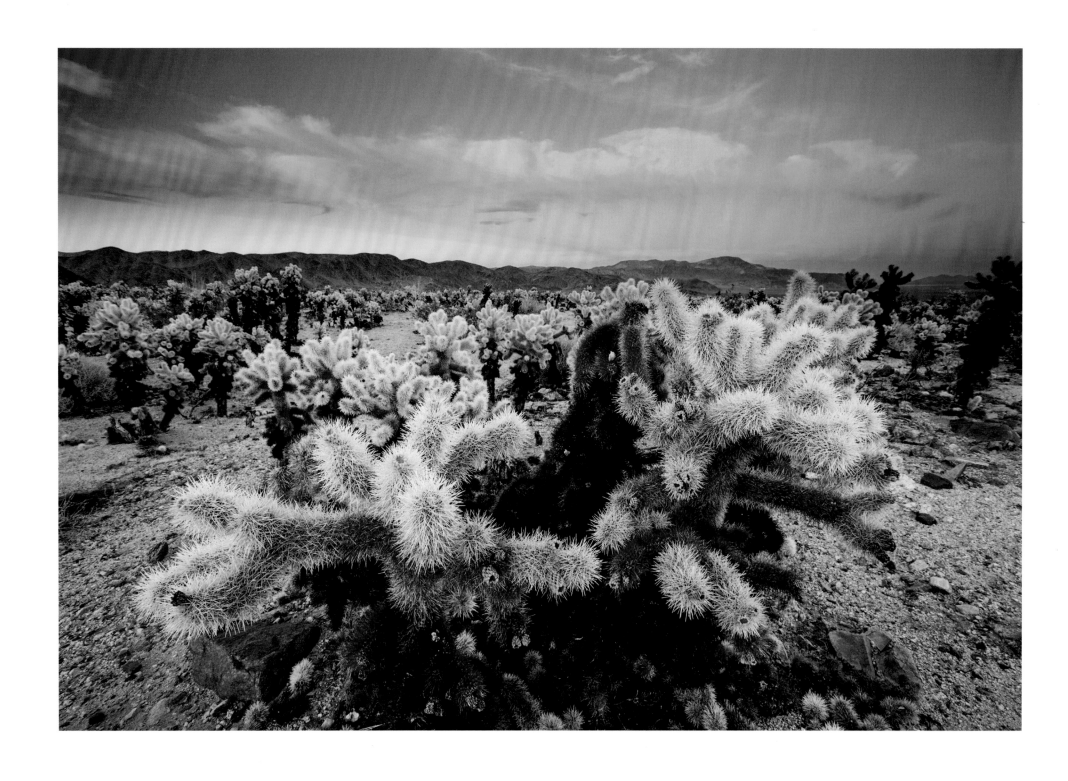

Joshua Tree National Park, California
Details of cholla cactus (Cylindropuntia bigelovil).

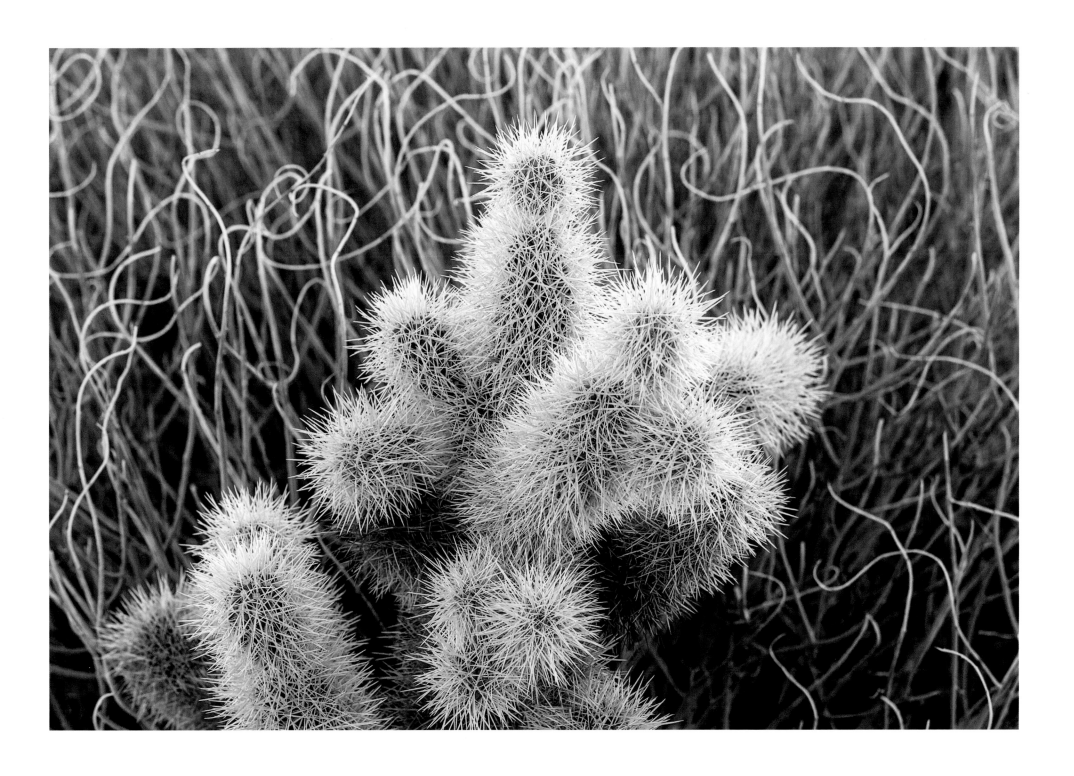

Joshua Tree National Park, California
Details of cholla cactus, or teddy bear cactus, in the Cholla Cactus Garden.

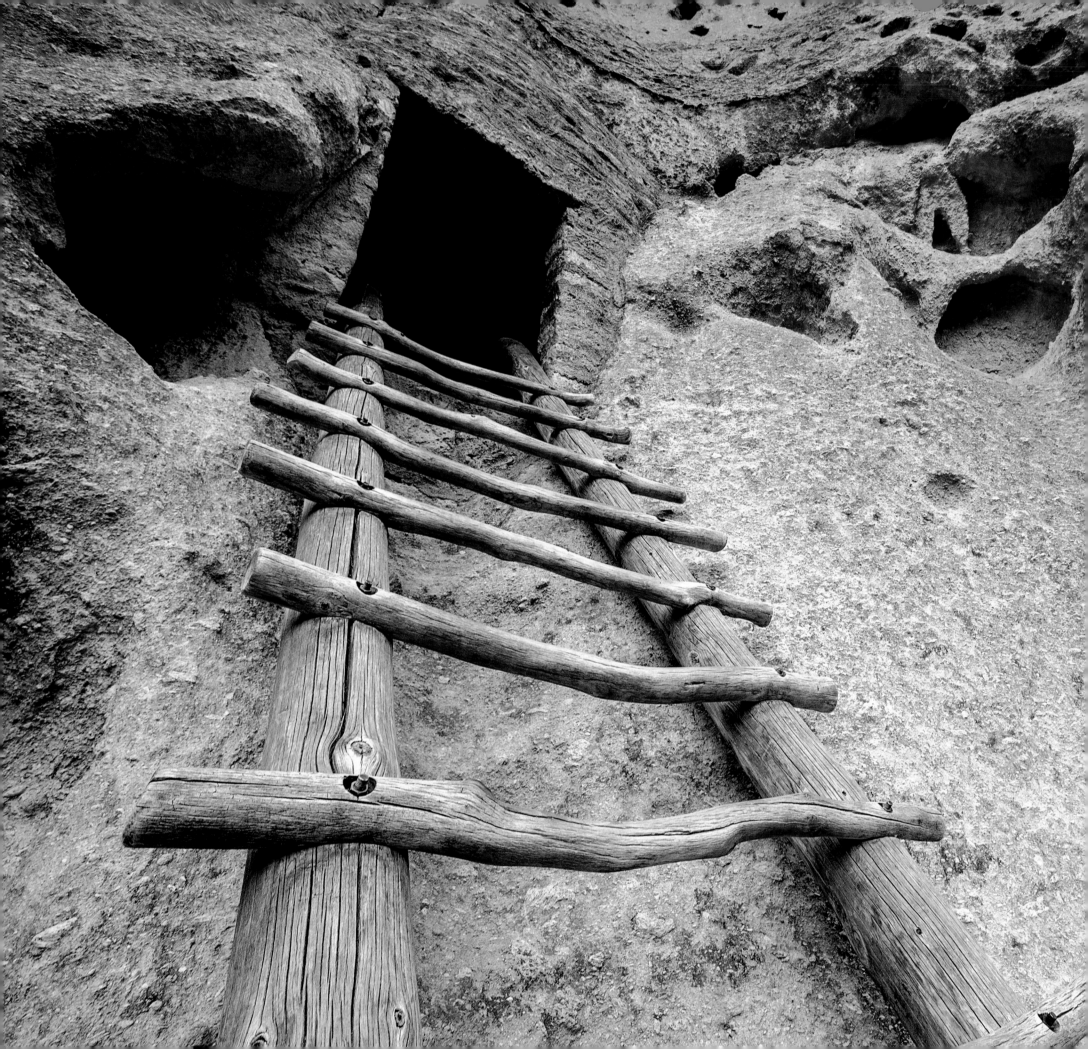

Bandelier National Monument, New Mexico

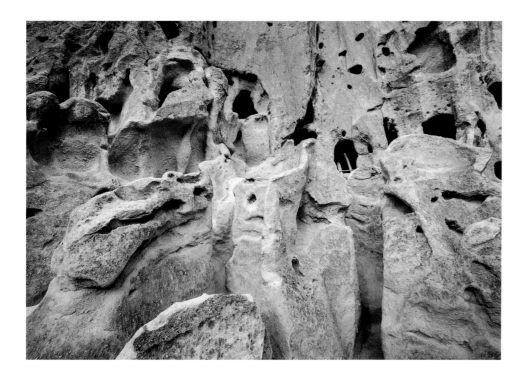

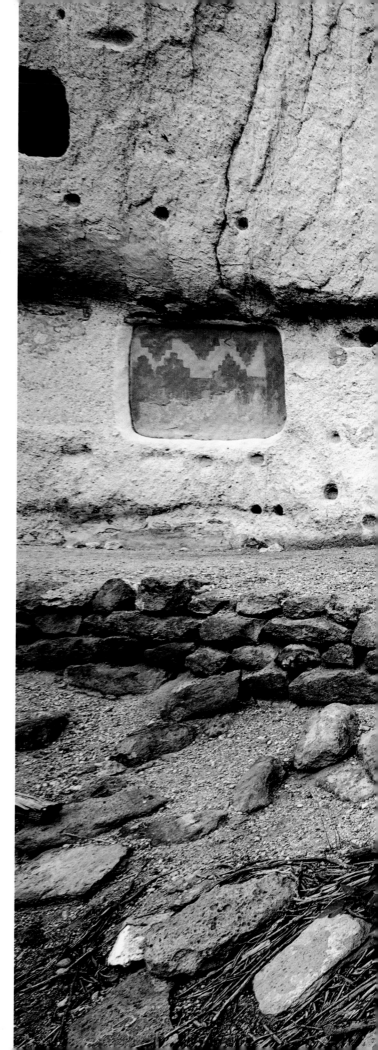

ABOVE AND RIGHT: Bandelier National Monument, New Mexico

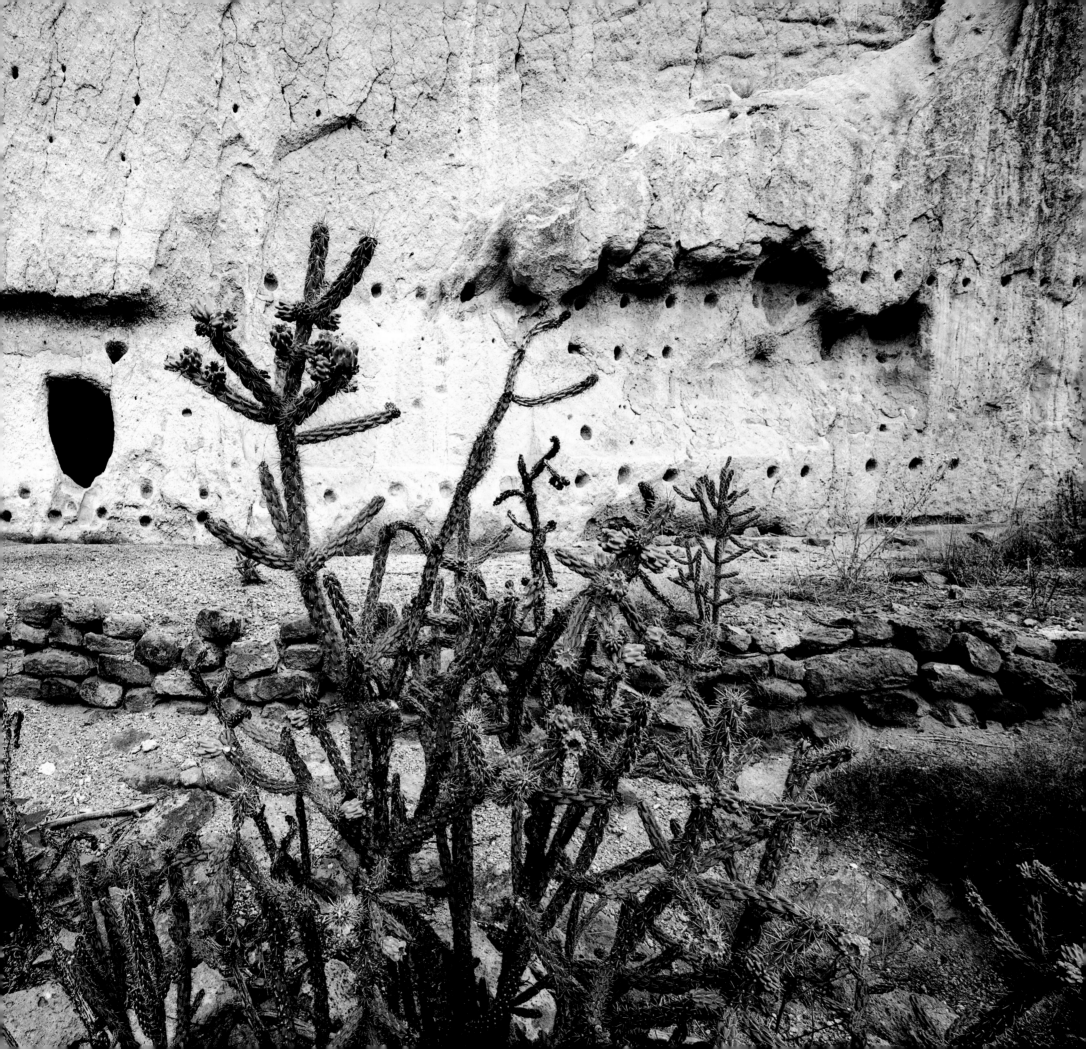

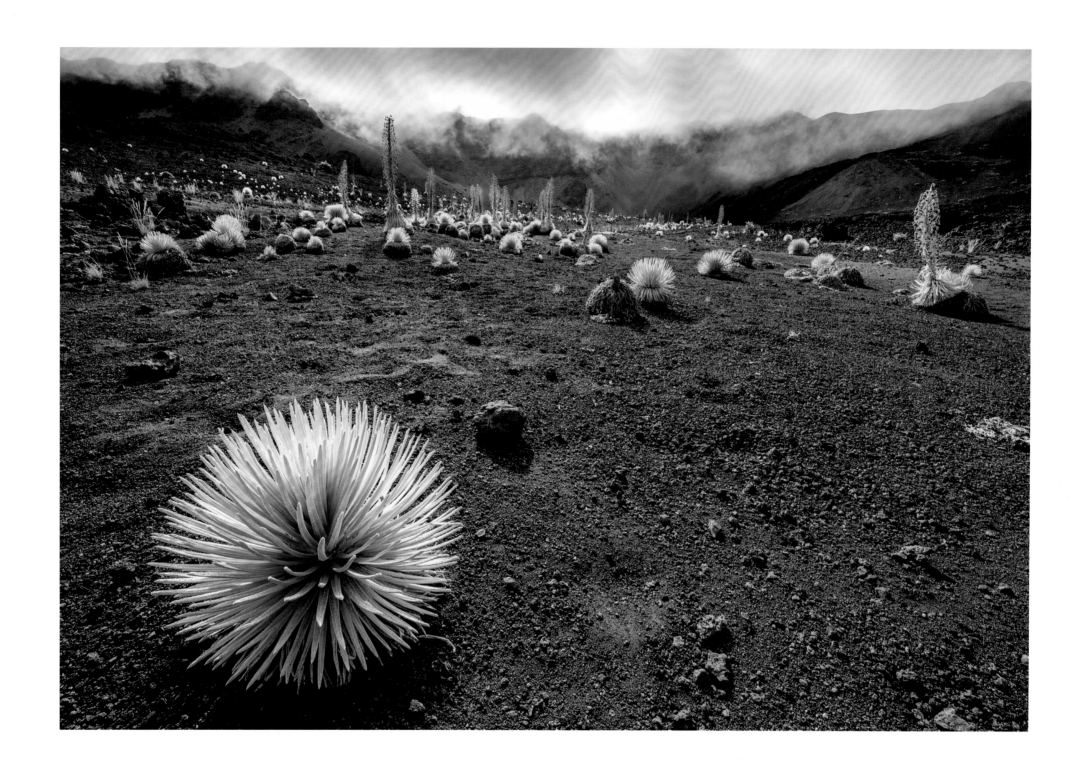

Haleakalā National Park, Maui, Hawai'i
Silversword (Argyroxiphium sandwicense), *an endangered species, inside the Haleakalā Crater.*

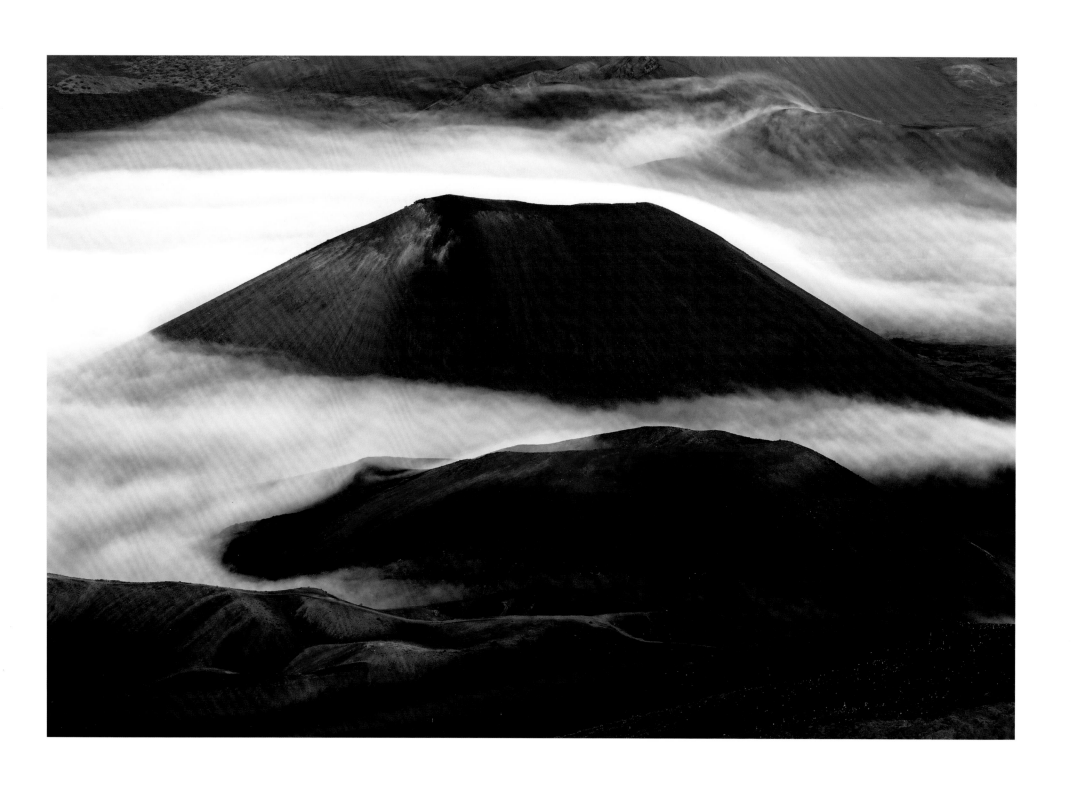

ABOVE AND FOLLOWING PAGES: Haleakalā National Park, Maui, Hawaiʻi
Clouds forming on cinder cones and formations inside the Haleakalā Crater.

127

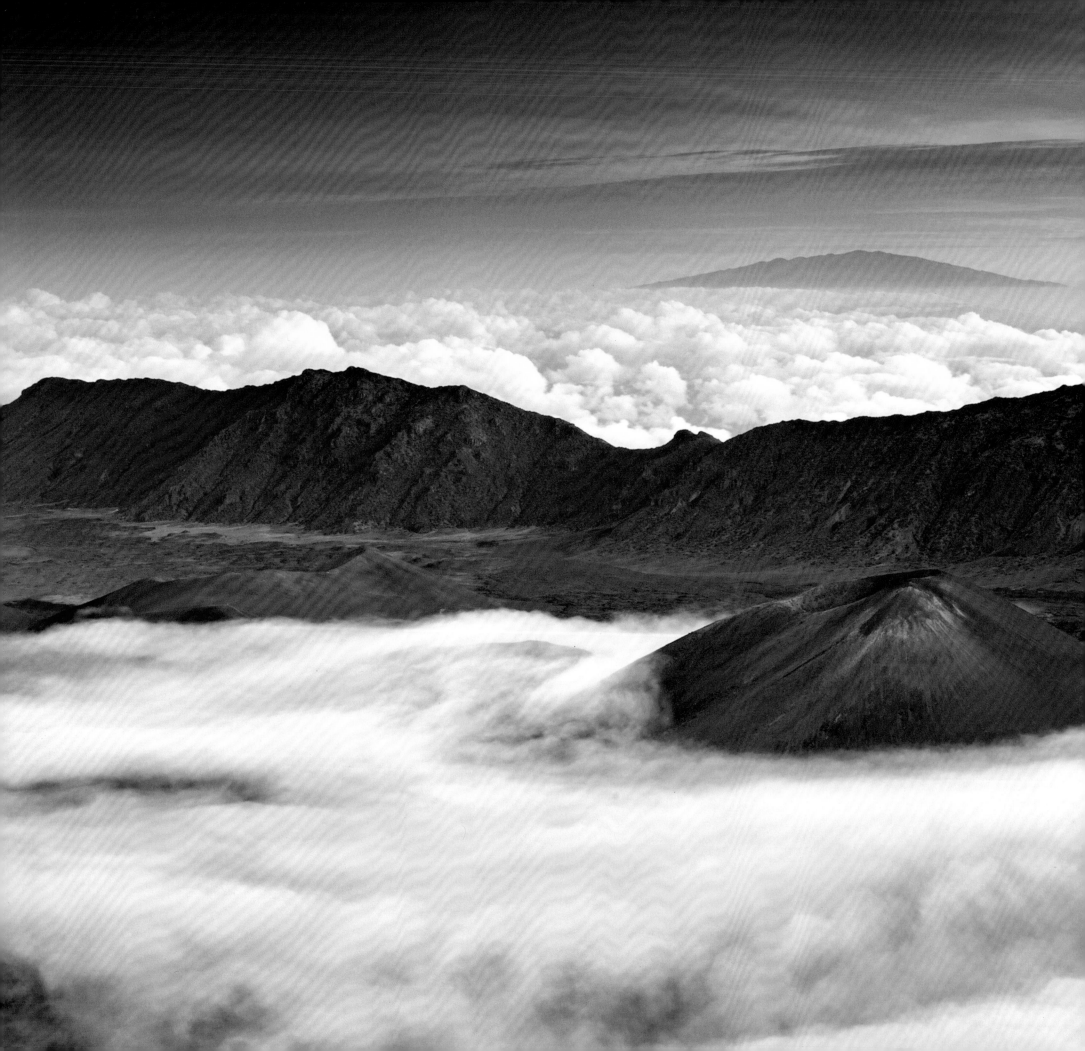

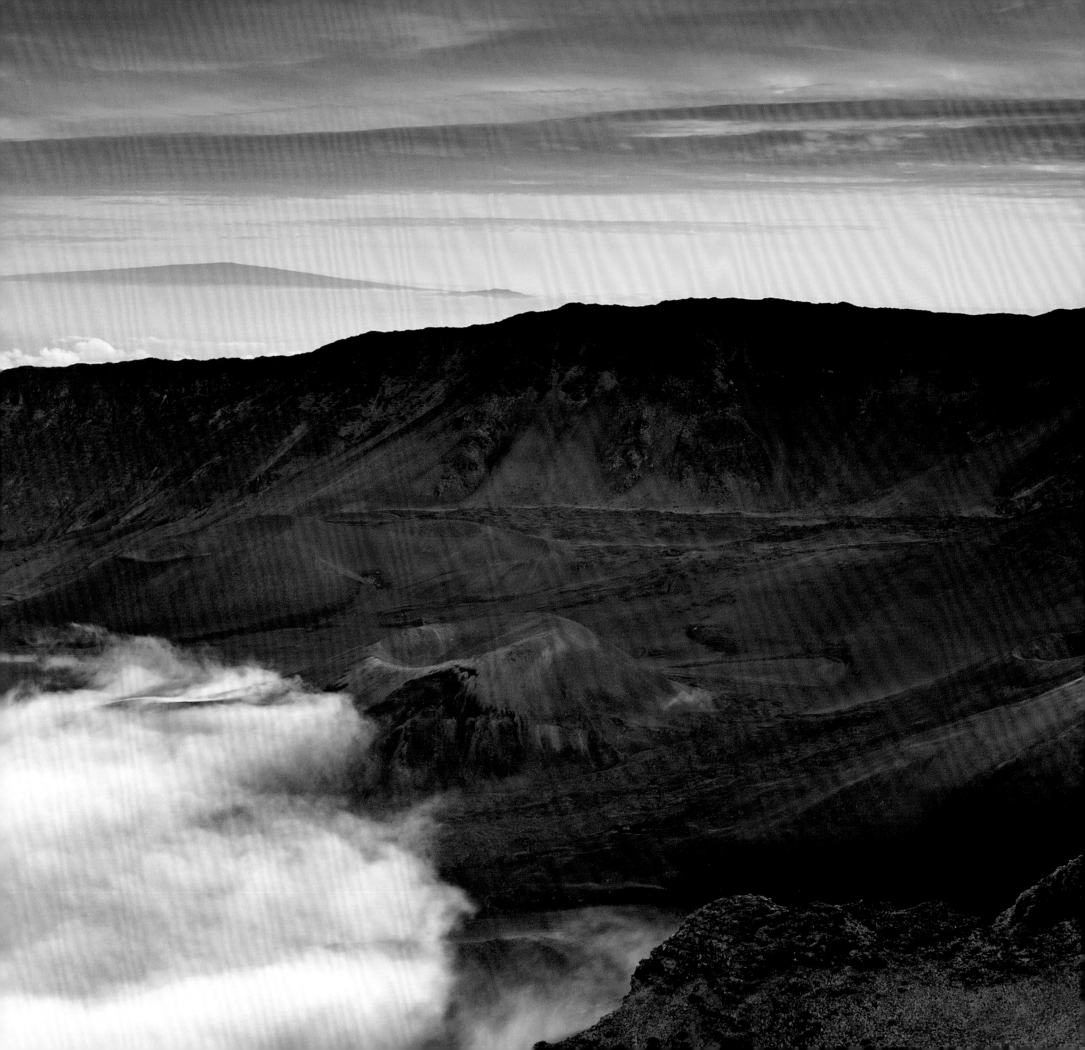

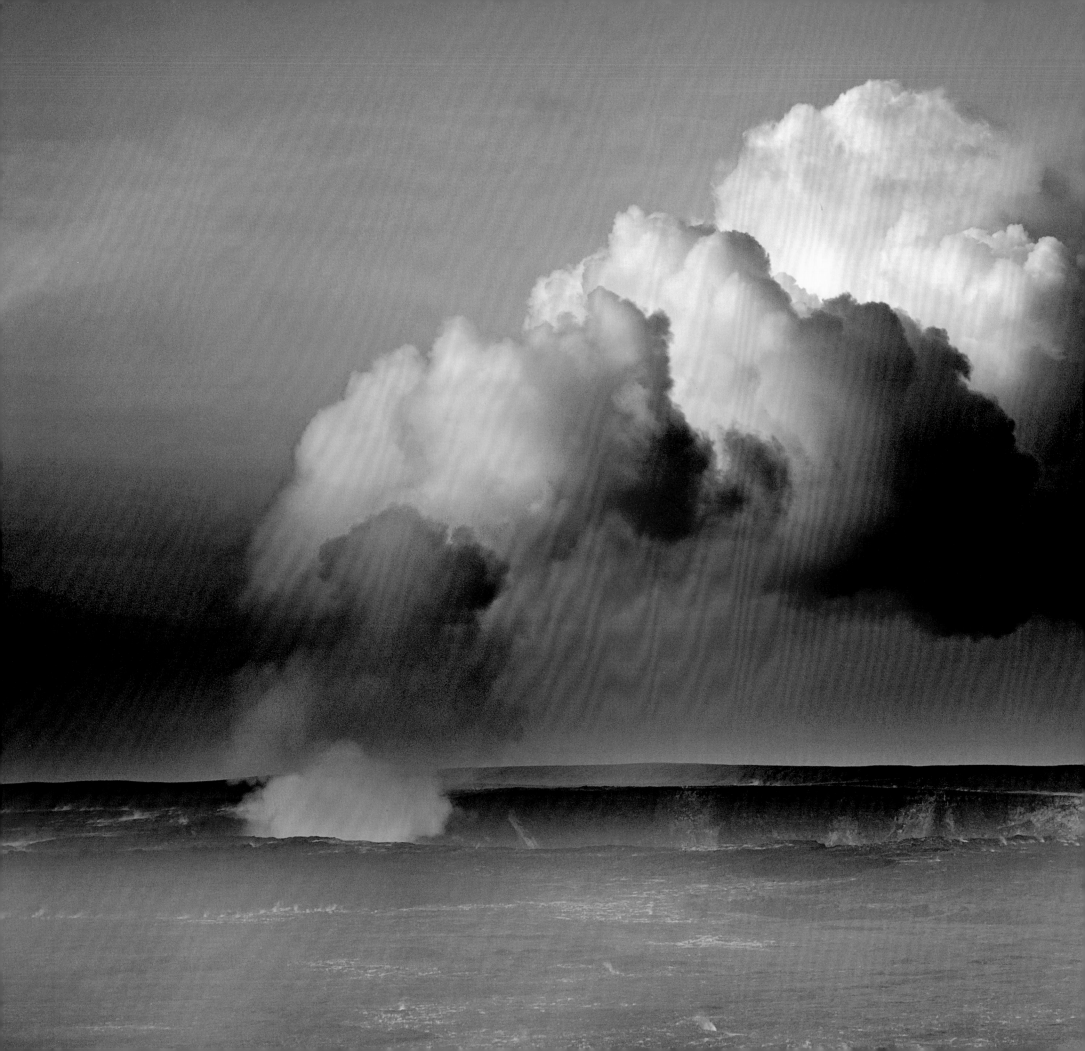

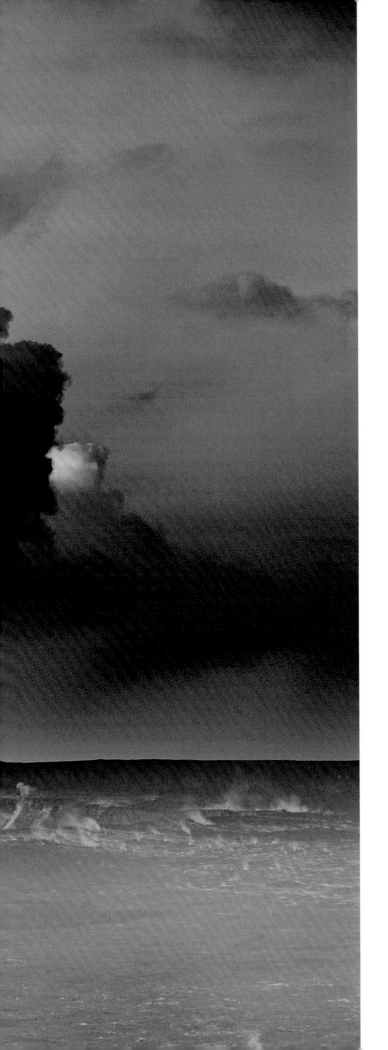

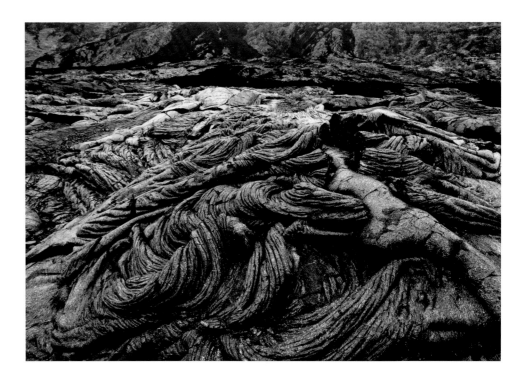

LEFT: Hawai'i Volcanoes National Park, Hawai'i
A giant sulfur dioxide gas plume from Kīlauea volcano is illuminated by the rising sun.

ABOVE: Hawai'i Volcanoes National Park, Hawai'i
Hardened lava flow.

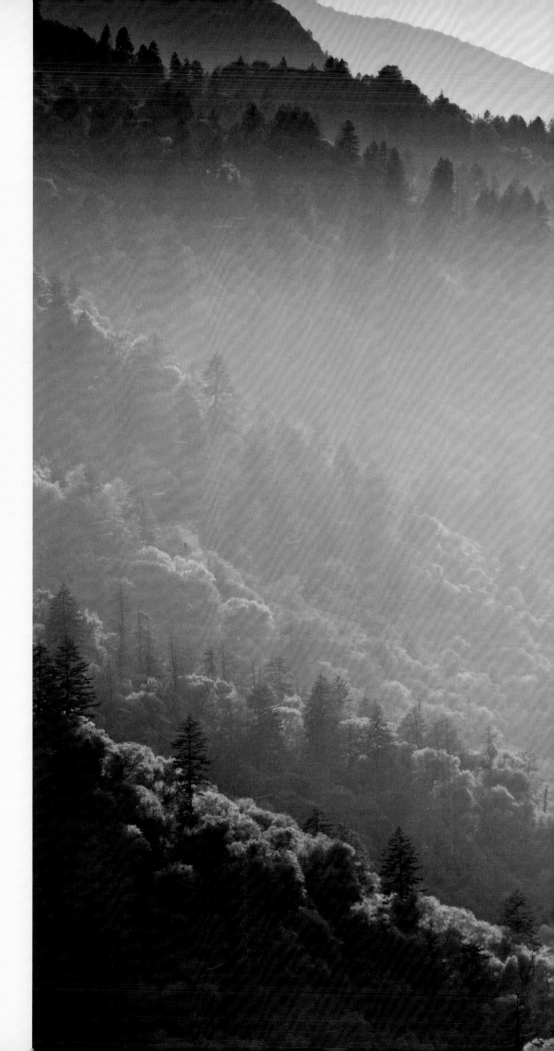

ABOVE: Glacier National Park, Montana
A buck deer along the Highline Trail.

RIGHT: Great Smoky Mountains National Park; North Carolina, Tennessee
The Great Smoky Mountains as seen from a scenic overlook during summer.

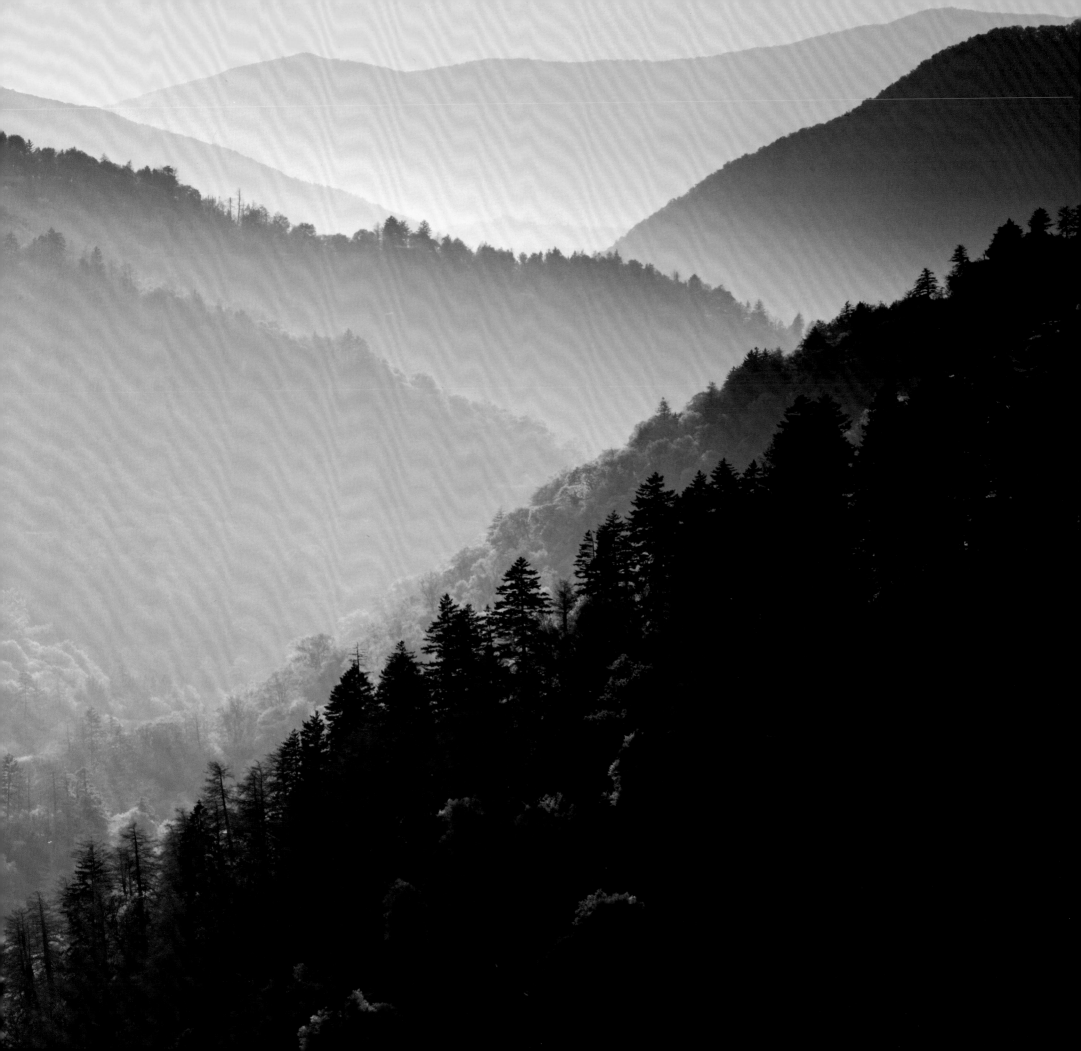

GREAT SMOKY MOUNTAINS NATIONAL PARK

Encompassing more than eight-hundred square miles of western North Carolina and eastern Tennessee, the boundaries of Great Smoky Mountains National Park hold some of the oldest mountains in the world and much more. The Smokies are one of the most biologically diverse places on the planet, with more than eighteen thousand species of plants, animals, and invertebrates documented in the park and more being discovered every year. Dubbed the "Salamander Capital of the World," this park is home to more than thirty species of amphibian, ranging in size from a few inches to two-and-a-half-feet long. In fact, in any one square mile of the park, salamanders would outweigh all the mammals combined. Considering the Smokies' most famous resident, the American black bear, can weigh up to six hundred pounds, that is no small feat. The flora is as impressive as the fauna in the Smokies, which boast one of the largest tracts of old-growth temperate forest in North America, more native tree species than any other national park, and over a million wildflowers in bloom on any given spring day.

However, the unparalleled natural beauty of the Smokies has not gone untouched by human hands. The Cherokee people have called *Shaconge*, "place of the blue smoke," their home for thousands of years. Early European immigrants continued to settle the Great Smoky Mountains, building homes and logging much of the area's forests before the park was established in 1934. Roads, trails, fire towers, and buildings were constructed by the Civilian Conservation Corps in the 1930s under President Roosevelt's New Deal. Today, more than ten million visitors come to Great Smoky Mountains National Park each year to camp, hike, fish, enjoy the scenic vistas, and visit historic structures. As America's most-visited national park, the Smokies carefully balance the love and enjoyment of this treasured public land with the preservation of its rich history and incomparable natural resources.

As part of that balance, the nonprofit organization Friends of the Smokies supports Great Smoky Mountains National Park by funding projects like trail rehabilitation on more than eight hundred miles of hiking trails and restoration of historic homesites, churches, and schools. When native elk were returned to the park one-hundred-fifty years after being eradicated by hunting, Friends of the Smokies played a vital role in reintroducing the herd, now thriving in its protected habitat. By providing environmental education for thousands of schoolchildren annually through the Parks as Classrooms program, Friends of the Smokies helps create the next generation of park stewards and supporters. After all, it is our children and grandchildren who will look after our national parks for the next one hundred years of the National Park Service, hiking these mountains, fishing these streams, and breathing the clean mountain air.

—Friends of the Smokies

Great Smoky Mountains National Park; North Carolina, Tennessee

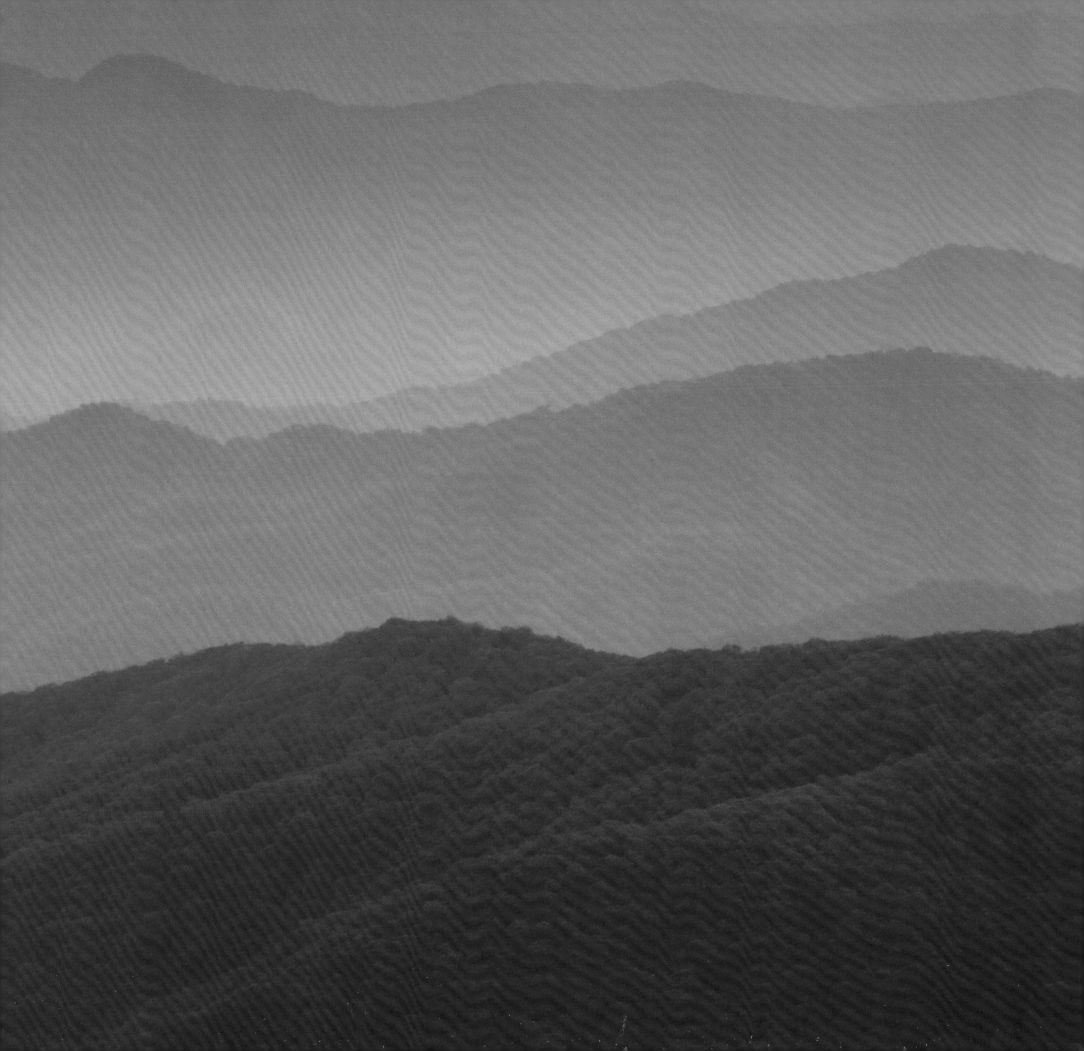

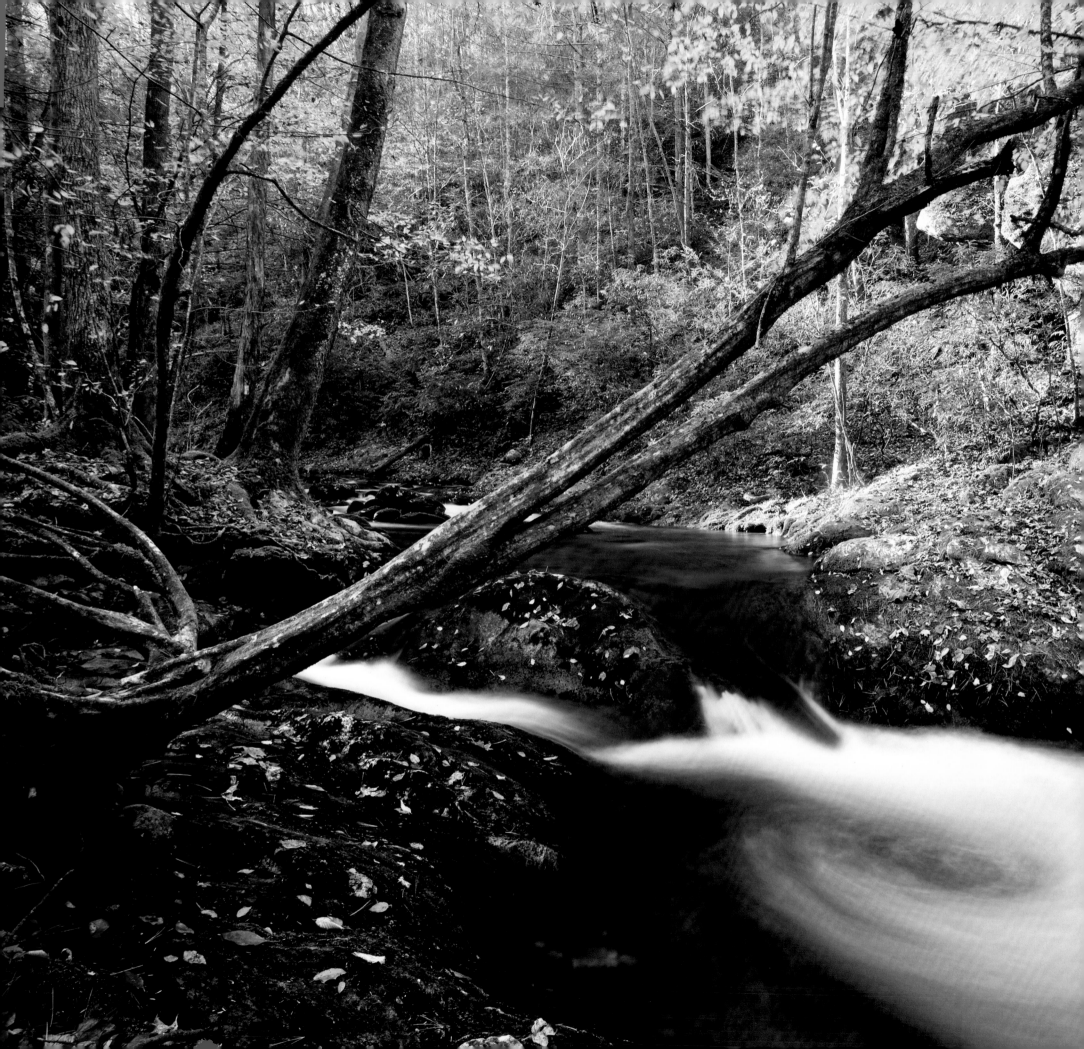

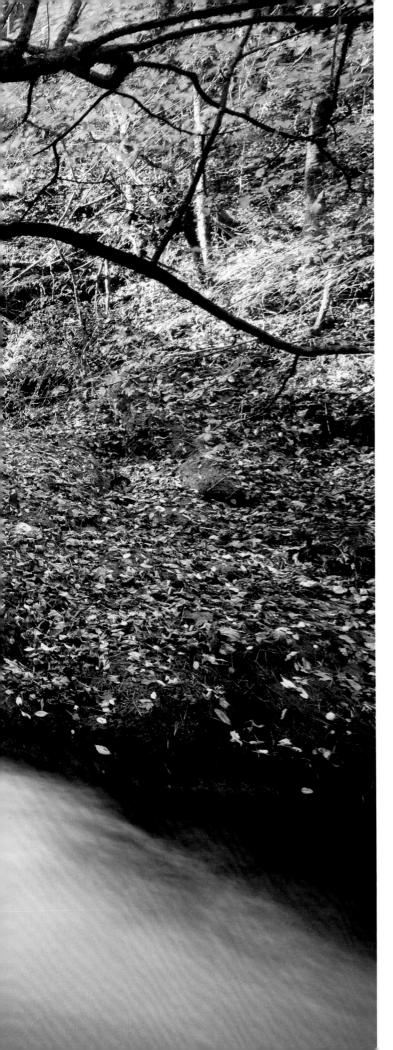

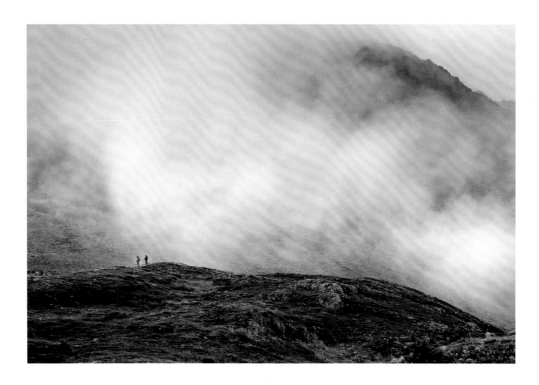

LEFT: Great Smoky Mountains National Park; North Carolina, Tennessee
The Little River flows through the Tennessee side of the national park.

ABOVE: Kenai Fjords National Park, Alaska
Hikers along a stretch of the Harding Icefield Trail, approximately four miles into the park.

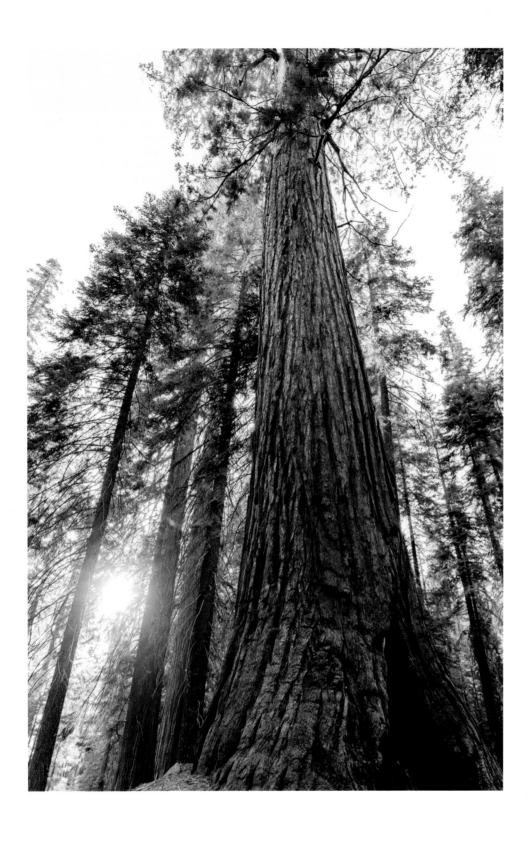

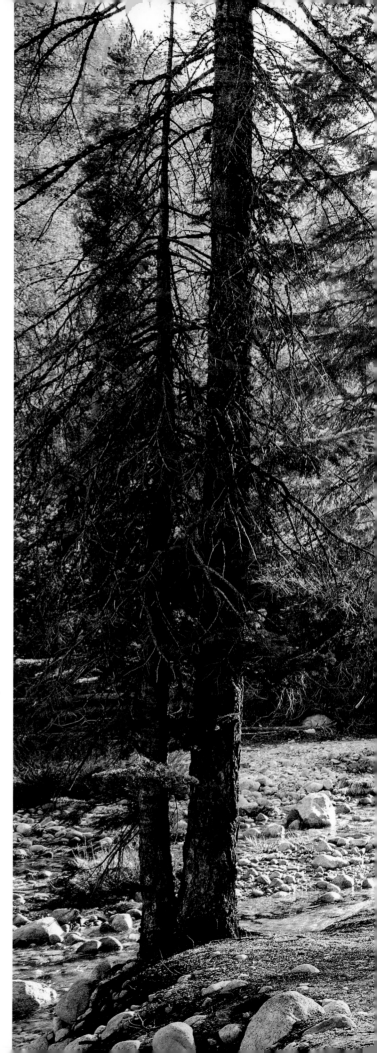

ABOVE: Sequoia National Park, California
Evening light on giant sequoia trees (Sequoiadendron giganteum).

RIGHT: Sequoia National Park, California
Campsite at Lodgepole Campground along the Kaweah River.

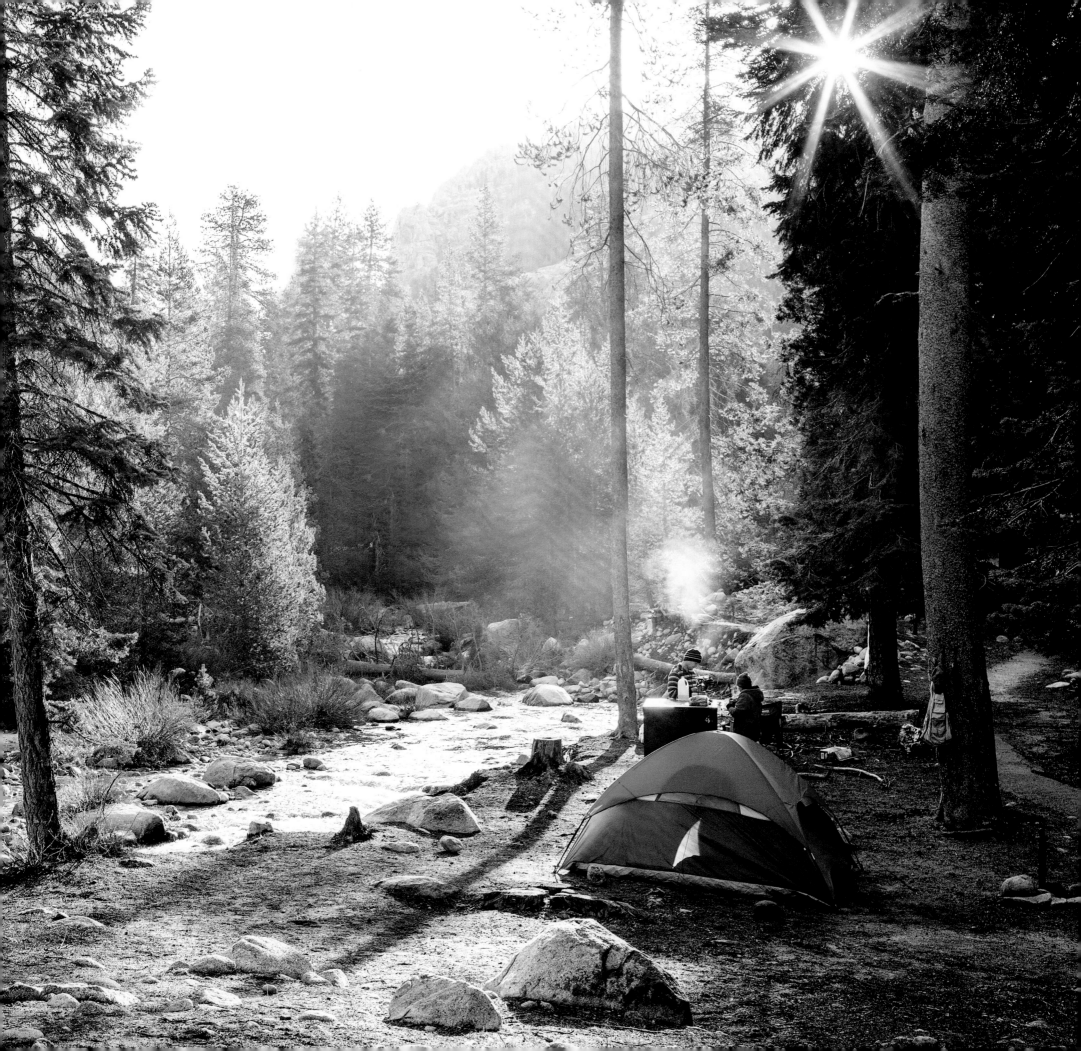

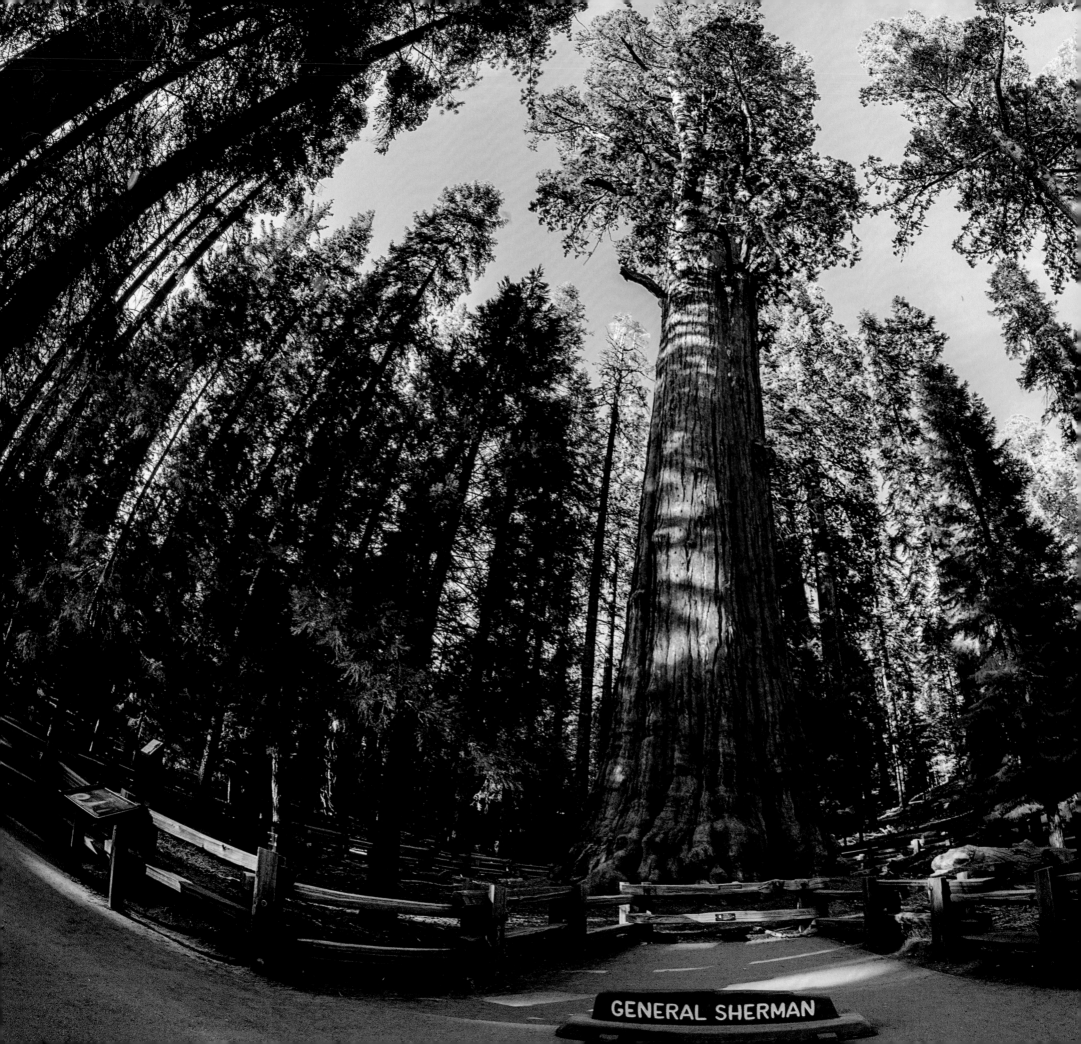
GENERAL SHERMAN

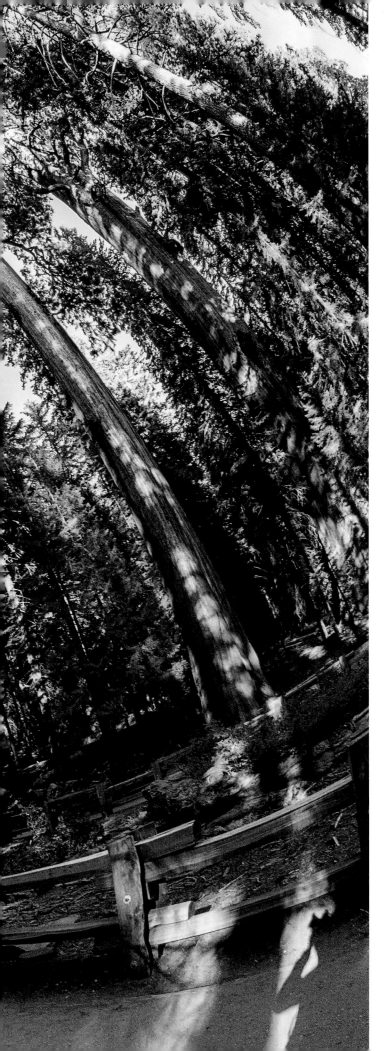

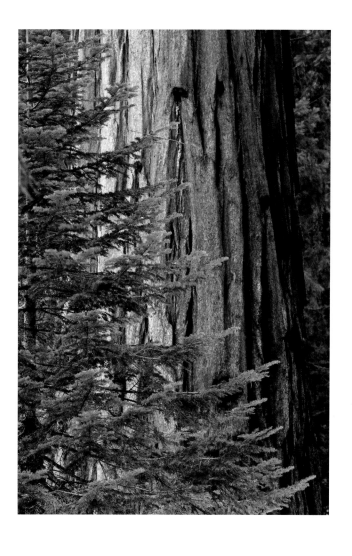

LEFT: Sequoia National Park, California
General Sherman, a giant sequoia, is the largest known living single-stem tree on earth, by volume. It is estimated to be 2,300 to 2,700 years old.

ABOVE: Sequoia National Park, California
Detail of a giant sequoia.

141

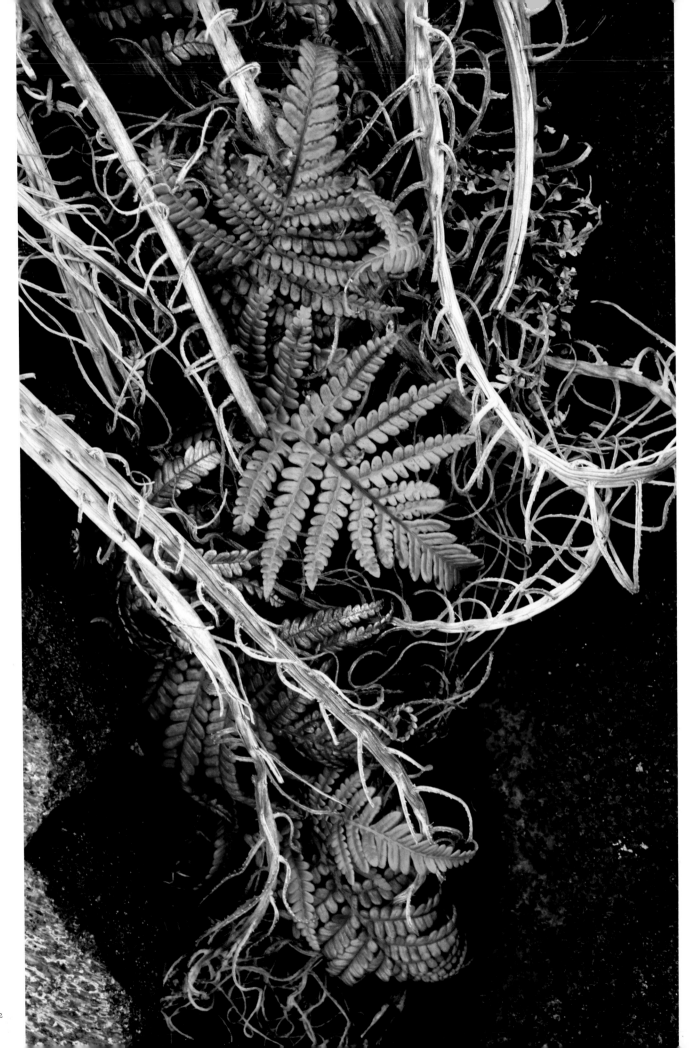

LEFT: Hawai'i Volcanoes National Park, Hawai'i
Detail of ferns and roots on hardened lava beds.

OPPOSITE: Sequoia National Park, California
A man puts his hand on the cut portion of a fallen giant sequoia.

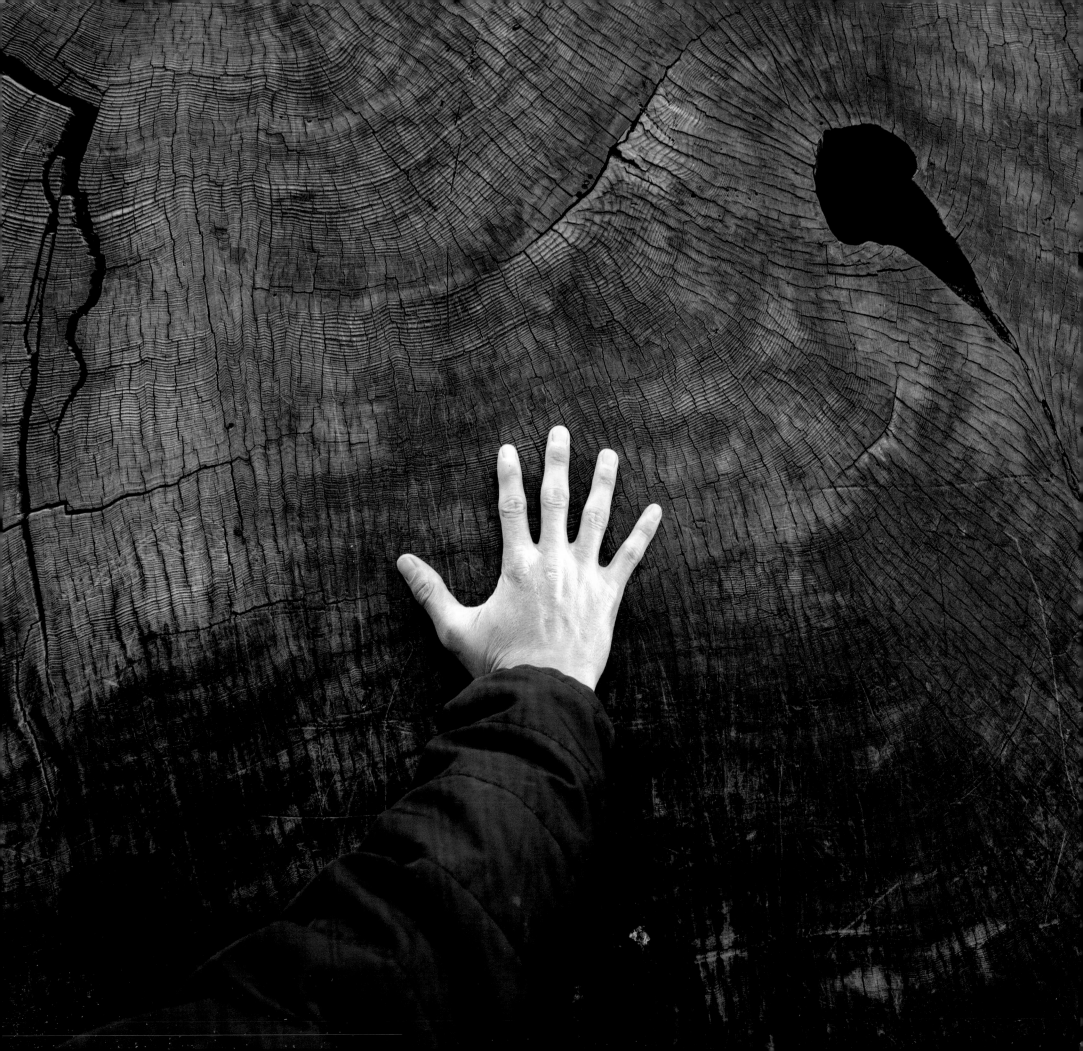

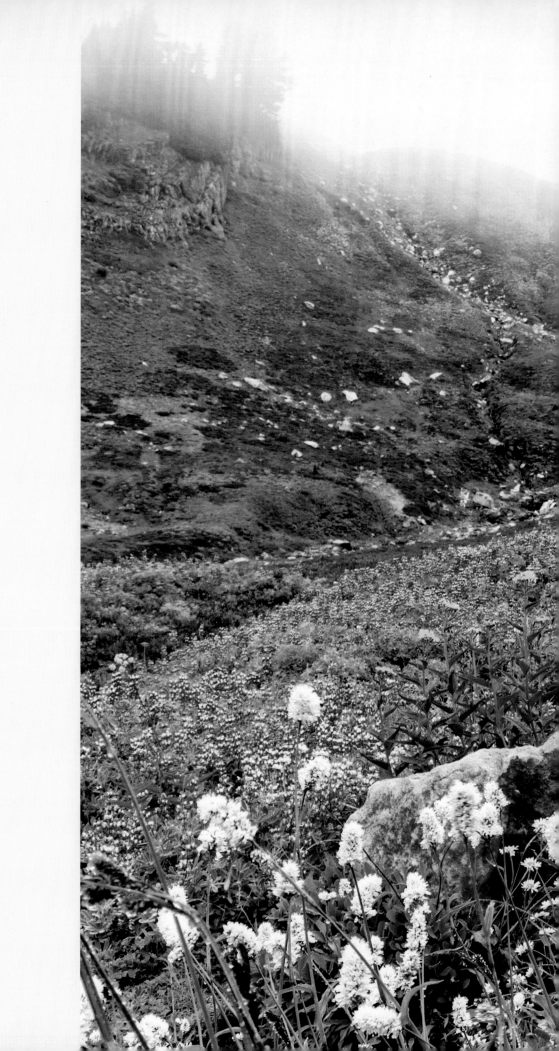

Mount Rainier National Park, Washington
Wildflowers along the Skyline Trail out of Paradise.

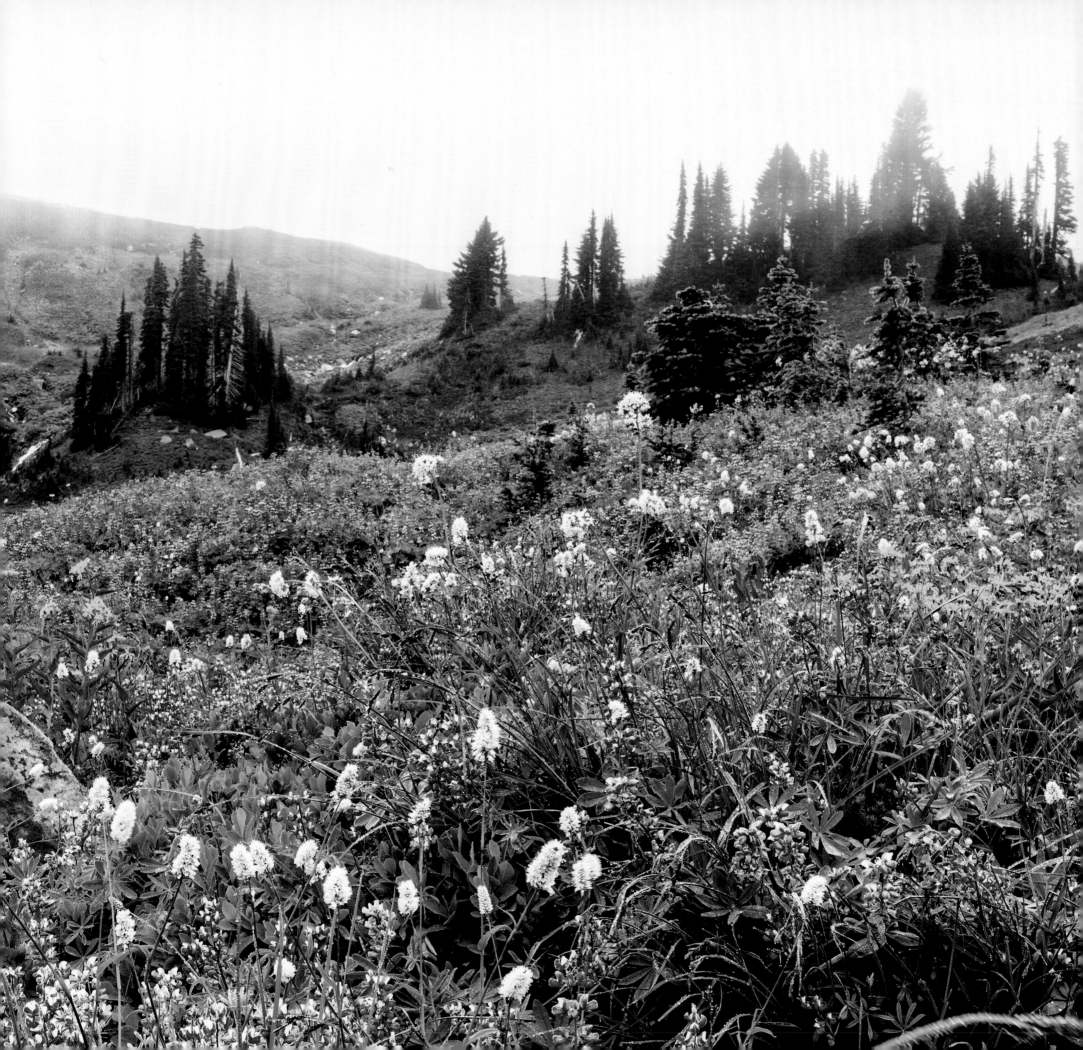

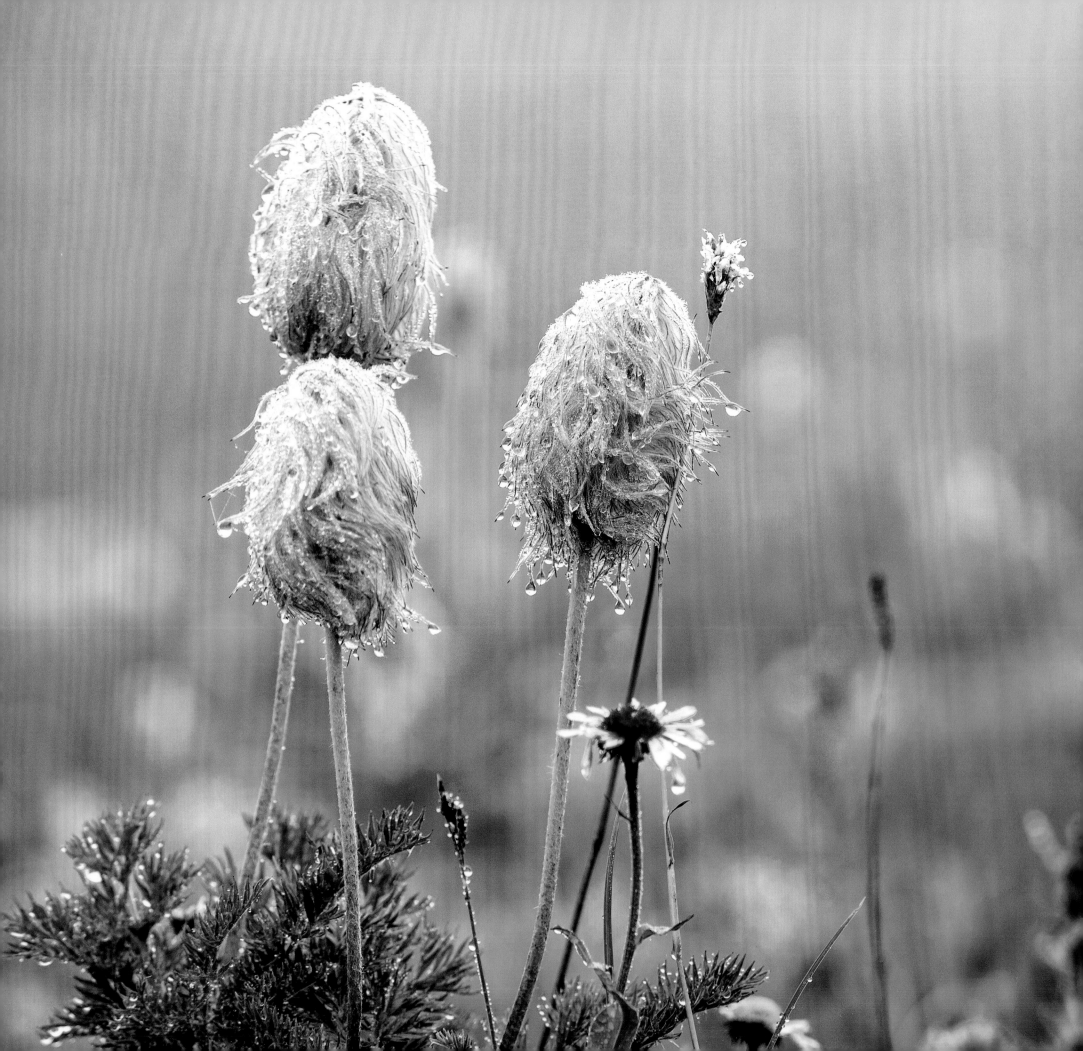

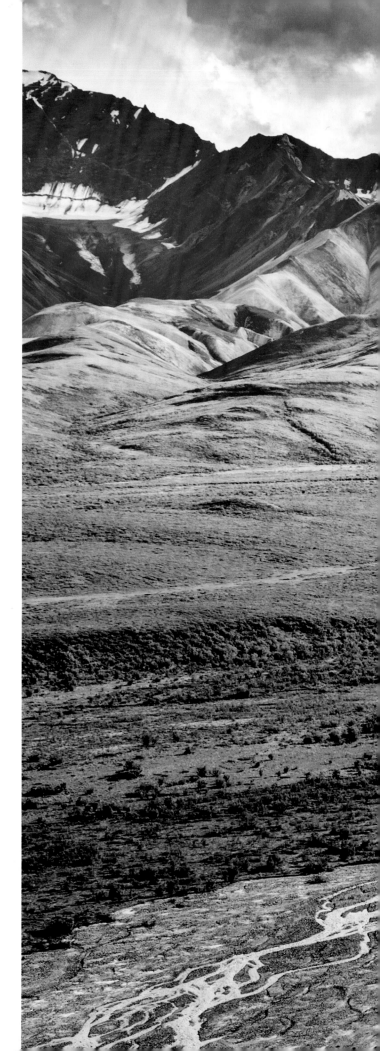

Denali National Park and Preserve, Alaska
Polychrome Pass.

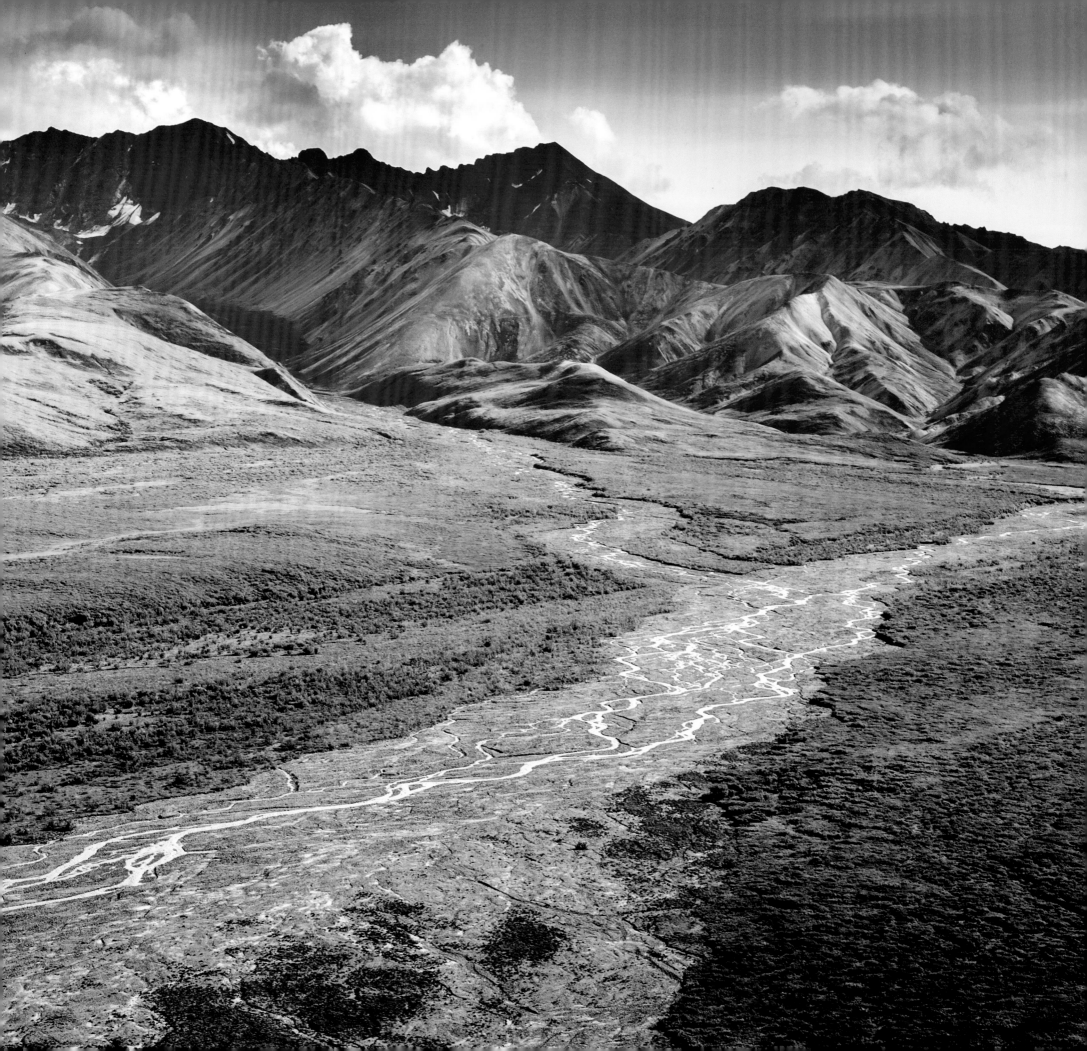

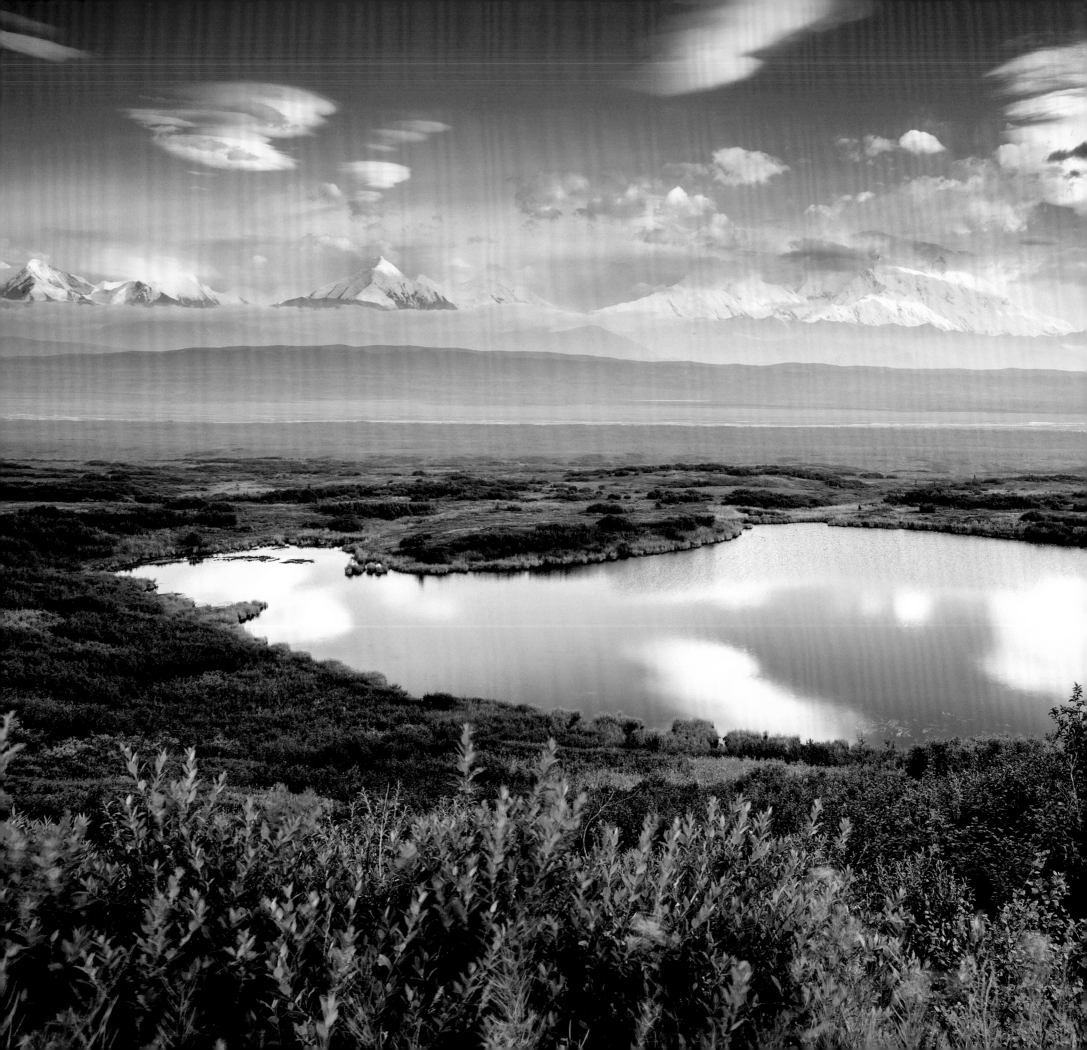

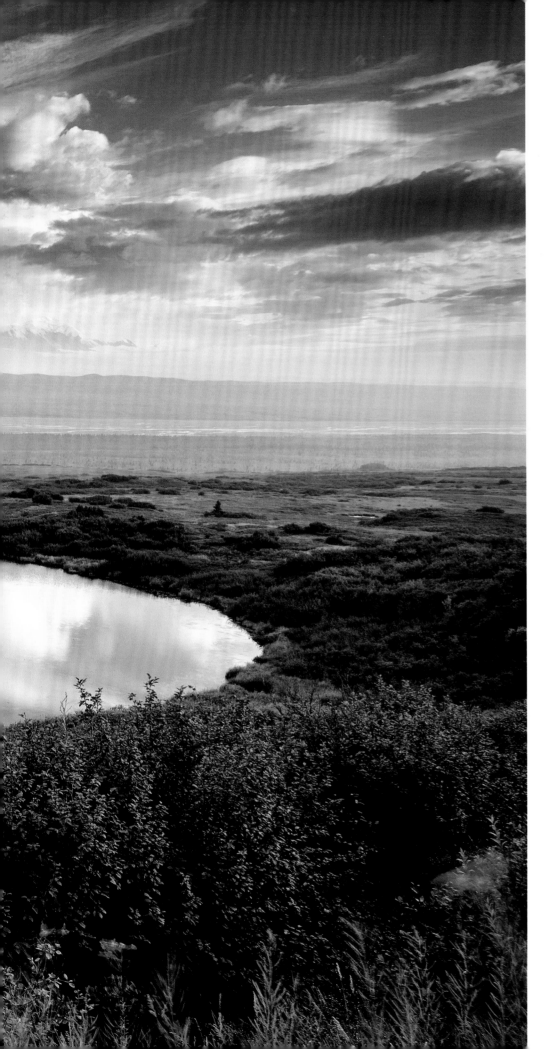

LEFT: Denali National Park and Preserve, Alaska
View of Mount McKinley somewhat obscured by clouds.

ABOVE: Mount Rainier National Park, Washington
Detail of wildflower.

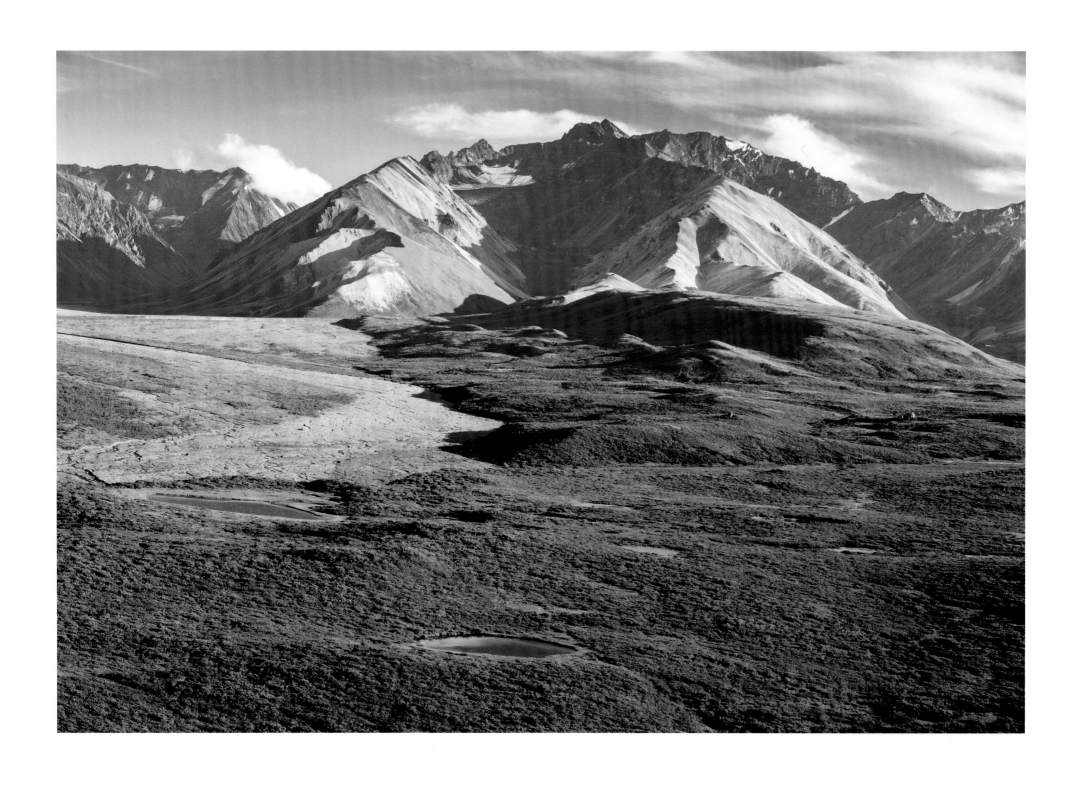

Denali National Park and Preserve, Alaska
Pools of water formed from chunks of melted glacial ice are visible in the foreground in this landscape shot taken from Polychrome Pass.

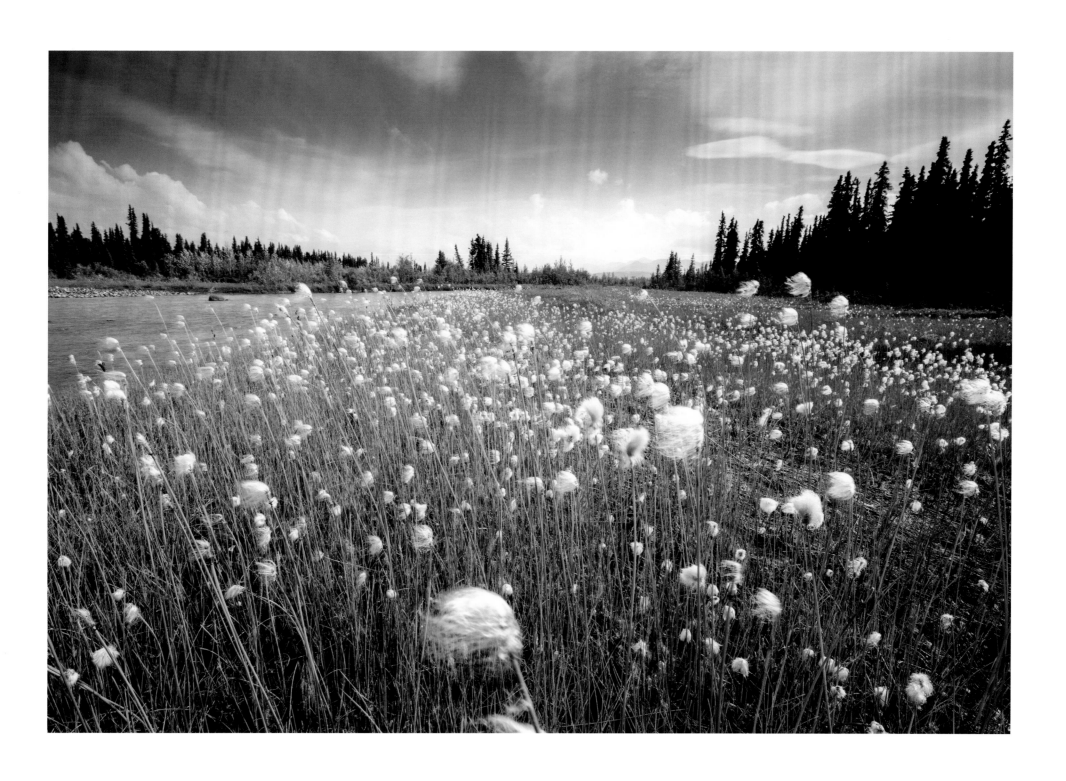

Denali National Park and Preserve, Alaska
Detail of wildflowers that are often seen around bodies of water in the park.

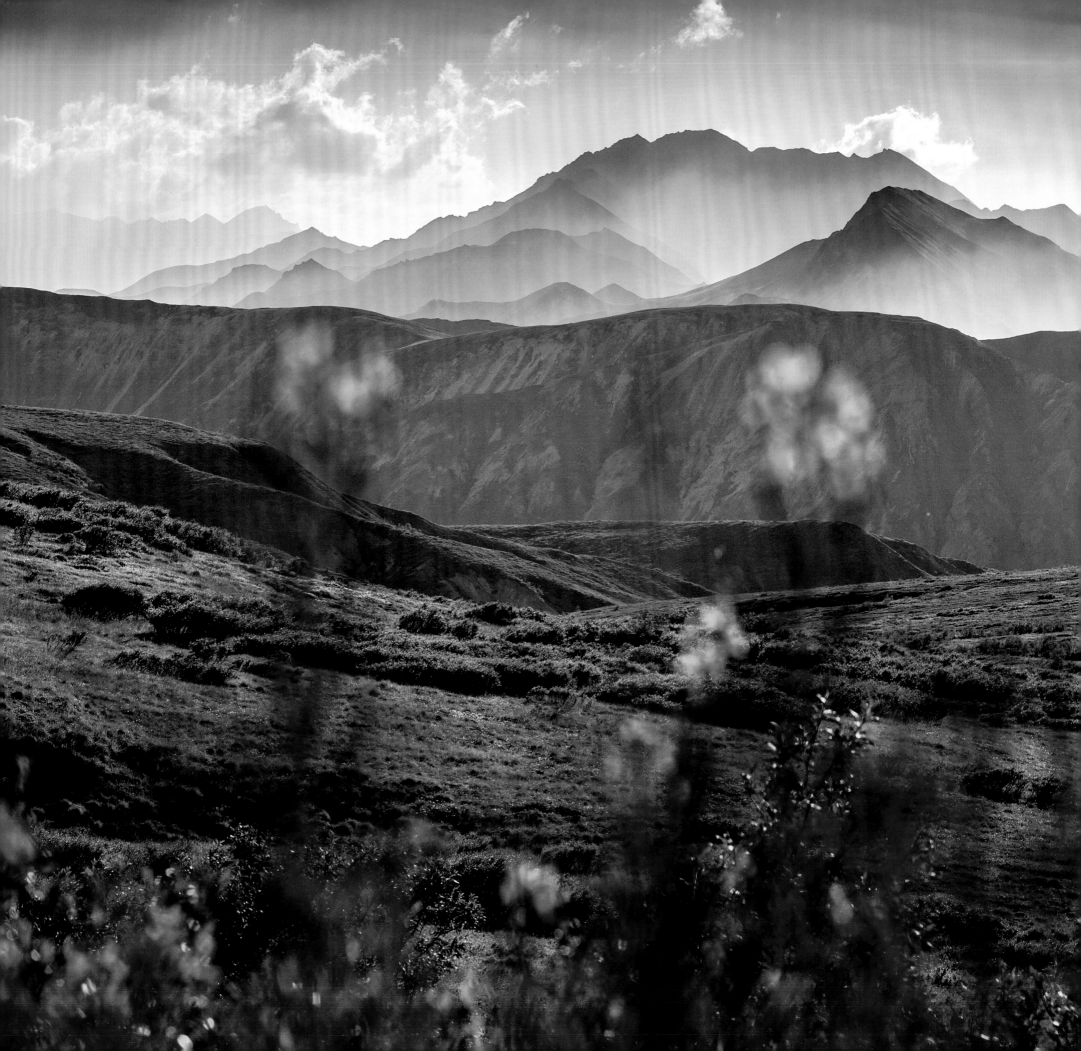

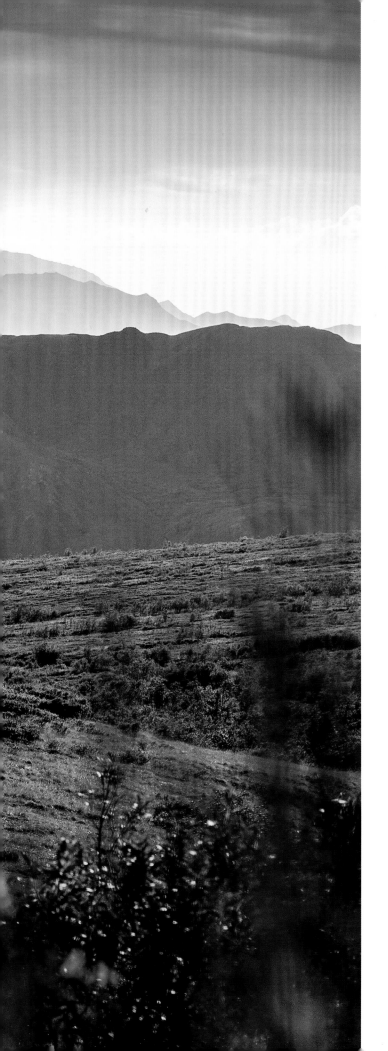

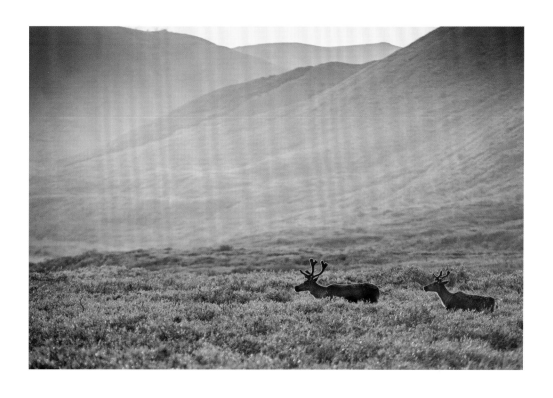

LEFT: Denali National Park and Preserve, Alaska
Scenic view of mountains and fireweed wildflowers inside the park.

ABOVE: Denali National Park and Preserve, Alaska
Caribou at last light in the tundra near Highway Pass along the park road.

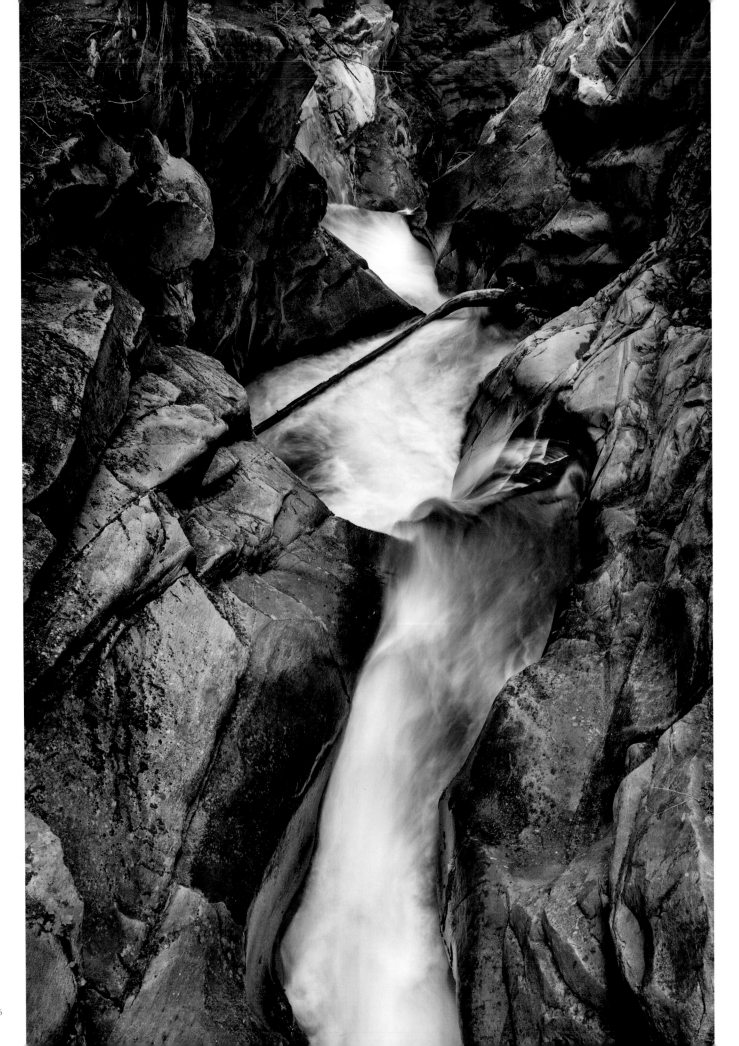

LEFT: Mount Rainier National Park, Washington
Waterfalls along the trail to Comet Falls.

OPPOSITE: Rocky Mountain National Park, Colorado
Emerald Lake.

156

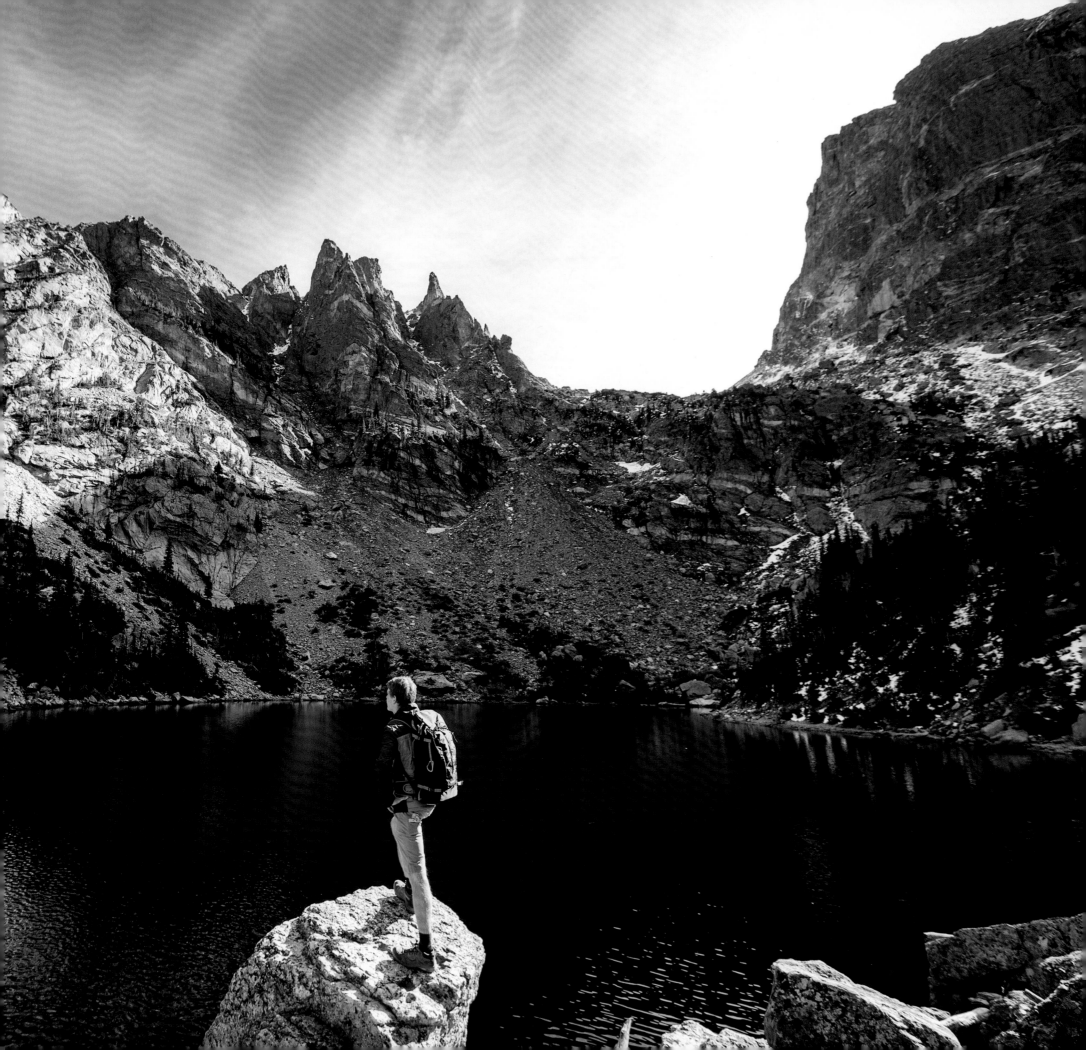

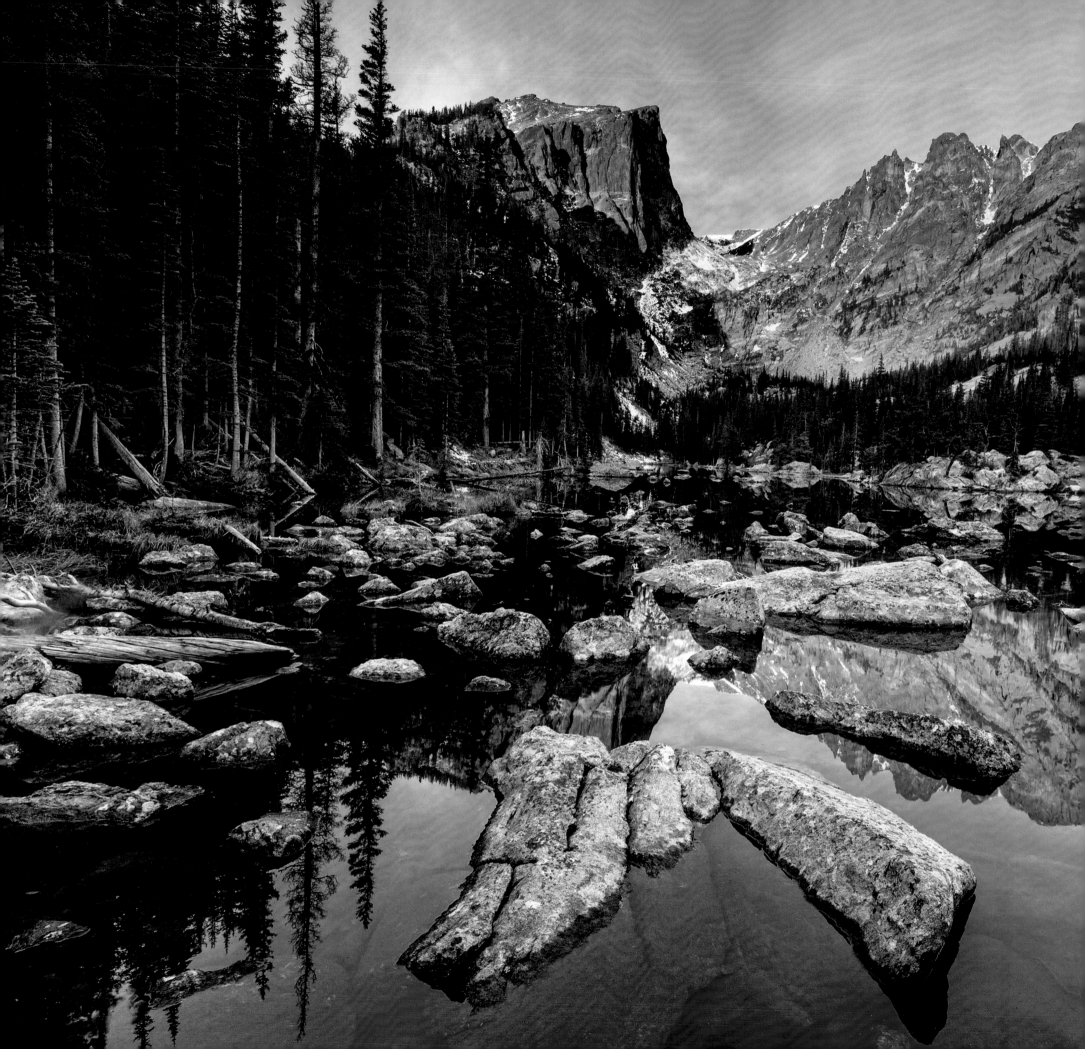

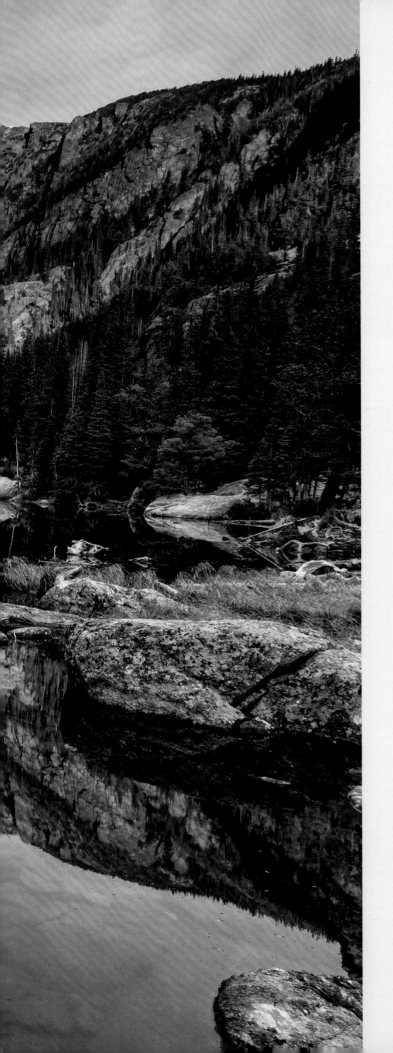

Rocky Mountain National Park, Colorado
Sunrise on Dream Lake.

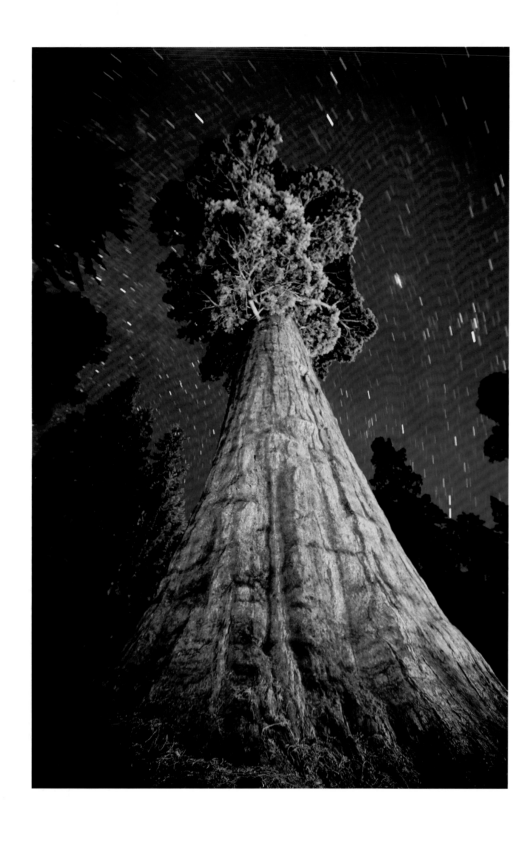

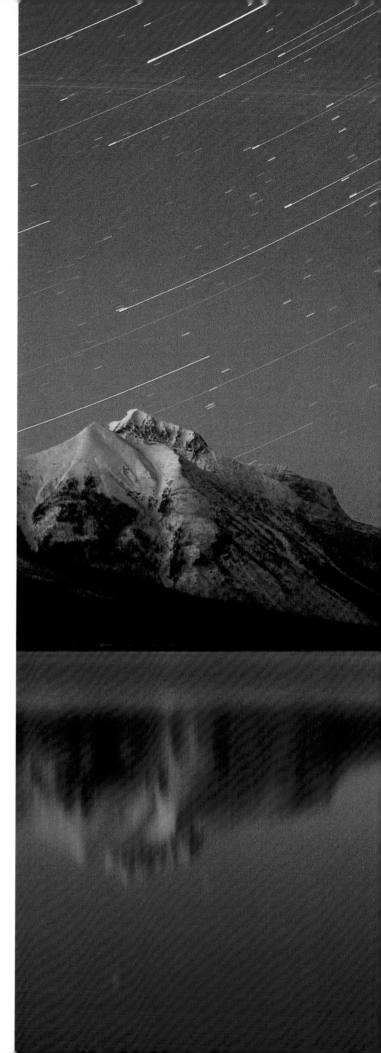

ABOVE: Sequoia National Park, California

RIGHT: Glacier National Park, Montana
Star trails over Lake McDonald in winter.

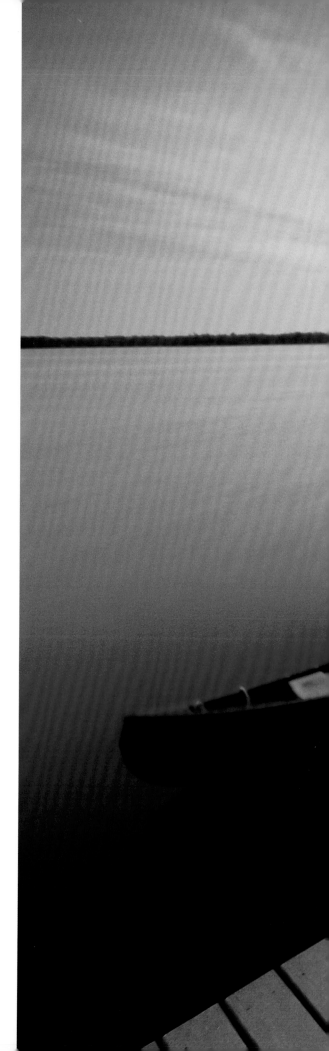

AMERICA'S EVERGLADES
The Largest Subtropical Wilderness in the United States

Everglades National Park is only a one-hour drive from the hustle and bustle of Miami, but the park encompasses 1.5 million acres of tropical and subtropical habitat and has one of the world's most diverse ecosystems.

Ecologically, the Everglades is a place, a marsh, a region, a watershed, an ecosystem. It is the mirrored glint of sunlight on shallow water that is moving slowly, beneath a great swath of saw grass, toward the sea. When Marjory Stoneman Douglas wrote her definitive description of the region in 1947, she used the metaphor "river of grass" to explain the blending of water and plant life. The Everglades is a vast watershed that has historically extended from Lake Okeechobee in central Florida one hundred miles south to Florida Bay (a distance that's about a third of the southern Florida peninsula). The greater Everglades watershed includes interconnected ecosystems of water, land, and climate spanning nearly eighteen thousand square miles. This is a large, diverse, and complex region including sixteen counties and stretching from Orlando in the north to the Florida Keys in the south. This enormous area supports mangrove forests, provides nursery and nesting conditions for many species of birds, fish, and invertebrates, and sustains plentiful sea grasses and aquatic life. This ecosystem also furnishes the drinking water supply for nearly eight million Floridians.

Lying at the interface between temperate and subtropical climates, the Everglades is recognized nationally and internationally for its wetland quality and biodiversity. When Congress passed a bill in 1947 to create Everglades National Park, it was the first time in history a park had been created solely for the preservation of animals and plants and the environment that sustains them. Everglades National Park was designated an International Biosphere Reserve in 1976, a World Heritage Site in 1979, a Wetland of International Importance in 1987, and a specially protected area under the Cartagena treaty in 2012.

Few places are as biologically rich as the Everglades, which host a vast array of plants and animals adapted to a wet, subtropical environment. Nearly forty-five species of mammals, hundreds of fish species, and thousands of invertebrates inhabit the Everglades and related bays, coastal estuaries, and offshore areas. More than fifty kinds of reptiles and twenty types of salamanders, frogs, and toads live in the watershed. An astonishing three hundred fifty species of birds have been recorded, sharing a home with alligators and the black bear. Sadly, seventy-five species are on the decline, including endangered species such as the Florida panther, the wood stork, and the West Indian manatee. The mix of salt and freshwater makes it the only place on Earth where alligators and crocodiles exist side by side.

Over one million visitors entered through the park's two entrance stations in 2014, but this doesn't include those who passed through the nearly five hundred thousand acres of surrounding water for marine-based recreation.

—The Everglades Foundation

Everglades National Park, Florida
A man stands on a chickee, deep in the Florida backcountry.

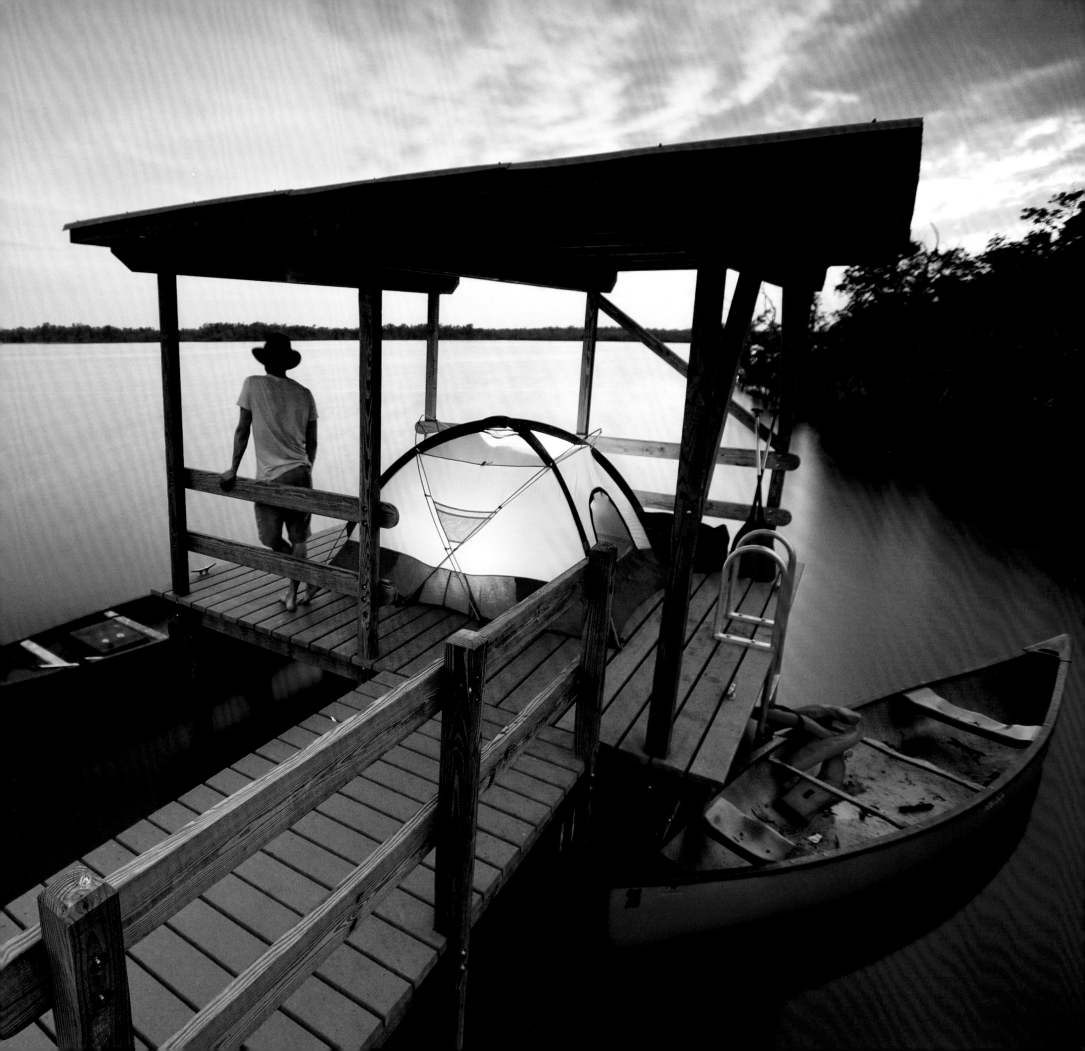

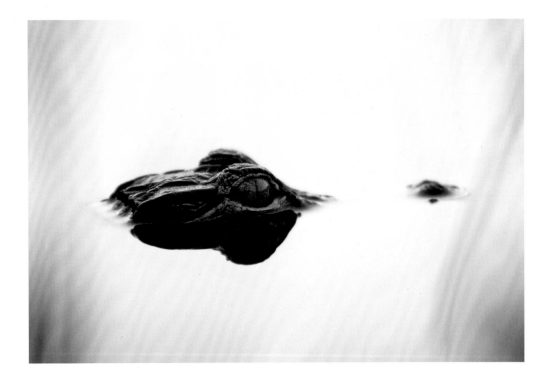

ABOVE: Everglades National Park, Florida
Juvenile alligator.

OPPOSITE: Everglades National Park, Florida

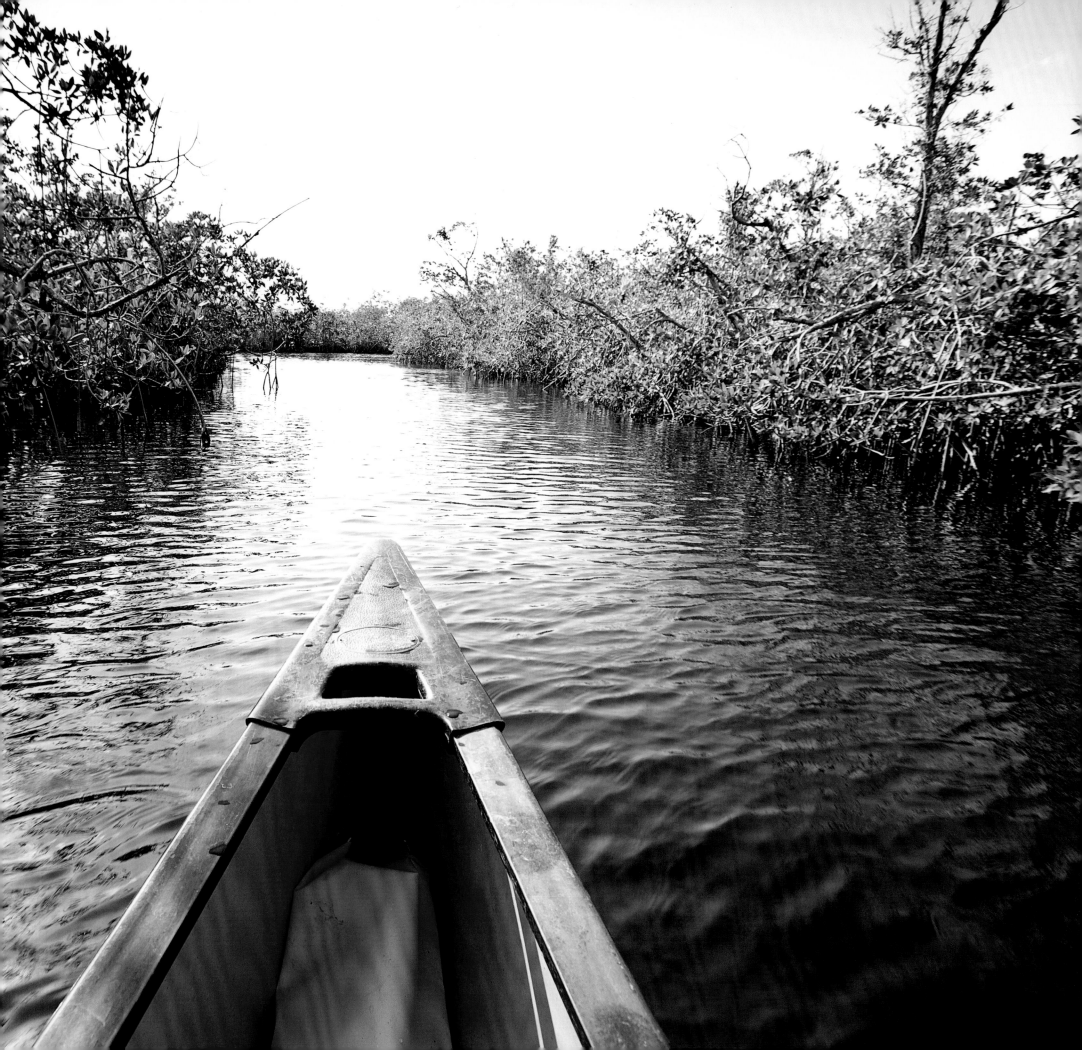

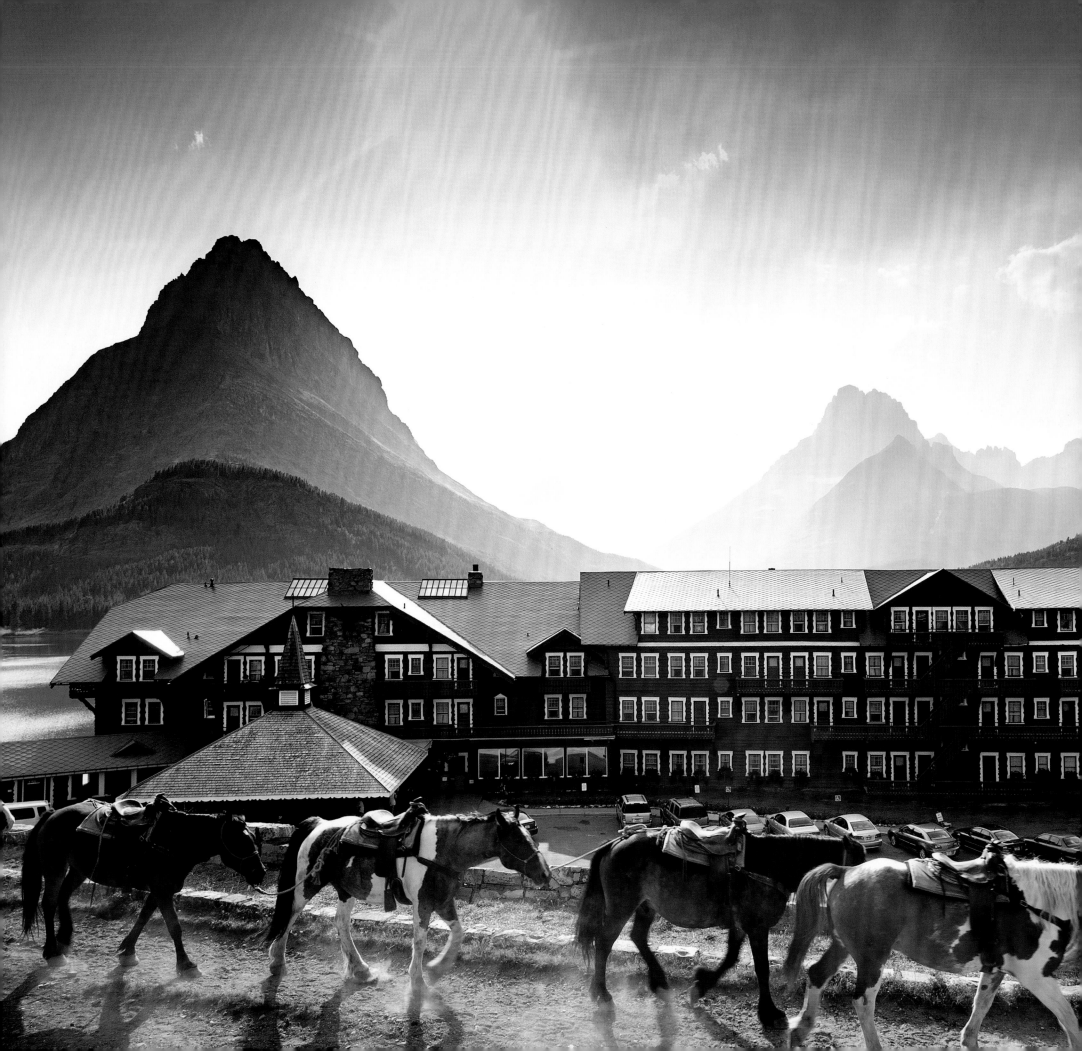

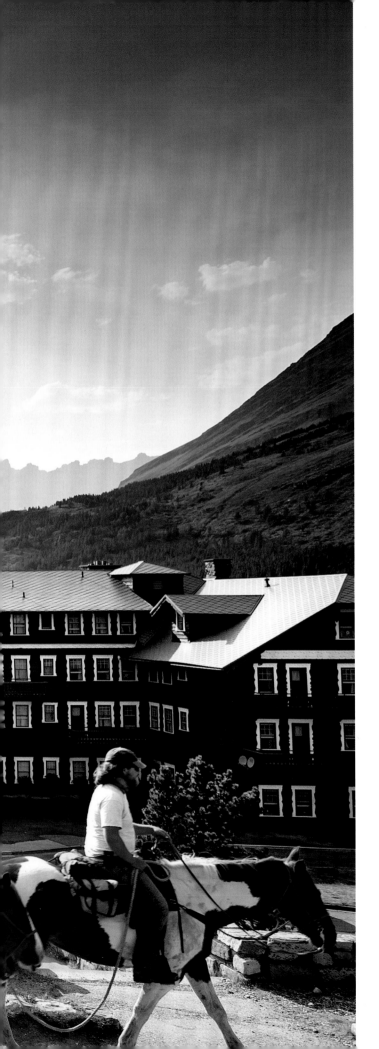

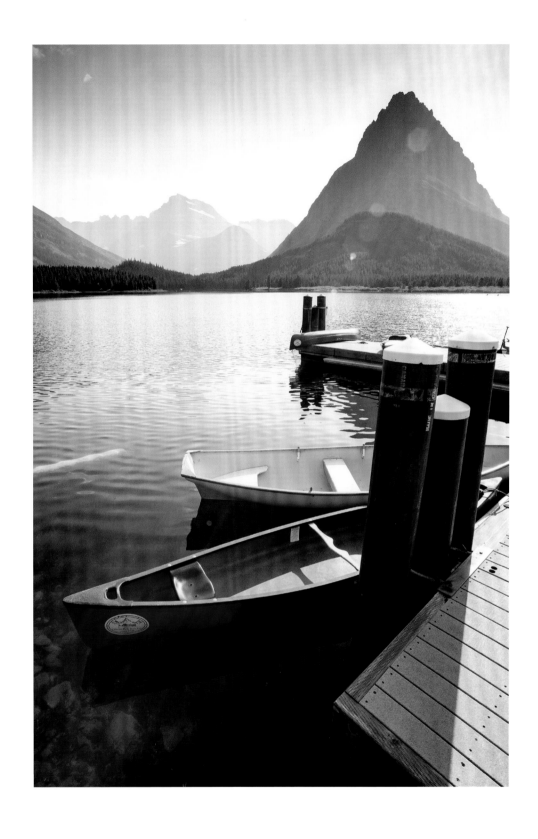

LEFT: Glacier National Park, Montana
Horse caravan and tour at Many Glacier Hotel.

ABOVE: Glacier National Park, Montana
Many Glacier area at sunset.

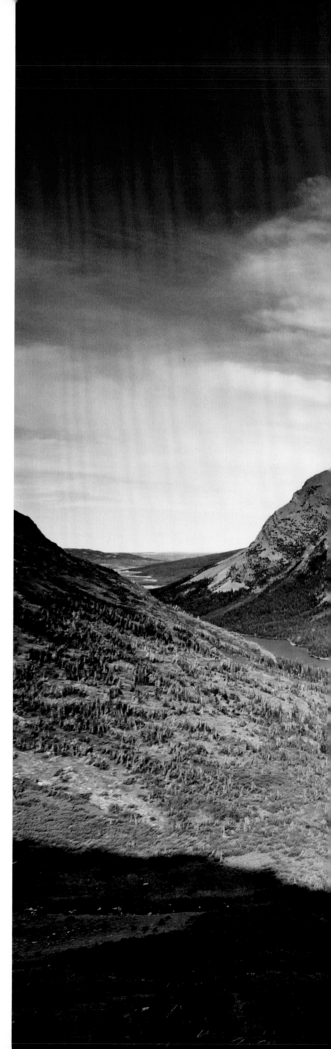

GLACIER NATIONAL PARK
The Backbone of the World

Since its establishment as the tenth national park in 1910, Glacier has awed visitors with its expansiveness and unique beauty. Sprawling over more than a million acres in the Northern Rocky Mountains, the park is composed of forests, alpine meadows, towering snowcapped peaks, lakes, and glacier-carved valleys. This diversity of habitat creates opportunities for a wide range of wildlife.

Glacier National Park is home to nearly seventy species of mammals, including elk, grizzly bears, wolverines, gray wolves, and lynx. Elk graze the prairies on the east side of the park, while the rarely seen northern bog lemming resides in the wet, coniferous forests of the park's west side.

Several wolf packs occupy the park, as does the largest grizzly bear population in the lower forty-eight states. The lynx is a seldom seen and majestic animal, while the park's mountain goats can be frequently spotted as they climb the steepest slopes of the Continental Divide, and the golden-mantled ground squirrel is a common site for those visiting the prairie meadows of Logan Pass. There are also more than two hundred sixty species of birds found in a variety of habitats throughout the park, including the colorful harlequin duck, which can be seen in the turbulent waters of McDonald Creek.

A variety of unique plant species abound as well, including thirty species that are endemic to the region—many of which are relics of the postglacial age—and grow exclusively in the Northern Rocky Mountains.

While the diverse flora and fauna of Glacier National Park are remarkable, most visitors are initially drawn by the scenery. Vertical, glacier-scoured mountains crown the horizon and stand sentinel to the turquoise lakes and streams, which are fed by melting snowpack; dense, ancient forests rise up to the snowy tree line; and vast prairies, often colored by wildflowers in the spring, sprawl beneath the impressive mountain peaks.

Visually stunning, the Glacier National Park experience is further enriched by interaction. With more than 747 miles of trails, Glacier offers visitors a chance to explore and experience the park's wildlands, historic homestead sites, ever-changing landscapes, Native American history, alpine meadows, and glacially carved valleys.

The experience of Glacier is awe inspiring and often leaves visitors with a feeling that there exists in these wild spaces something much bigger and more profound than oneself—a feeling that is at once humbling and invigorating. It also leaves visitors with an understanding of how important it is to preserve the natural landscape of Glacier—a national treasure that Native Americans appropriately called the "backbone of the world."

—Glacier National Park Conservancy

Glacier National Park, Montana
Silhouette of a man standing on a ridge looking over Lower Grinnell Lake along the Grinnell Glacier Trail.

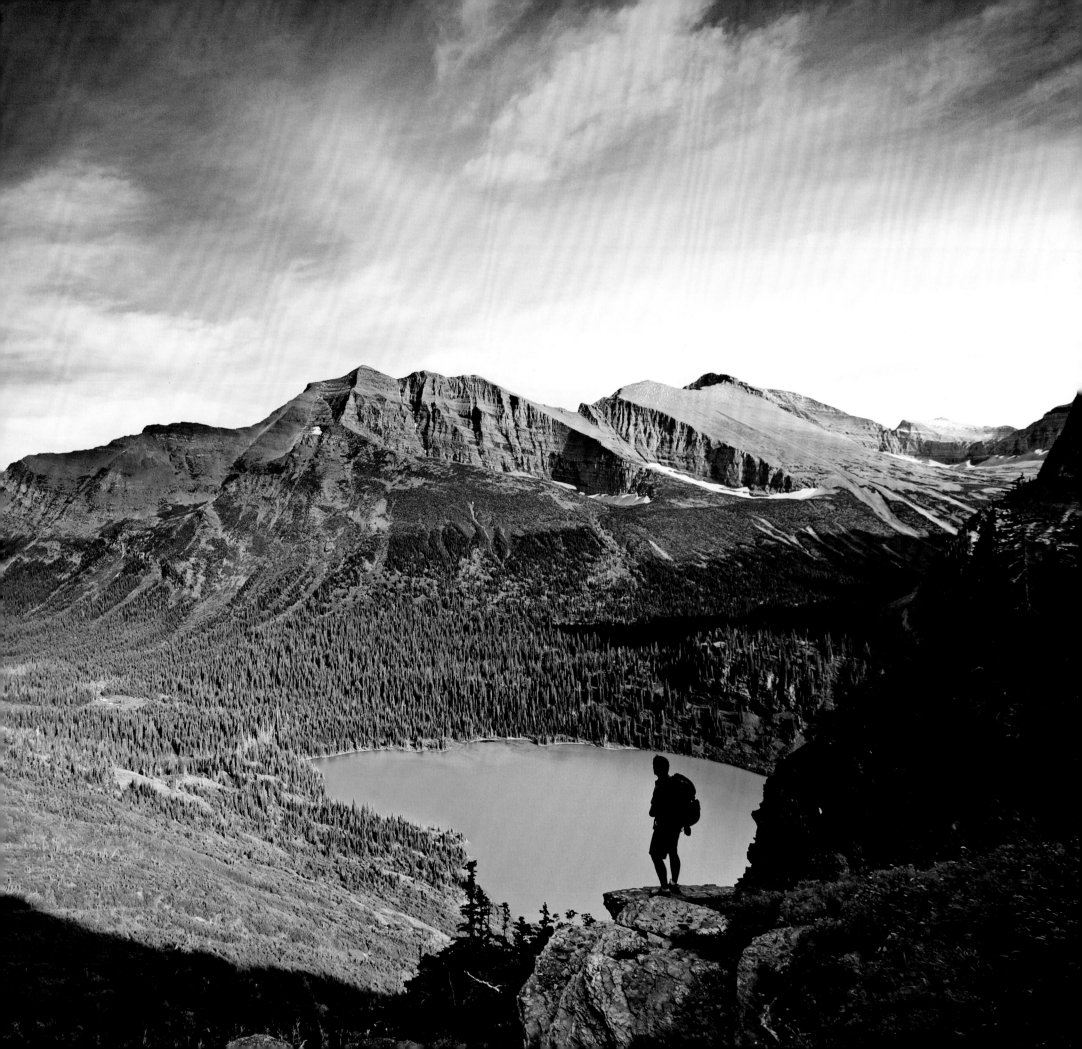

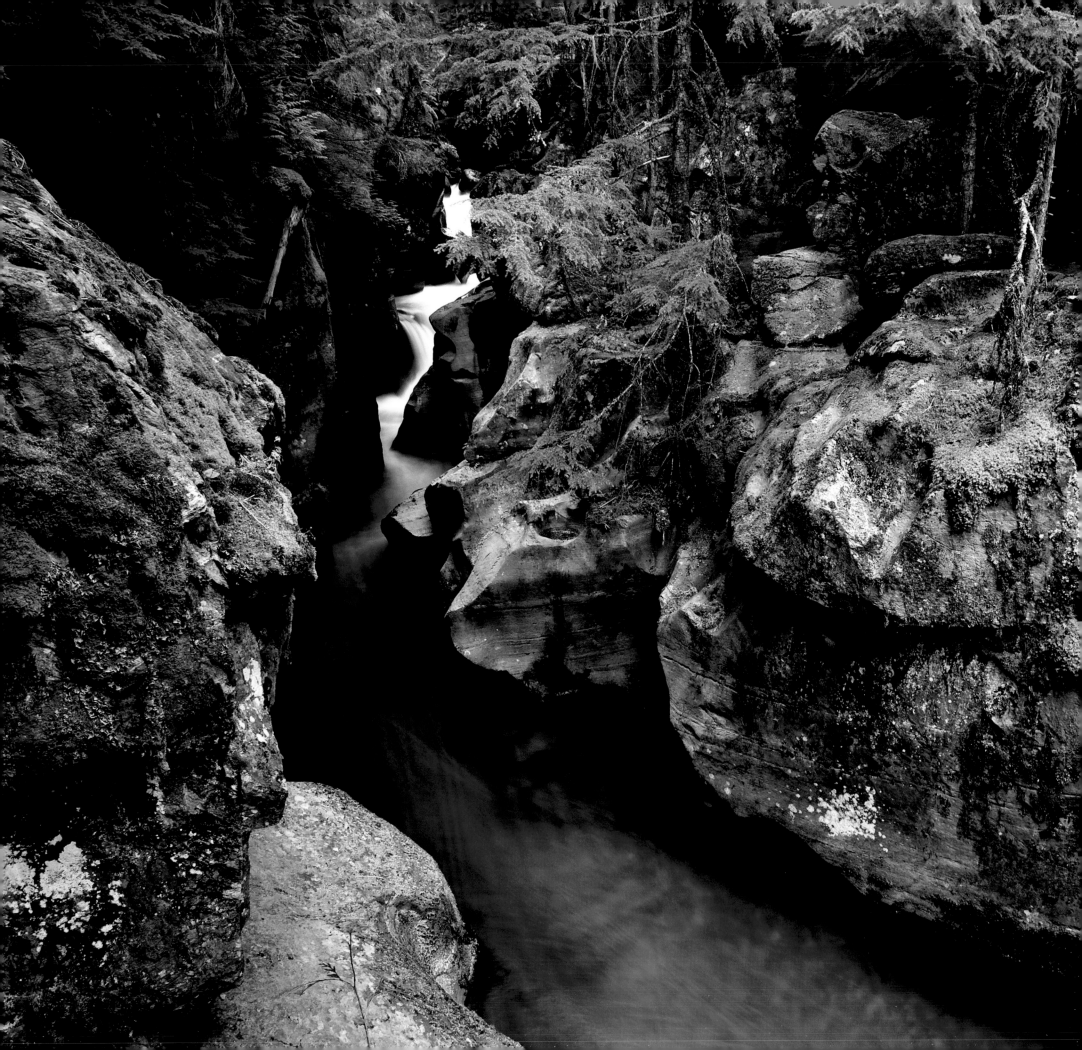

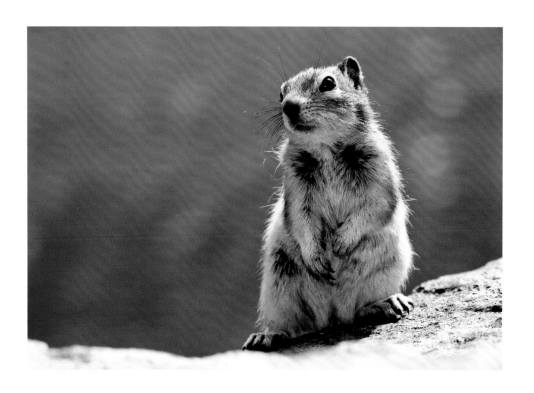

LEFT: Glacier National Park, Montana
Avalanche Creek.

ABOVE: Glacier National Park, Montana
Portrait of a golden-mantled ground squirrel
(Callospermophilus lateralis).

171

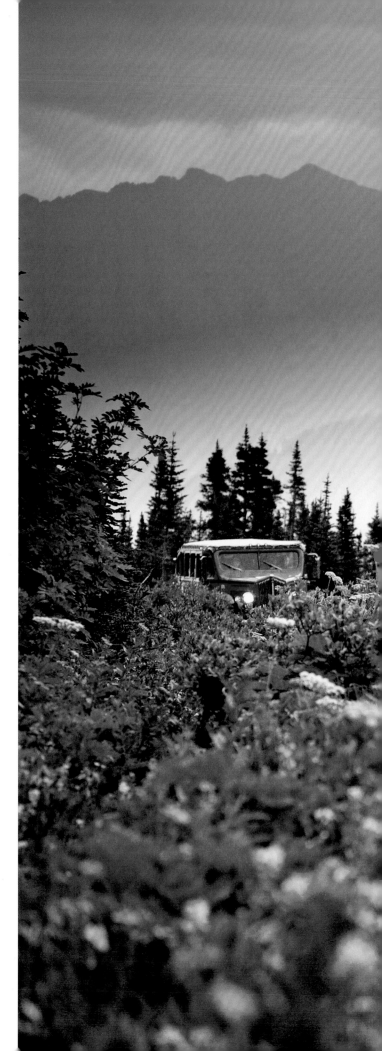

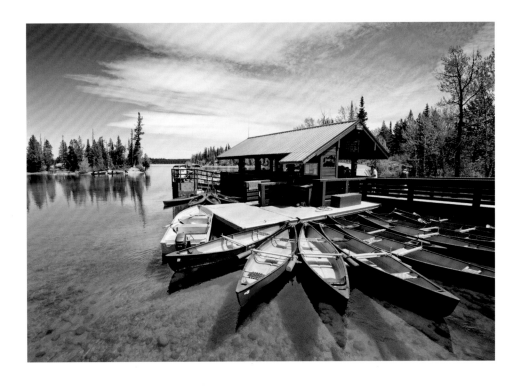

ABOVE: Grand Teton National Park, Wyoming
Jenny Lake.

RIGHT: Glacier National Park, Montana
*The distinctive red motor coaches are a popular
way for visitors to enjoy the park.*

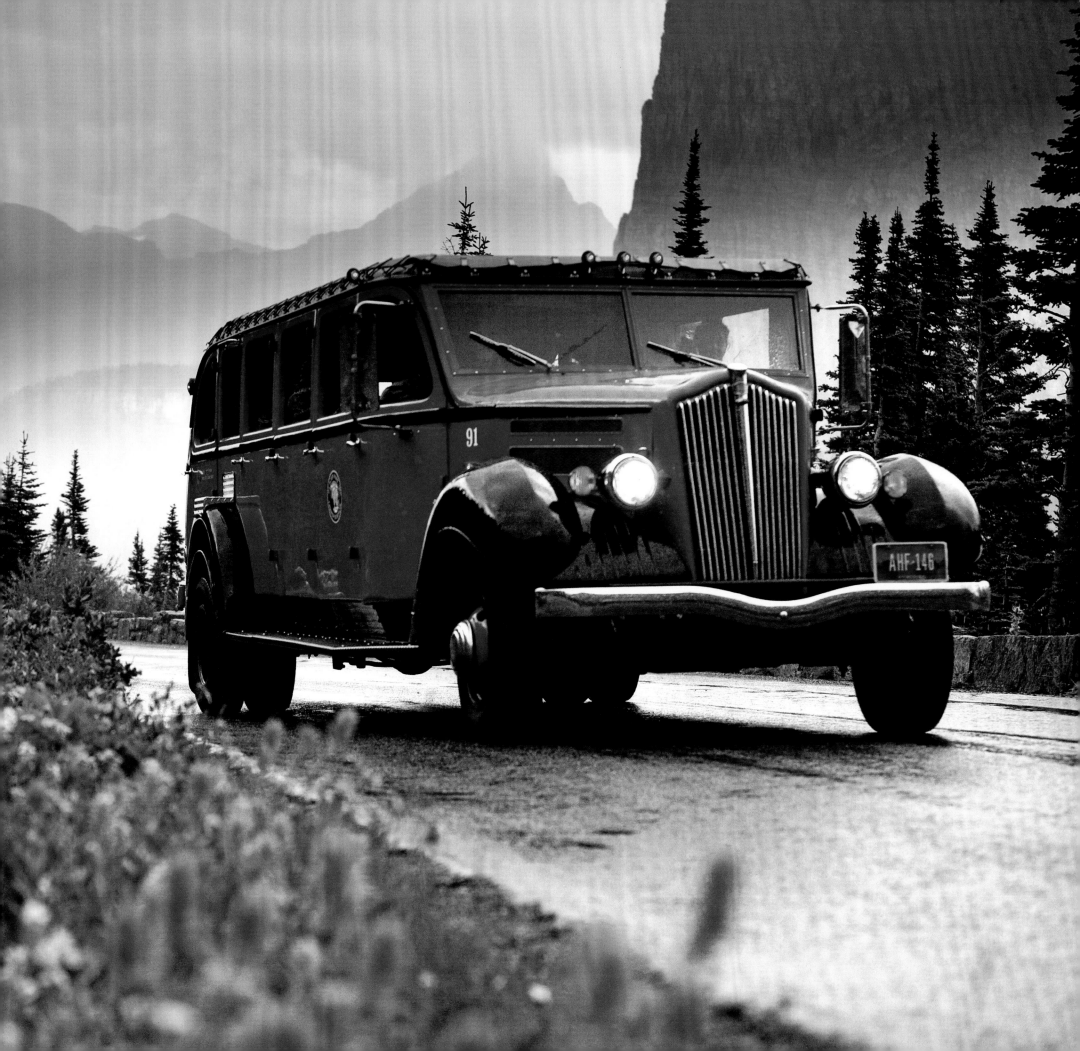

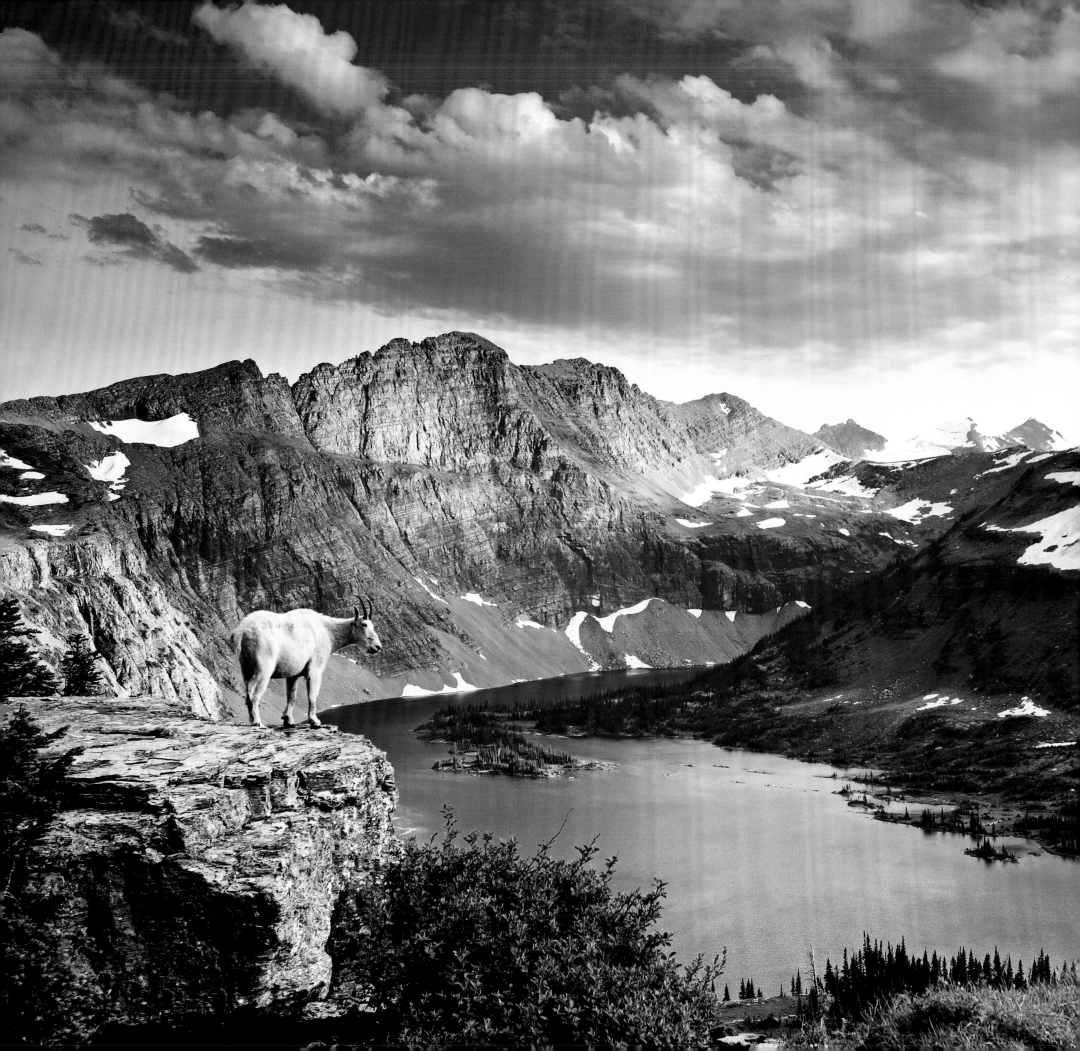

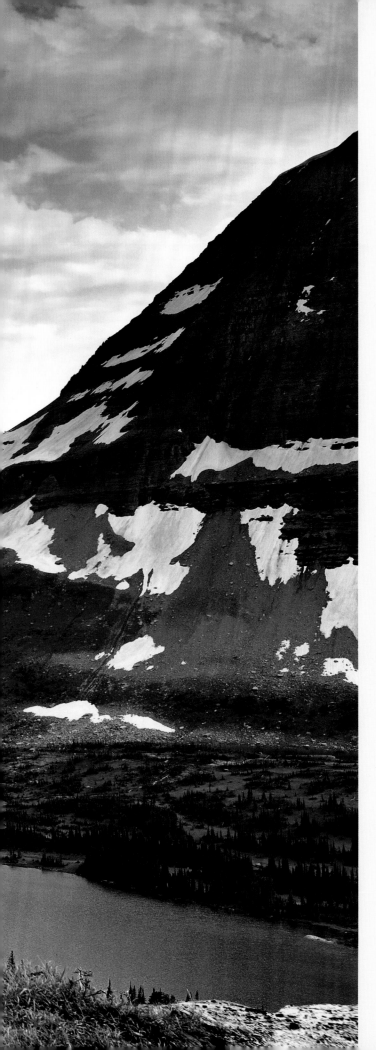

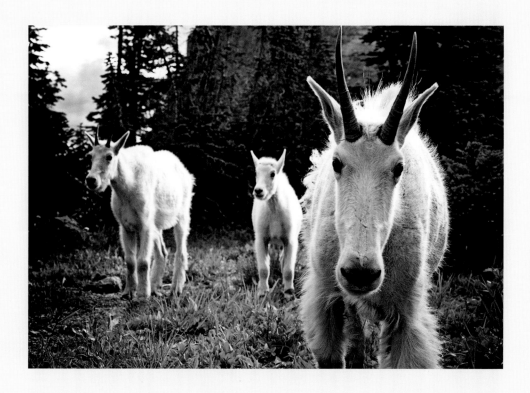

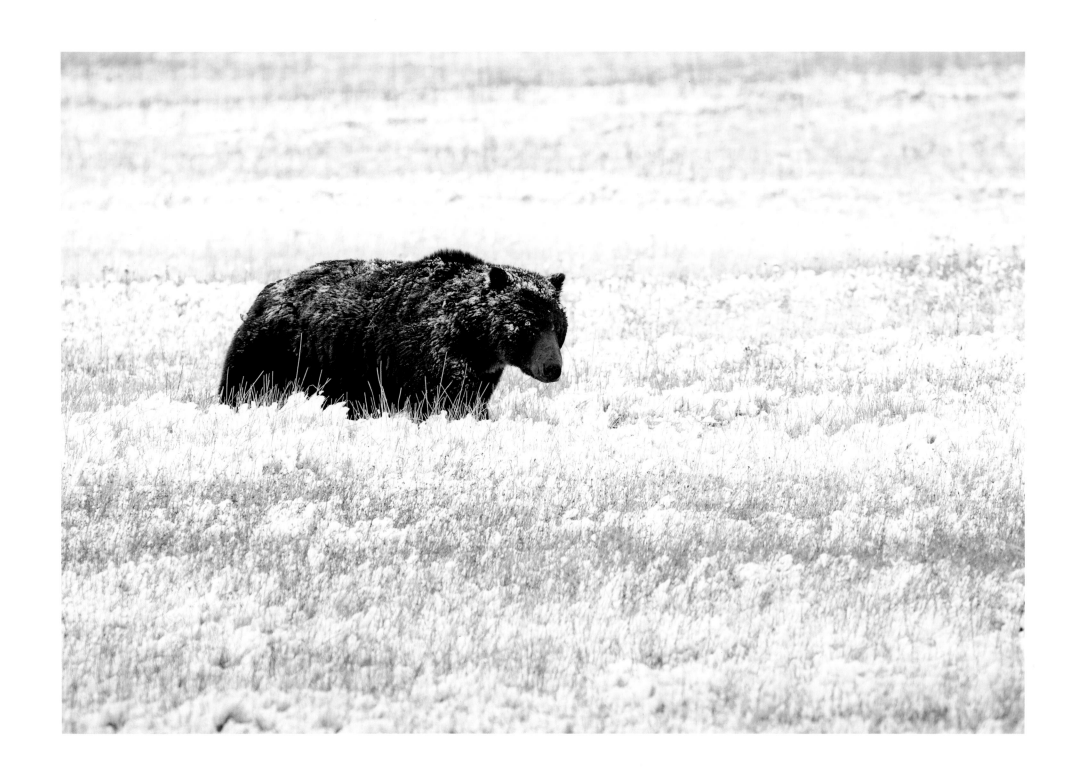

Yellowstone National Park; Idaho, Montana, Wyoming
A grizzly bear (Ursus arctos) *in an autumn snowstorm.*

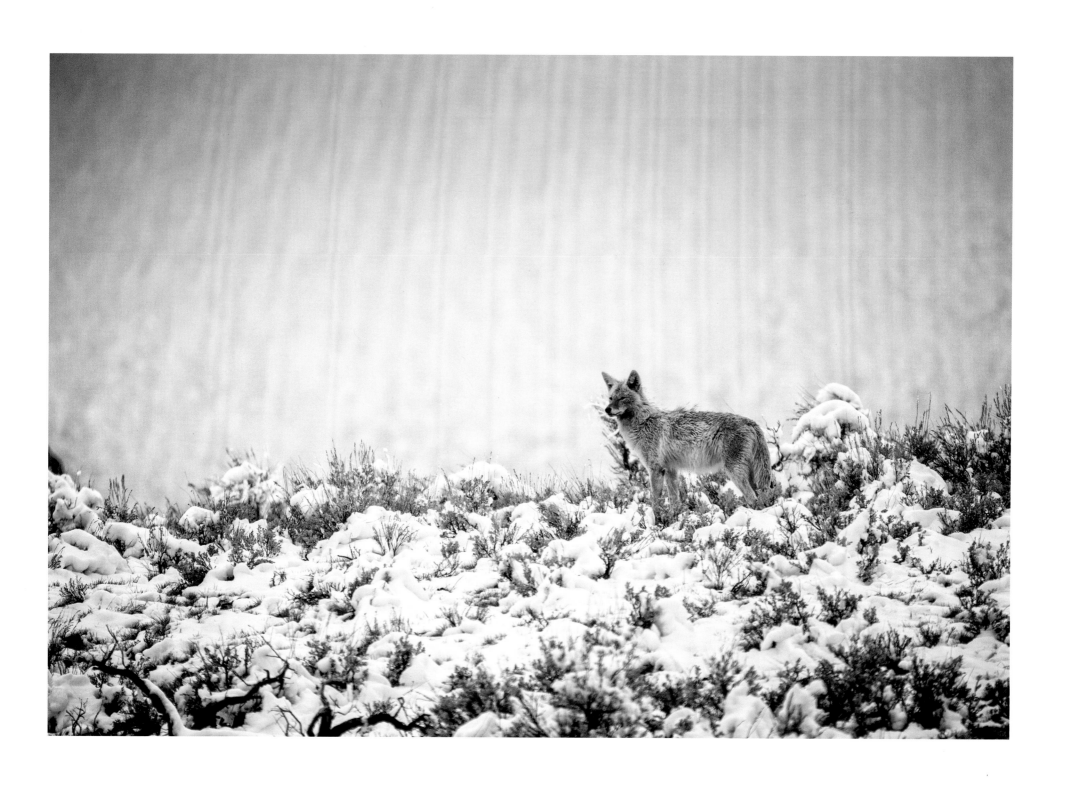

Yellowstone National Park; Idaho, Montana, Wyoming
Coyote (Canis latrans).

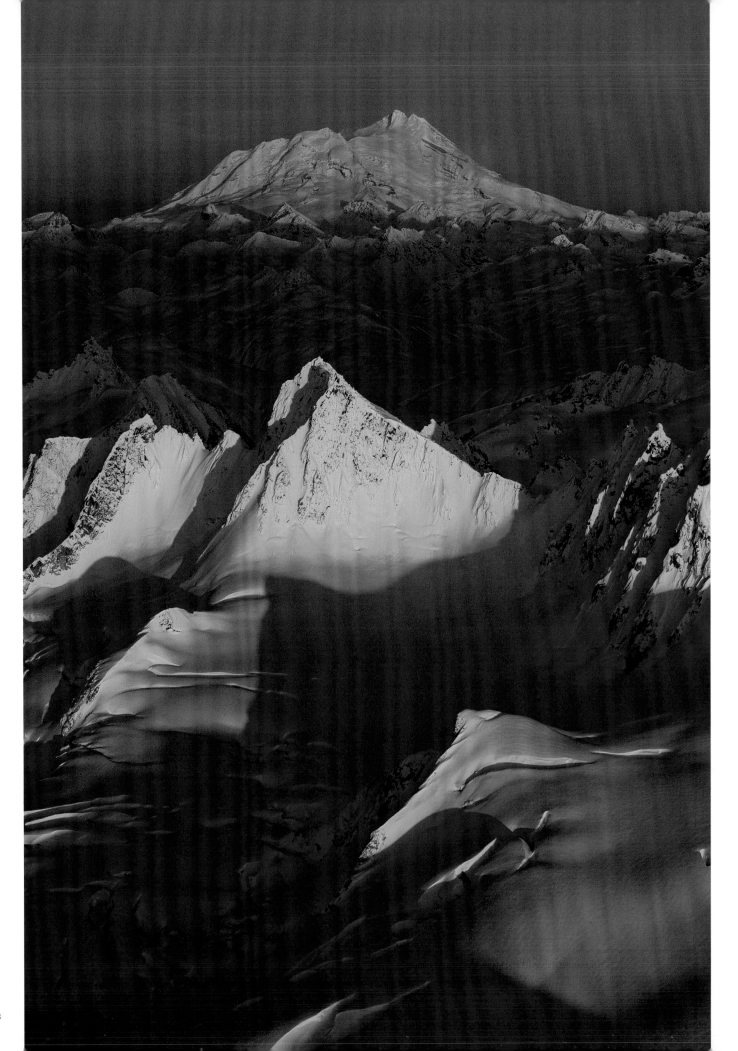

LEFT AND OPPOSITE: Lake Clark
National Park and Preserve, Alaska
Aerial view in mid-winter.

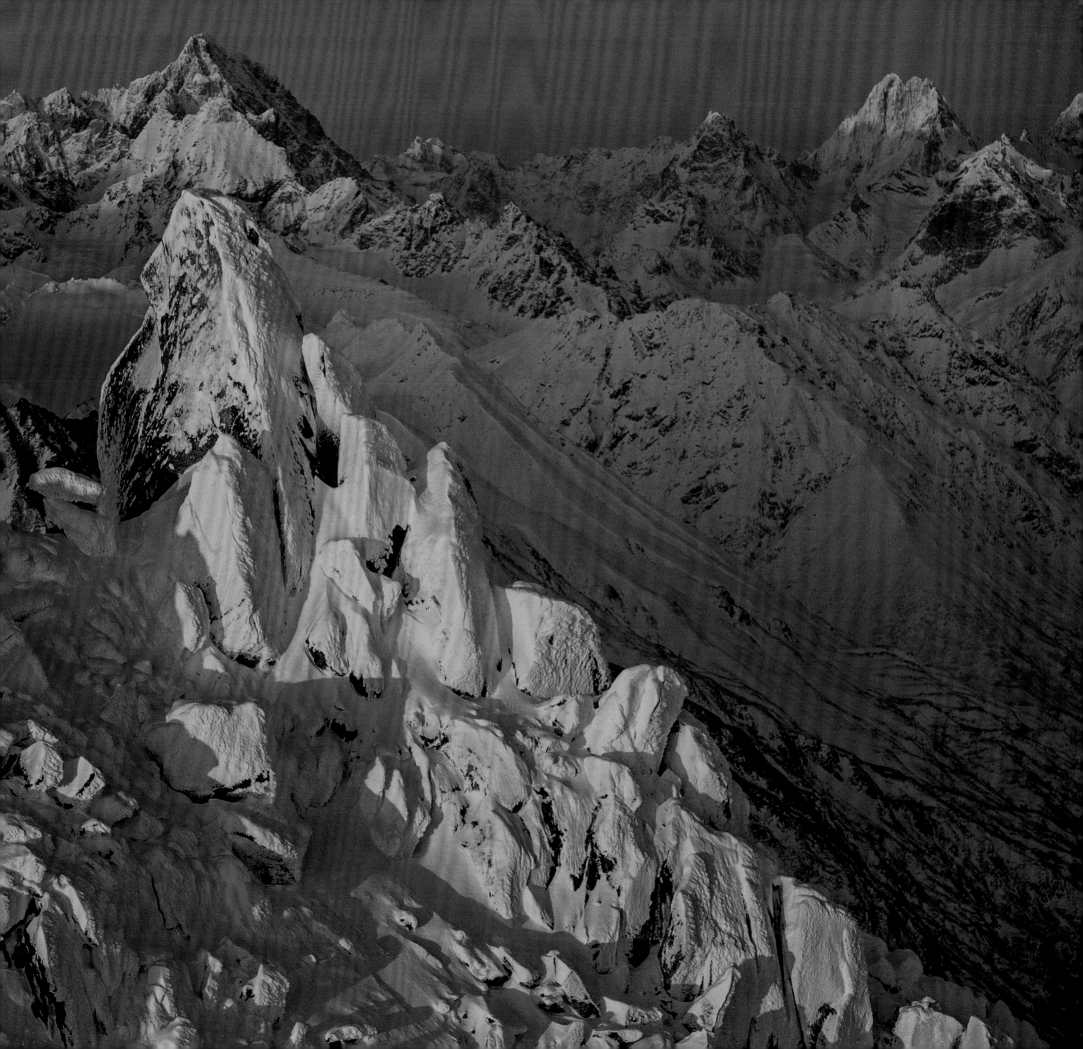

GRAND TETON NATIONAL PARK

Grand Teton National Park, a 310,000-acre marvel of geology, natural history, and cultural preservation tucked into the northwestern corner of Wyoming, is best known for its craggy skyline formed approximately ten million years ago. This land has been a magnet for human activity for thousands of years, and today it continues to inspire us with breathtaking scenery, pine-scented breezes, and spiritual renewal.

Established as a national park in 1929 and expanded in 1950 after John D. Rockefeller Jr. gifted thirty-three thousand acres of private land to the government, Grand Teton continues to be one of America's top destinations, attracting more than four million visitors last year. Wildlife sightings are common here due to the park's architecture. Bisected by the Snake River, a narrow valley stretches along the base of the Teton Range, funneling charismatic species such as elk, bison, moose, and bear onto a diverse landscape. With the recovery of gray wolves and recolonization of the area by grizzlies, the park once again has a full complement of native predator and prey species, perpetuating a dynamic ecological system seldom rivaled in the natural world.

Biodiversity isn't Grand Teton's only draw. Recreation brings visitors with the promise of adventure on trails, rock, water, and ice. Elite athletes and casual sightseers alike find relatively quick access from the valley's sagebrush plain to the steep rock walls and hanging canyons of the mountains. Even those who aren't backcountry aficionados can be immersed in a wilderness experience just a short distance from the car.

For visitors who prefer history to hiking, Grand Teton's cultural offerings are worth the trip. The David T. Vernon Collection, gifted to the park by Laurance S. Rockefeller in 1972, is one of the most comprehensive Native American art and artifact collections in the world, representing more than one hundred tribes. A newly restored portion of this museum-class collection recently returned to Grand Teton for display. Old dude ranches, a ferry that shuttled settlers and tourists across the Snake River until the late 1920s, and the Lucas-Fabian cabins that sheltered a lone woman homesteader are a few of the structures that have survived to give a glimpse of the rugged living conditions of the past.

Many people don't realize that despite Grand Teton's ability to withstand harsh winters, spring melts, and millions of footsteps each year, it is actually quite fragile. Limited federal funding over the decades has resulted in a maintenance backlog and has left places like Jenny Lake, the park's most popular destination, in serious decline. Private support, however, is turning those challenges around. Grand Teton National Park Foundation, the park's primary fundraising partner, is injecting much-needed cash and partnerships for improvements, education, and outreach projects. Private gifts helped build the Craig Thomas Discovery and Visitor Center, a $25 million state-of-the-art facility that opened in 2007, and they continue to supplement wildlife research and protection projects as well as youth outreach each year. Most recently, donors are financing a $17 million restoration of the popular Jenny Lake area for the National Park Service centennial in 2016.

The Foundation builds upon Grand Teton's long conservation story and also spreads the message that private philanthropy is a necessary component of twenty-first-century national park support. At a time when interest in our park system is greater than ever, wilderness enthusiasts are aiding the evolution of Grand Teton and giving citizens both a voice and a way to partner with this special park to bring positive changes for the next one hundred years. It's an opportunity to ensure that future generations can experience the same sights, sounds, and feelings that first drew people to this place so long ago.

—Grand Teton National Park Foundation

Grand Teton National Park, Wyoming
Sunrise on the Tetons.

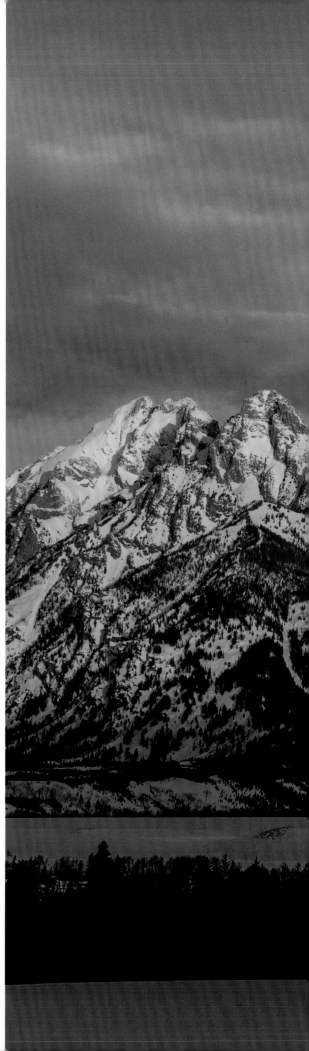

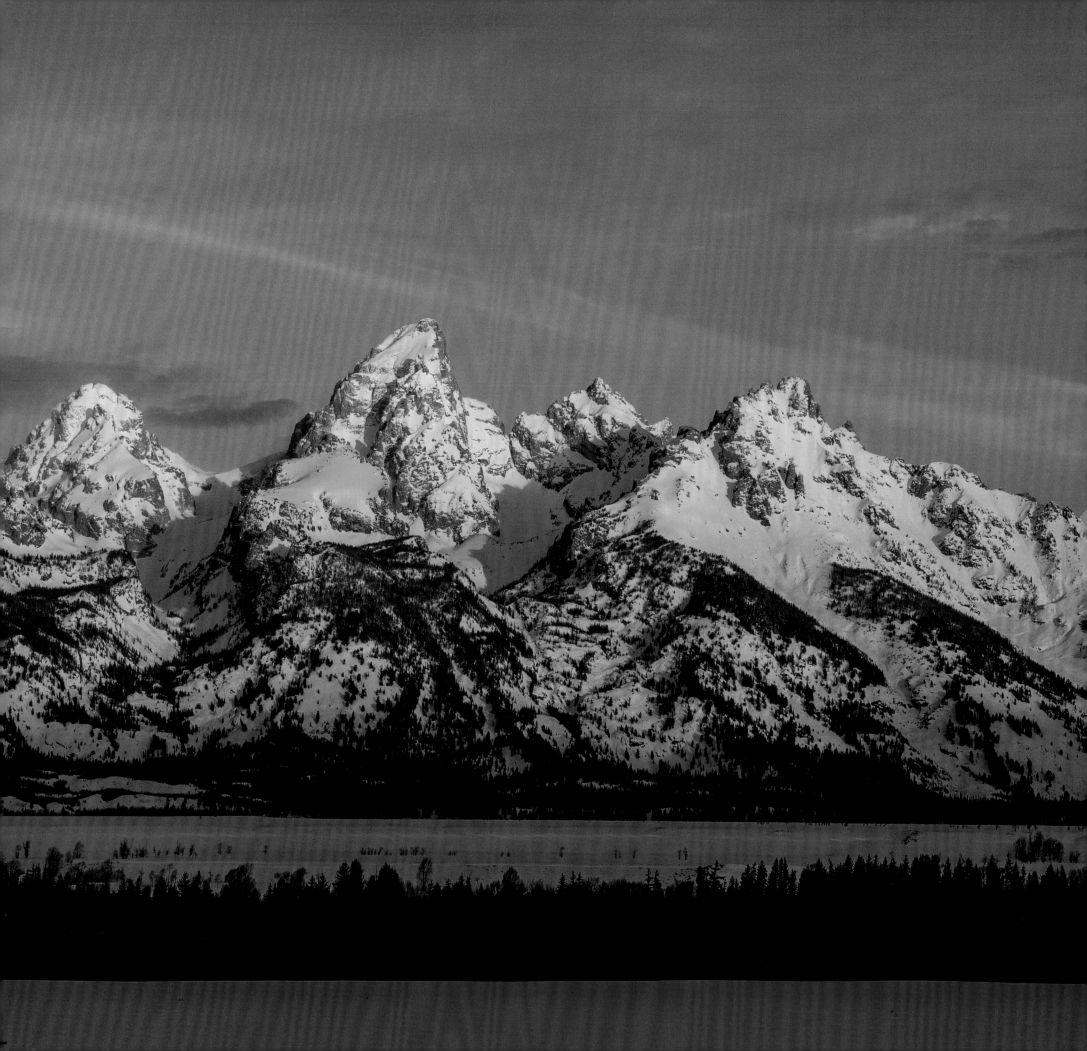

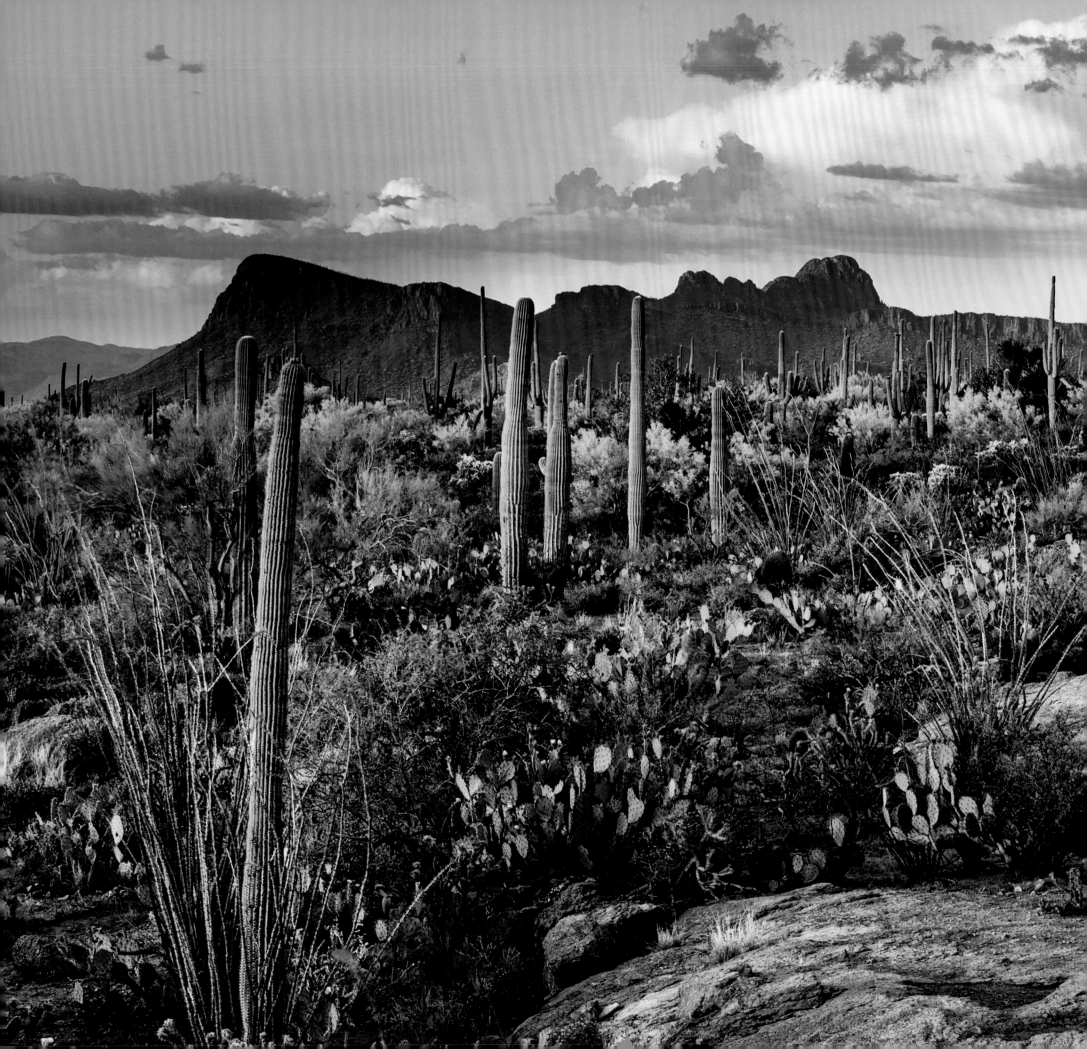

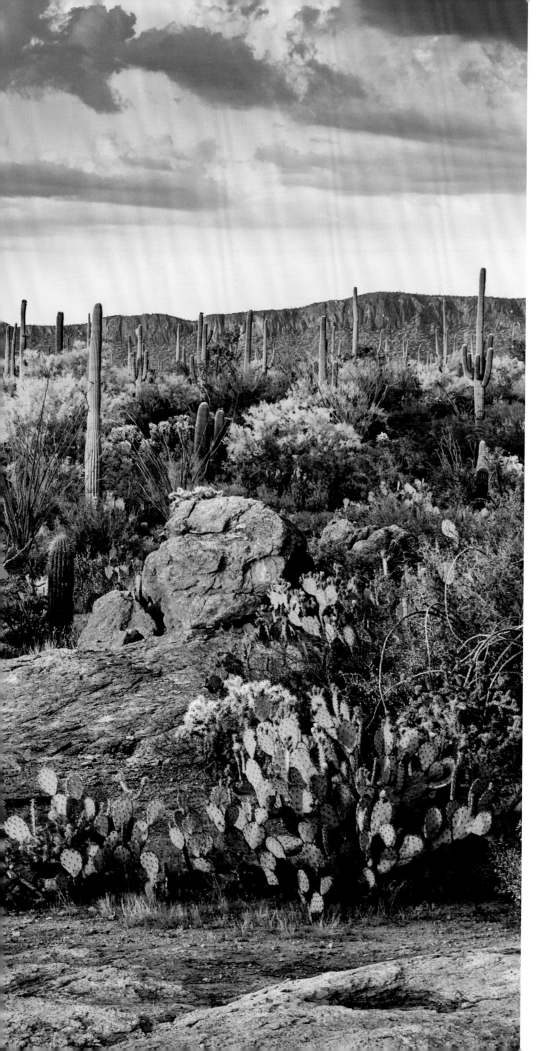

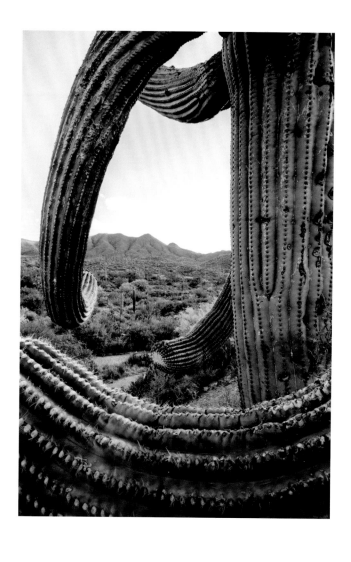

LEFT AND ABOVE: Saguaro National Park, Arizona

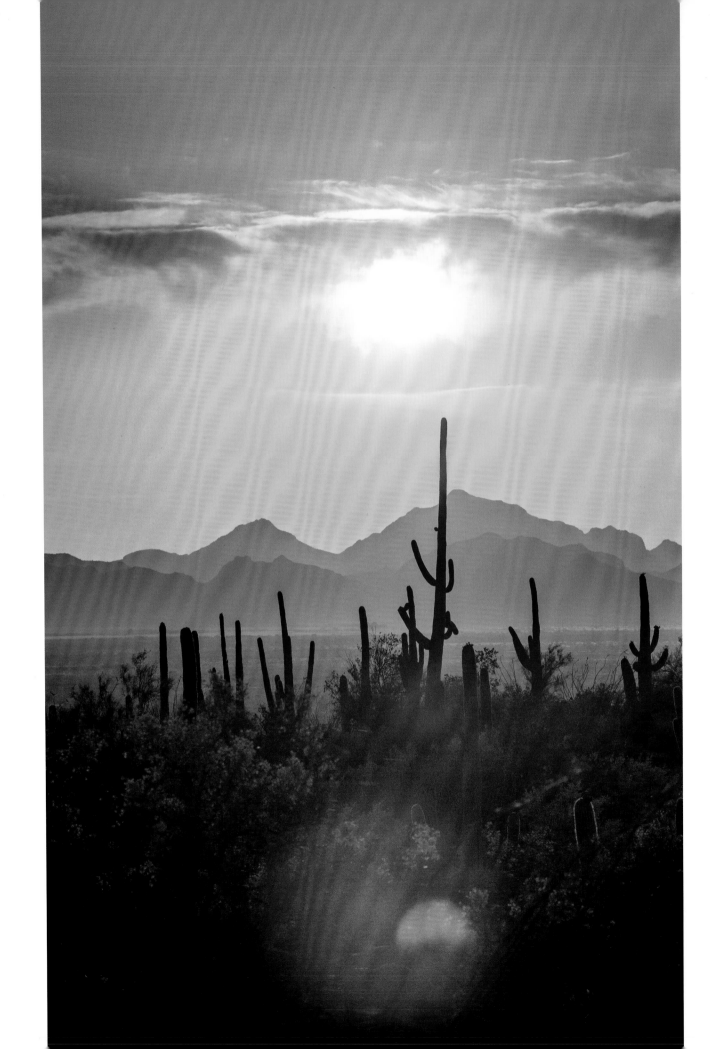

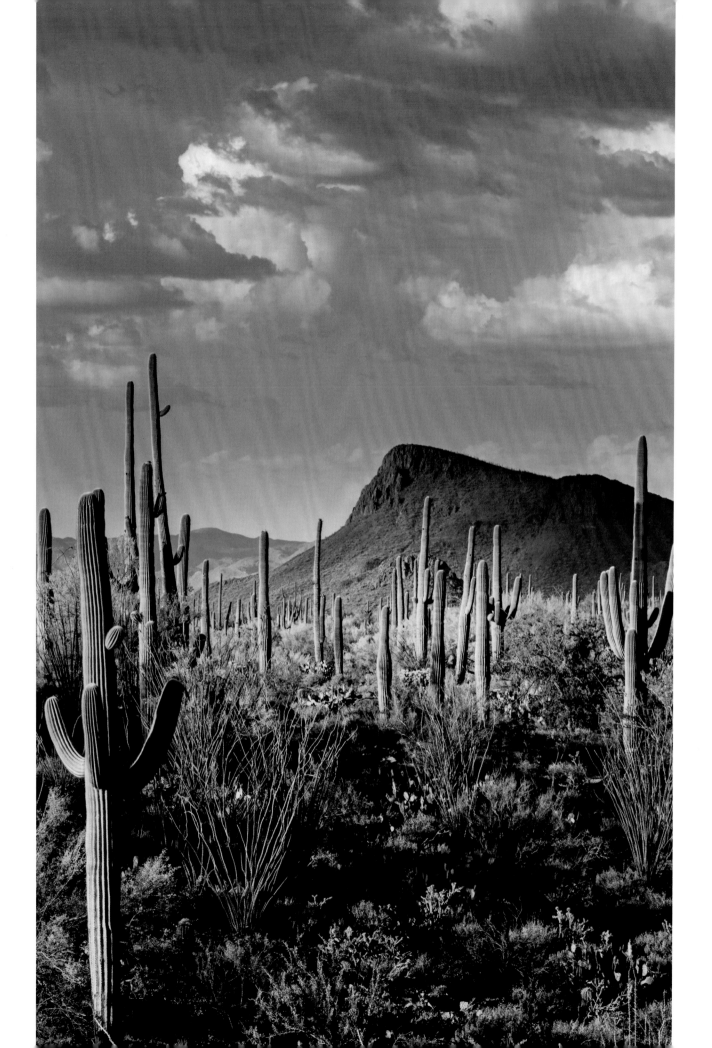

OPPOSITE AND LEFT:
Saguaro National Park, Arizona

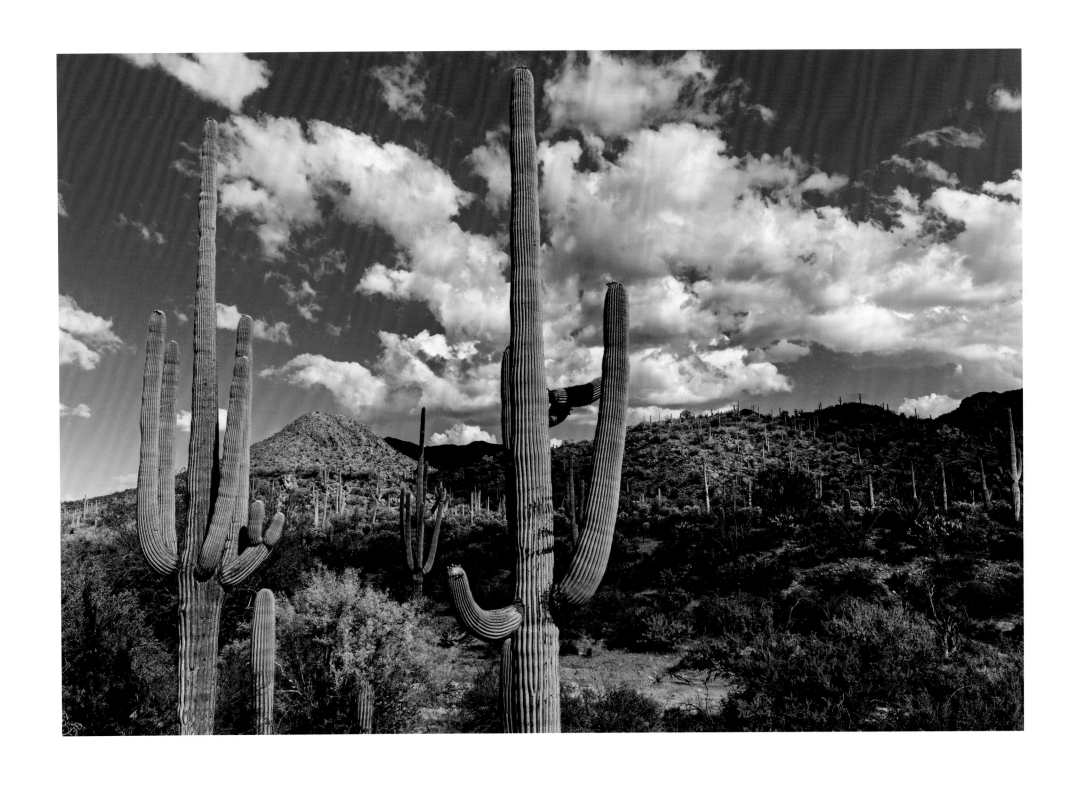

Saguaro National Park, Arizona

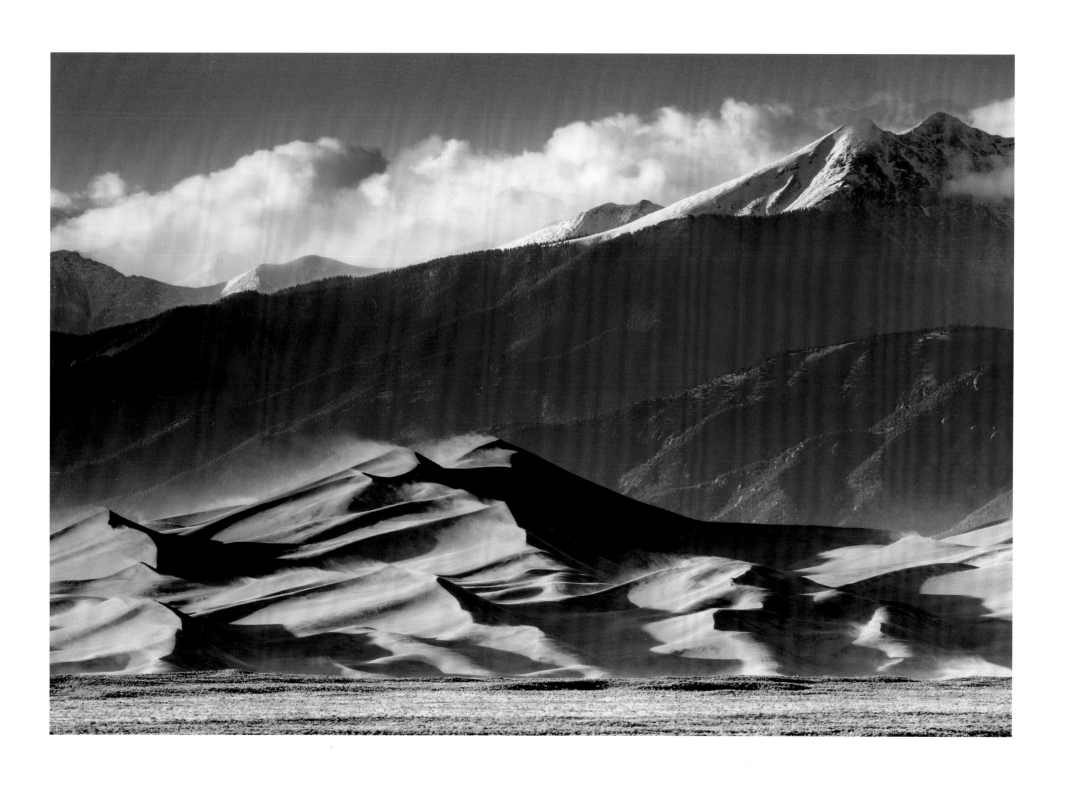

Great Sand Dunes National Park and Preserve, Colorado

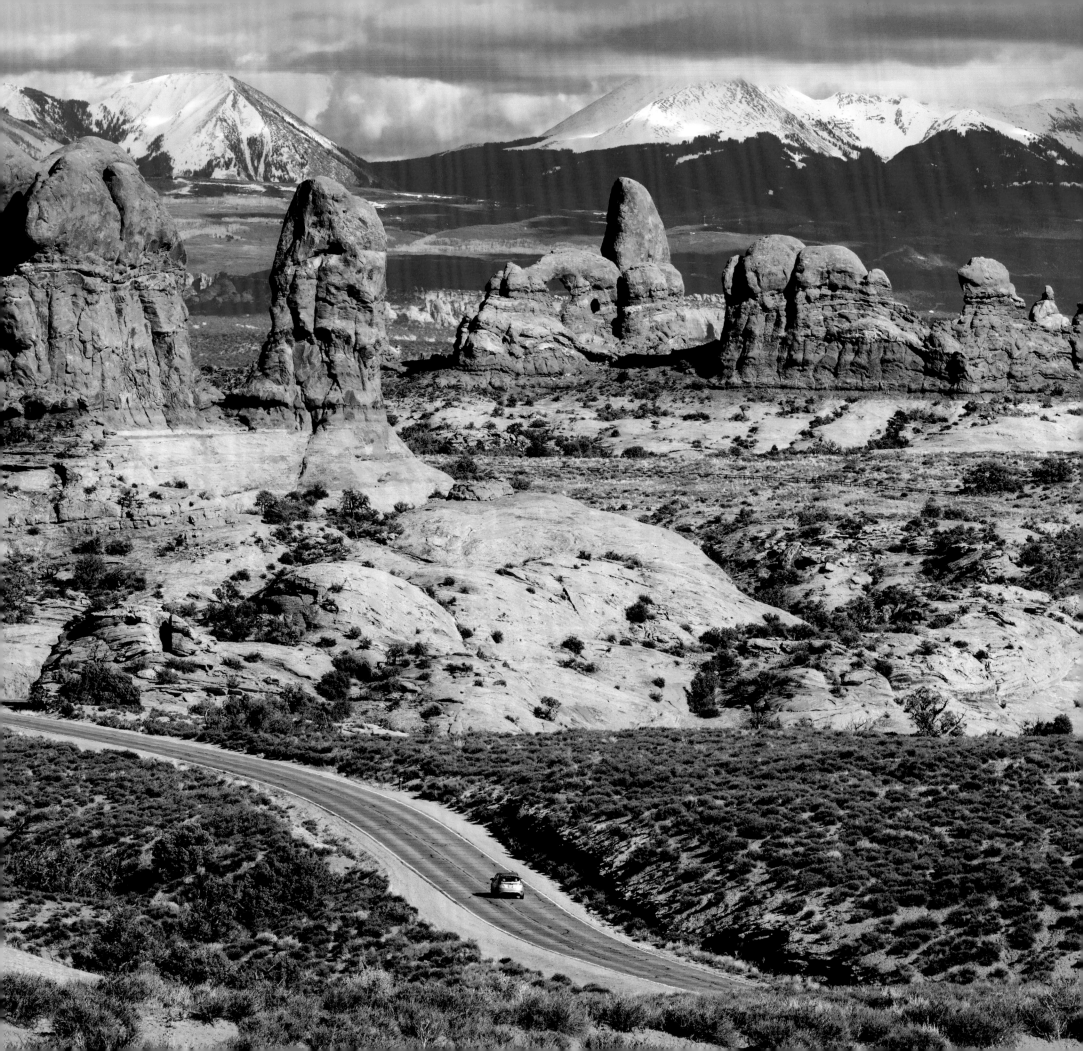

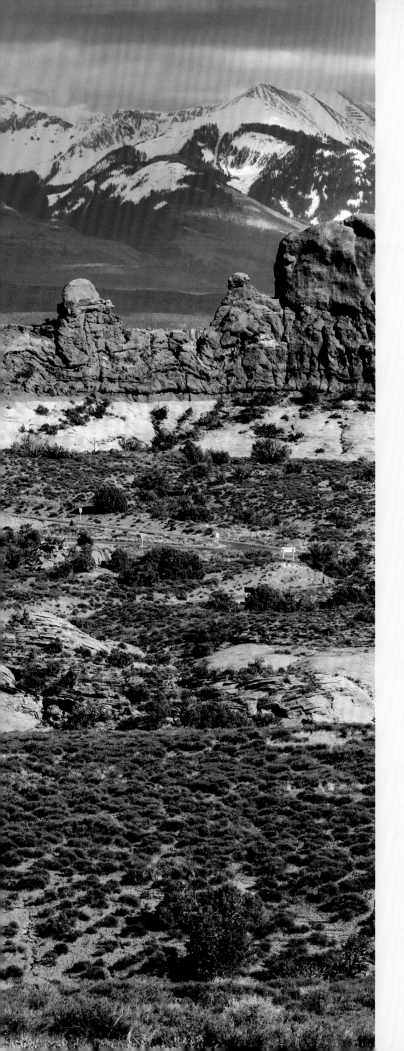

Arches National Park, Utah

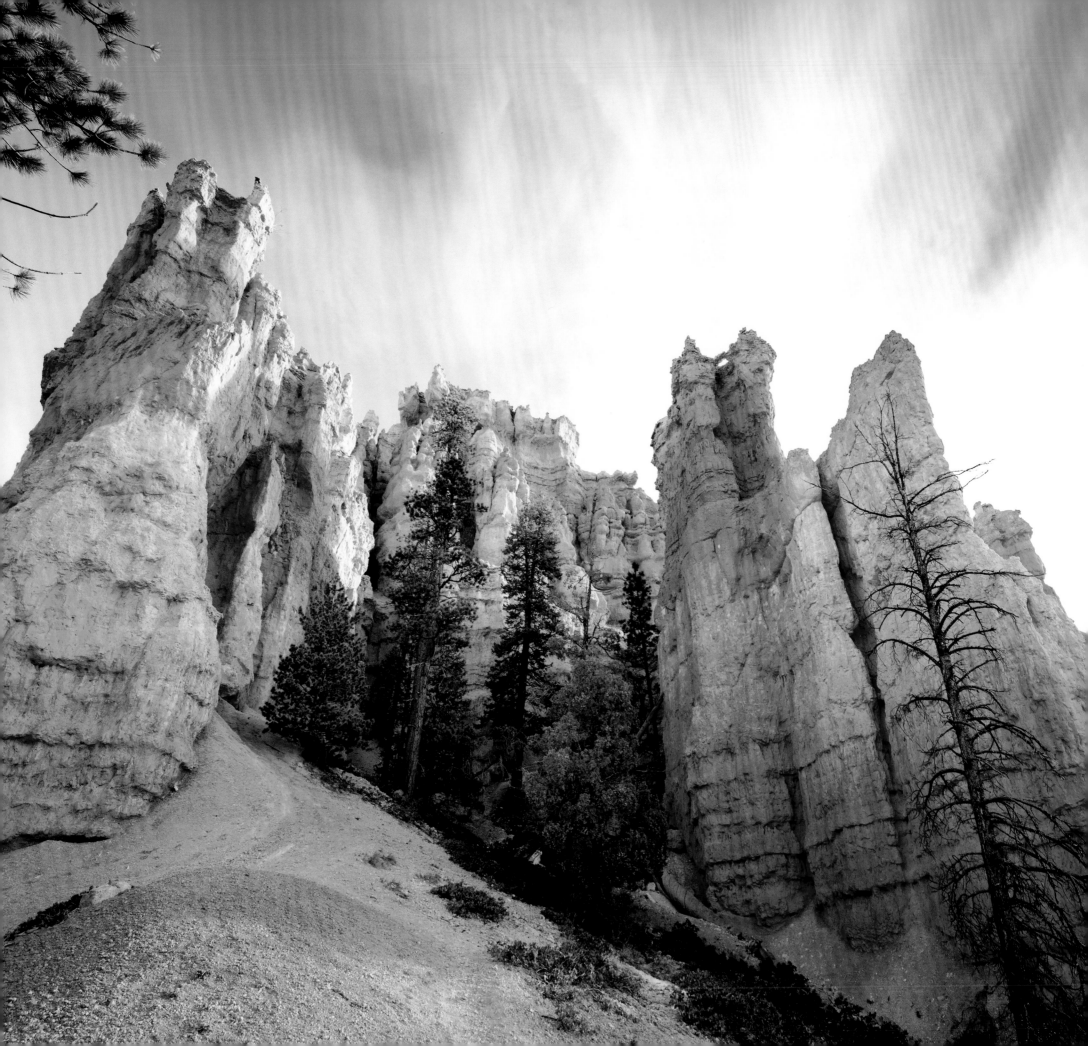

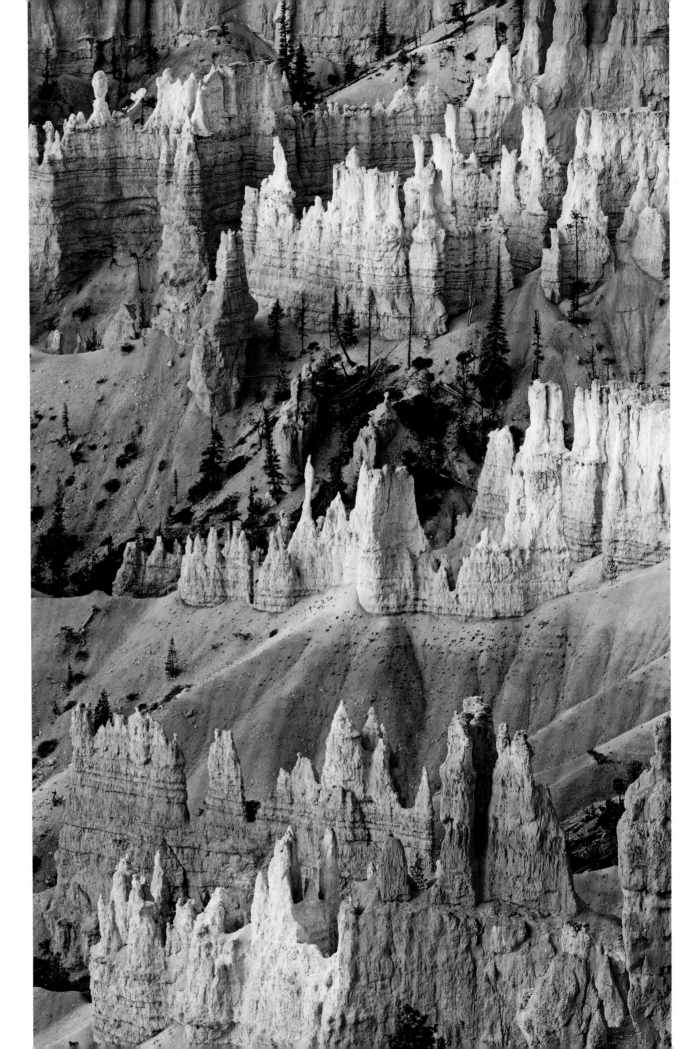

OPPOSITE: Bryce Canyon National Park, Utah
Queens Garden.

RIGHT: Bryce Canyon National Park, Utah

191

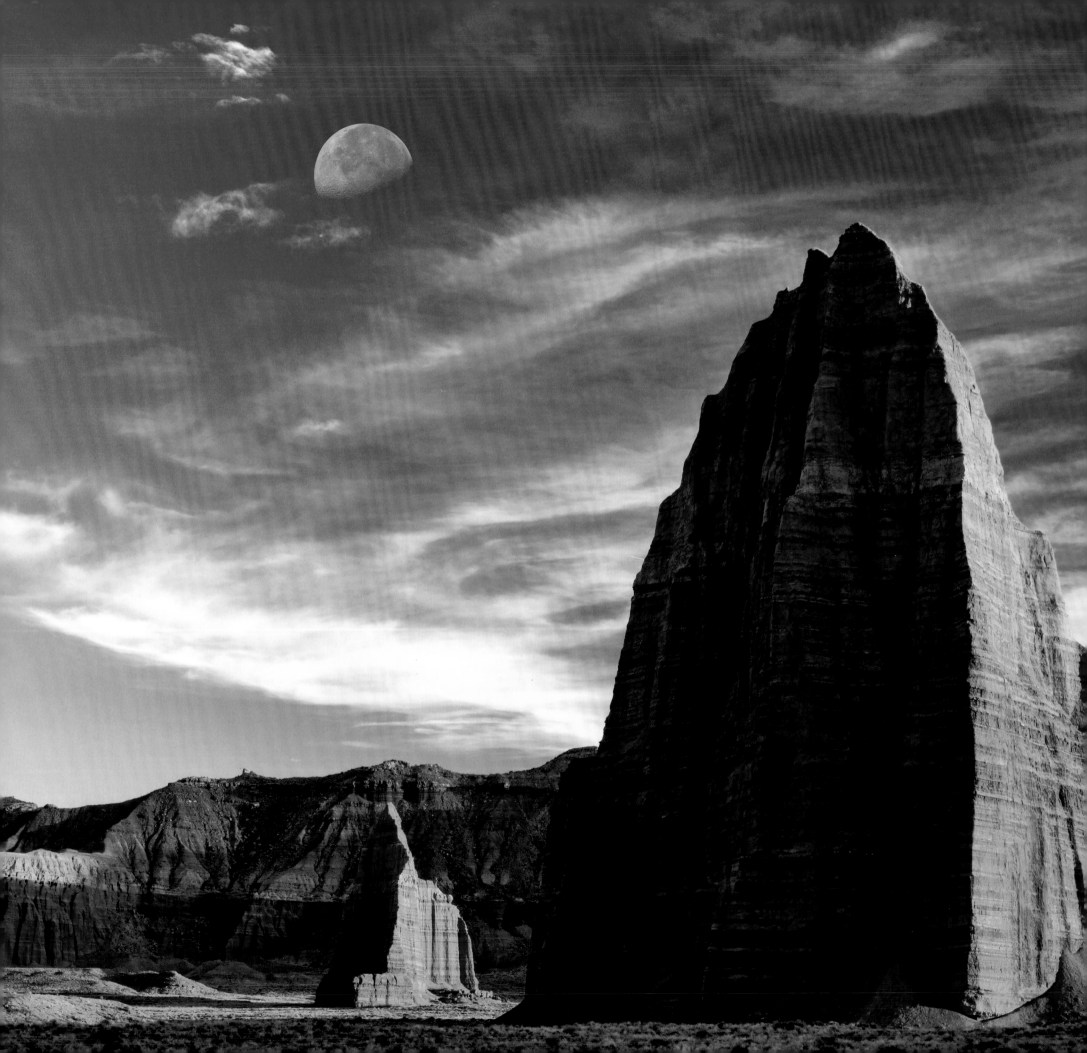

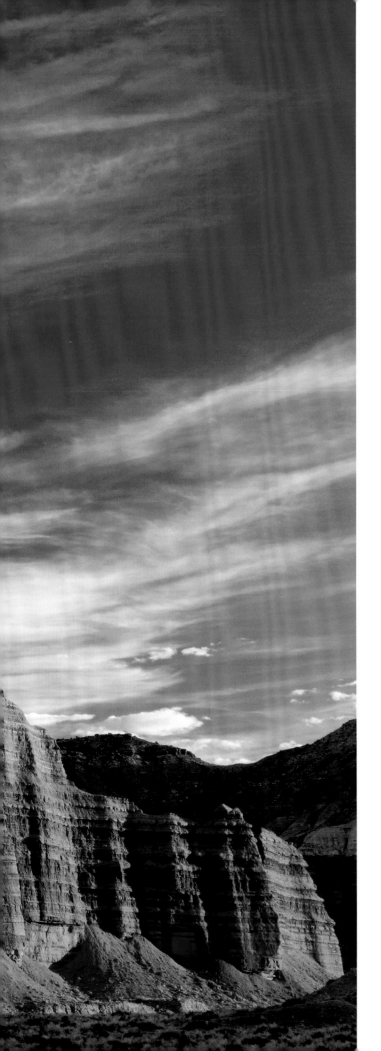

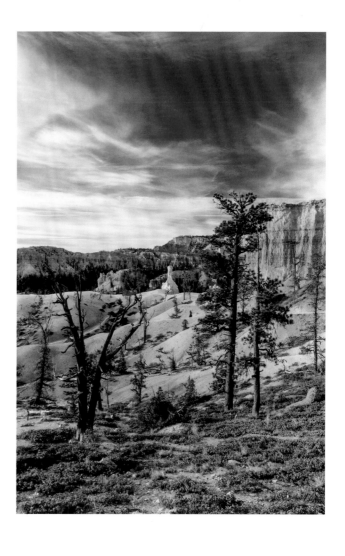

LEFT: Capitol Reef National Park, Utah
Temple of the Sun (foreground) *and Temple of the Moon* (background) *at moonset.*

ABOVE: Bryce Canyon National Park, Utah
Queens Garden.

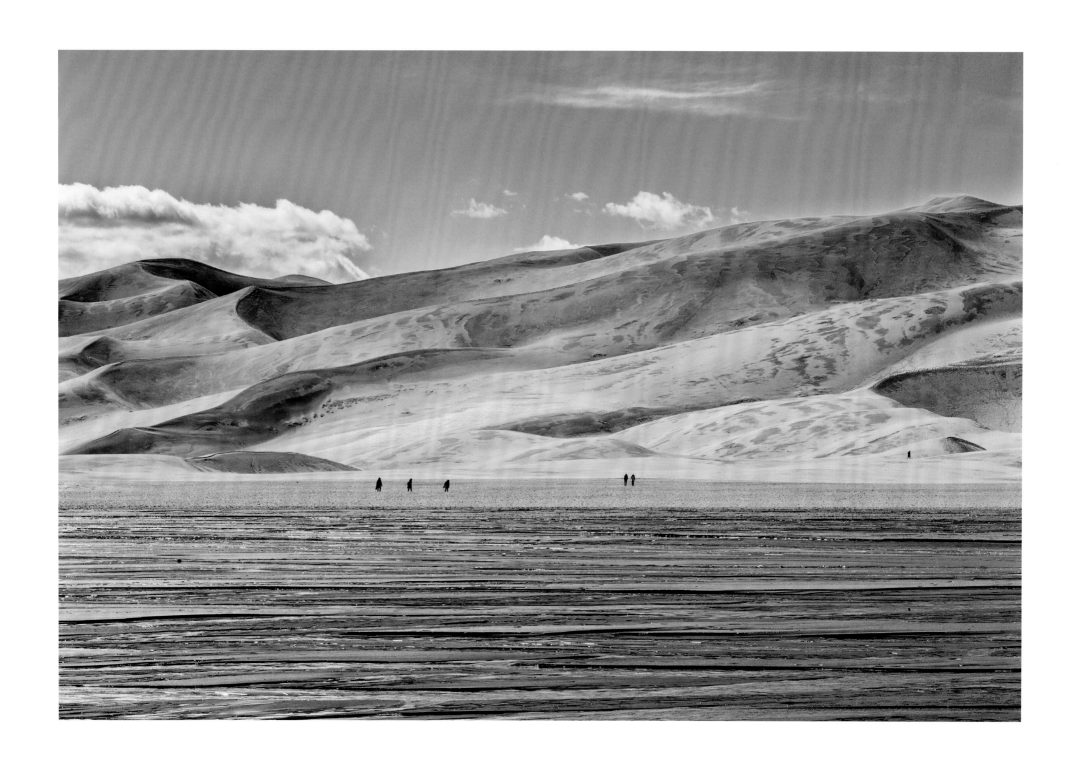

Great Sand Dunes National Park and Preserve, Colorado

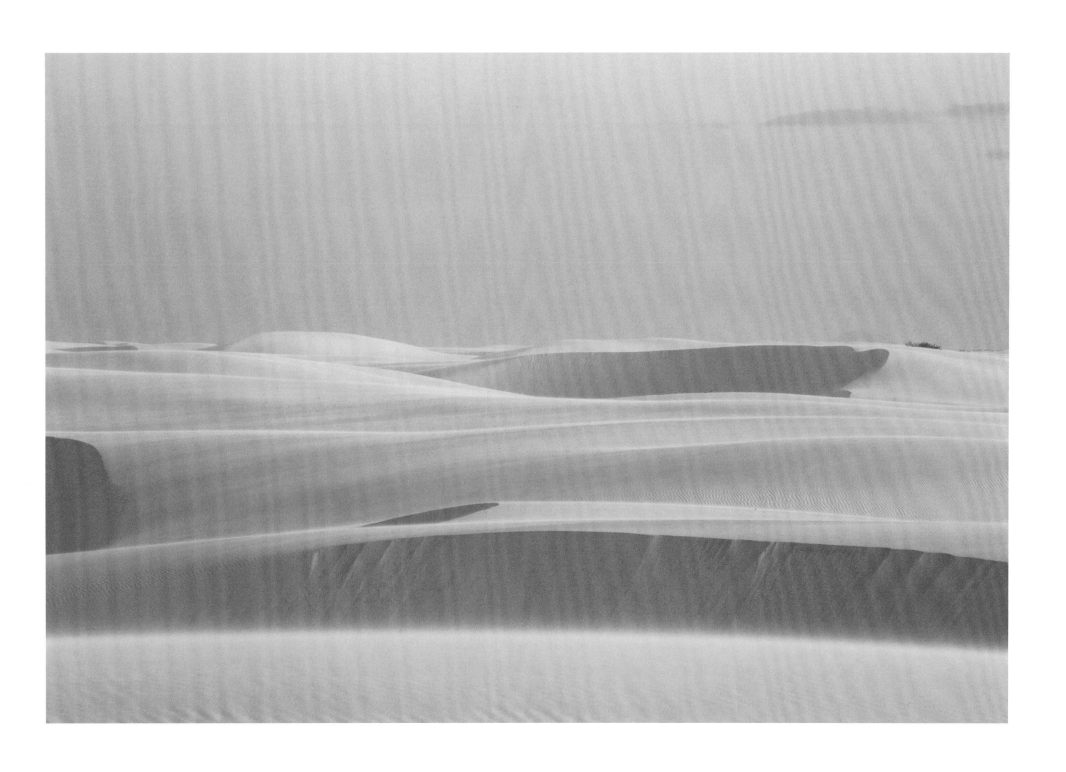

White Sands National Monument, New Mexico

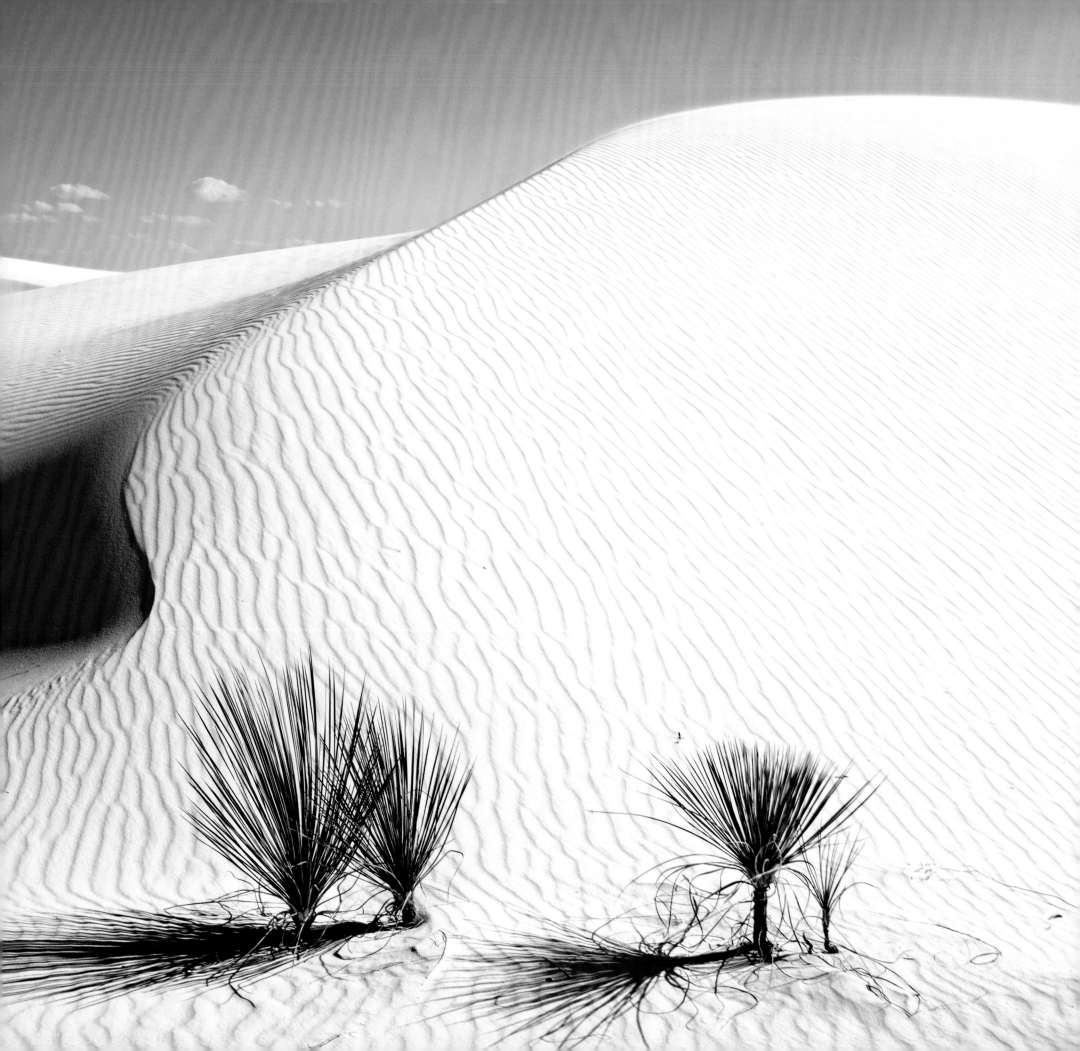

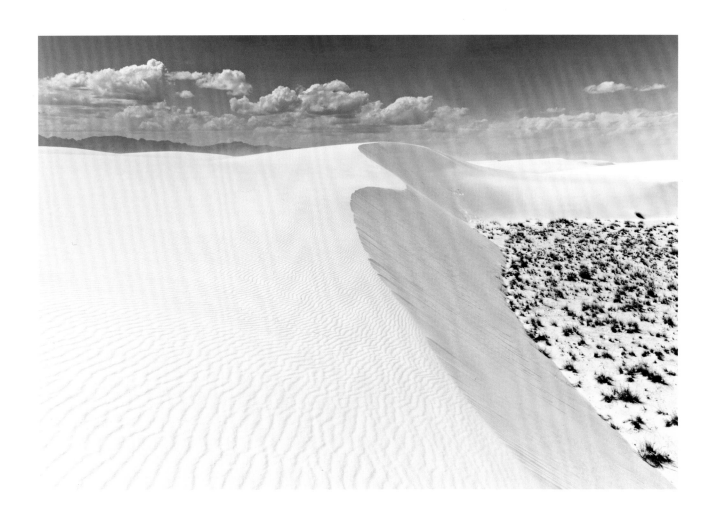

OPPOSITE AND ABOVE: White Sands National Monument, New Mexico

ABOVE AND RIGHT: White Sands National Monument, New Mexico

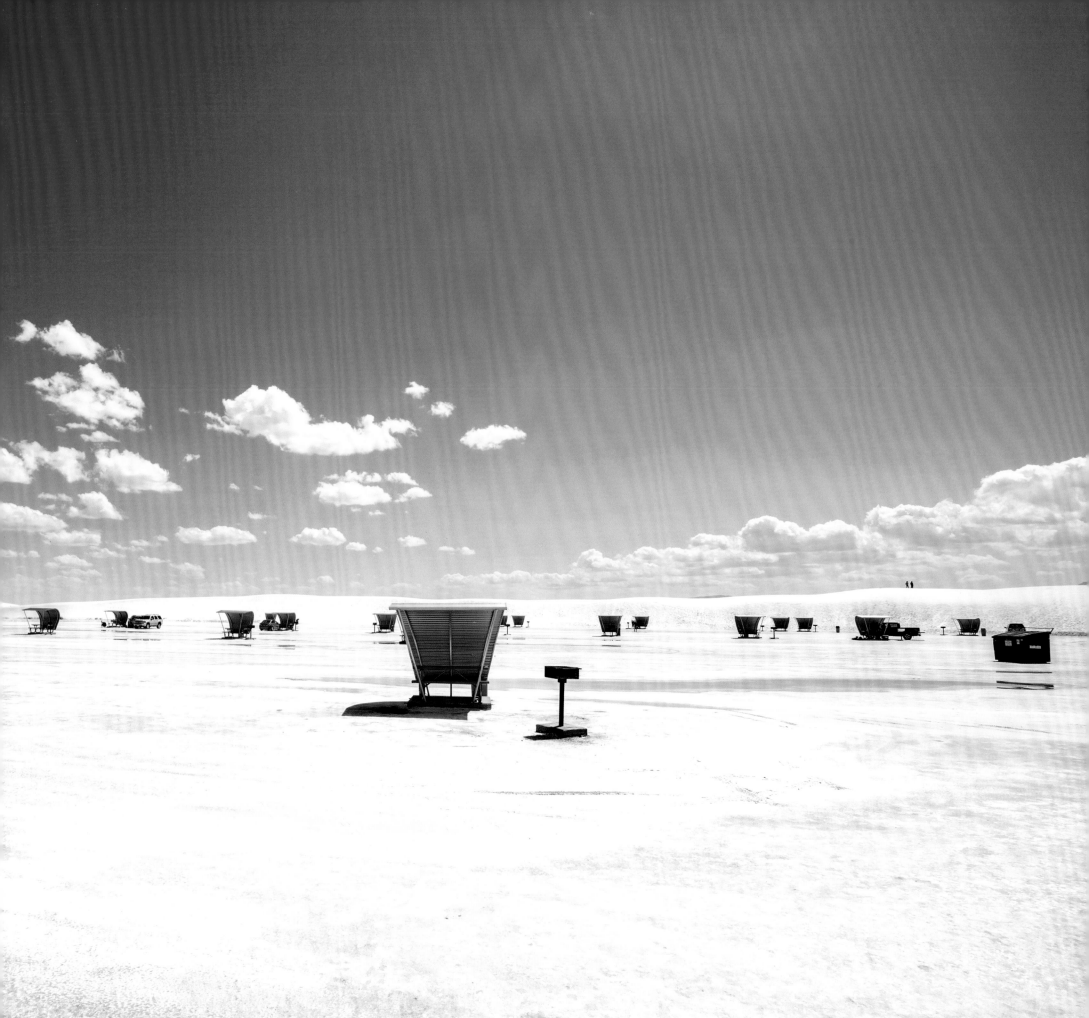

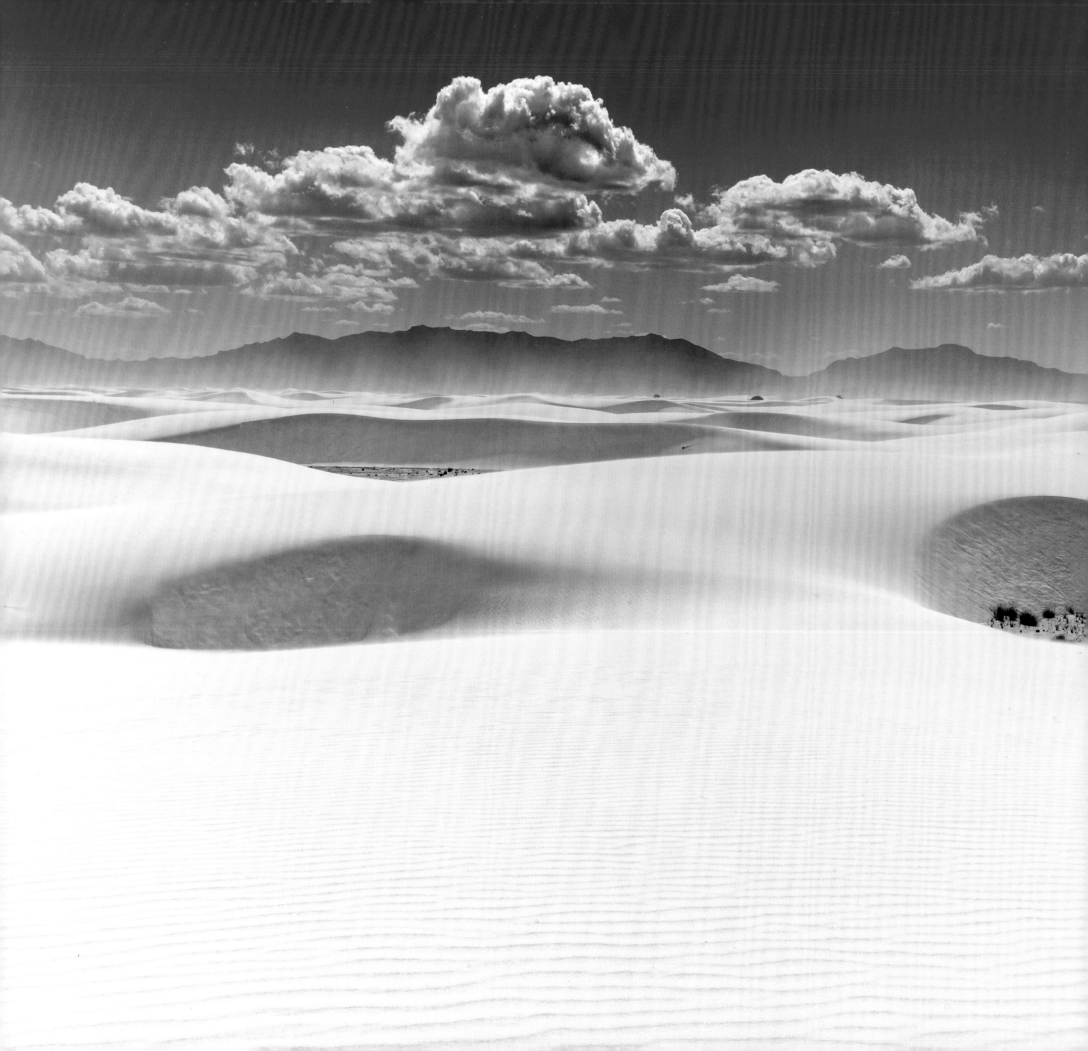

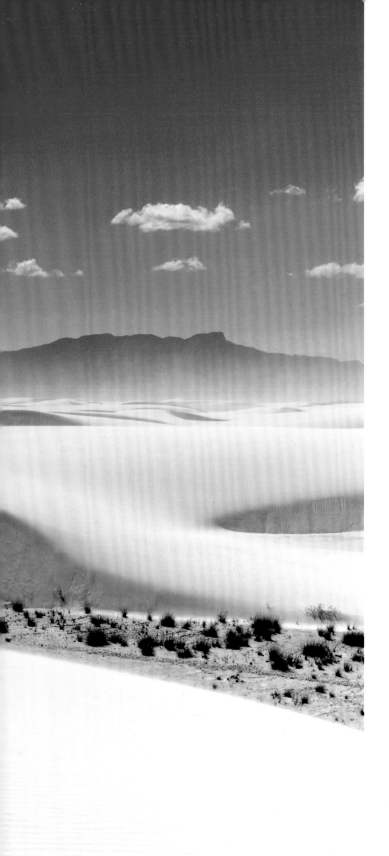

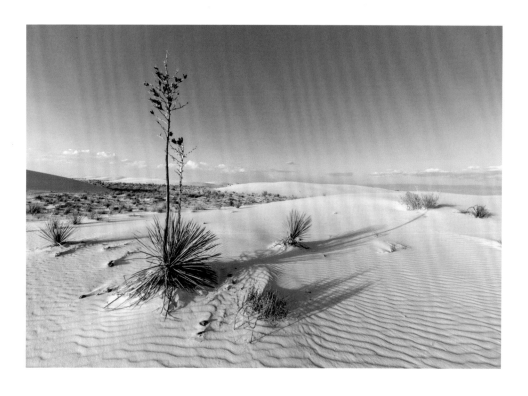

LEFT AND ABOVE: White Sands National Monument, New Mexico

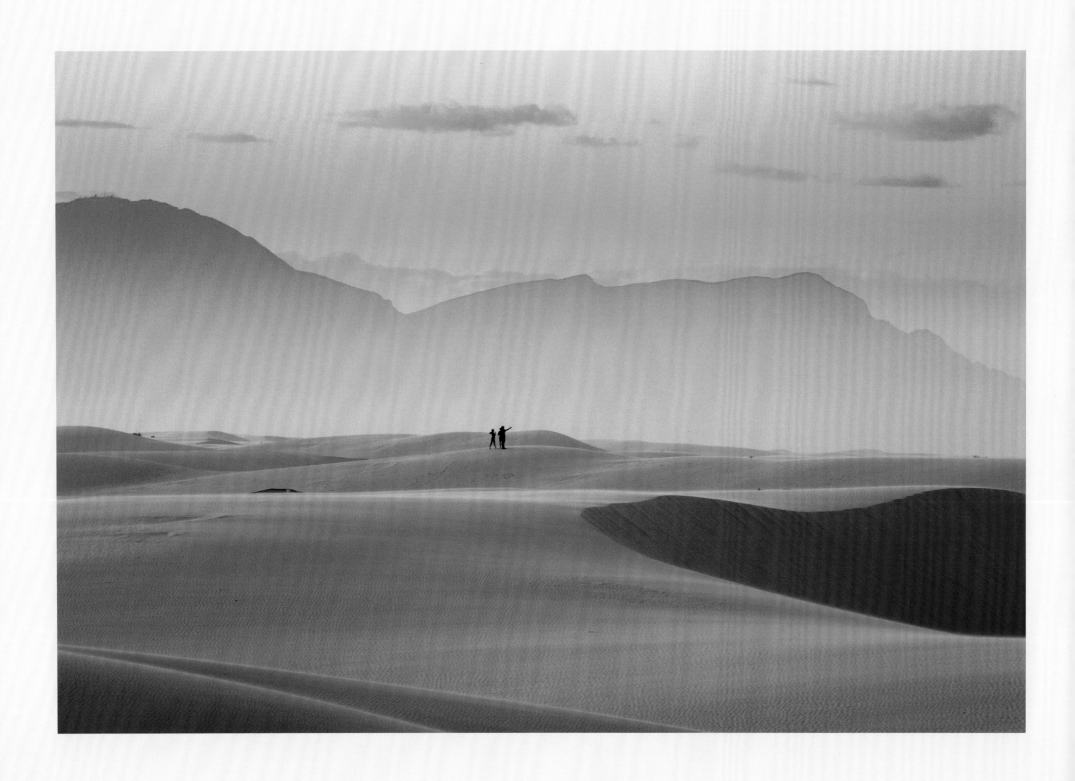

ABOVE AND OPPOSITE: White Sands National Monument, New Mexico

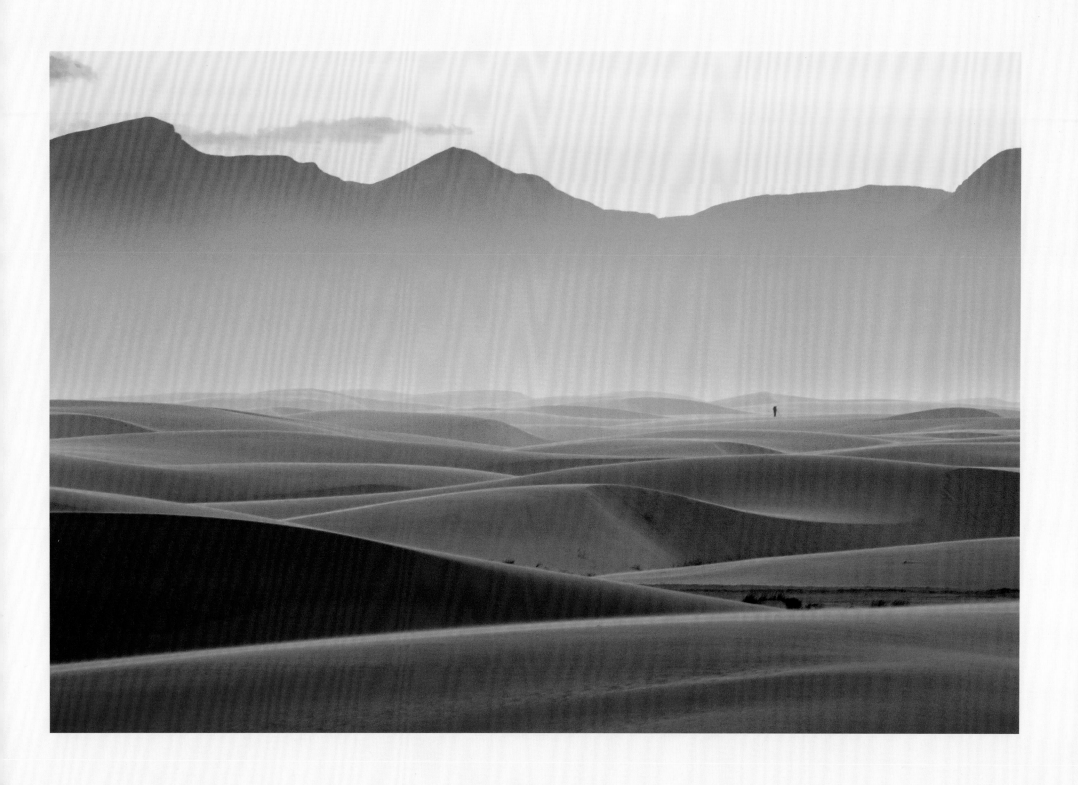

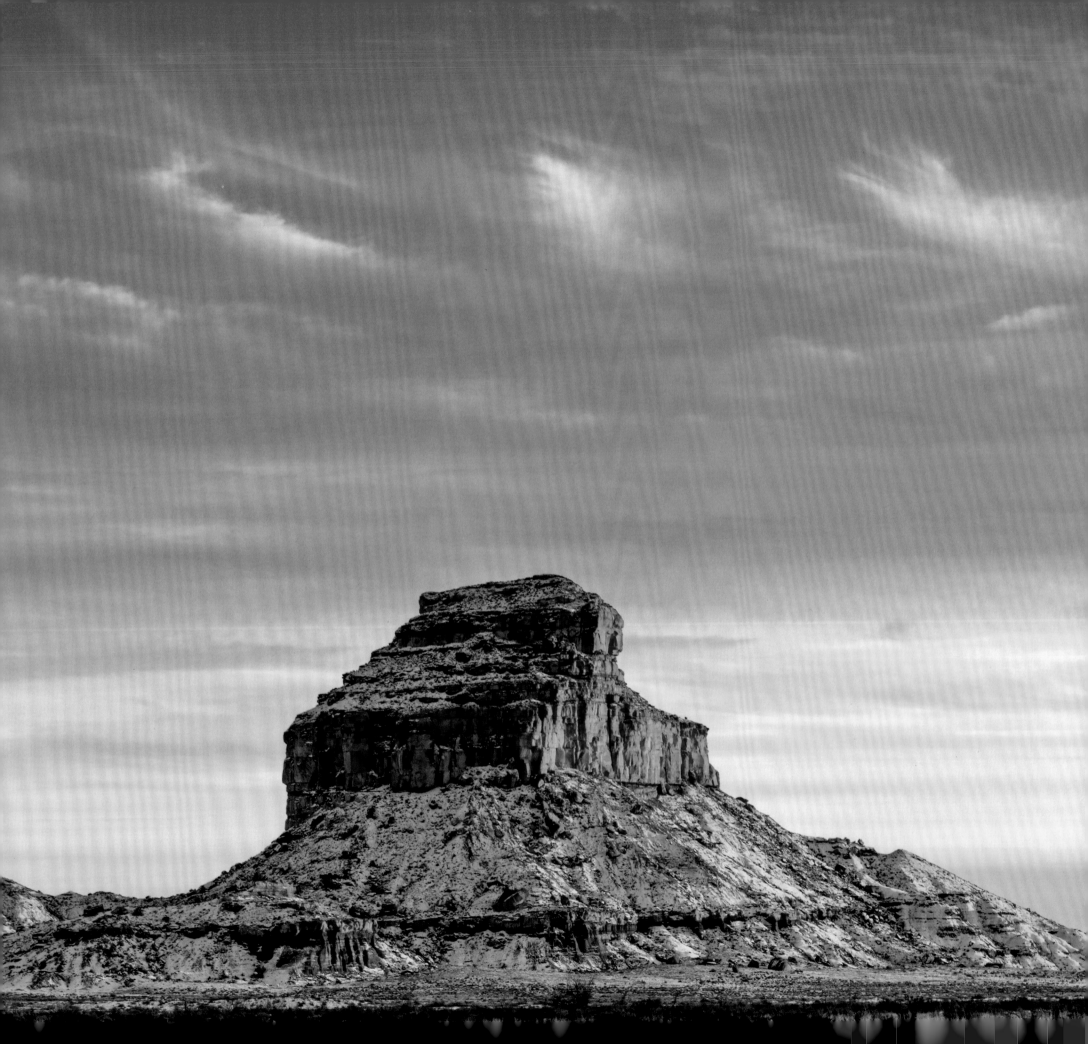

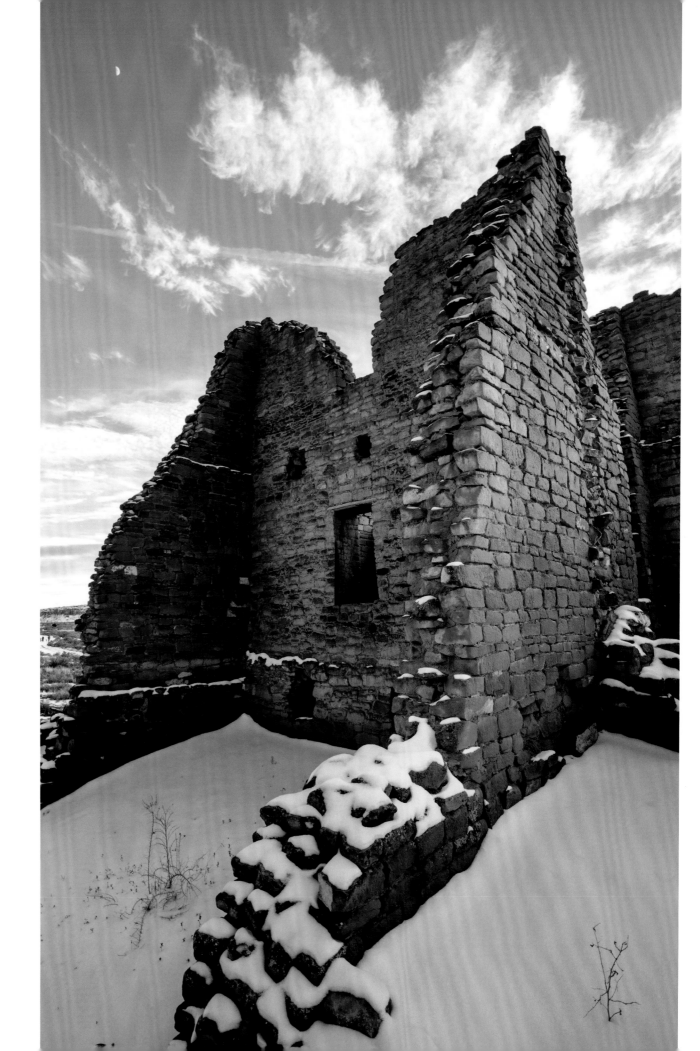

OPPOSITE: Chaco Culture National
Historical Park, New Mexico
Fajada Butte at sunset.

RIGHT: Chaco Culture National
Historical Park, New Mexico
*View through ancient pueblo ruins in
Chaco Canyon.*

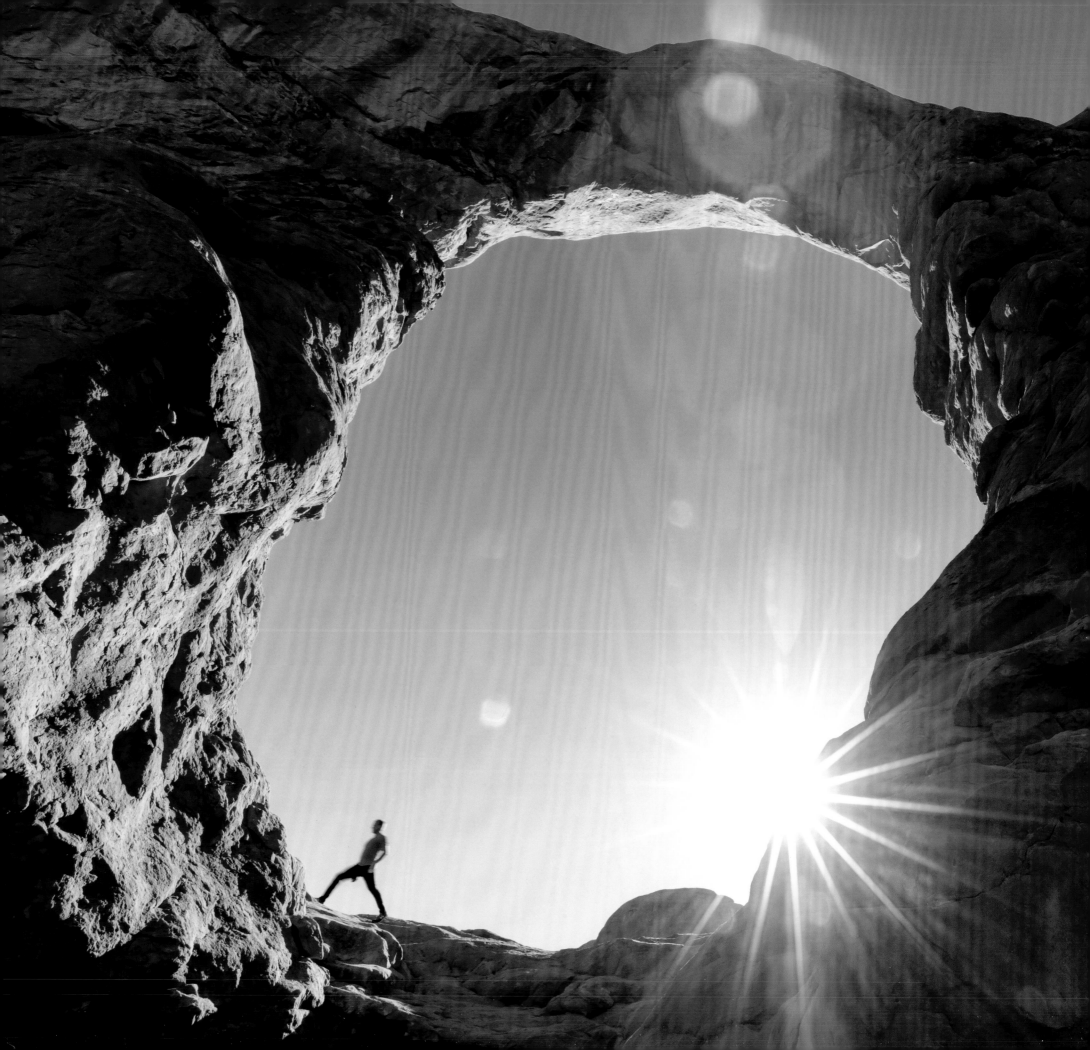

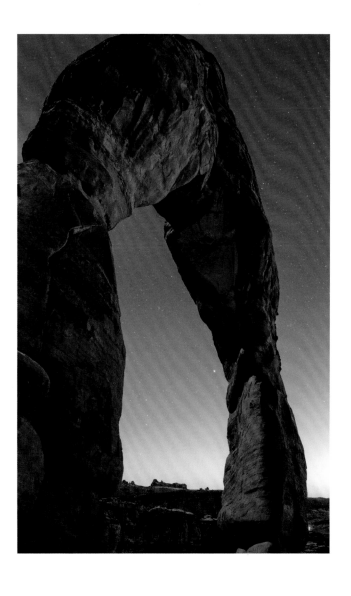

LEFT: Arches National Park, Utah
Window Rock.

ABOVE: Arches National Park, Utah
Delicate Arch.

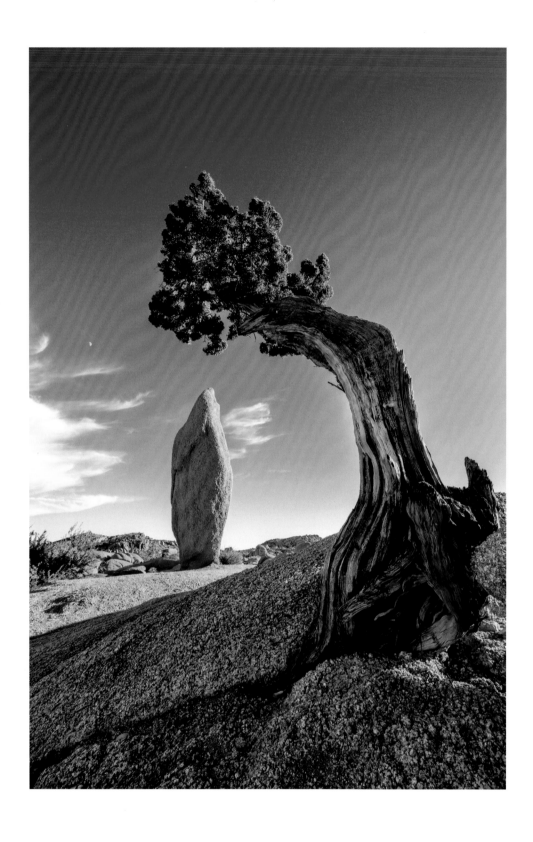

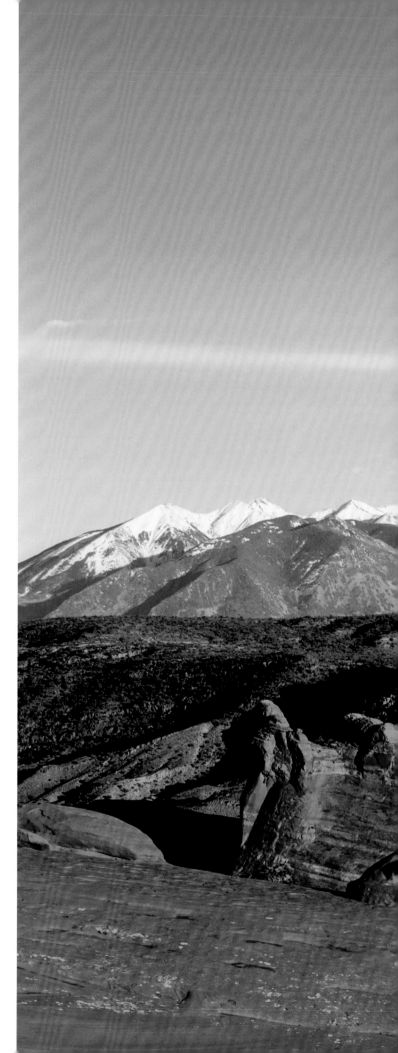

ABOVE: Joshua Tree National Park, California
Balanced rock and juniper in Jumbo Rocks Campground.

OPPOSITE: Arches National Park, Utah
Delicate Arch.

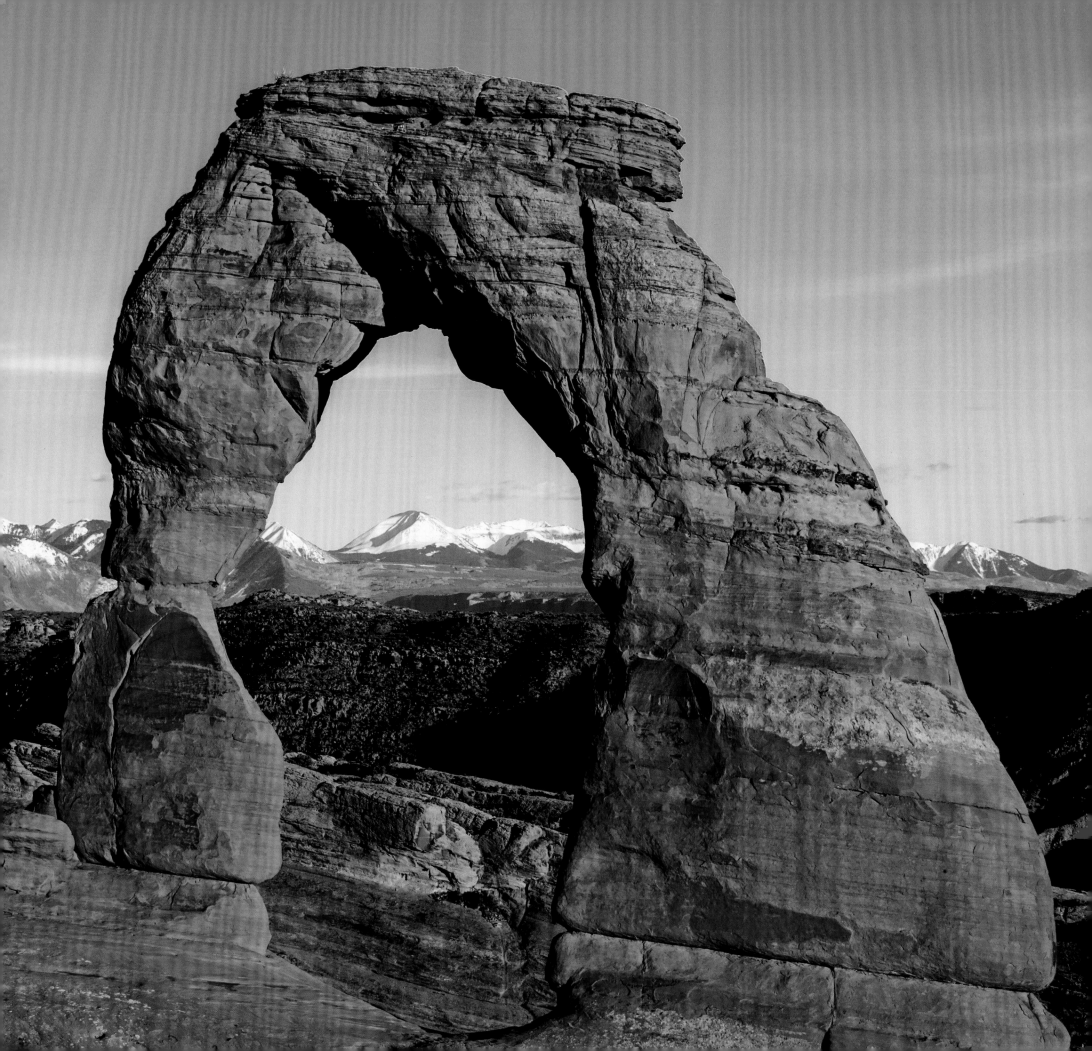

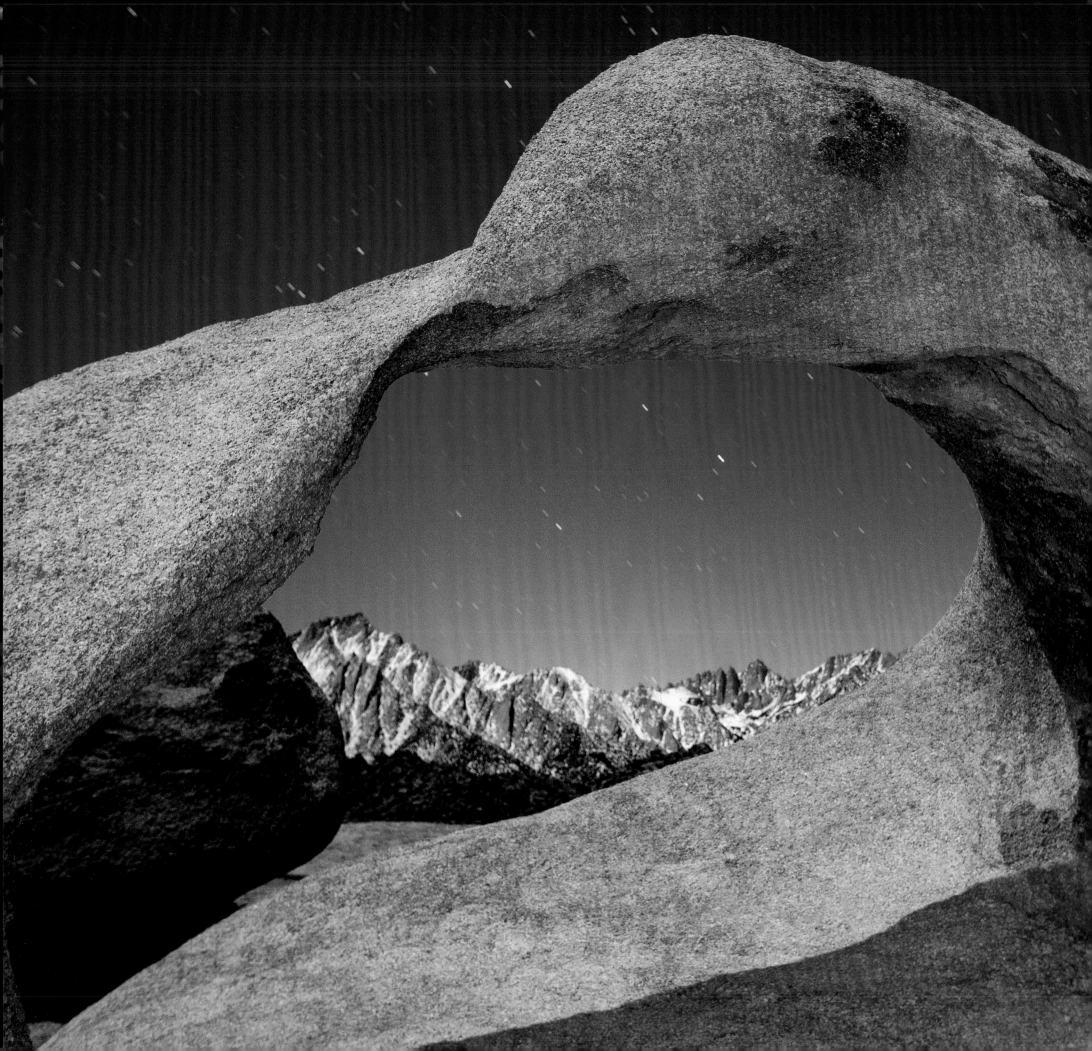

Mobius Arch with stars in Lone Pine, California, looking toward Sequoia National Park.

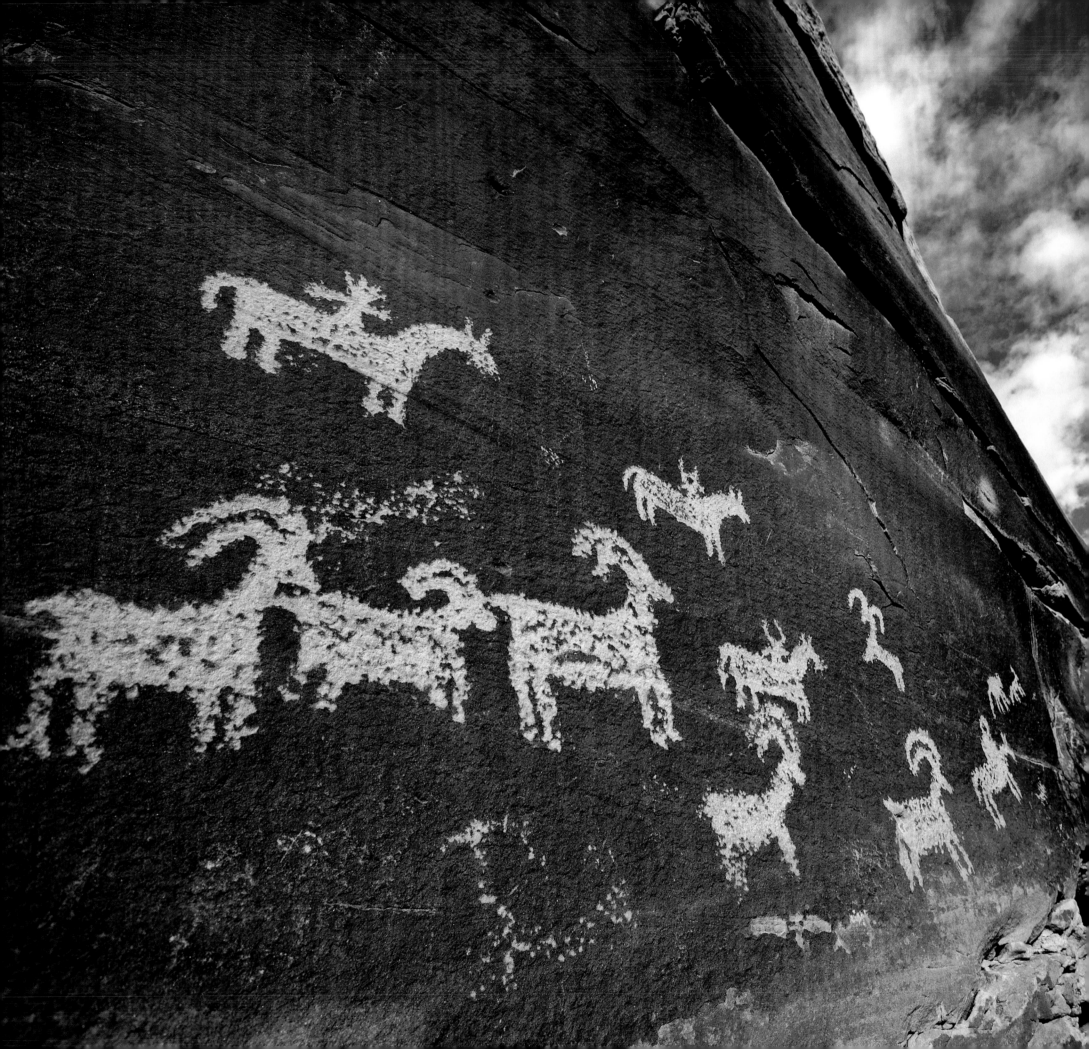

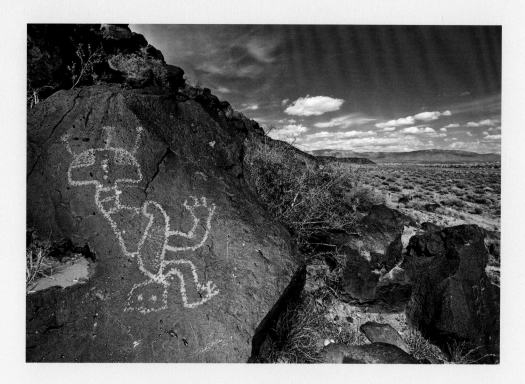

LEFT: Arches National Park, Utah
These petroglyphs were carved by the Utes sometime between A.D. 1650 and A.D. 1850.

ABOVE: Petroglyph National Monument, New Mexico

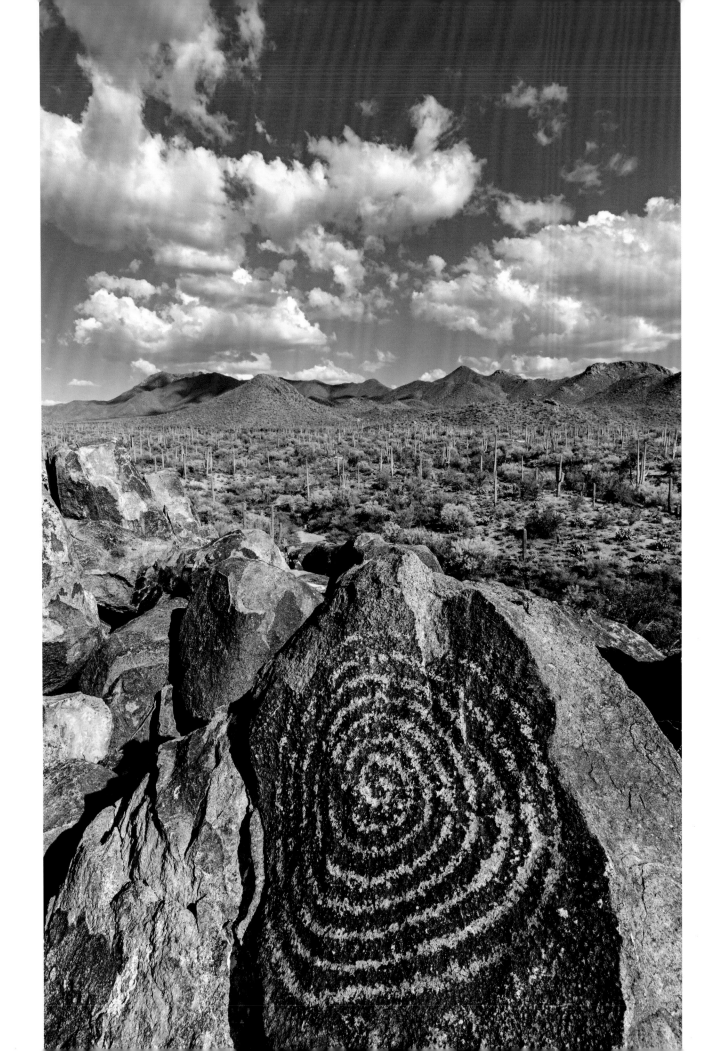

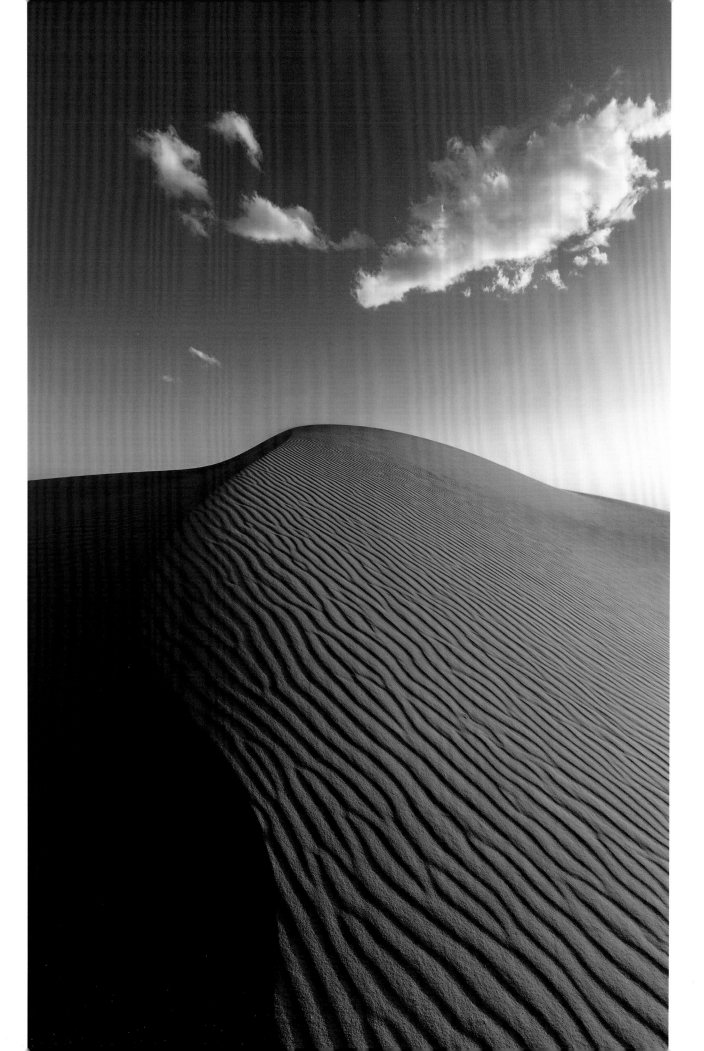

OPPOSITE:
Saguaro National Park, Arizona

LEFT:
White Sands National Monument,
New Mexico

215

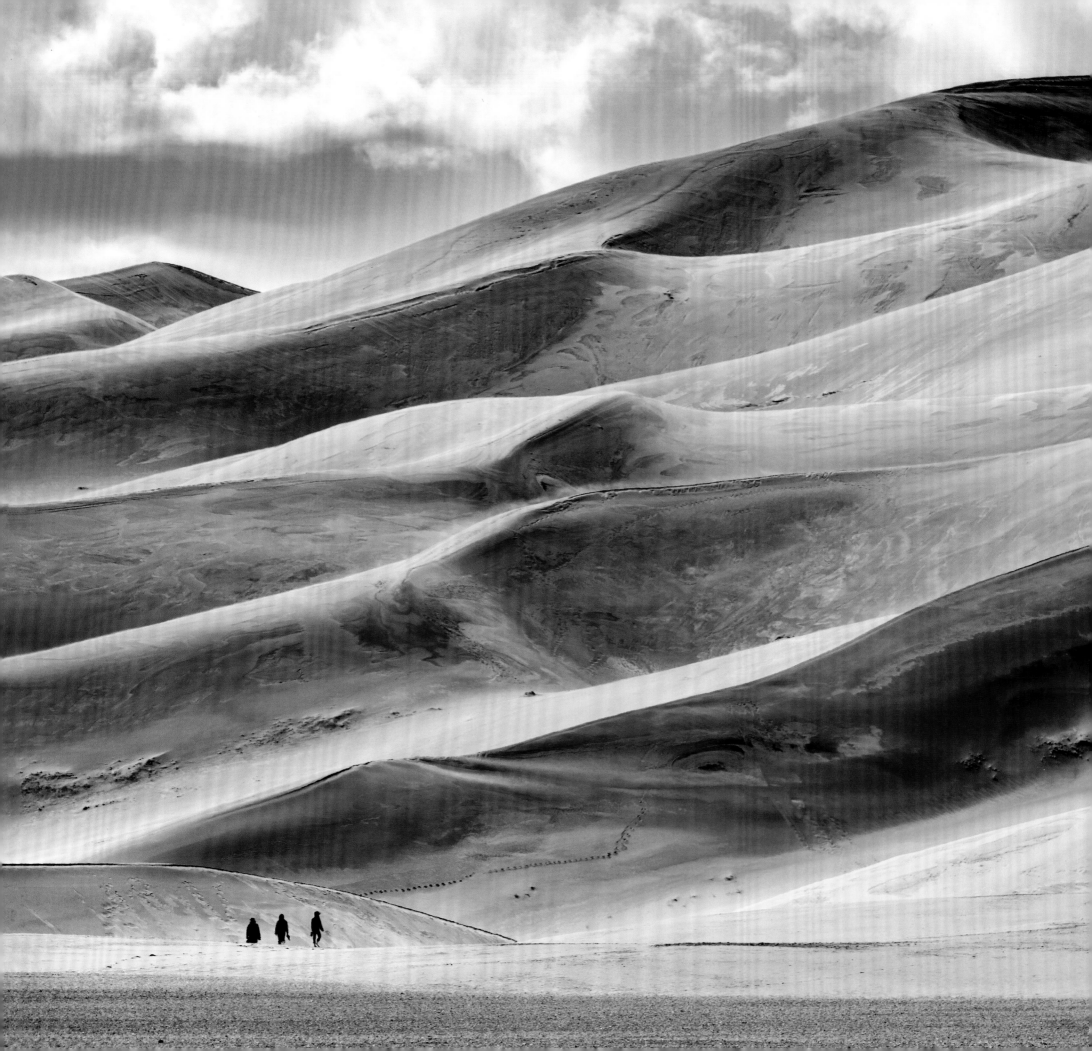

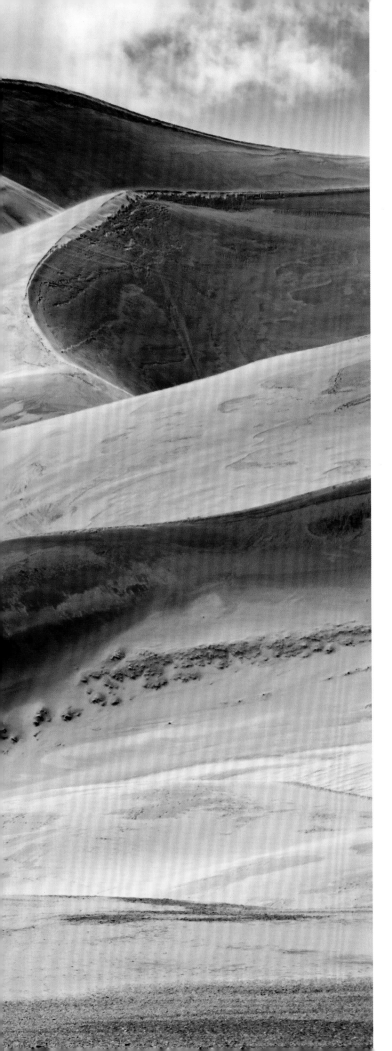
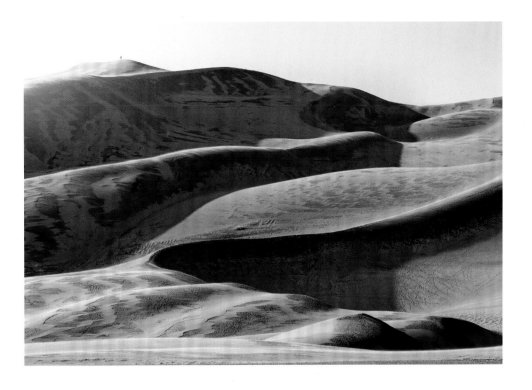

OPPOSITE AND ABOVE: Great Sand Dunes
National Park and Preserve, Colorado

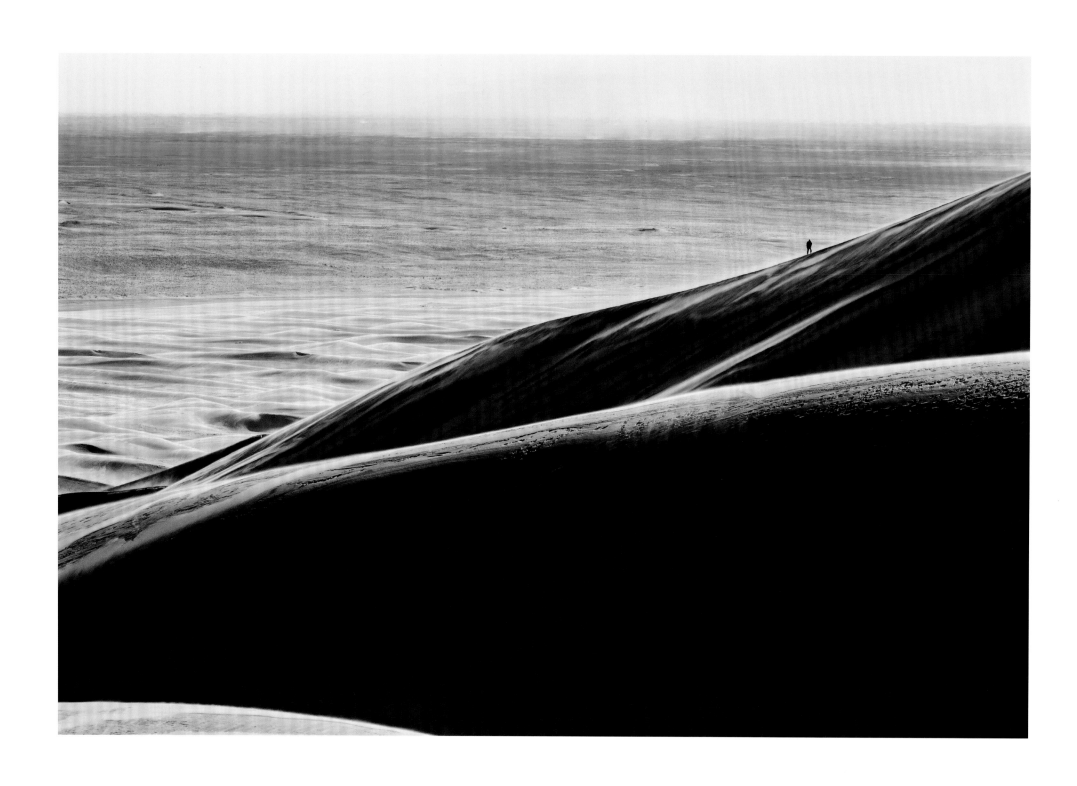

Great Sand Dunes National Park and Preserve, Colorado

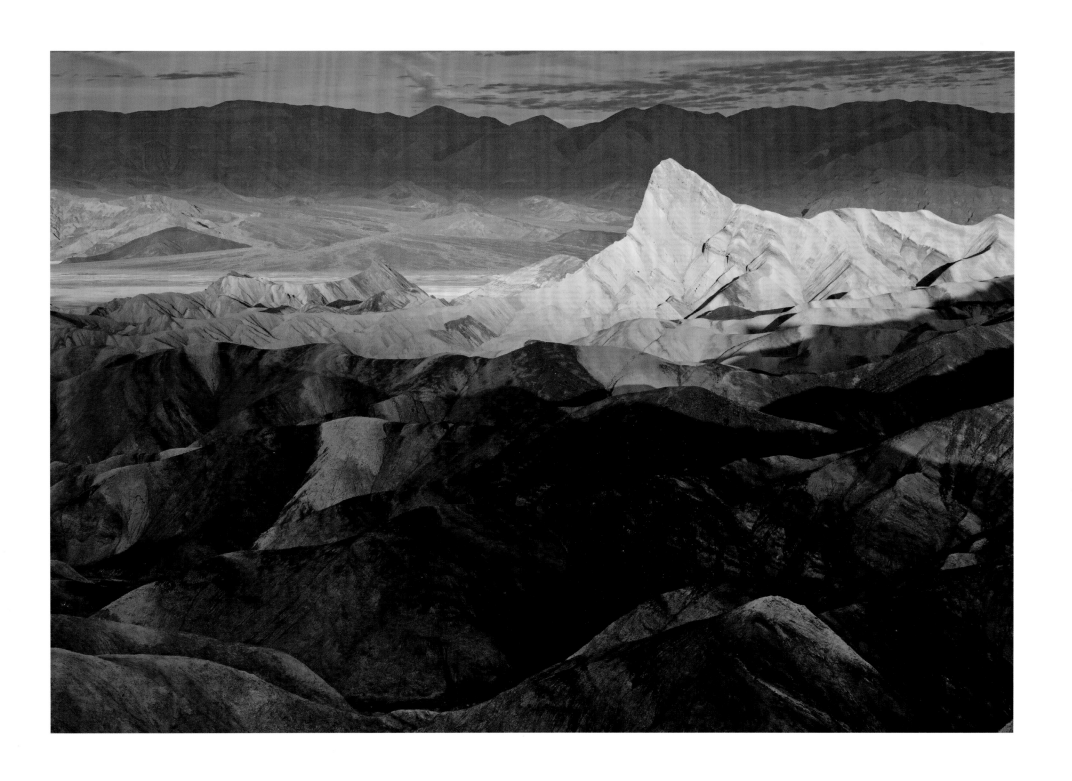

Death Valley National Park, California
Sunrise on Zabriskie Point.

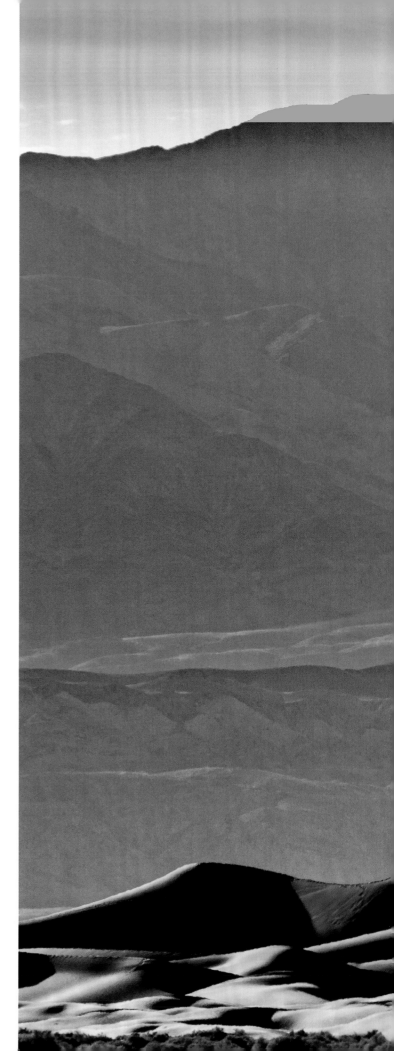

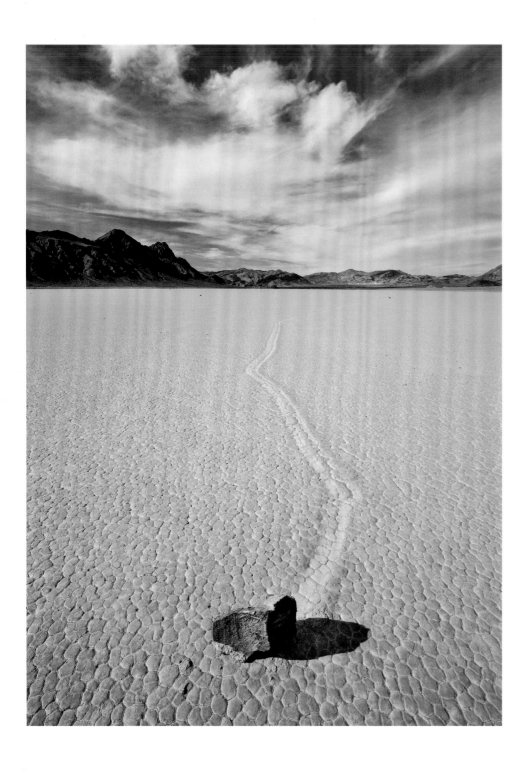

ABOVE: Death Valley National Park; California, Nevada
*"Moving" rocks of the famous Racetrack. Scientists haven't
fully determined exactly how the rocks move, but wind, rain,
and ice are all considered possible factors.*

RIGHT: Death Valley National Park; California, Nevada
*Mesquite Flat Sand Dunes near Stovepipe Wells. People can be
seen in the distance hiking the one-hundred-foot-tall dunes.*

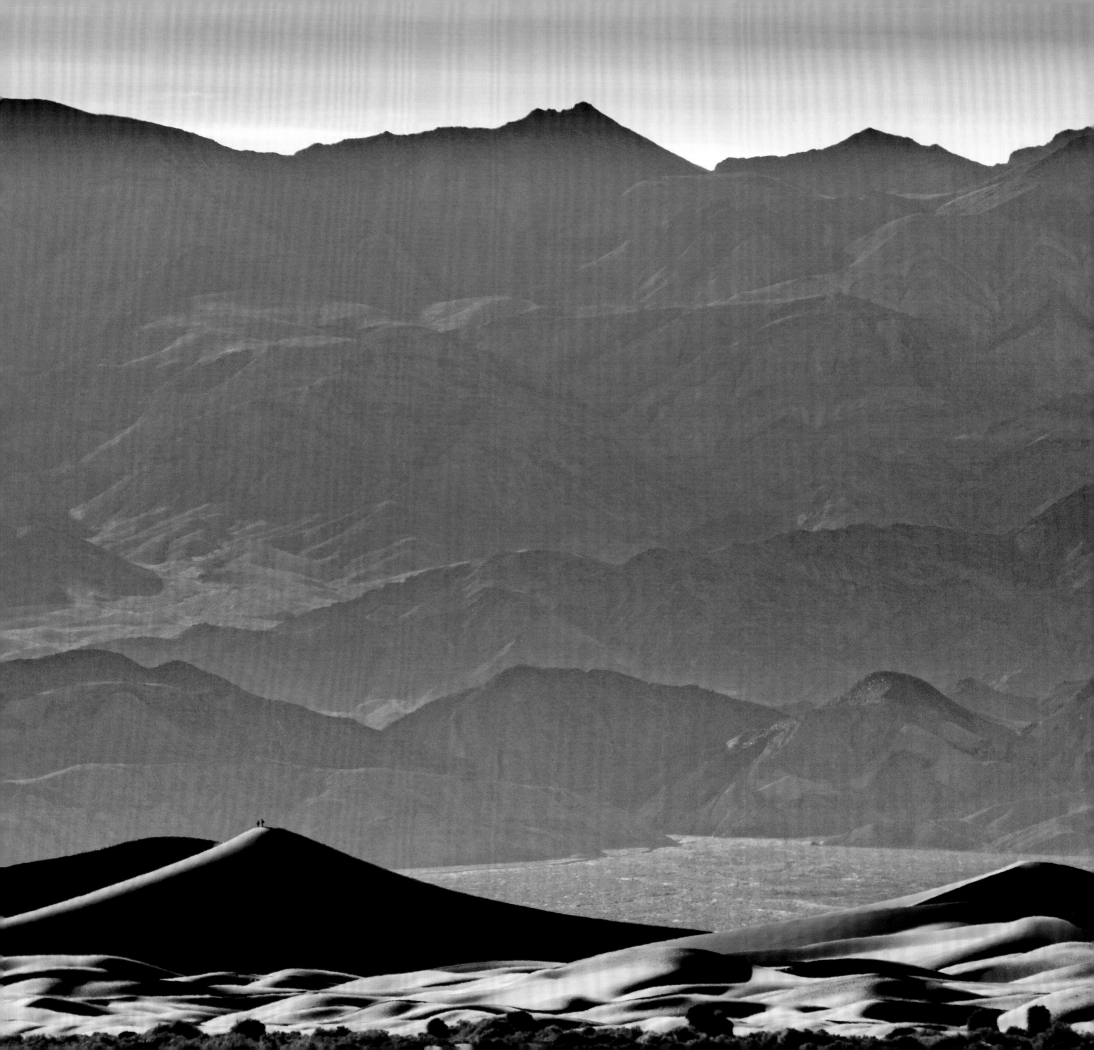

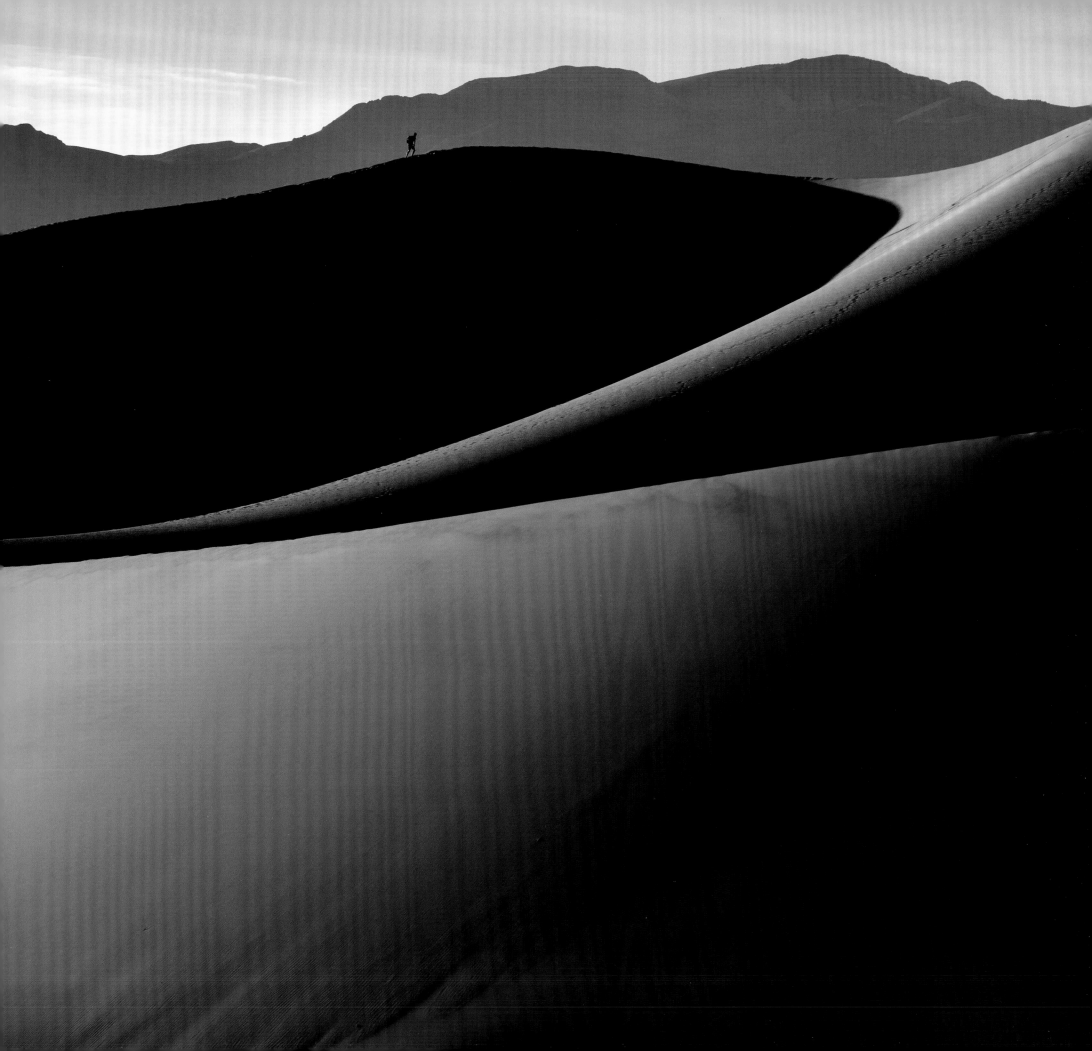

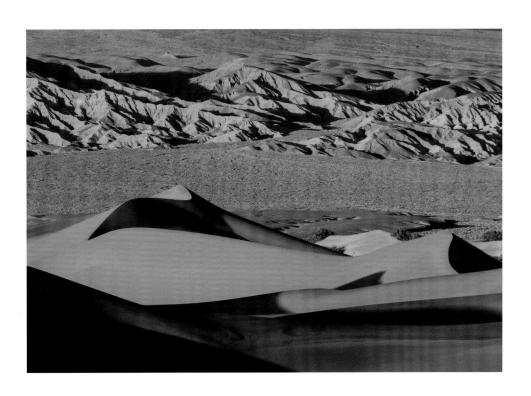

LEFT: Death Valley National Park; California, Nevada

ABOVE: Death Valley National Park; California, Nevada
Mesquite Flat Sand Dunes near Stovepipe Wells.

223

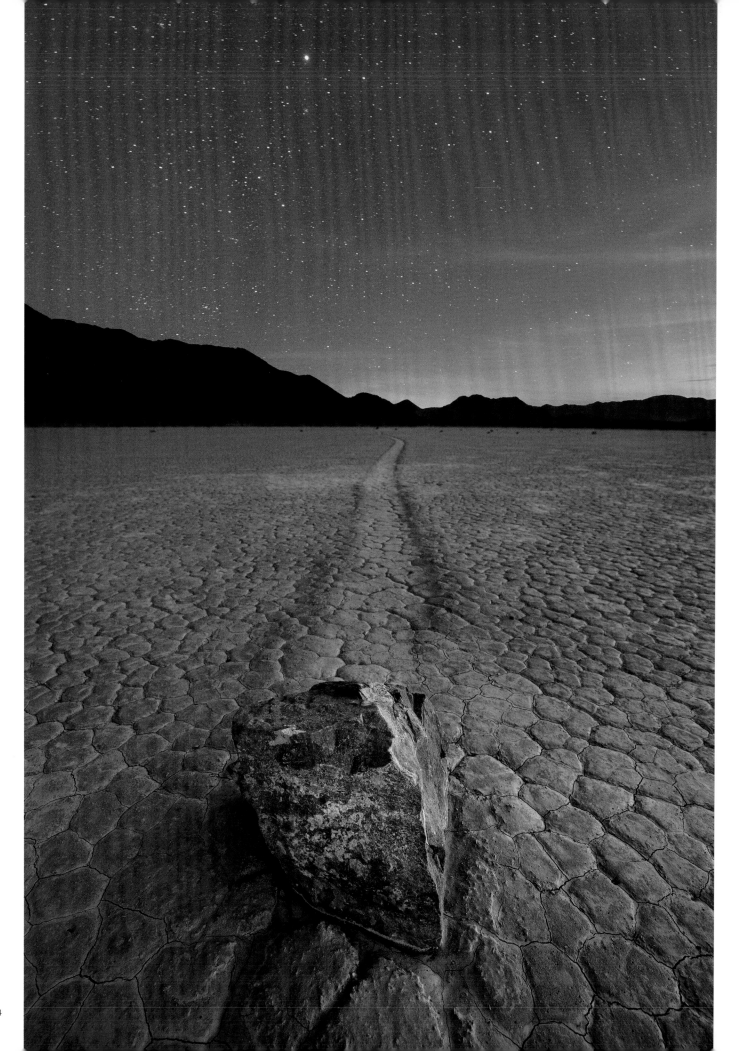

LEFT AND OPPOSITE: Death Valley
National Park; California, Nevada
"Moving" rocks of the famous Racetrack.

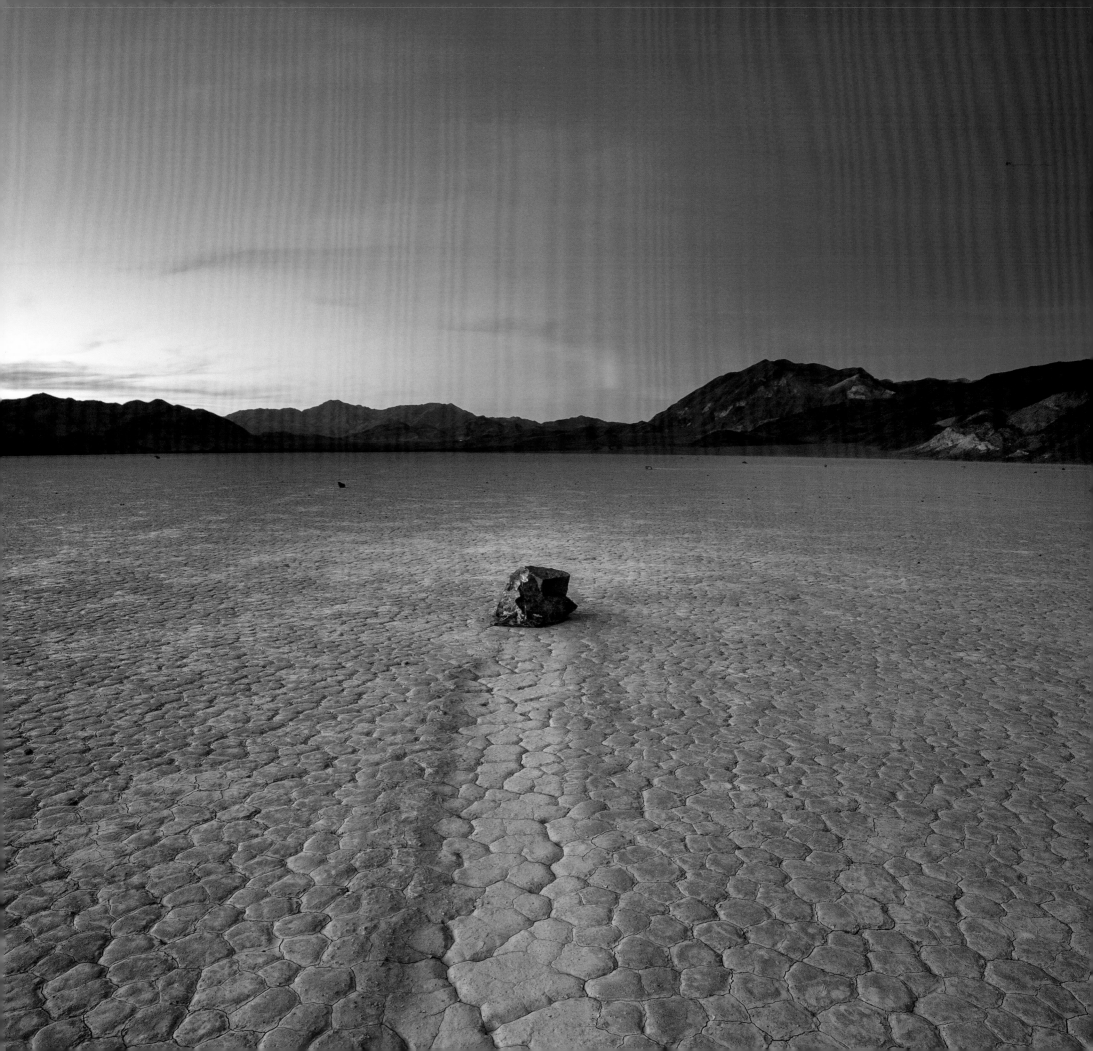

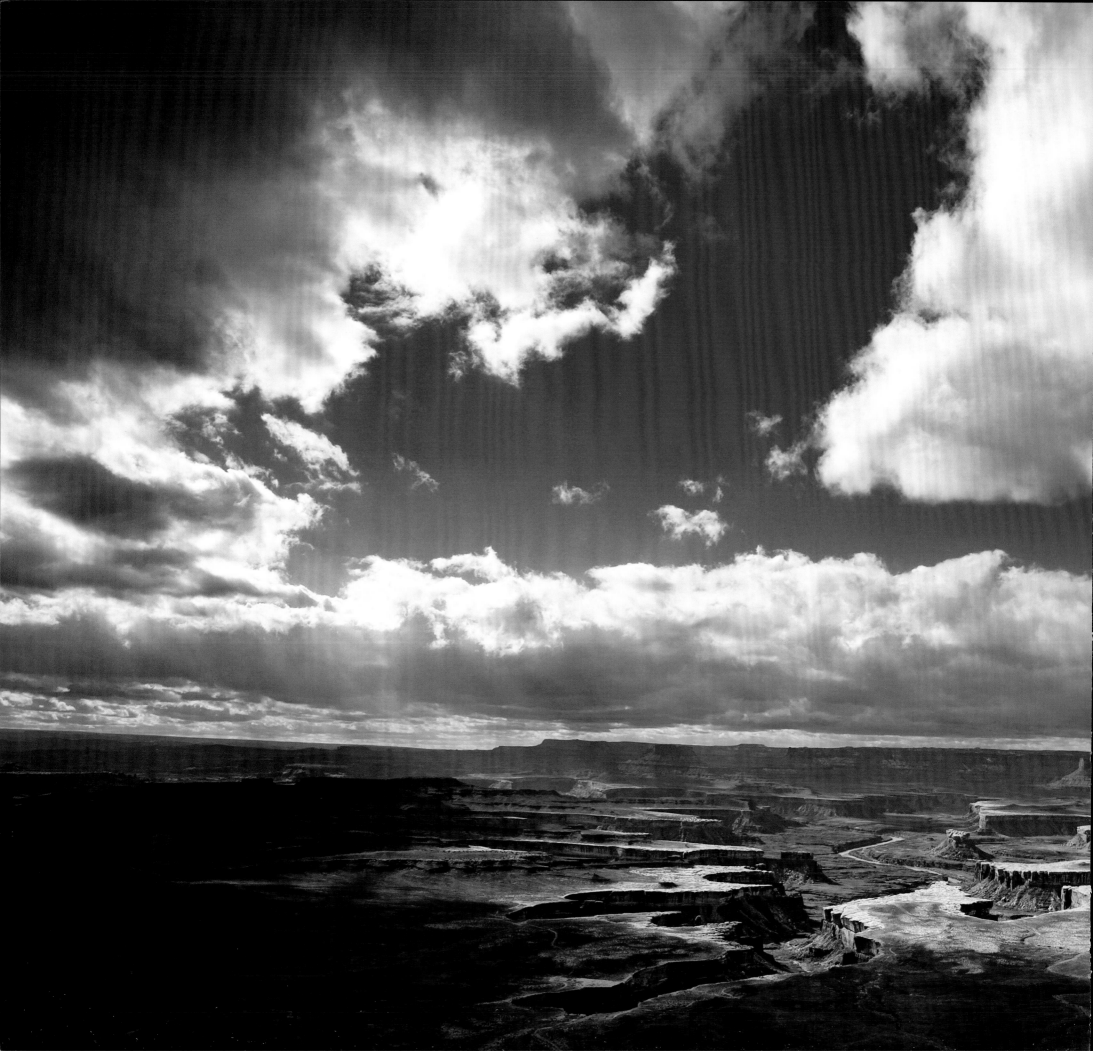

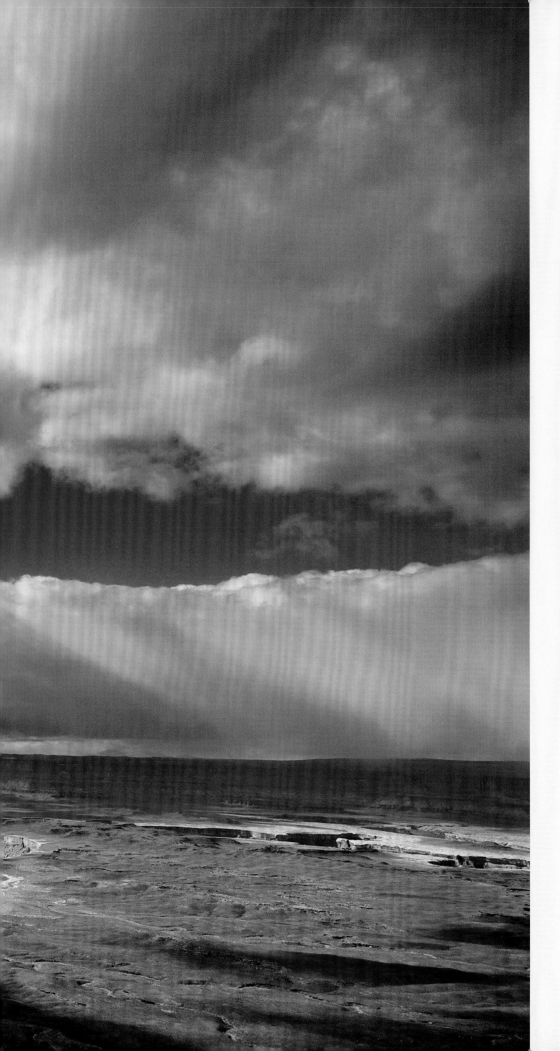

Canyonlands National Park, Utah

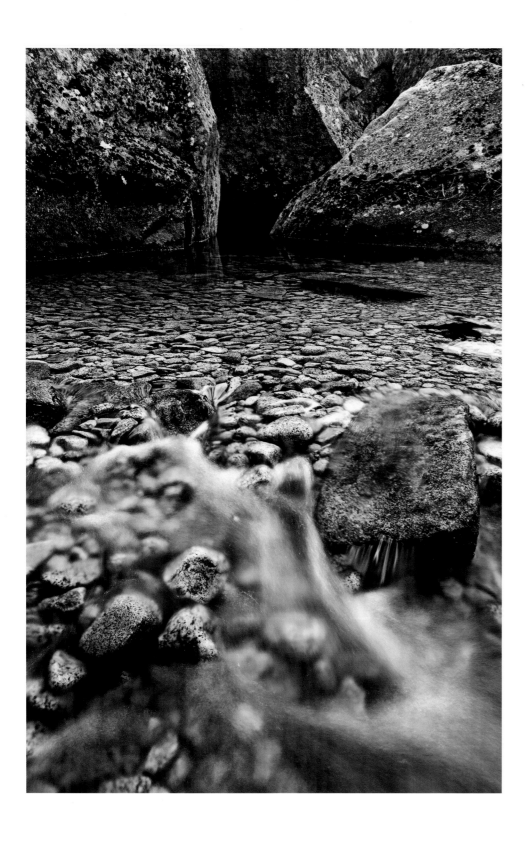

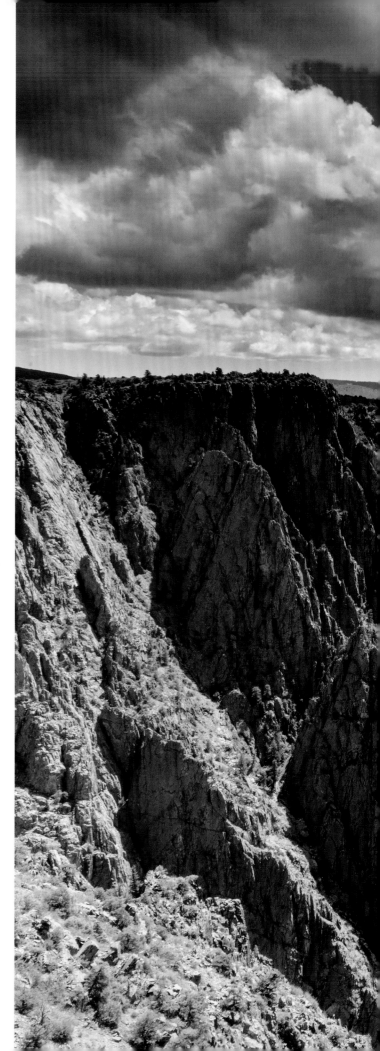

ABOVE: Yosemite National Park, California
Slow exposure of water flowing below Vernal Falls.

RIGHT: Gunnison National Park, Colorado
Black Canyon.

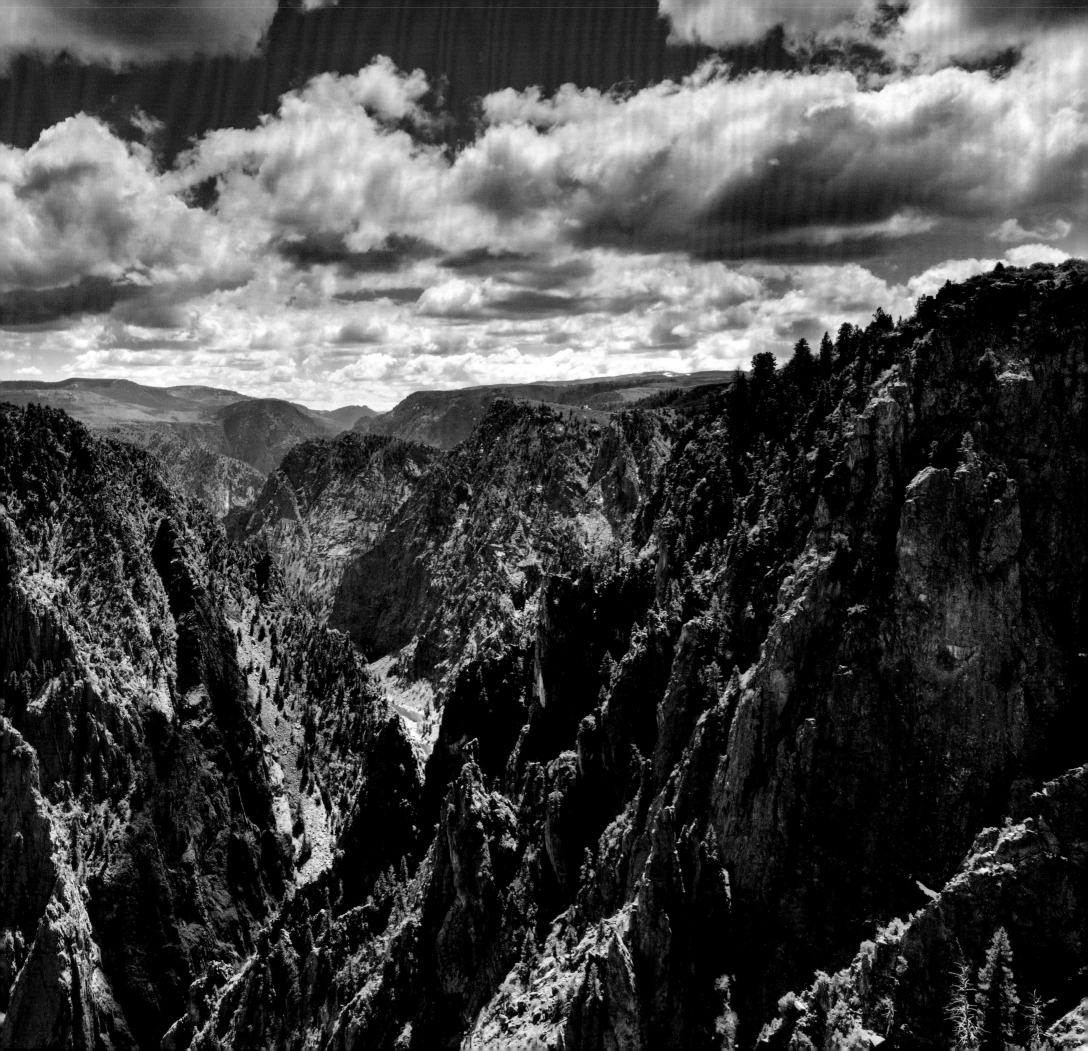

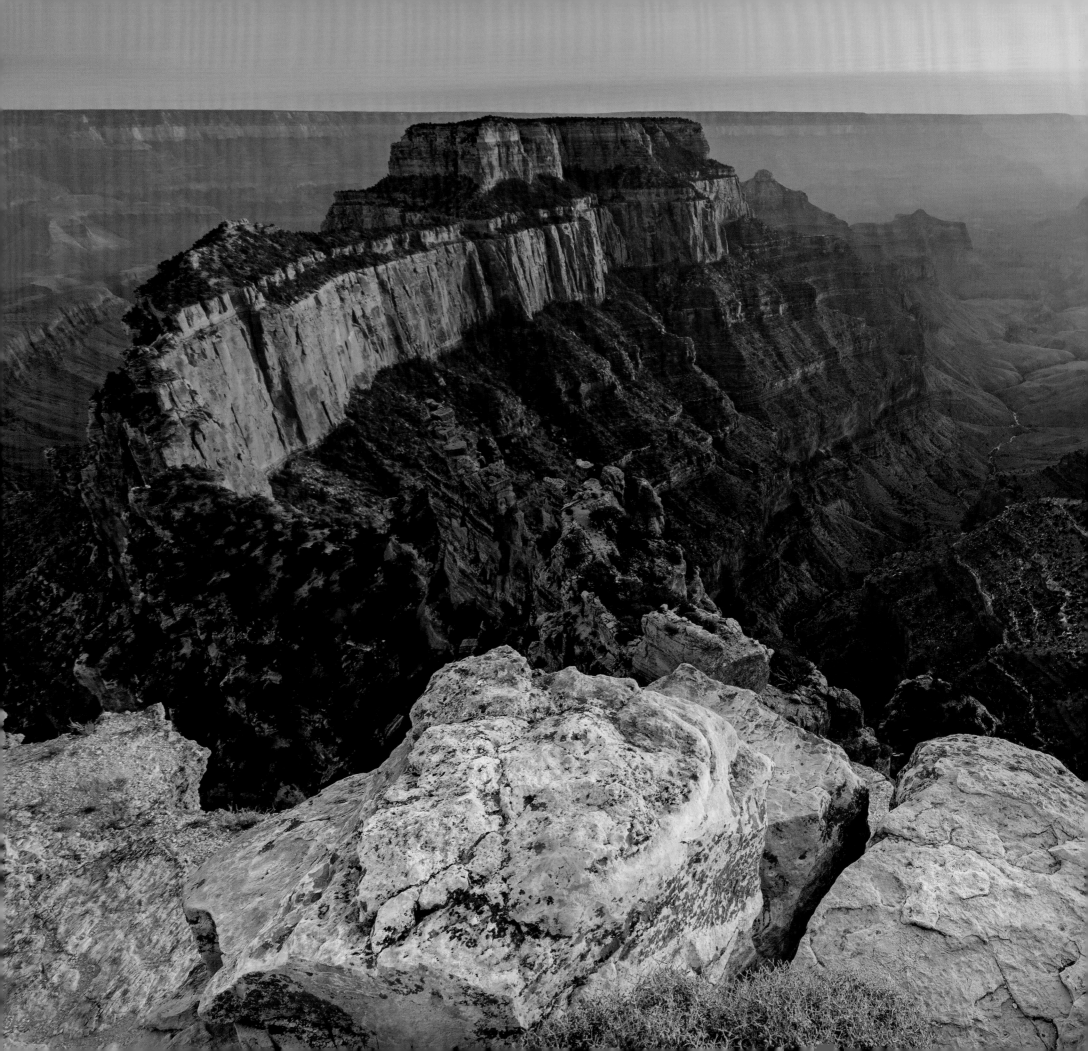

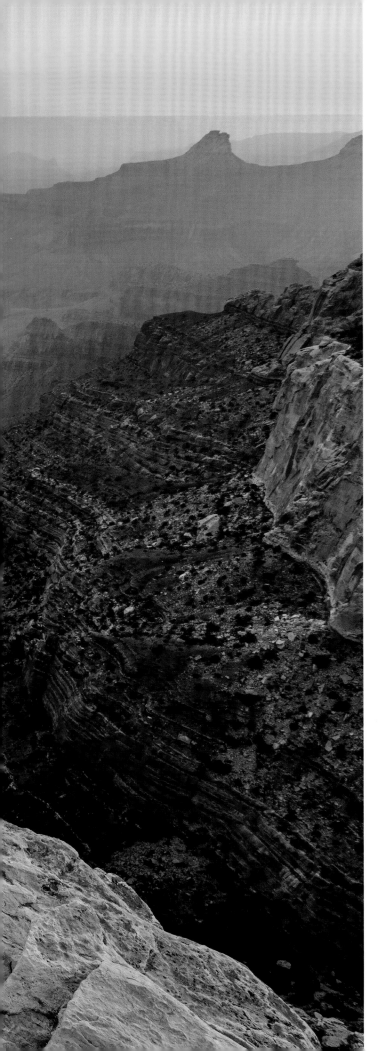

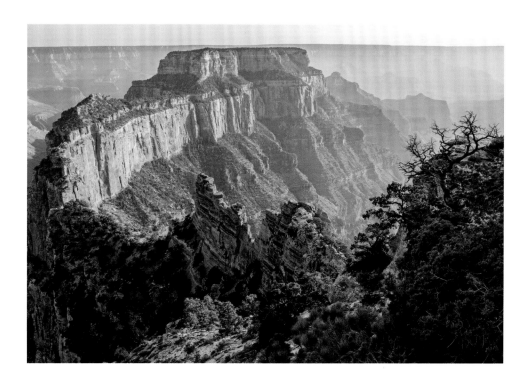

OPPOSITE AND ABOVE: Grand Canyon National Park, Arizona
As the light changes, the park transforms.

FOLLOWING PAGES: Death Valley National Park; California, Nevada
Sunrise on Zabriskie Point.

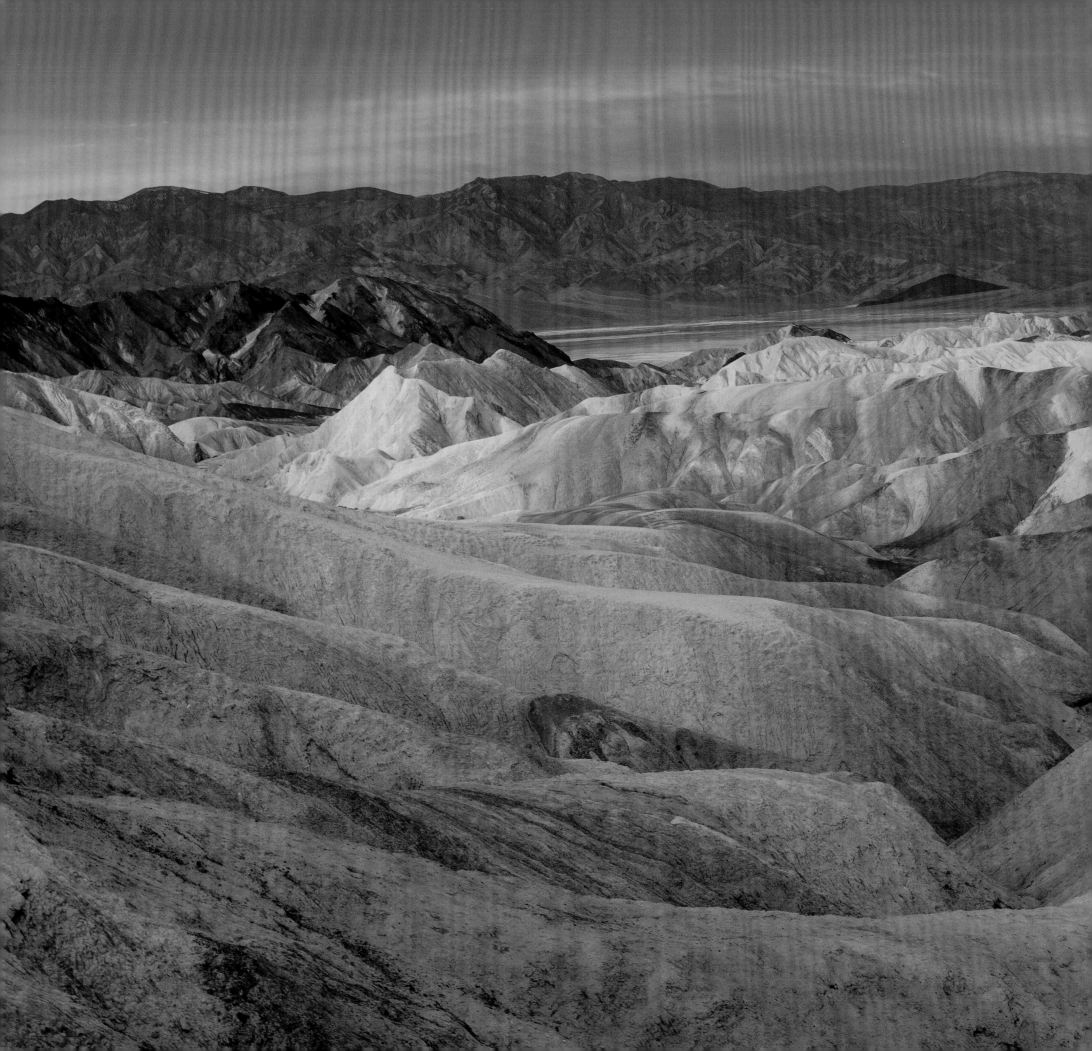

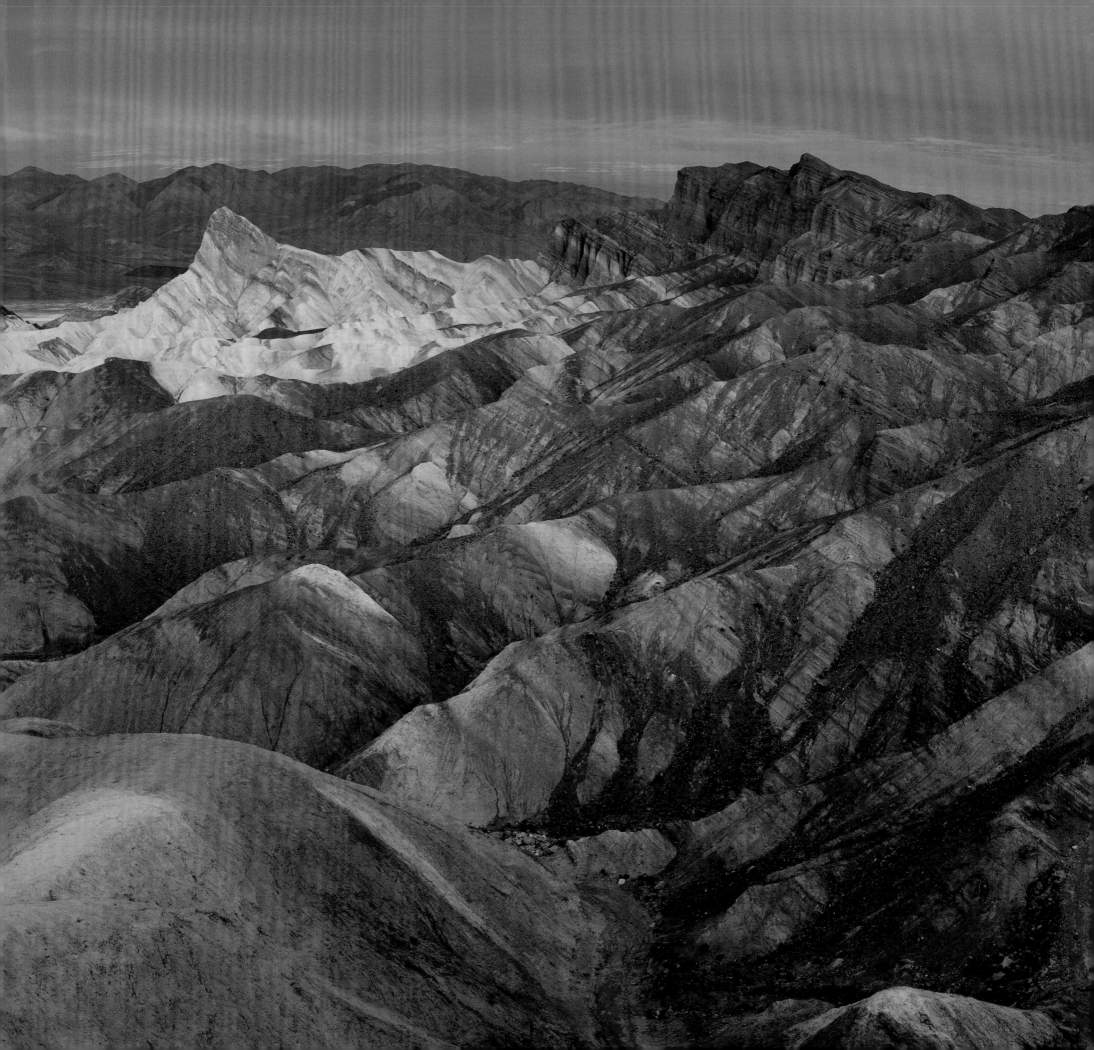

INDEX

Acadia National Park, Maine
60–61, 62, 63

Apostle Islands National Lakeshore, Wisconsin
32–33

Arches National Park, Utah
188–189, 206–207, 208–209, 212–213

Bandelier National Monument, New Mexico
117, 122–123, 124–125

Big Bend National Park, Texas
119

Bryce Canyon National Park, Utah
190–191, 193

Canyonlands National Park, Utah
226–227

Capitol Reef National Park, Utah
192–193

Chaco Culture National Historical Park, New Mexico
204, 205

Channel Islands National Park, California
4, 10–11, 12–13, 19, 24, 26–27, 28, 29, 30–31, 40–41, 42–43, 52–53

Crater Lake National Park, Oregon
2–3

Death Valley National Park; California, Nevada
219, 220–221, 222–223, 224, 225, 232–233, 240

Denali National Park and Preserve, Alaska
1, 6–7, 48–49, 91, 148–149, 150–151, 152, 153, 154–155

Everglades National Park, Florida
162–163, 164–165

Flathead National Forest, Montana
86–87

Glacier National Park, Montana
59, 132, 160–161, 166–167, 168–169, 170–171, 172–173, 174–175

Golden Gate National Recreation Area, Marin Headlands, California
46–47, 70

Grand Canyon National Park, Arizona
230–231

Grand Teton National Park, Wyoming
71, 172, 180–181

Great Sand Dunes National Park and Preserve, Colorado
187, 194, 216–217, 218

Great Smoky Mountains National Park; North Carolina, Tennessee
132–133, 134–135, 136–137, 238–239

Gunnison National Park, Colorado
228–229

Haleakalā National Park, Maui, Hawai'i
16–17, 126, 127, 128–129

Hawai'i Volcanoes National Park, Hawai'i
130–131, 142

Joshua Tree National Park, California
116–117, 120, 121, 208

Kenai Fjords National Park, Alaska
88, 89, 137

Lake Clark National Park and Preserve, Alaska
178, 179

Lake Mead National Recreation Area; Arizona, Nevada
106–107, 235

Mount Rainier National Park, Washington
8, 25, 58, 64–65, 66–67, 68–69, 144–145, 146–147, 151, 156

Olympic National Park, Washington
34, 35, 36–37, 38–39, 44, 45, 50

Organ Pipe Cactus National Monument, Arizona
110–111, 112, 114–115, 118

Petroglyph National Monument, New Mexico
213

Rocky Mountain National Park, Colorado
157, 158–159

Santa Monica Mountains National Recreation Area, California
13

Saguaro National Park, Arizona
182–183, 184, 185, 186, 214

Sequoia National Park, California
90, 138–139, 140–141, 143, 160, 210–211

White Sands National Monument, New Mexico
195, 196, 197, 198–199, 200–201, 202, 203, 215, 236–237

Yellowstone National Park; Idaho, Montana, Wyoming
15, 22–23, 72–73, 92–93, 94–95, 96–97, 98–99, 176, 177

Yosemite National Park, California
21, 50–51, 54, 55, 56, 57, 74–75, 76, 77, 78–79, 80–81, 82, 83, 84–85, 92, 228

Zion National Park, Utah
100–101, 102–103, 104, 105, 108–109, 113

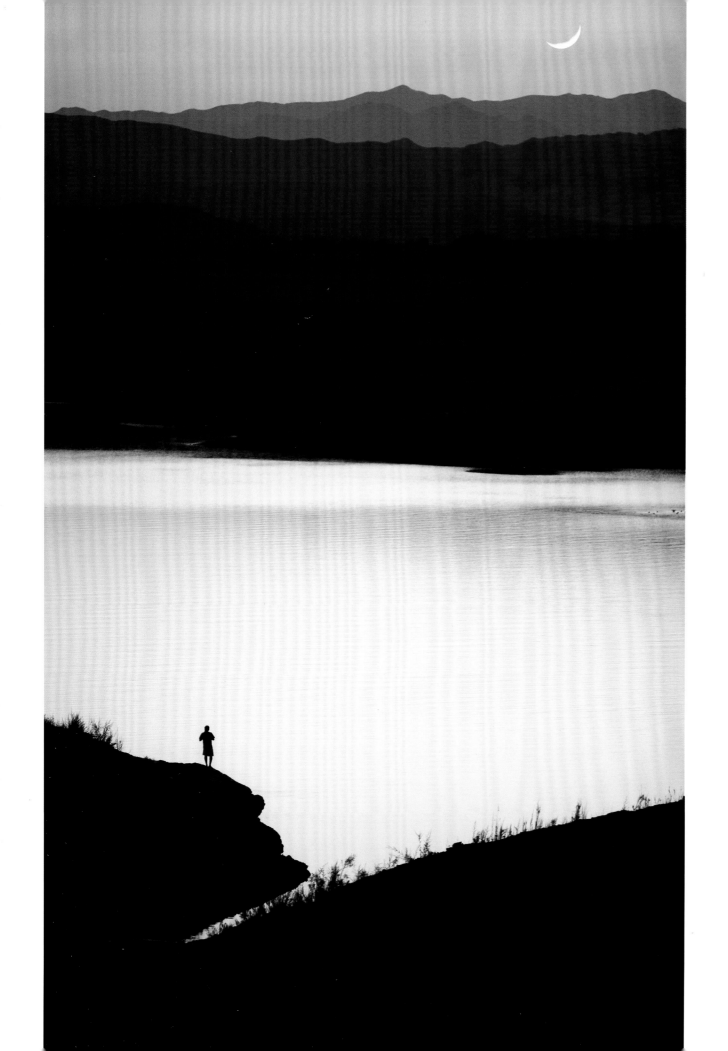

LEFT: Lake Mead National
Recreation Area; Arizona, Nevada

FOLLOWING PAGES: White Sands
National Monument, New Mexico

235

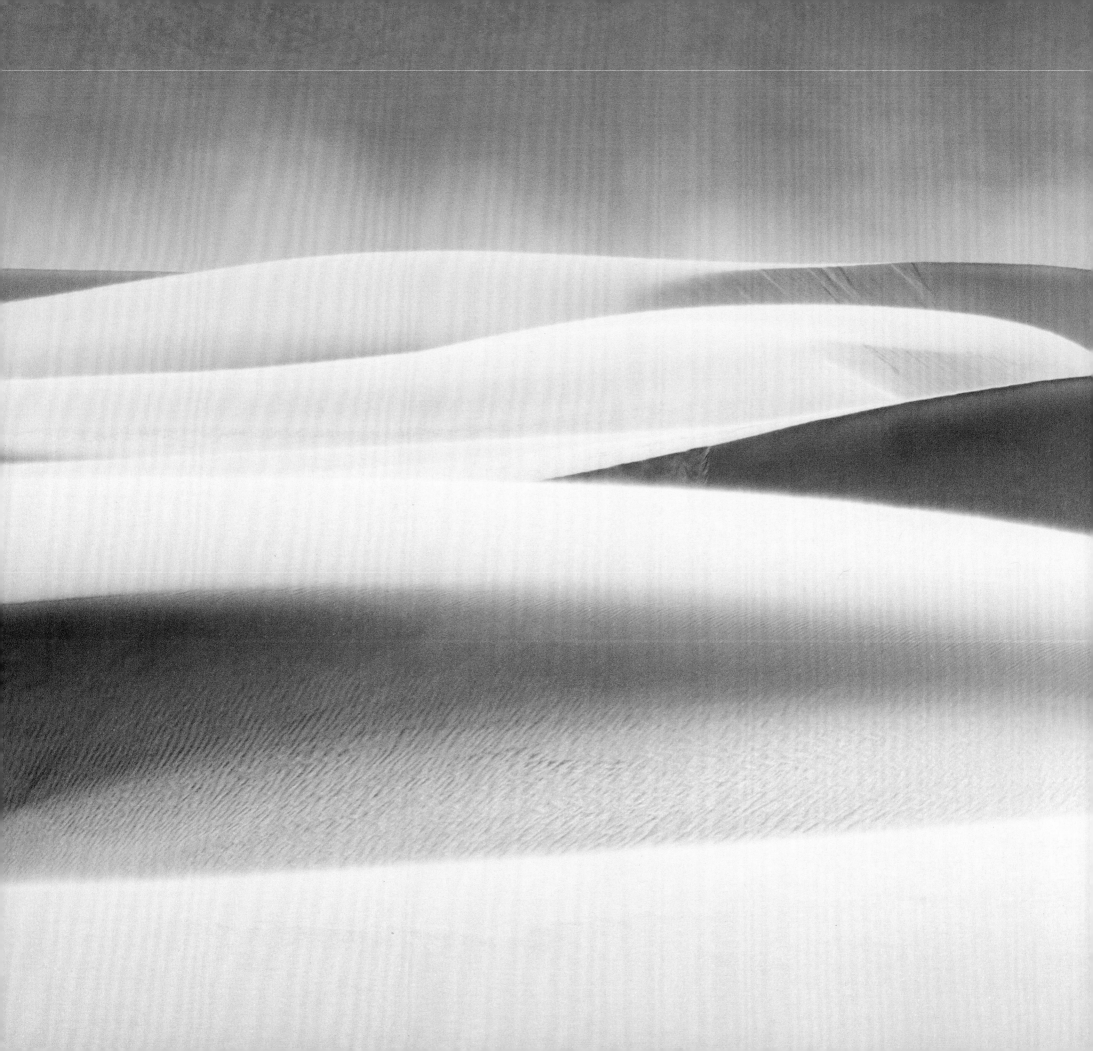

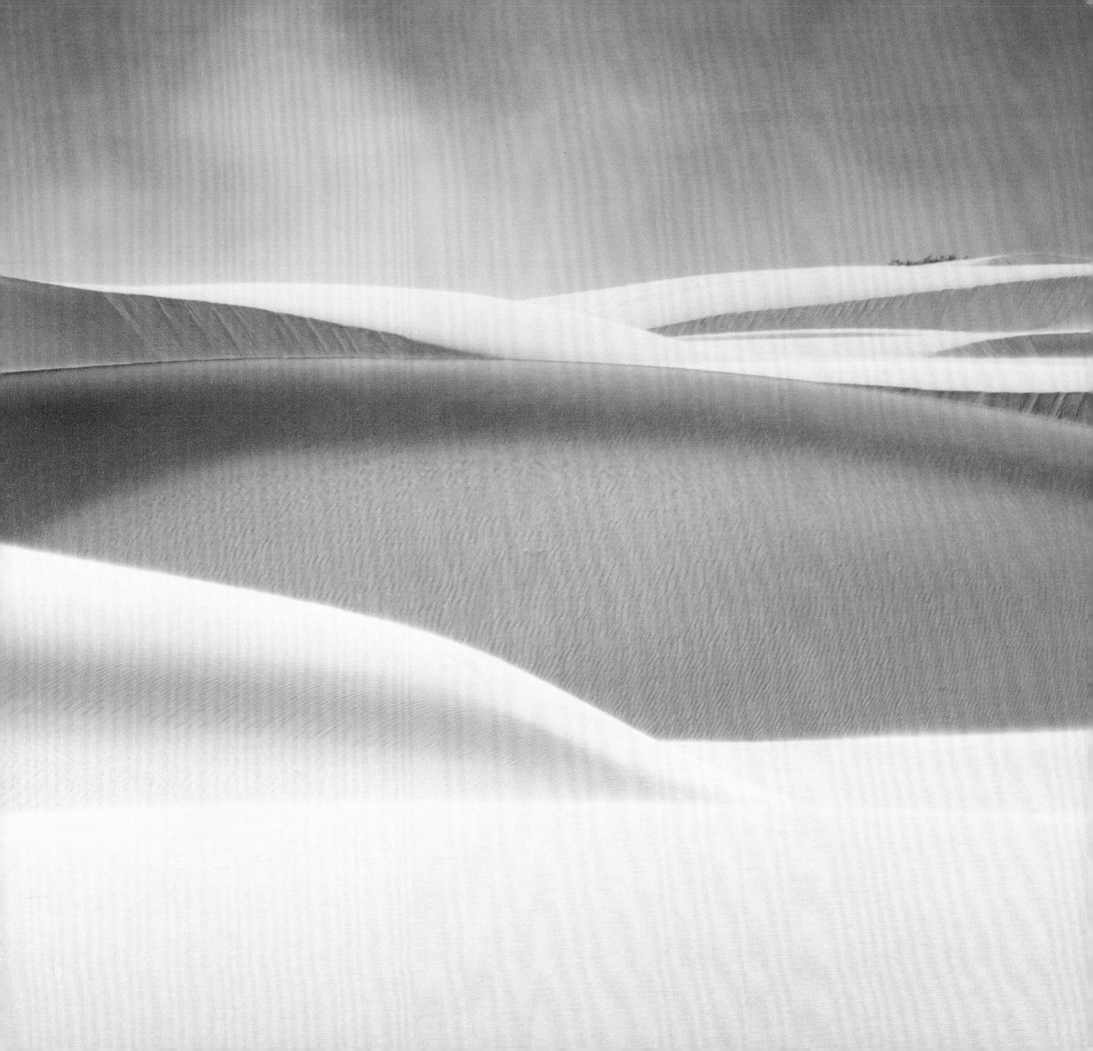

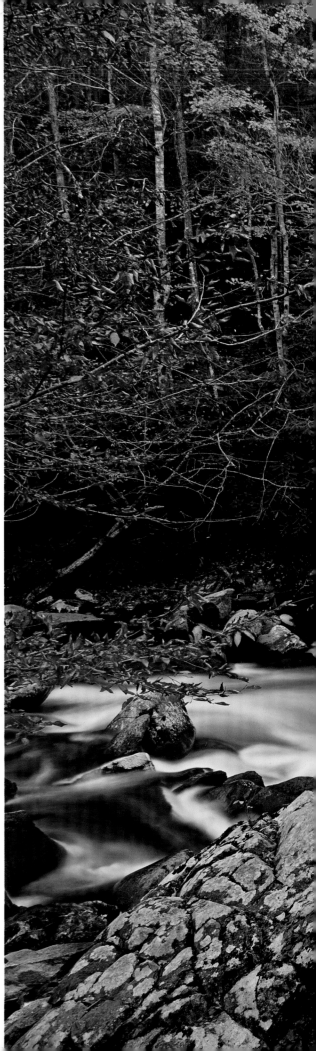

ACKNOWLEDGMENTS

A warm and heartfelt thanks to everyone in the National Park Service for your commitment to preserving our natural and cultural resources and the values of the National Park System for the enjoyment, education, and inspiration of this and future generations. I would like to give a special thanks to those individuals within the National Park Service who extended their support to the numerous assignments and special projects that I have had the opportunity to undertake, especially at Denali National Park and Preserve, Alaska, and Channel Islands National Park, California.

I would also like to thank my colleagues at Tandem Stills + Motion, Inc. in Culver City, California—Jon-Paul Harrison, Ian Maliniak, Nick Merwin, and Erika Nortemann—and all of the magazine editors, photography professionals, and daring spirits who sometimes just tagged along for a wild ride, including Scott Kirkwood, Amy Marquis, Melissa Ryan, Adina LoBiondo, Cat Aboudara, Eric Moore, Yvonne Stender, Axel Brunst, Jolene Hanson, Nicole Yin, and Heather Jerue. Thanks, too, to David, Carina, and Seth Luwisch for your friendship and all the Sunday dinners at your house.

I thank all of the organizations that have supported my photography, including the National Parks Conservation Association, the Nature Conservancy, Sierra Club, the Conservation Fund, NatureBridge, MercuryCSC, *Sunset* magazine, *Backpacker* magazine, *Outside* magazine, the G2 Gallery, United States Fish and Wildlife Service, the National Park Service, the National Wildlife Refuge System, and the Telluride Photo Festival.

A special thanks to the publishers of this book, Insight Editions, and their incredible team, including Raoul Goff and Dustin Jones.

Finally, I want to thank my parents for so many things, but especially for instilling in me a love of the outdoors and a creative spirit.

EARTH AWARE EDITIONS would like to thank the following conservancy groups for their contributions to this project as well as the work they do everyday as educators and stewards of the national parks.

 To learn more and get involved, visit www.evergladesfoundation.org

 To learn more about the work of the Yellowstone Park Foundation, please visit www.ypf.org.

 To learn more and become a member, visit www.friendsofthesmokies.org

 To learn more and become a member, visit www.glacierconservancy.org

 Visit www.gtnpf.org for more information about Grand Teton National Park Foundation. Find us on Facebook or on Instagram at @grandtetonfoundation.

 To learn more and get involved, visit www.friendsofacadia.org

ORGANIZATIONS SPONSORED

EARTH AWARE EDITIONS has contributed a percentage of the proceeds from *The National Parks: An American Legacy* to NatureBridge. We are also proud to support the work of the National Parks Conservation Association. The NPCA has worked for over ninety years to protect and enhance America's National Park System, and NatureBridge has provided immersive, multi-day science education programs in the National Parks for over forty years. NatureBridge is building a National Environmental Science Center in Yosemite National Park, opening in 2016 for the Park Service Centennial.

 To learn more about NPCA and become a member, visit www.npca.org

 To learn more and become a donor, visit www.naturebridge.org

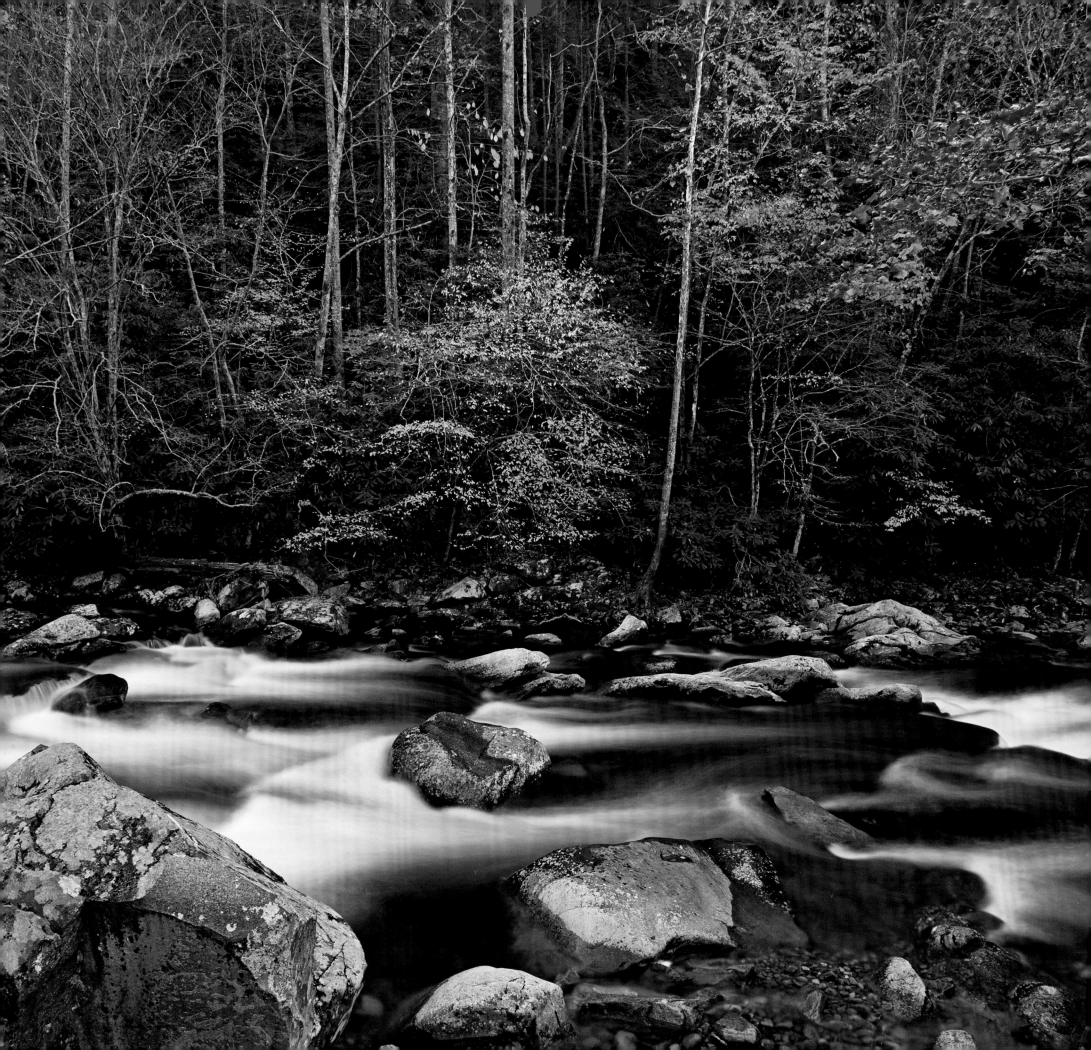

EARTH AWARE
EDITIONS

PO Box 3088
San Rafael, CA 94912
www.mandalaeartheditions .com

Published by Insight Editions, San Rafael, California, in 2015. No part of this book
may be reproduced in any form without written permission from the publisher.

Library of Congress Cataloging-in-Publication Data available.

ISBN: 978-1-60887-408-8

Publisher: Raoul Goff
Acquisitions Manager: Robbie Schmidt
Art Director: Chrissy Kwasnik
Designer: Malea Clark-Nicholson
Executive Editor: Vanessa Lopez
Project Editor: Dustin Jones
Production Editor: Rachel Anderson
Production Manager: Jane Chinn

 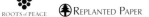
ROOTS of PEACE REPLANTED PAPER

Insight Editions, in association with Roots of Peace, will plant two trees for each
tree used in the manufacturing of this book. Roots of Peace is an internationally
renowned humanitarian organization dedicated to eradicating land mines worldwide
and converting war-torn lands into productive farms and wildlife habitats. Roots of
Peace will plant two million fruit and nut trees in Afghanistan and provide farmers
there with the skills and support necessary for sustainable land use.

Manufactured in China by Insight Editions

10 9 8 7 6 5 4 3 2 1

PAGE 1: Denali National Park and Preserve, Alaska
Hikers venture a few feet off the main park road to take in the view near Polychrome Pass.

PAGES 2-3: Crater Lake National Park, Oregon
A man stands on a cliff overlooking Crater Lake in early winter at sunset.

PAGE 4: Channel Islands National Park, California
The view from Inspiration Point on Anacapa Island.

PAGES 6-7: Denali National Park and Preserve, Alaska
Near Polychrome Basin.

page 8: Mount Rainier National Park, Washington
Skyline Trail.

PAGES 10-11: Channel Islands National Park, California
*Overlooking Scorpion Anchorage, a popular spot to kayak, swim, snorkel, and camp on
Santa Cruz Island.*

PAGE 12-13: Channel Islands National Park, California
Hikers on a guided tour of Santa Rosa Island with a National Park Service volunteer.

PAGE 13: Santa Monica Mountains National Recreation Area, California
A park ranger educates inner-city youth.

RIGHT: Death Valley National Park; California, Nevada
Salt rises to the surface in Badwater Basin creating interesting patterns and formations.

PREVIOUS PAGES: Great Smoky Mountains National Park; North Carolina, Tennessee
Little River, which flows through the Tennessee side of the park.

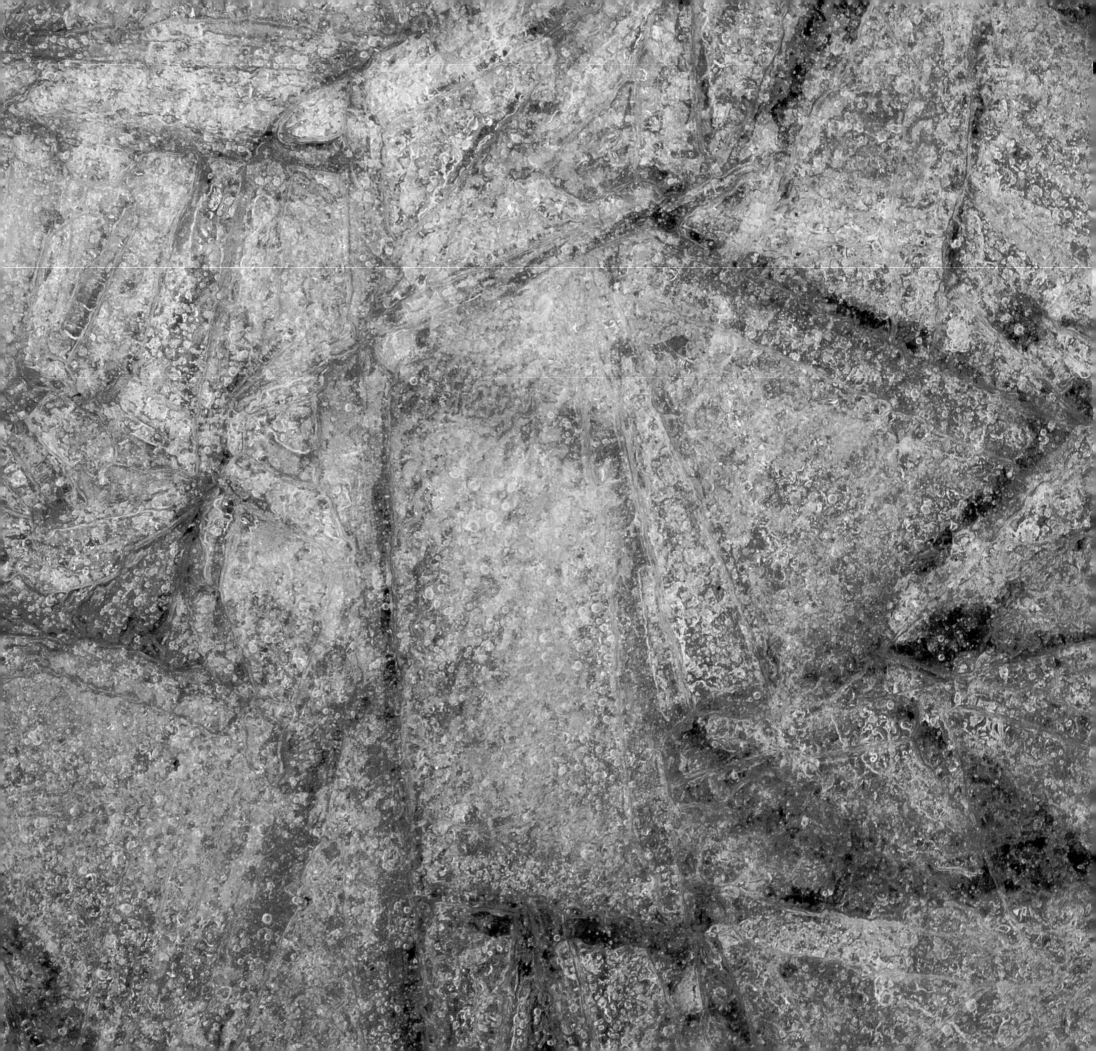